ISLAND HOMES

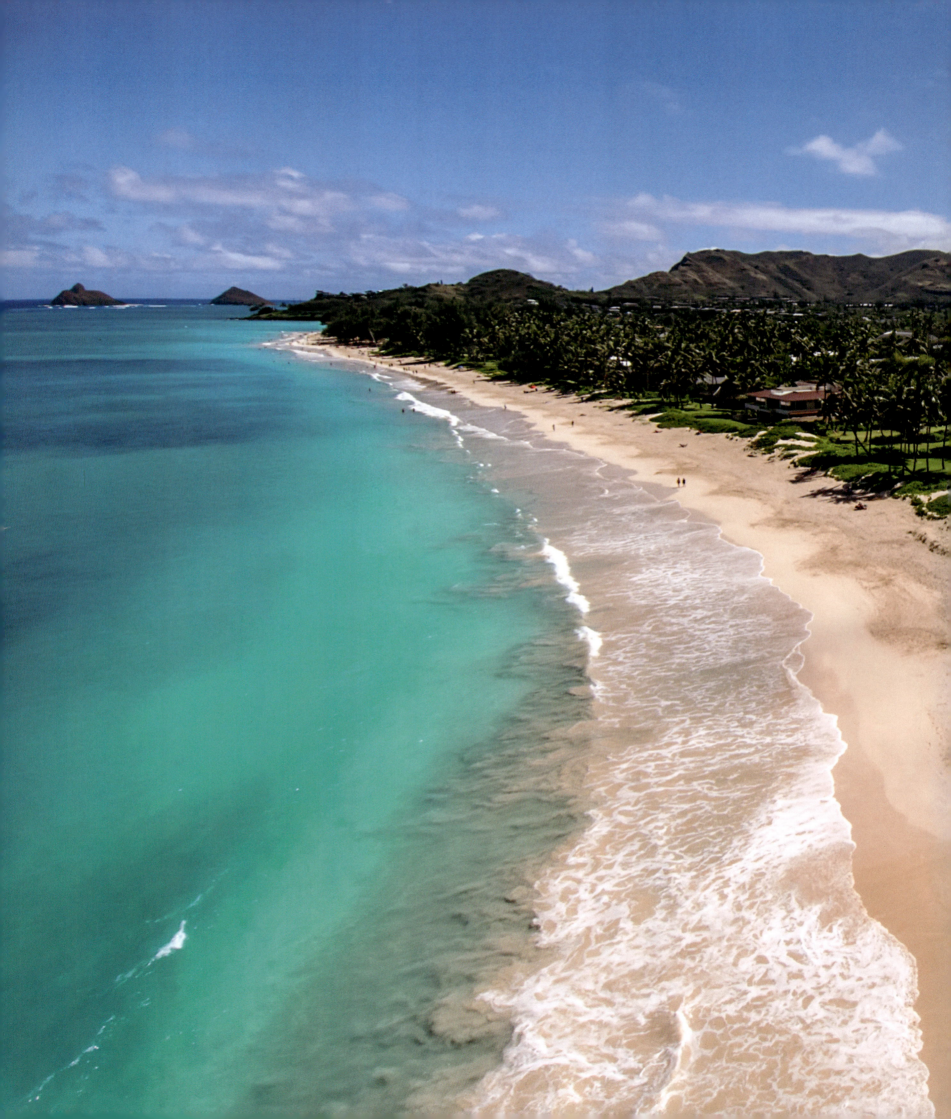

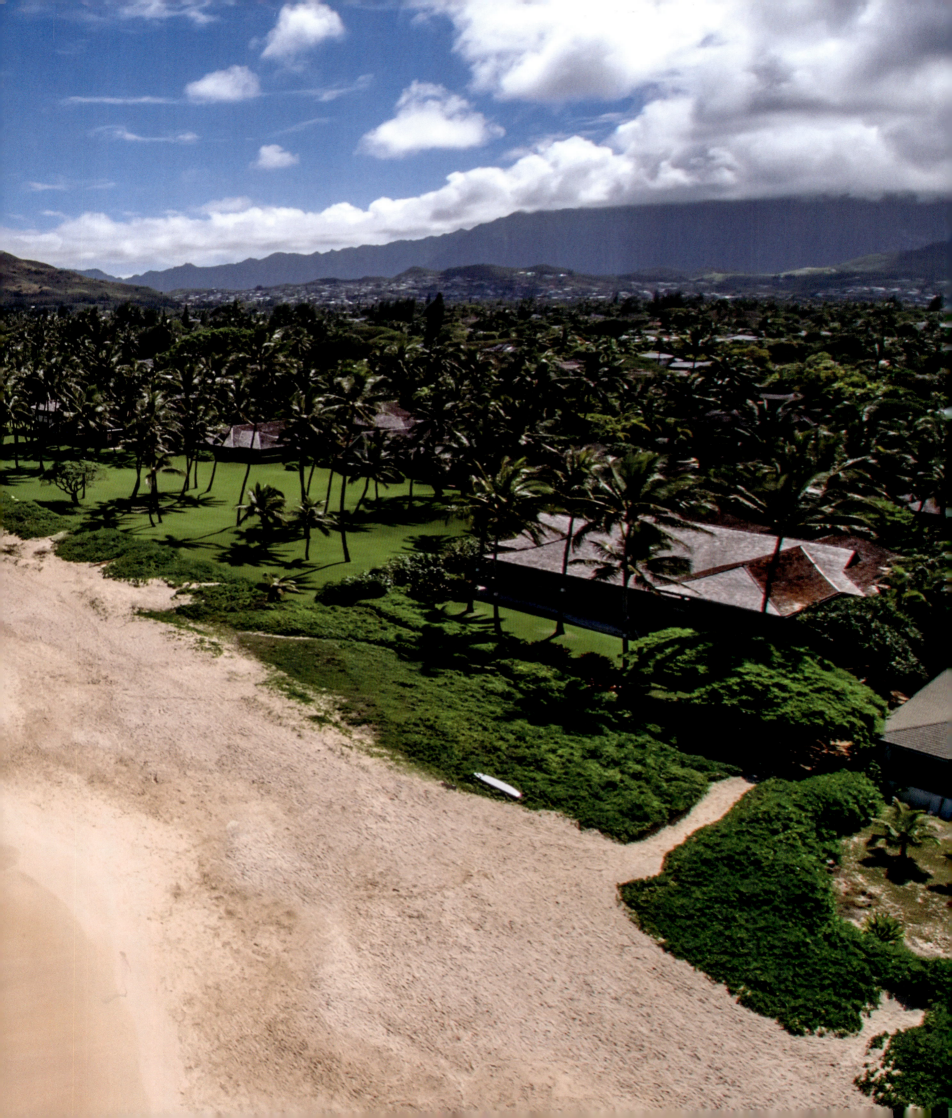

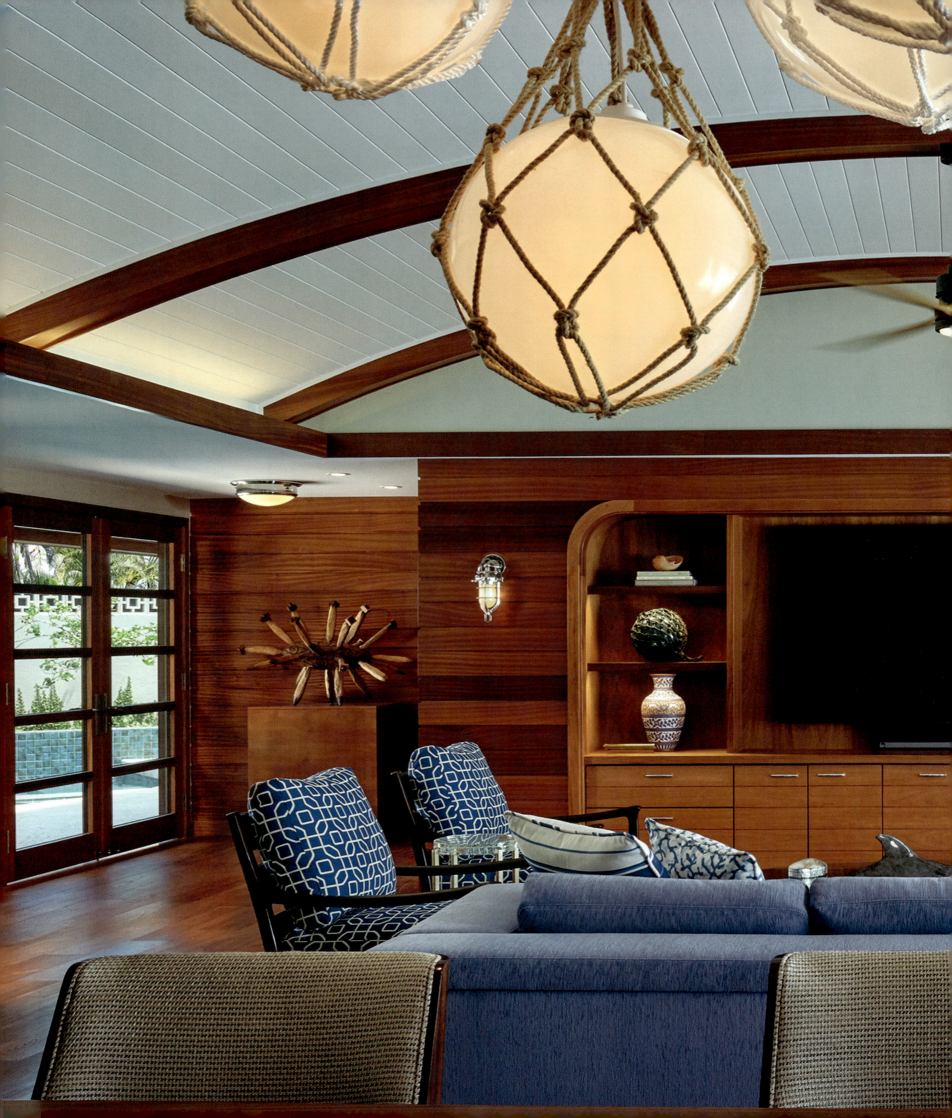

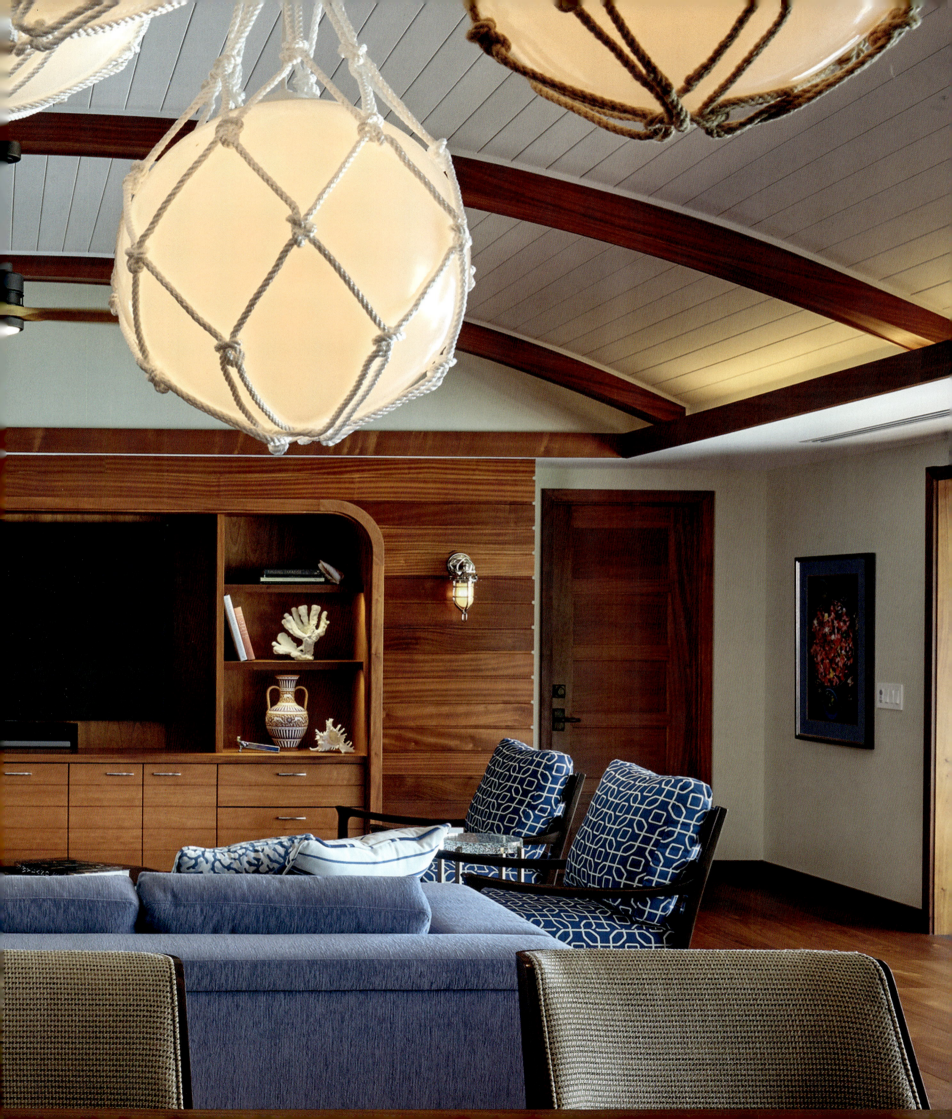

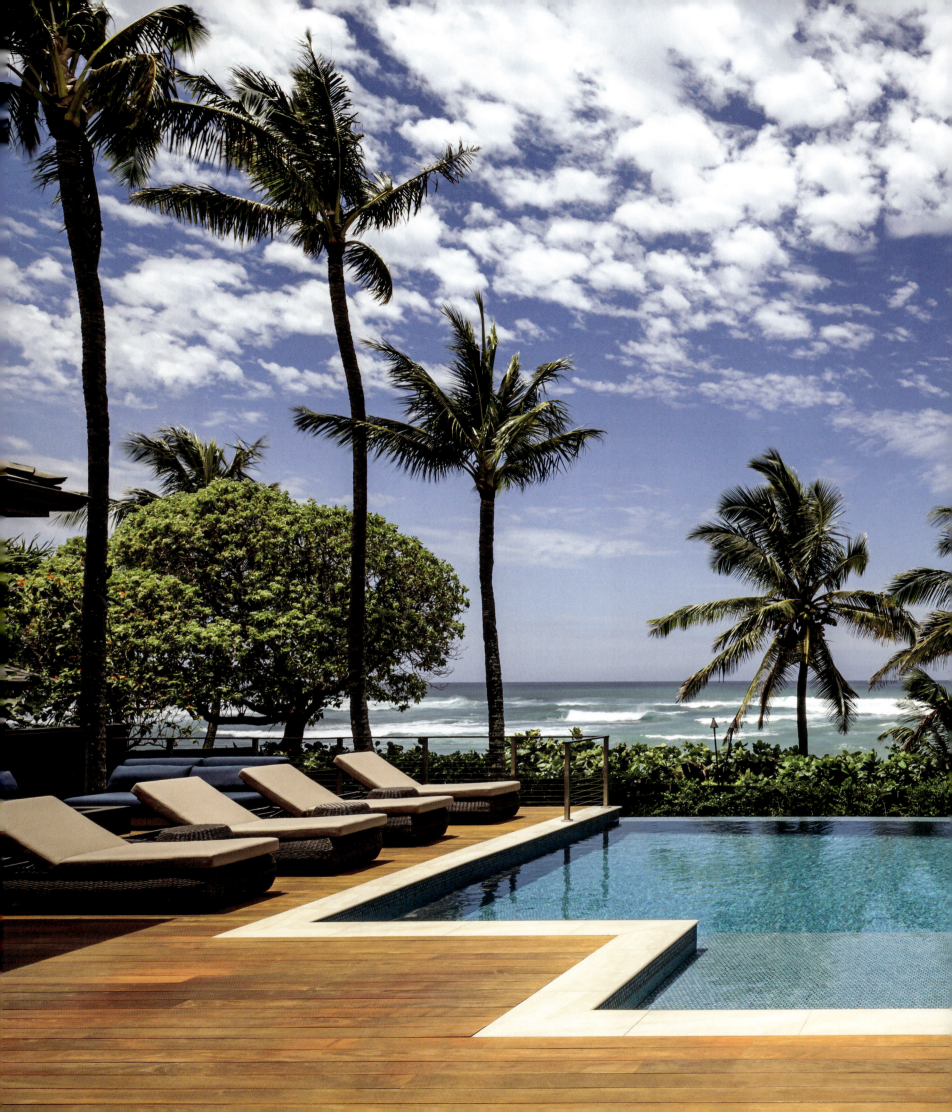

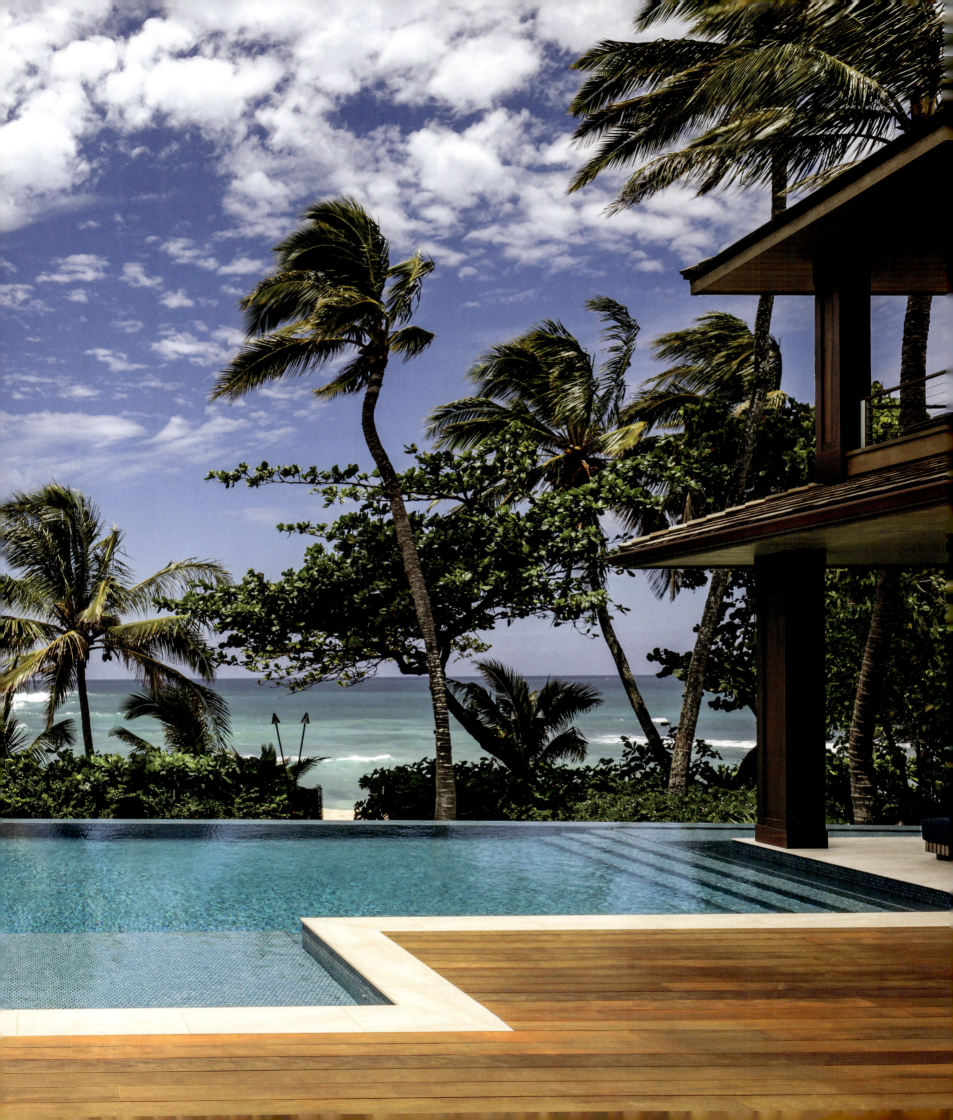

ISLAND

HOMES
CASUAL ELEGANCE IN DESIGN

PETER VINCENT ARCHITECTS

TEXT BY CLARE JACOBSON
FOREWORD BY MALIA MATTOCH MCMANUS
AFTERWORD BY DEBORAH L. STANLEY

Mahalo

To my devoted mother, Sally
To my dear friend and mentor, Jon McKee
To my beautiful wife, Catherine
To my wonderful children, Matthew, David and Sarah
To my incredible partners and awesome staff at PVA

And in loving memory of my son, Christopher

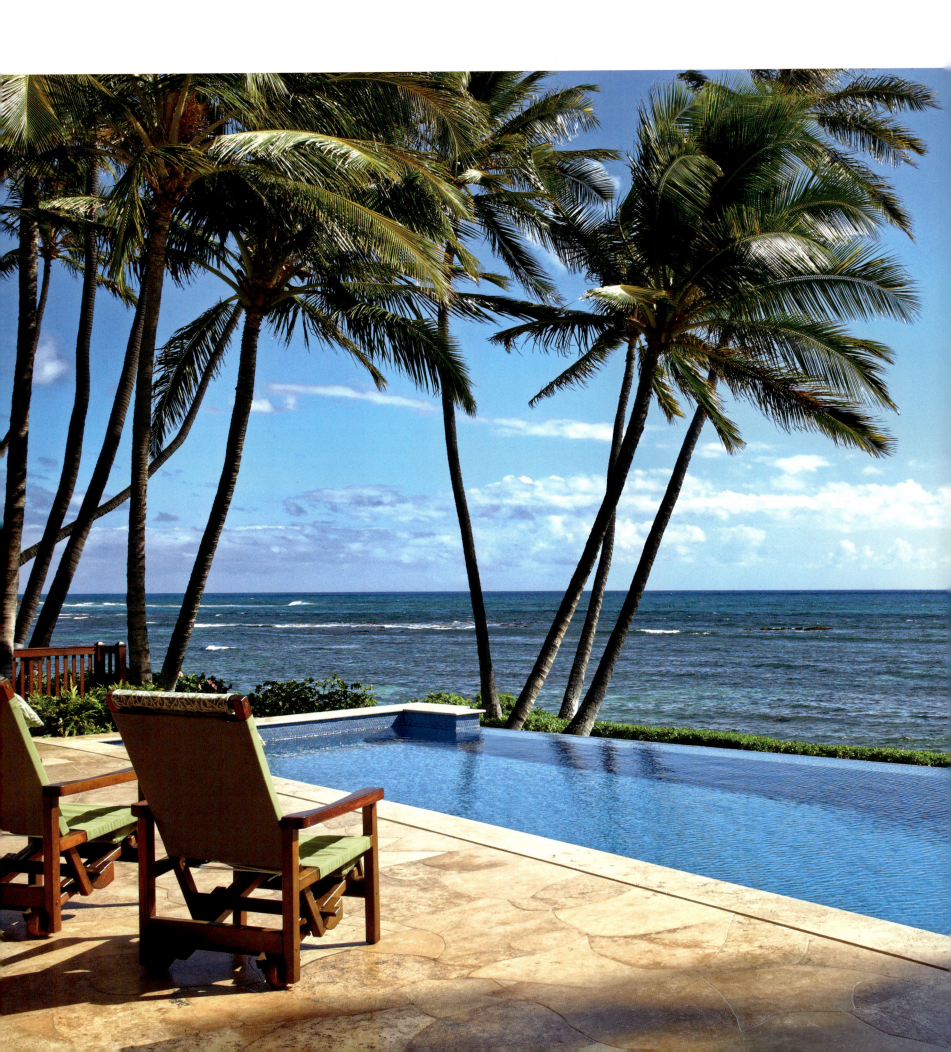

CONTENTS

Foreword, *Malia Mattoch McManus* 15
Introduction, *Peter N. Vincent*, FAIA 17

New Homes 18

Lualaʻi 24
Waiʻalae Residence 46
Hale Palekaiko 58
Los Gatos Farmhouse 74
Venice Modern Residence 92
Haleakalā 106

Renovations 132

Tantalus Residence 138
Nā Manu ʻEhā Residence 150
Mokulua Hillside Residence 162
Koko Kai Cliffside Residence 174
Honolulu Hillside Residence 192

Public Spaces 208

Kobayashi and Kosasa Family Dining Room 214
Hoakalei Golf Course Clubhouse 220
Koʻa Kea Hotel and Resort 226
Bank of Hawaiʻi Pearlridge 232

Afterword, *Deborah L. Stanley* 238
PVA firm bio 241
Project credits 242
Contributors 245

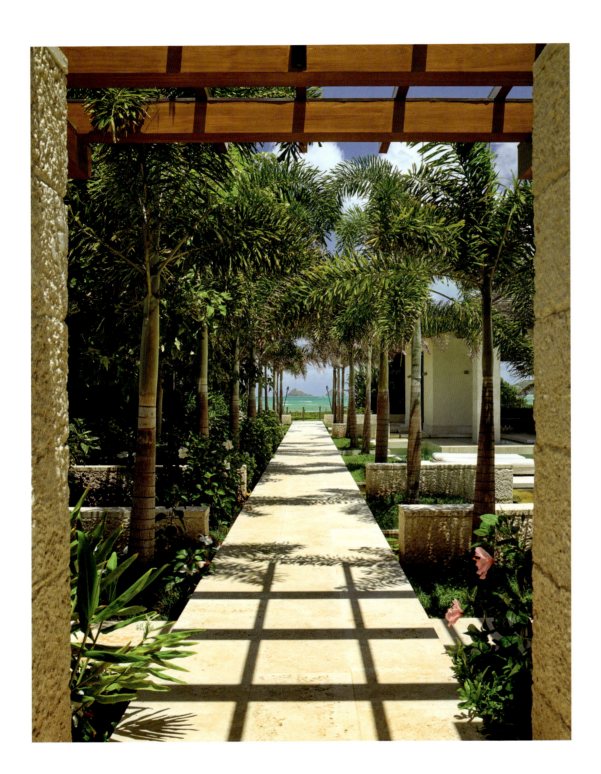

Island view from entry promenade of Luala'i

FOREWORD

Malia Mattoch McManus

The work of Peter Vincent Architects (PVA) weaves together the elements of which architectural dreams are made. White coral columns tucked into palm tree clusters. View corridors of sand dunes framed against offshore islands. PVA's signature deft, clean pattern of understatement and proportion releases the fundamentals of great Hawai'i design: shade and light, trade winds and fragrance. The works allow Hawai'i to breathe, compelling those lucky enough to live within them to be ever conscious of their setting.

"I think we were at the forefront of the move away from the McMansion era to designs that were more sympathetic to Hawai'i's culture and environment," Peter notes. "What fits here is not limited to a particular style, but it must process an understanding and respect of the site."

Each home featured in this book wins the argument that exterior space is as integral as interior space to casual living. On many of these pages, it is sublimely difficult to separate the two. Walls slide open to grass steps, fire pits, and water. Breeze flows through. Light saturated with gold moves across walls of coral, wood, stone.

"I have always loved the Hawaiian concept of having separate buildings, this idea to break massing down into small-scale elements," Peter says. In his protective hands, structure never trumps setting. His outdoor rooms are as intricate as his interiors because, on the Hawaiian Islands, celebrations and moments of reflection are likely to be made under a rainbowed sky or starry night. The exterior space serves as the splendid focus of any gathering.

PVA threads that vision throughout its work, from oceanside estates to a high-rise hospital. Its Kobayashi and Kosasa Family Dining Room gives families most in need of respite a sense of outside space by emulating the elements of the Hawaiian ahupua'a—the division of land from mountain to sea, here representing in playful colors and textures.

That ethos carries through PVA's portfolio, spanning from residential to commercial to institutional buildings. "All with strong indoor-outdoor relationships, in different ways," Peter remarks, "which is how I've come to think about architectural design." The variety of projects suggests an architectural firm twice the size of PVA.

Peter's collaborative, flexible approach creates the opportunity for quick pivots toward the fitting design, whether lavish or utilitarian, modern or traditional. "He has very good taste, and it's unusual to find an architect who does that breadth of work and is that flexible and chameleonlike," notes owner's representative Nate Smith, who collaborated with Peter on numerous luxury homes included in these pages. "He has a range to his vocabulary, and yet you can count on him to deliver a high level of design, composition, and quality."

PVA's range of contemporary and traditional forms shows itself here, whether in the Wai'alae Residence (scaled perfectly under modern shed roofs) or Lanikai Beach Grand Cottage (where shingle siding and an eyebrow dormer help define the cottage look). All bear a signature lack of ostentation and a warmth for their clients, be they a tycoon, a parent of a hospitalized child, or a customer of a surf shop.

"He's willing to venture into scopes of work other than residential design and implement vocabularies and ideas that may not be conventional," says Nate. "It sounds like that's easy, but it's challenging. When designers get into a rhythm of what they do, they tend to stay within their comfort zone. Peter embraces the challenge to tackle a variety of projects."

This book represents both a chapter in the evolution of Hawai'i architecture and its influence on design as well as a catalog of works from which future generations can draw. The fluid, harmonious style PVA puts forward in each project delivers function and luxury rendered with a trusted and graceful footprint upon this, our home in the islands. Sit in the outdoor rooms PVA has created. Take in the light and soft air it has let into every page.

INTRODUCTION

Peter N. Vincent, faia

This book is as much about the stories behind the work of Peter Vincent Architects (pva) as the architecture itself. Each project—some of which date back nearly to the beginning of my firm's thirty-year history—has its own memorable tale of the many relationships that culminated to bring it to fruition. Similarly, relationships have helped to form my personal history, and I share some of that here.

My journey in architecture began at the age of twelve, when my mother and I moved into a newly built home in Paradise Valley, Arizona. I found the blueprints of the house and became infatuated with them, scouring every detail. When my mother commissioned a swimming pool, I watched intently when the designer visited our house and drew the plans right in front of me. The spark was lit! I befriended my elementary school shop teacher, who took me under his wing and taught me drafting and woodworking. In my younger days, I also made jewelry, then ventured into landscaping, both of which influenced my later work.

The Italian visionary architect Paolo Soleri's Cosanti (the genesis to Arcosanti—a prototype ecological community in central Arizona) was right around the corner from my house, and Frank Lloyd Wright's Taliesin West was just a few miles away. My proximity to both fueled my passion for architecture.

I developed a keen interest in sustainable design, then called "passive solar architecture." Its basic principles—proper siting, orientation, solar exposure, and natural ventilation and daylighting, as well as strategic use of landscape—remain at the forefront of my firm's design work.

After attending college and working in Boston for a few years, I received a job offer to work in Rome, Italy—a dream come true for an aspiring young architect. Rome is an architectural mecca, with works of the masters at every turn. There I learned that the "background" buildings are as important as those that make a statement. My firm in Rome was led by Barry Berg, an American who had trained under world-renowned architects I.M.Pei and Richard Meier. We worked primarily on projects in Saudi Arabia, and so studied the ancient cultures and architecture of West Asia as well as design themes that respond to both the culture and the climate. We used this research to design modern interpretations of age-old traditions, and I continue to do so in much of my work today.

Later, another remarkable job opportunity presented itself, this time in Hawai'i. I made the move and immediately fell in love with the islands. I was assigned as project architect on a major renovation of the Kā'anapali Beach Hotel on Maui, which touted itself as being Hawai'i's most Hawaiian hotel. The general manager of the hotel—a seventh-generation kama'āina (native born), developed a po'okela (to strive for excellence) program for the hotel. This allowed the entire design team to attend workshops at Honolulu's Bishop Museum to learn about Hawai'i's history and culture. It was at this program that I began developing a deep respect for Hawai'i and its rich cultural heritage.

Two years later, I started pva as a sole practitioner in Honolulu's Chinatown neighborhood. The firm grew, and we've been very fortunate to have received many accolades over the years. Today I am joined by partners Michael Subiaga (a twenty-five-year veteran of pva) and Todd Hassler, aia, as well as an immensely talented staff and a cadre of consultants, builders, vendors, and craftspeople who bring our visions to reality.

pva's overarching design goals remain true to my roots—to have a clear understanding of each client's objectives and to develop designs that not only meet their needs but also draw upon the unique characteristics of each location. Our work emphasizes integration into the site and the creation of a strong relationship between interior and exterior spaces.

The diversity of pva's work is by design. We embrace the varied challenges each unique project brings. And we endeavor to create thoughtful, timeless work—regardless of project type or style—that is in harmony with its surroundings. The Hawaiian term mālama 'aina, meaning to take care of the land, is a goal that we strive to incorporate into projects that now extend beyond our island home.

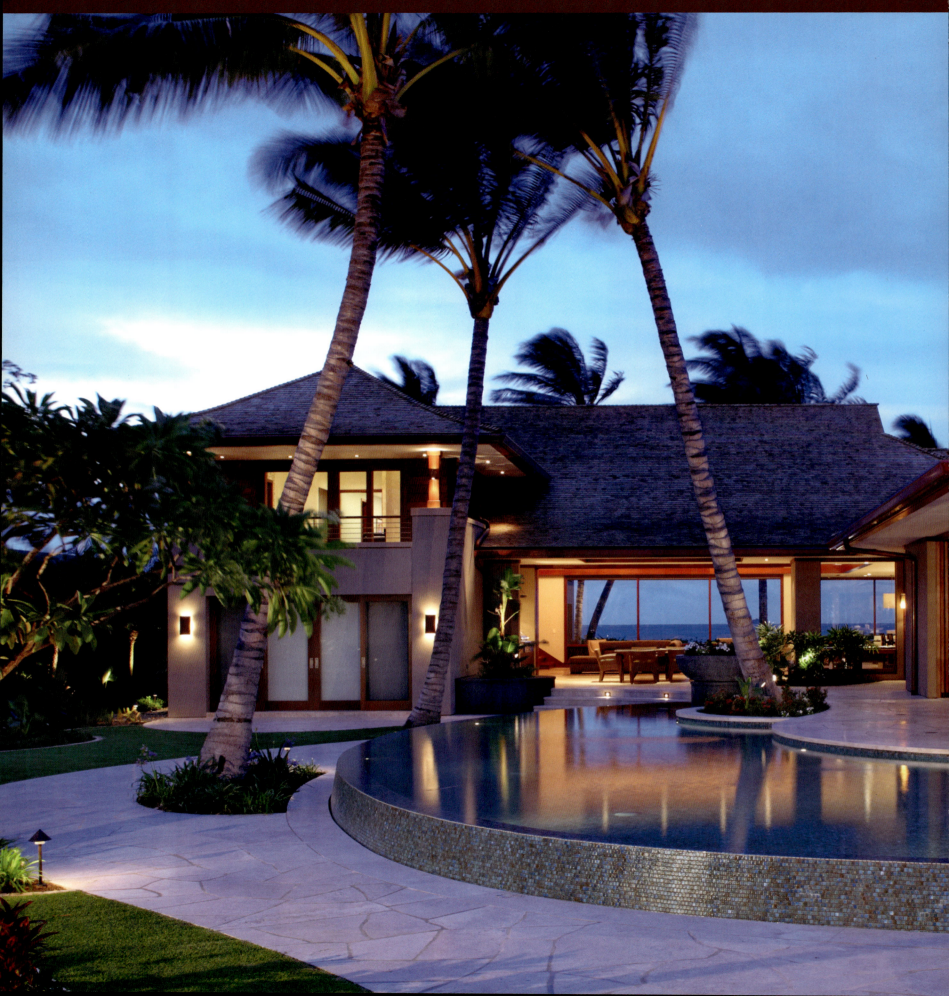

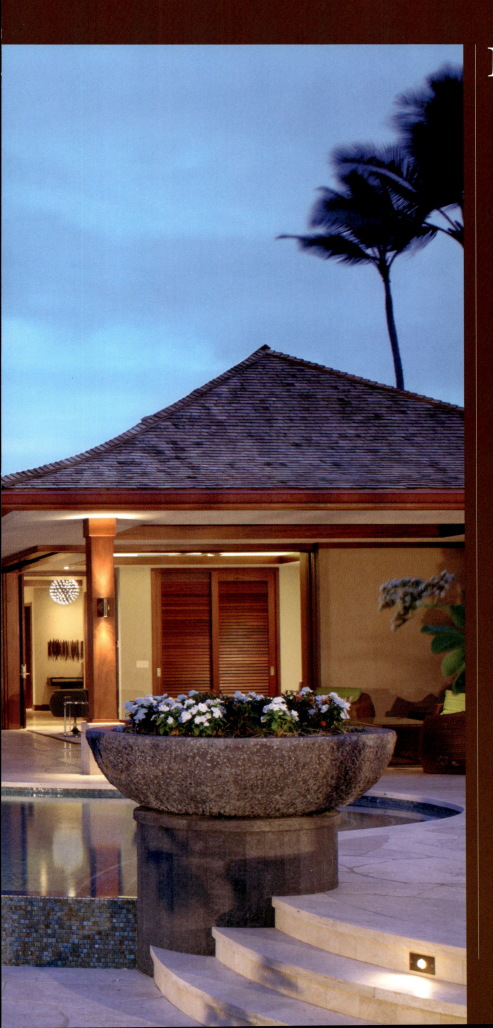

NEW HOMES

"I have very eclectic tastes in art, design, and music—an appreciation for a variety of tastes," says Peter Vincent, "and I enjoy that in architecture as well. I really love both modern and traditional work, and many things in between."

Peter's architecture and interior design firm, Peter Vincent Architects (PVA), is similarly not stuck in one trend. As the new homes in this chapter show, the firm's aesthetic combines what its designers find valuable at a site with what they appreciate about contemporary architecture. Each work responds to the context of its location, and the particularities of its site, the desires of its client, rather than some preordained type.

Part of PVA's eclecticism may have to do with Peter's background. His early years—ten years in Washington, DC, ten in Paradise Valley, Arizona, and five in Boston, Massachusetts—exposed him to a wide variety of buildings and aesthetics. During a break from studies at the Boston Architectural Center (now Boston Architectural College), Peter spent some time in Tuscany, where he helped to research and document an eleventh-century castle. "I've drawn Tuscan columns as they are supposed to be drawn," Peter says, "and I will not say I'm an expert in classical architecture, but I do understand its basic proportions." For PVA, these proportions are important regardless the style of its design. Proportions are inherent to PVA's modern work as much as its traditional homes. They even influence the rustic design of the Los Gatos Farmhouse (see page 74), where doors and windows have a rigorous alignment with the wood battens. Peter recalls that a landscape architect once told him that a house's proportions are what identify it as a PVA design.

After working in Boston, Peter moved to Rome, Italy. There, among other projects, he worked as a job caption for a large villa in Jeddah, Saudi Arabia. "It was about 55,000 square feet," he says, "all marble clad, very elaborate, onyx dome in the center." The design was based on a traditional Palladian four-square plan, but it was developed in a contemporary manner. In one room, Peter recalls, "We had these round oculus windows on one side so that the light would come in at an angle at a certain time of the day." The design was meant to mimic daylight streaming into souks, West Asian markets. "And then this interior firm came in and they put up heavy curtains around and covered all these windows." Peter and his colleagues were

MAUNALUA BAY ESTATE
Honolulu, Oʻahu, Hawaiʻi, 2002

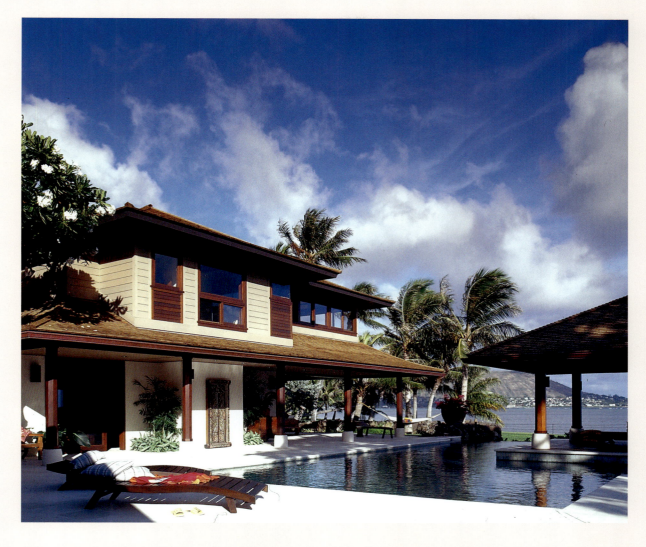

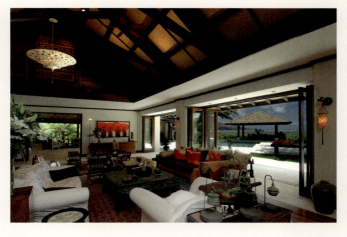

PVA's early work shows many of the defining elements seen in the more recent homes featured in this chapter. Take the Maunalua Bay Estate—PVA's first significant residential project. "The clients interviewed a few architects, but we just hit it off," Peter recalls. "I had done some residential work—nothing that grand—but I think they felt good about me." They felt good enough to take him on a trip to Bali. "They loved Bali," Peter says, "and wanted the house to be influenced by that." Some of the architectural ideas Peter found there—entrances that create privacy and a sense of surprise, beautifully crafted stone and wood, outdoor baths protected by high walls—influenced not only the Maunalua Bay Estate but also later PVA works. And the project's village-like concept of small indoor-outdoor structures, where each has a particular use, had effects beyond PVA's work. "I think it became kind of a new direction for Hawaiʻi," Peter says. He recalls that luxury homes built just before this project were typically showy, with elements like grand stairways in the entry foyer and two-story, shimmering drapes. "When something that felt right for Hawaiʻi, something that connoted island culture, started coming into being, it really caught on," Peter says. "It's not so much about the style as it is about a climactic response, and something that feels like it fits in too." Peter admits the importance of this design to PVA. "The experience was great," he says, "so I really used this house as a bit of a springboard for more projects." The clients also apparently feel PVA's approach worked. After twenty years, they remain the owners of Maunalua Bay Estate.

understandably unhappy; the interior design had upended the architectural intention. In his own firm he seeks to create a cohesion between the architecture and the interiors. PVA staff either designs the interiors or collaborates with outside firms to achieve a unified look. The team might design around a client's existing art collection or furniture, or it might custom select objects that work specifically with the architectural intention.

Peter then returned to Boston, where he worked for a small firm on the new headquarters for Ocean Spray Cranberries. "They wanted a real colonial building because of their heritage," Peter recalls, "and we tried to make it a more contemporary colonial building, which makes sense for a 165,000-square-foot, three-story office building." PVA similarly balances different aesthetics into one cohesive design, as can be seen in Haleakalā (see page 106), which combines rich, traditional elements with light, contemporary ones.

Eventually Peter found work in Hawaiʻi. "I just sort of ended up here by happenchance," he says. "It was just one of those things in life, and it turned out to be a good thing." One job led to another, and Peter founded his own firm in 1992. "Hawaiʻi is an easy place to love, of course," says Peter, "and like other experiences there was a significant culture here." PVA incorporated some local aesthetics, such as geometric patterns, into its work. The Hawaiian climate influenced his work as well. "I really got into trying to blur the boundaries between the inside and the outside," Peter says. "The lānai—an outdoor room that generally is covered—is very much part of our designs." For PVA, outdoor living areas are not bits of leftover space around the house, but rather shaped places that are integrated with the larger design. "You don't sense that there's any barrier," Peter says. "There's very little differentiation between going from an inside space to the covered lānai to under a trellis where it's partially shaded and then to the exterior." The connection between indoor and outdoor is essential in PVA's work not only in its projects in in Hawaiʻi but also in those in other agreeable climates, such as California.

The specific site, client, and program of a project makes each custom-built home that PVA designs unique. Unlike firms that replicate a look from one house to the next, PVA prides itself in its variety. "I guess the common thread is just the quality of our design overall and how well the detailing is implemented," says Peter. He notes as an example how the roof meets the wall at the Venice Modern Residence (see page 92). The client was interested in a Scandinavian-style design, which required a crisp line at the juncture. For some this simple job might seem simplistic, but PVA knew it would take thoughtful detailing and exacting construction to get it right.

The informal attitude of the Venice Modern Residence is another common thread in many PVA projects. "I have very few people come and say we really want a showplace," says Peter. "Most people say, 'We want it more understated, and we want it comfortable, but high quality and durable.'" He continues, "But that's Hawaiʻi, people are here to relax. And so, they really want something kind of casually elegant."

LANIKAI BEACH GRAND COTTAGE
Kailua, Oʻahu, Hawaiʻi, 2002

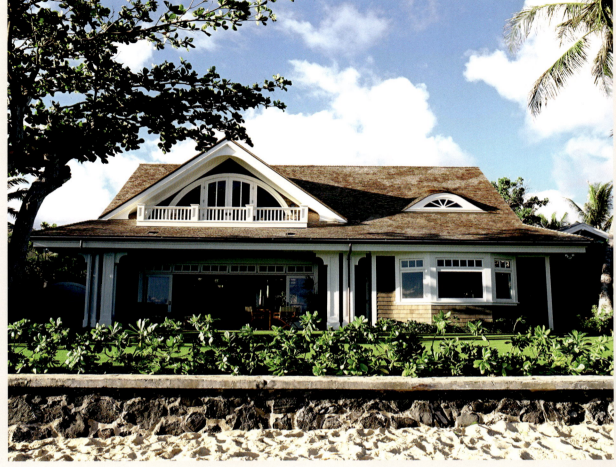

Another early work, Lanikai Beach Grand Cottage, shows additional design ideas that would develop at PVA. The house espouses a beautiful yet unassuming presence in Lanikai, a neighborhood that was heading in a different direction. "People were building big homes—McMansions, if you will," says Peter. "I really wanted this home to be more akin to what the community was when it was developed, which was beach cottages." This cottage is designed around a central outdoor courtyard. The bulk of it fits onto a single floor, and roof dormers provide second-floor space. Shingle siding and a playful eyebrow dormer add to the cottage look. The design was well received by its neighbors. "People just liked it," Peter says. "It had a warmth and friendliness about it." To complete the cottage style, PVA worked with the client on the interiors. "We did all the furniture and fabrics," says Peter. "We even selected the china." When the original owners sold the house, the new occupants commissioned PVA to renovate it—a precursor, of sorts, to the PVA renovations discussed in the next chapter. "The house has undergone some transformations in the nearly twenty years since it was built," Peter says, "but it still has its original character and charm."

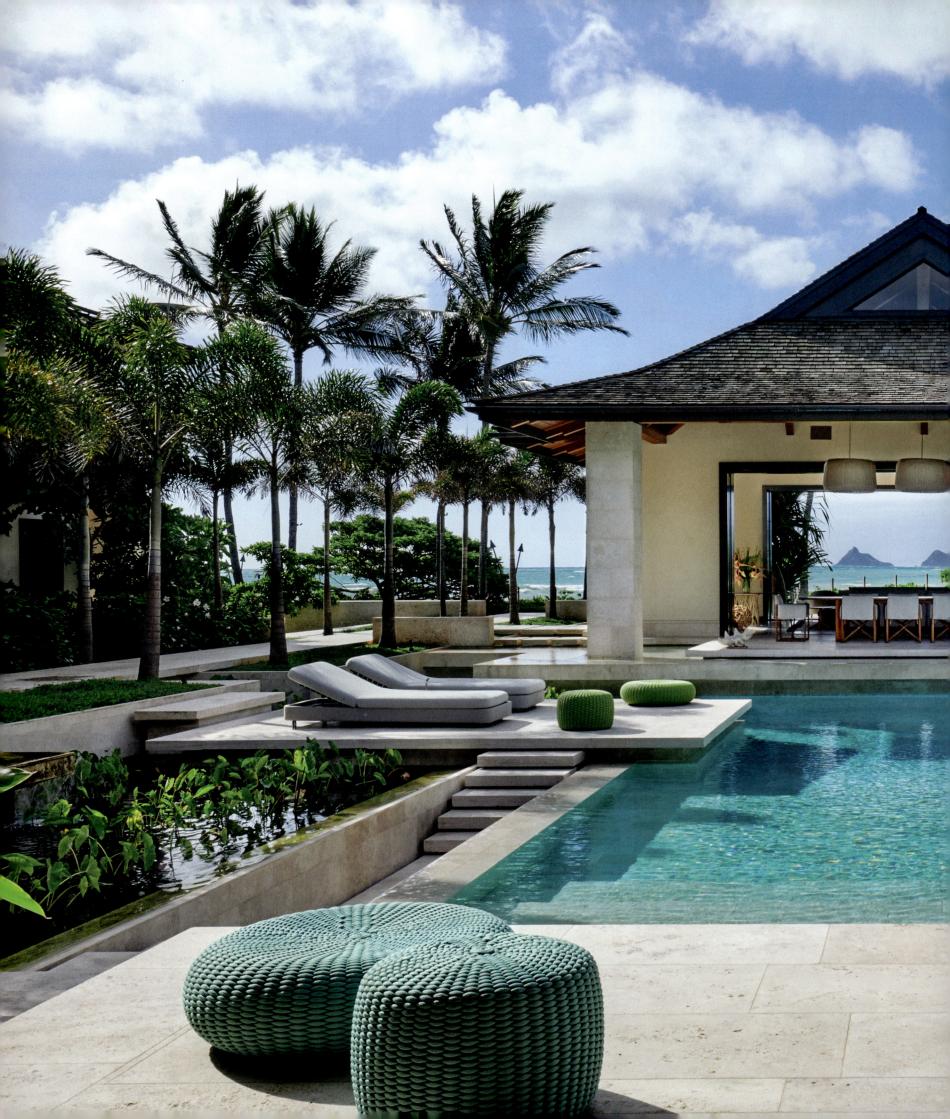

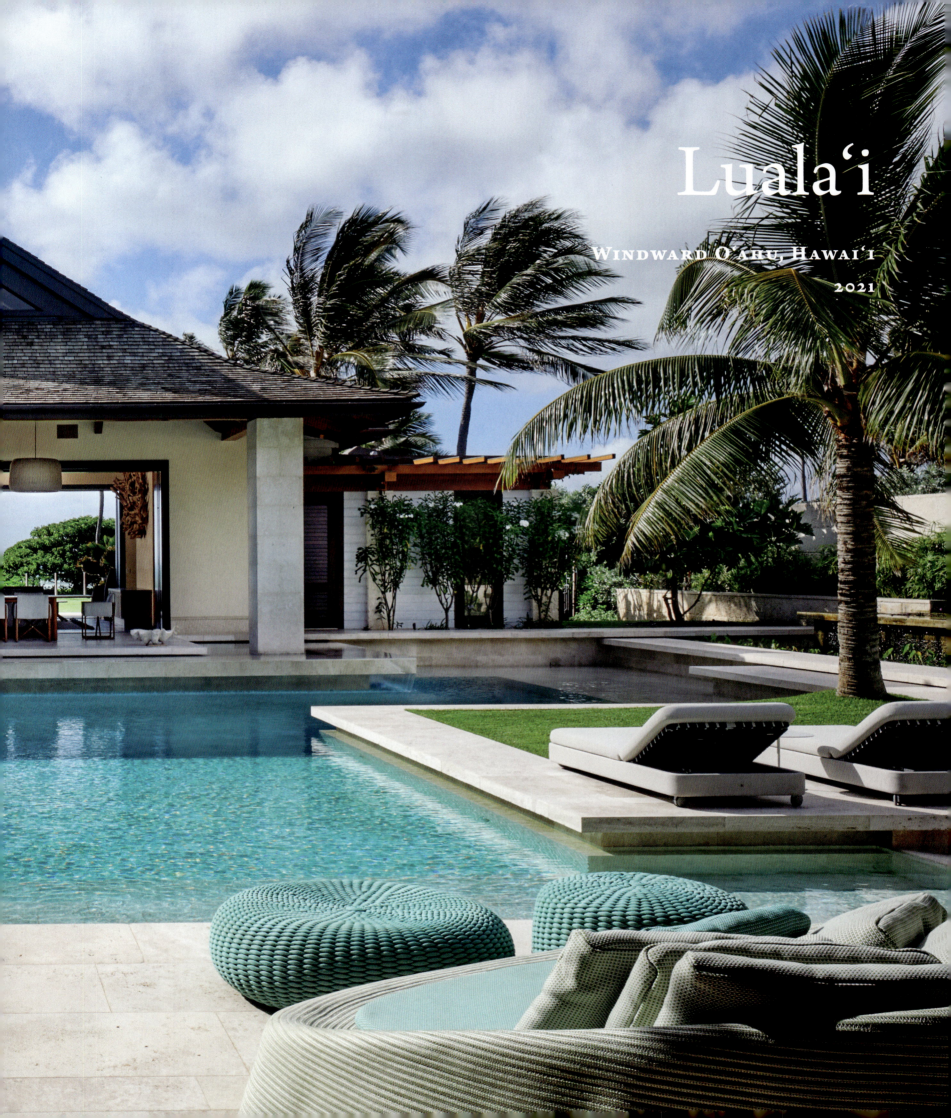

Lualaʻi

Windward Oʻahu, Hawaiʻi
2021

Luala'i occupies an enviable site. With its picture-postcard view of the bay and the much-photographed islets Moku Nui and Moku Iki (the Mokulua Islands, known as the Mokes), the parcel seems ideally suited for endless hours of water watching. But Peter realized that designing a home means more than optimizing its view.

The site is a rich and complex 60,000 square feet affected by three factors: trade winds from the northeast, a road and canal to the northwest ma uka (inland) side, and an extant house that needed to be incorporated into the design. PVA's solution was to design a collection of structures that respond to these complexities in a seemingly simple, clean design.

First, the trade winds. "They are often welcoming and cooling," says Peter, "but they make the thought of eating a candlelit dinner outside a challenge." PVA decided it could use the extant house and new pool pavilion as wind breaks; its bulk would allow relaxed dining in a new open-air pavilion (lānai) and comfortable lounging beside the pool. The pavilion's large sliding-glass pocket doors bring additional protection on the windiest days while still allowing a visual connection to the beach. On the three sides that don't front the beach, the lānai faces the pool, giving this entertainment pavilion the look and feel of floating on water.

This means the view from the lānai doesn't end after the sun goes down. "When that ocean view goes dark at night," Peter says, "you still have this incredible interior experience and a very rich visual experience." The pool is designed as a tidepool garden, with intricate layers that provide many platforms for sunning and edges for hanging onto. It incorporates a variety of plantings and a "Moses walk," which separates a water garden from the pool.

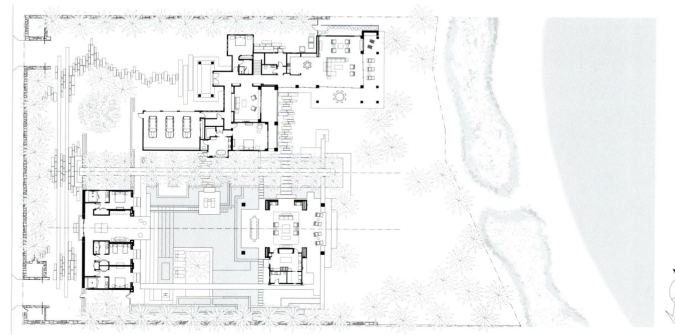
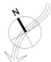

Pool pavilion frames view of Mokulua Islands, as seen from guesthouse lānai.

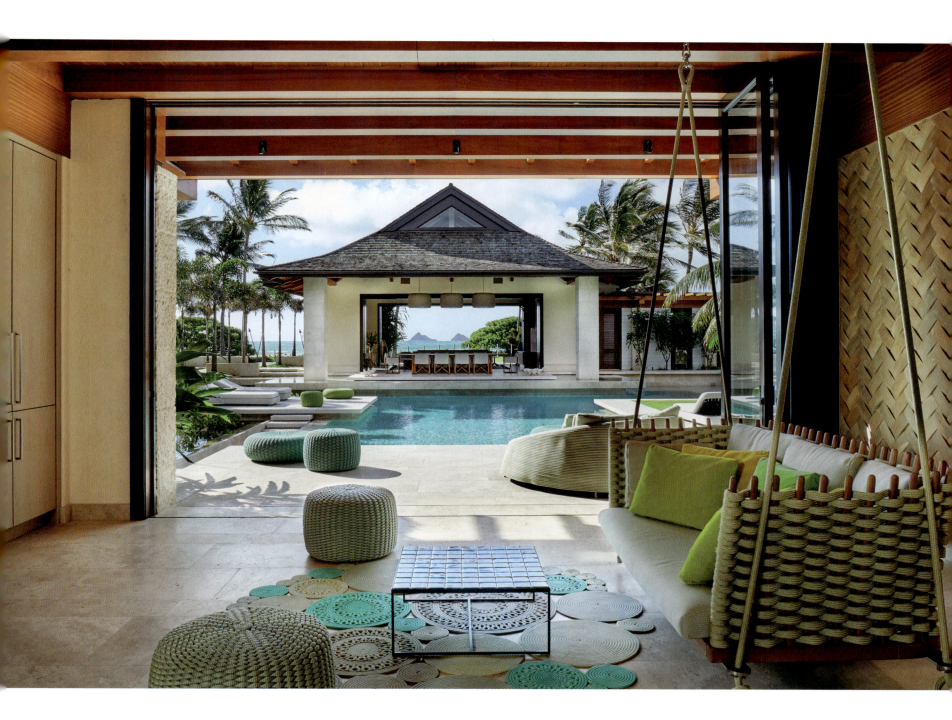

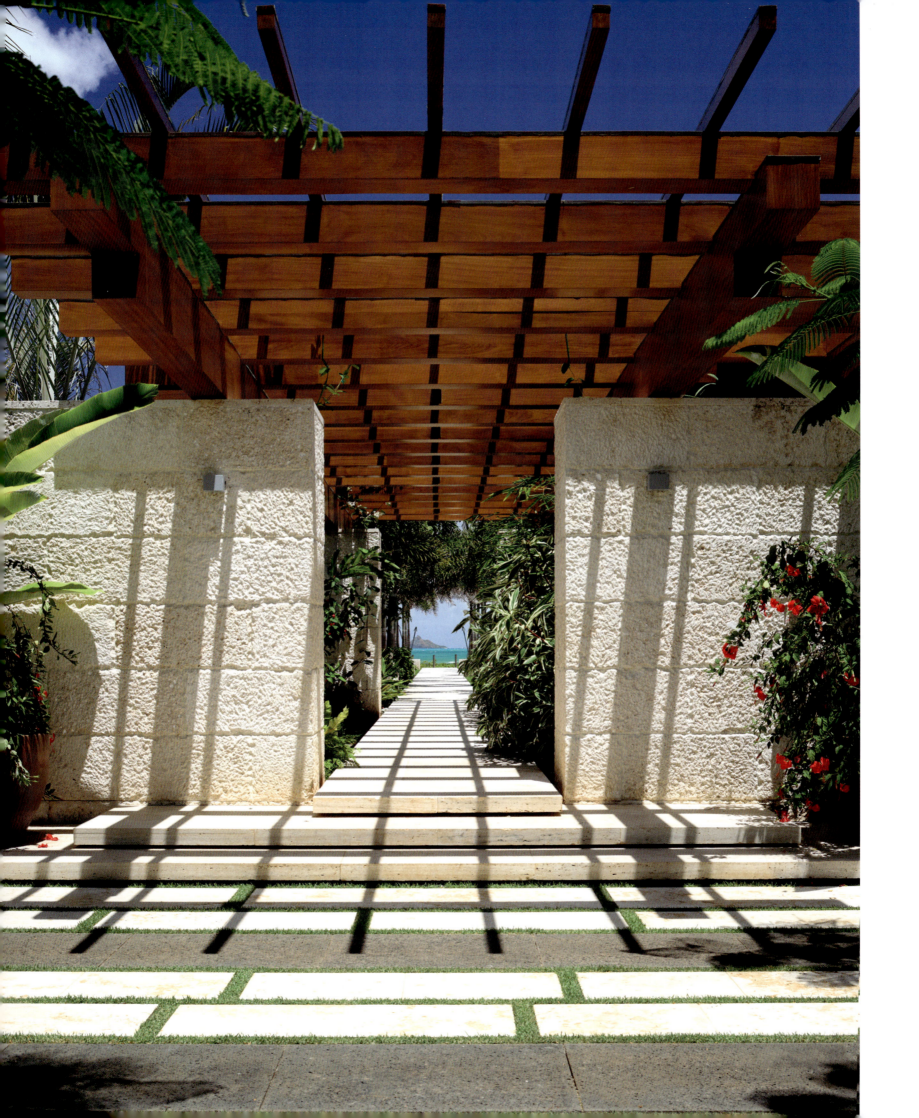

OPPOSITE: *Trellis-covered promenade provides dramatic point of entry.*

BELOW: *Permeable driveway creates garden setting, punctuated by new main entry.*

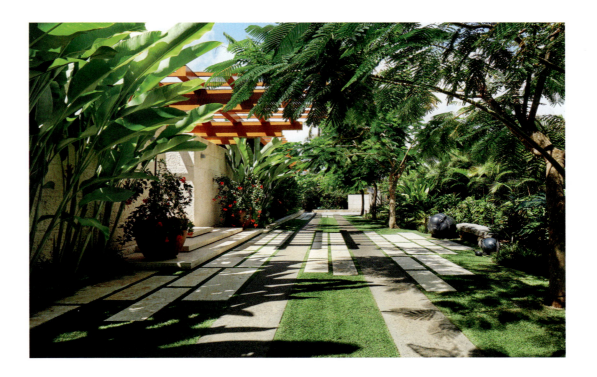

Next the road and canal. While the ma uka side of many beachfront properties may be its least desirable, Luala'i has another waterside amenity: a coconut tree–lined canal. A three-bedroom guesthouse nestles into this green corner. It was inspired by the garage at the James A. Culbertson House designed by Greene and Greene; its wide, vine-covered trellises help the garage become a garden element in the front yard. At Luala'i, the trellis extends beyond the stone walls of the guesthouse and adds to the three-dimensional landscaping. "This project was probably our best integration of landscaping architecture to date," Peter notes. PVA worked with San Francisco–based Surfacedesign on the landscape design.

Finally, the onsite building. The relatively new, developer-built home was not a model that PVA wanted to emulate. But PVA did match the spec home's dark window casings and its cedar-shingled, double-pitched, Hawaiian roof. It also made minimal renovations—such as adding wood siding and replacing cabinets with lighter-colored material—to bring the older building into conversation with the new design. "We ultimately wanted to merge the two," says Peter, "to make it seem like a unified project." The biggest change was making the side of the original house into its front. This new entry is a formal boundary between the private spaces of the extent house and the more public spaces of the additions. It is also a welcoming, palm-lined walk with a beeline view to the Mokes.

Let's not forget the Mokes. Amid the other important considerations for Luala'i, taking advantage of the sight line to that picture-postcard view did not get lost. One of PVA's primary intentions was to connect the ocean deep into the site. Even from the ma uka guesthouse, the pair of lovely islets remains in view, centered in the sturdy stone columns of the pavilion. "We love the view of the Mokes," Peter says, "but then by putting them in this kind of framed lens highlights them even more."

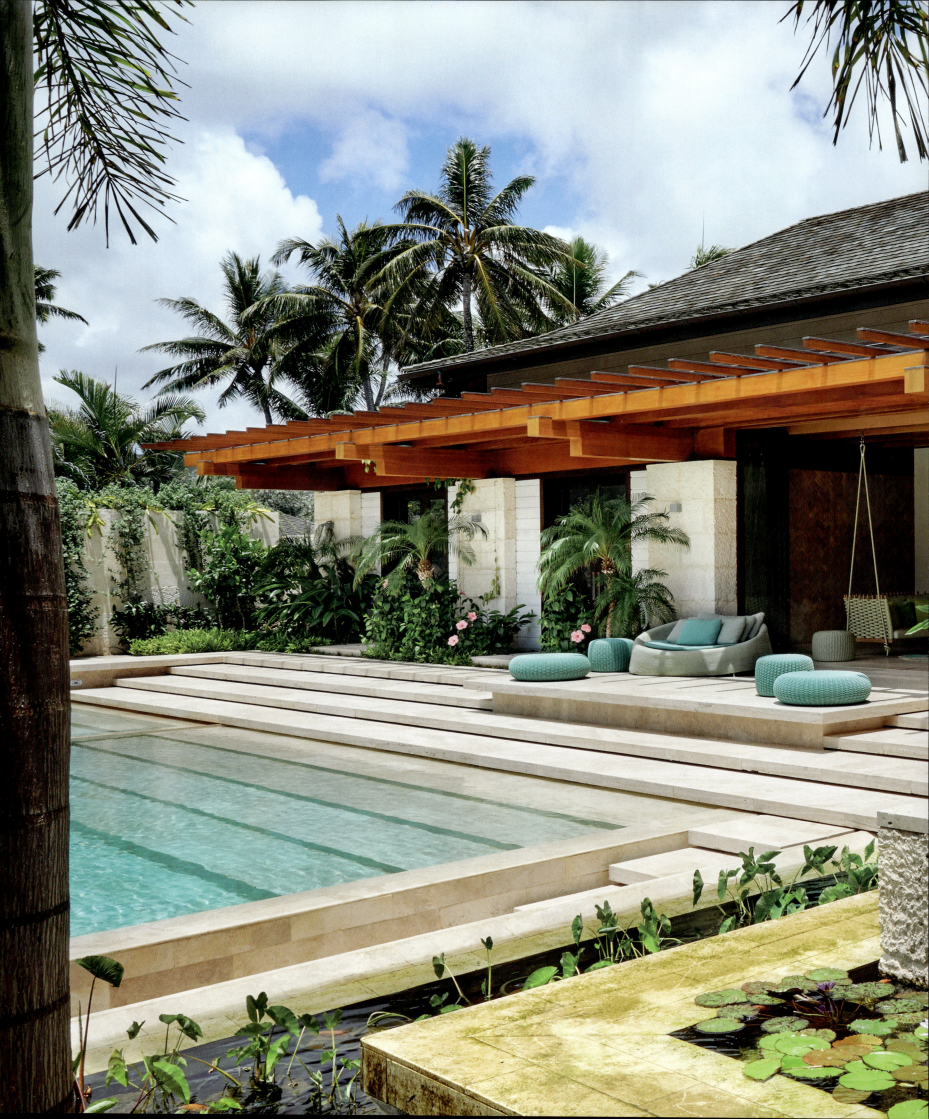

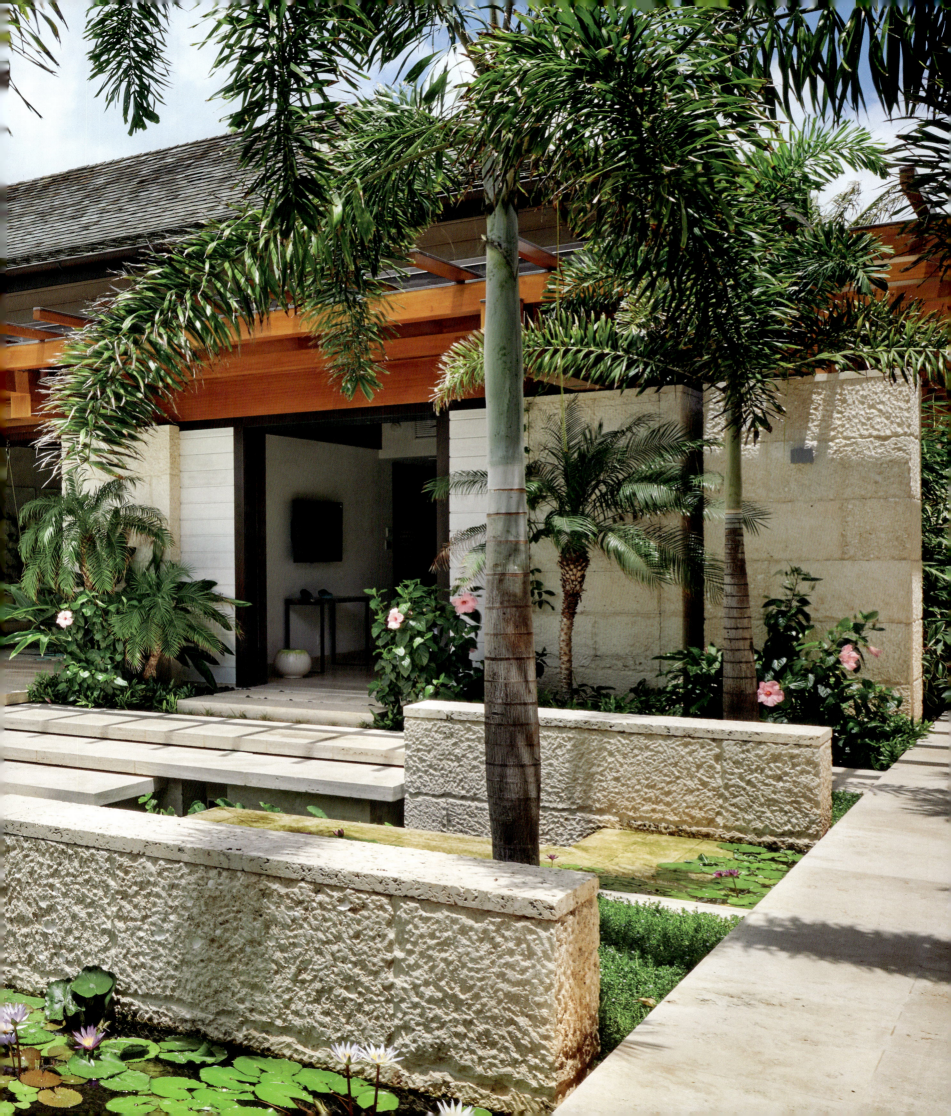

NEW HOMES

View toward guesthouse from main dining lānai.

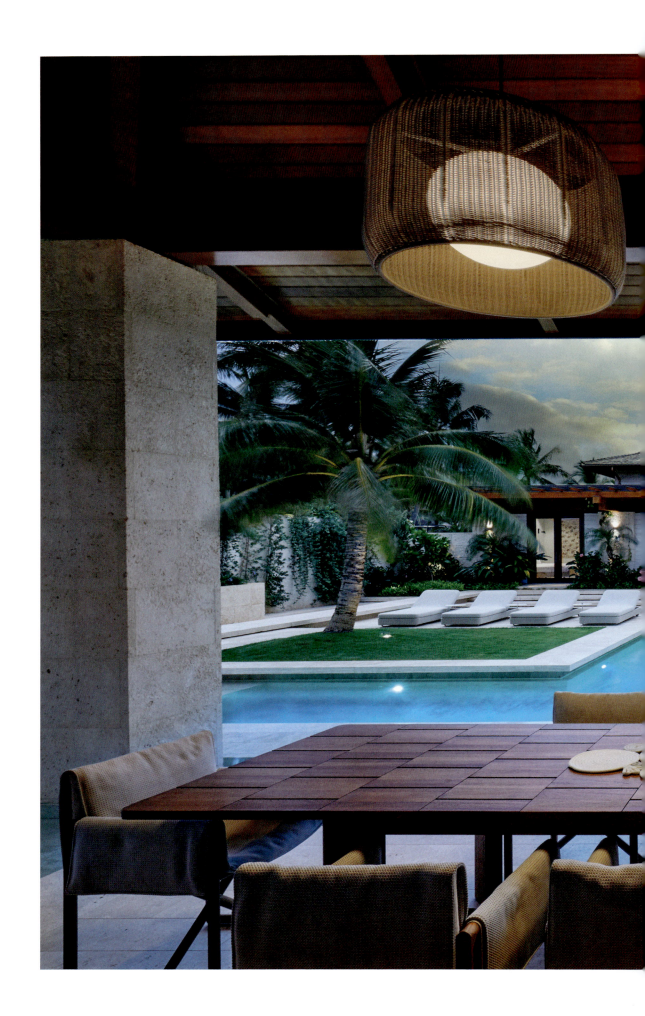

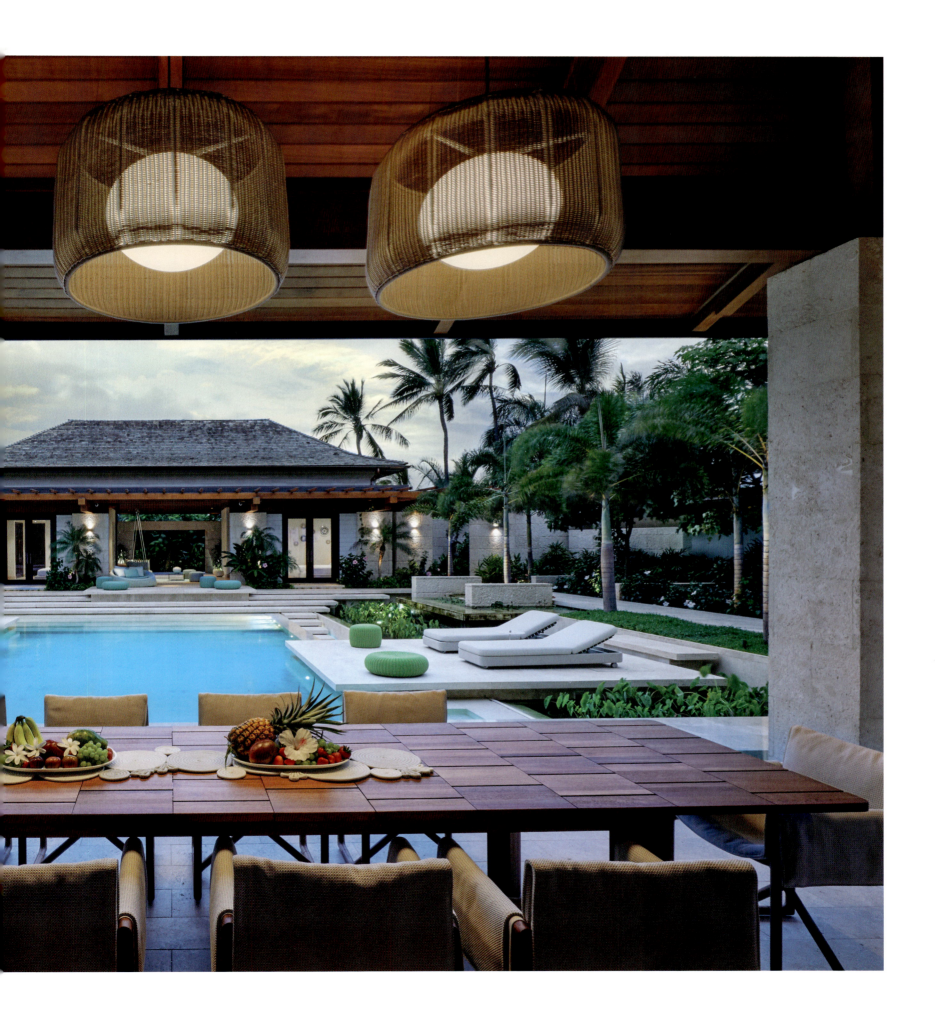

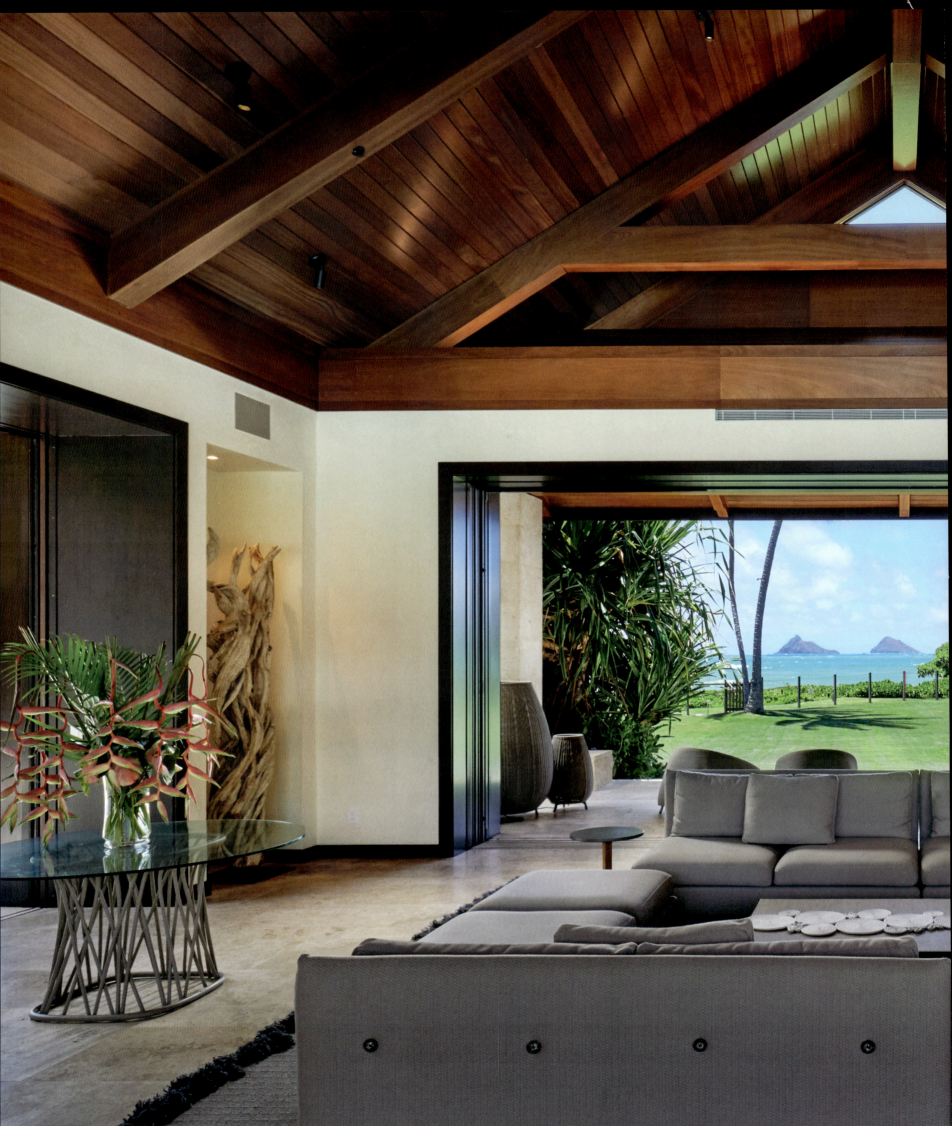

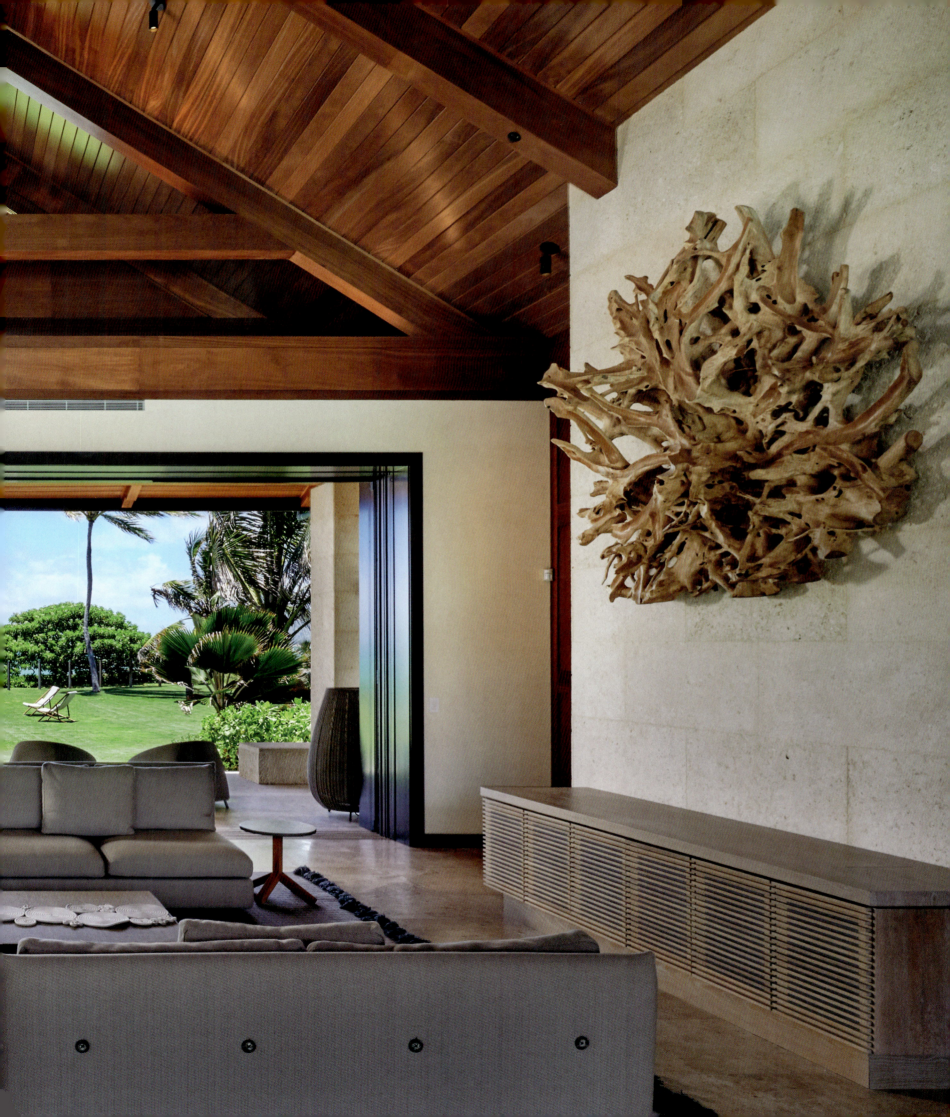

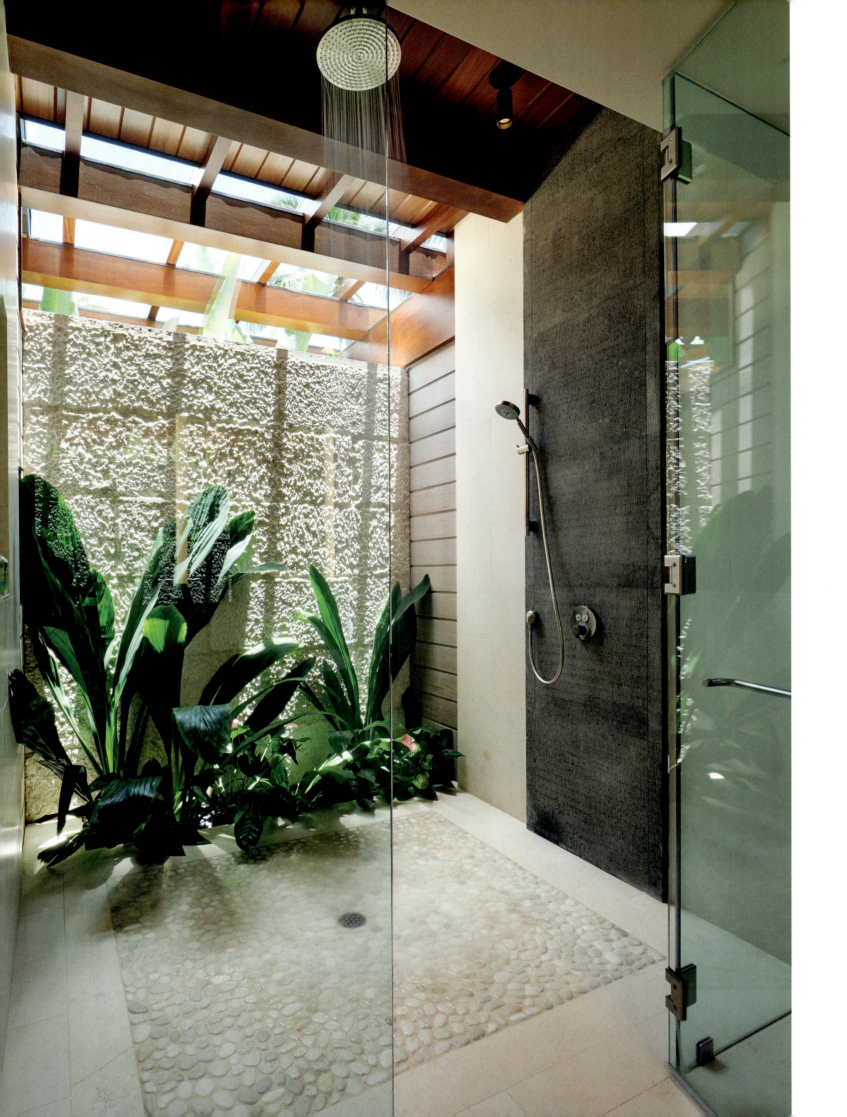

OPPOSITE: *Guesthouse shower emphasizes home's indoor-outdoor relationship.*

BELOW: *Main-house powder room.*

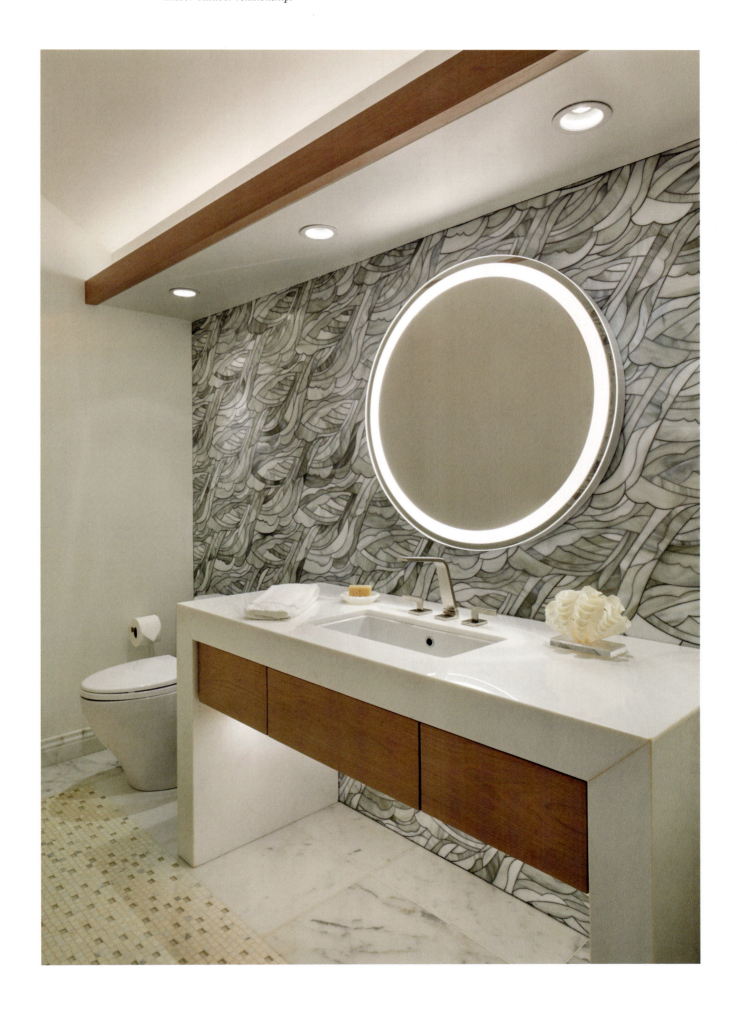

BELOW: *View across pool from entry promenade.*

BOTTOM: *Cross section through site.*

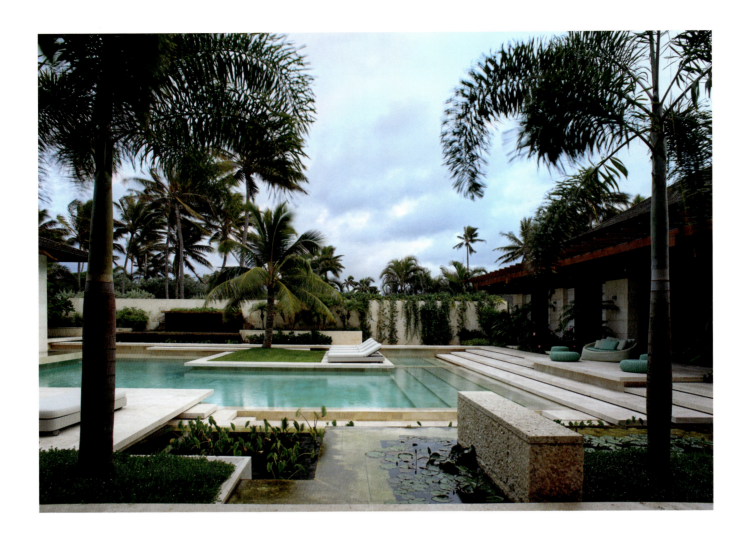

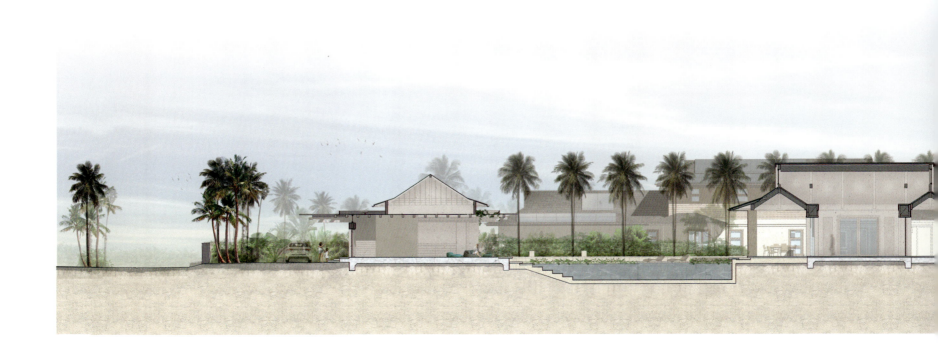

Pool courtyard is contemporary interpretation of tidepool gardens.

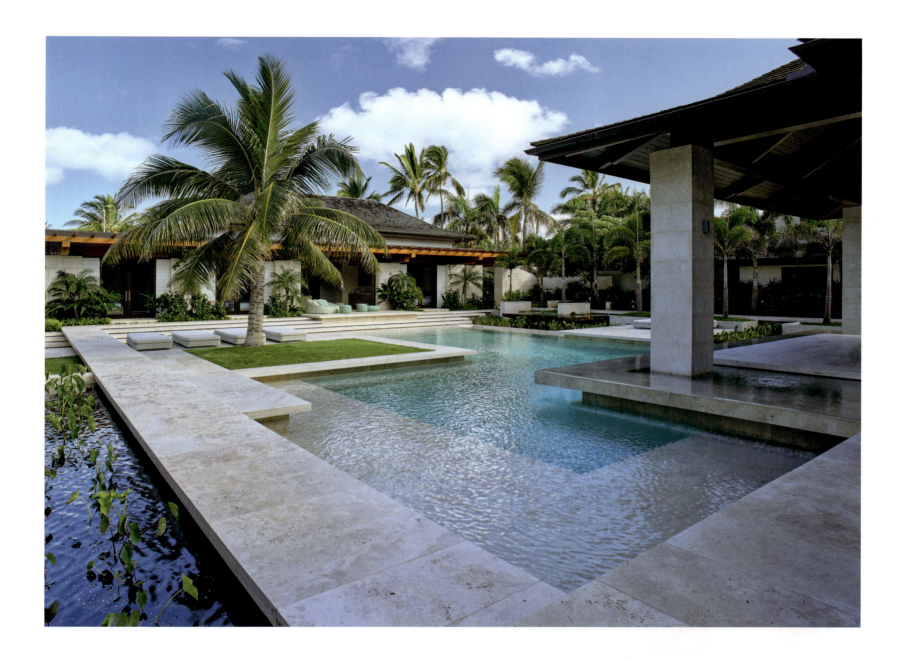

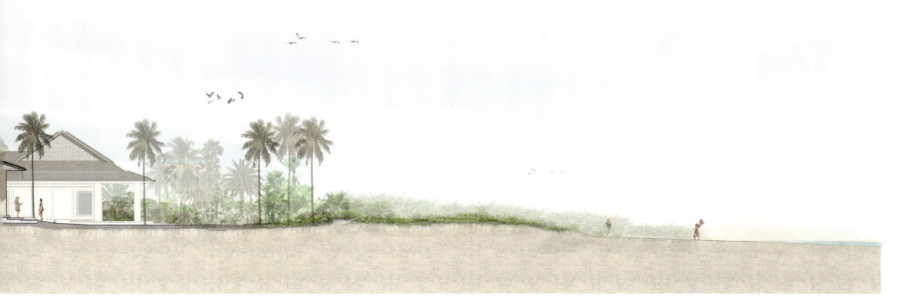

Entry promenade provides separation between public and private spaces.

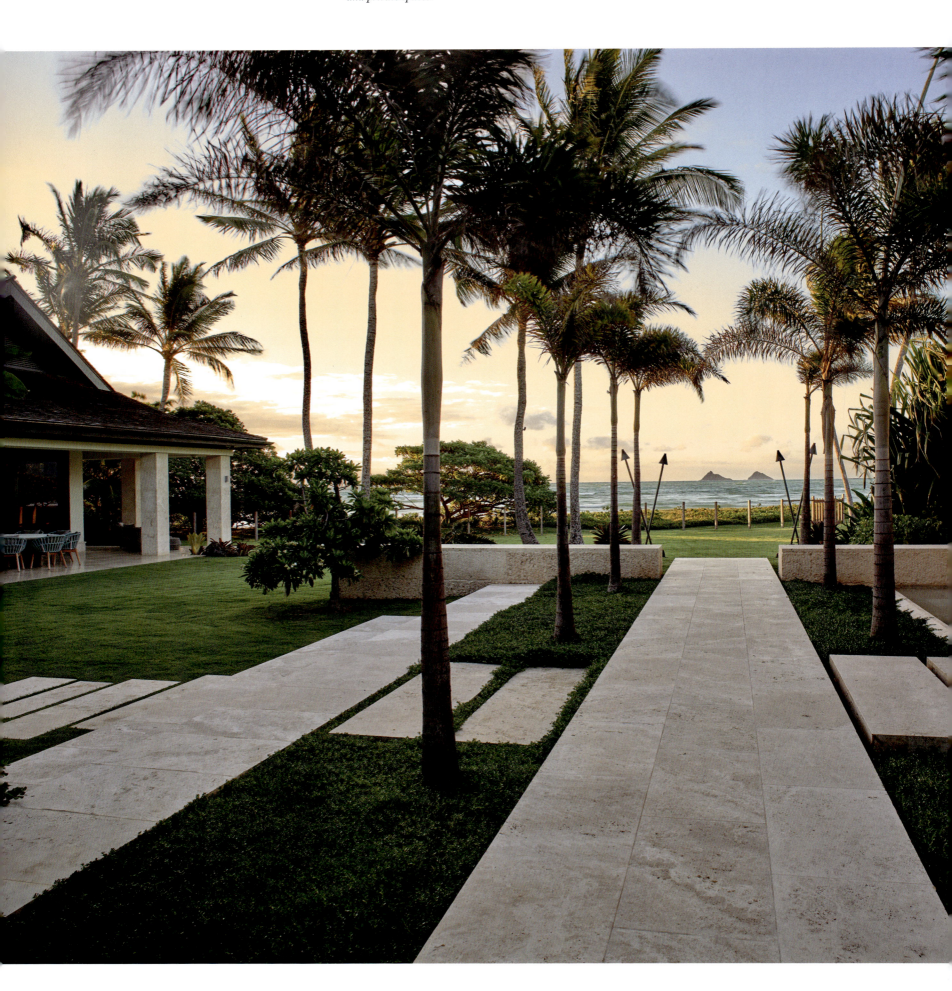

BELOW AND BOTTOM: *Views of "floating" dining lānai.*

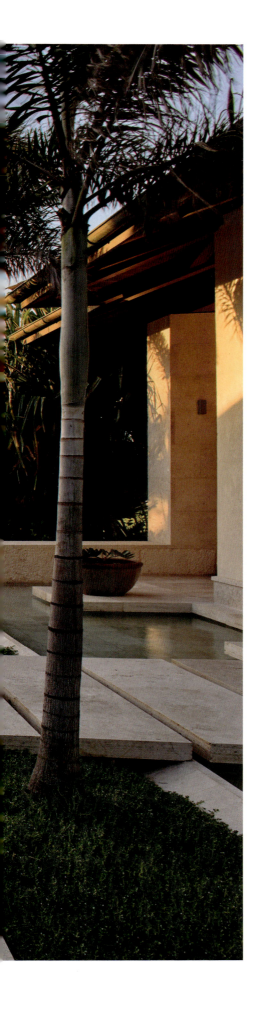

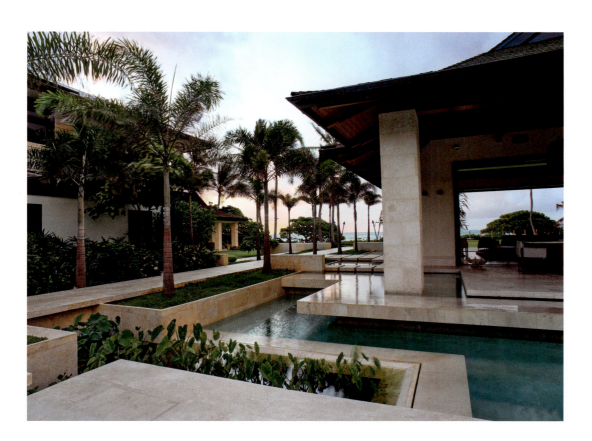

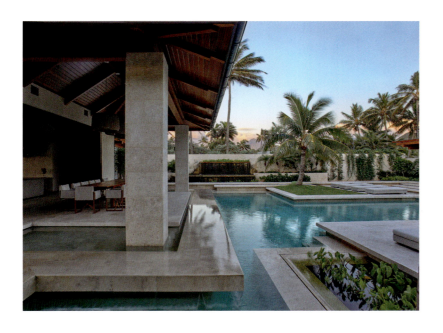

BELOW: *Structures' deep setback provides park-like setting along beach.*

BOTTOM: *View of coast from second-floor primary bath.*

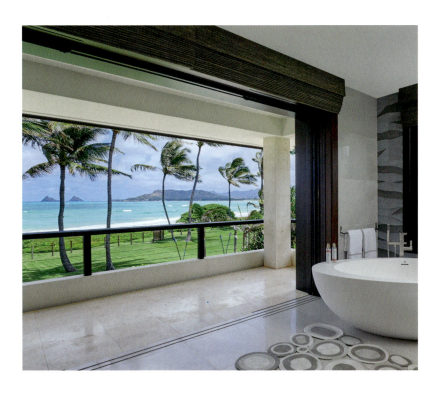

Earth, sky, fire, and water are featured elements of the design.

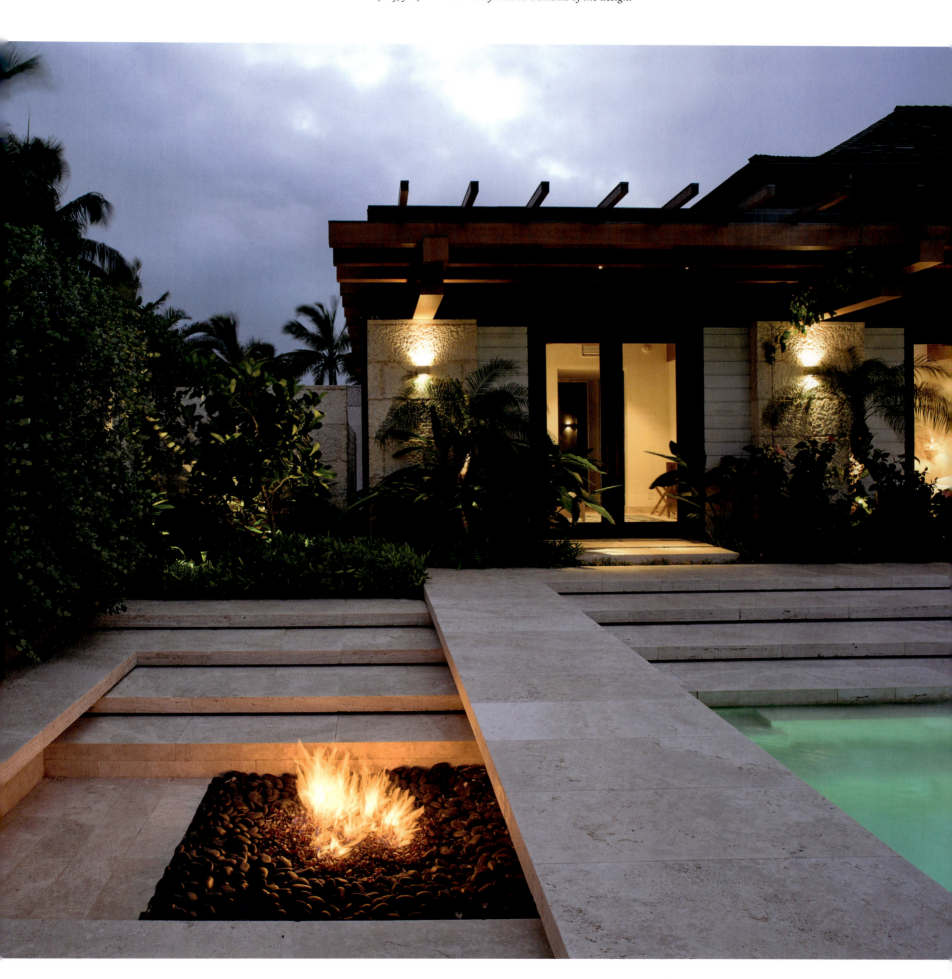

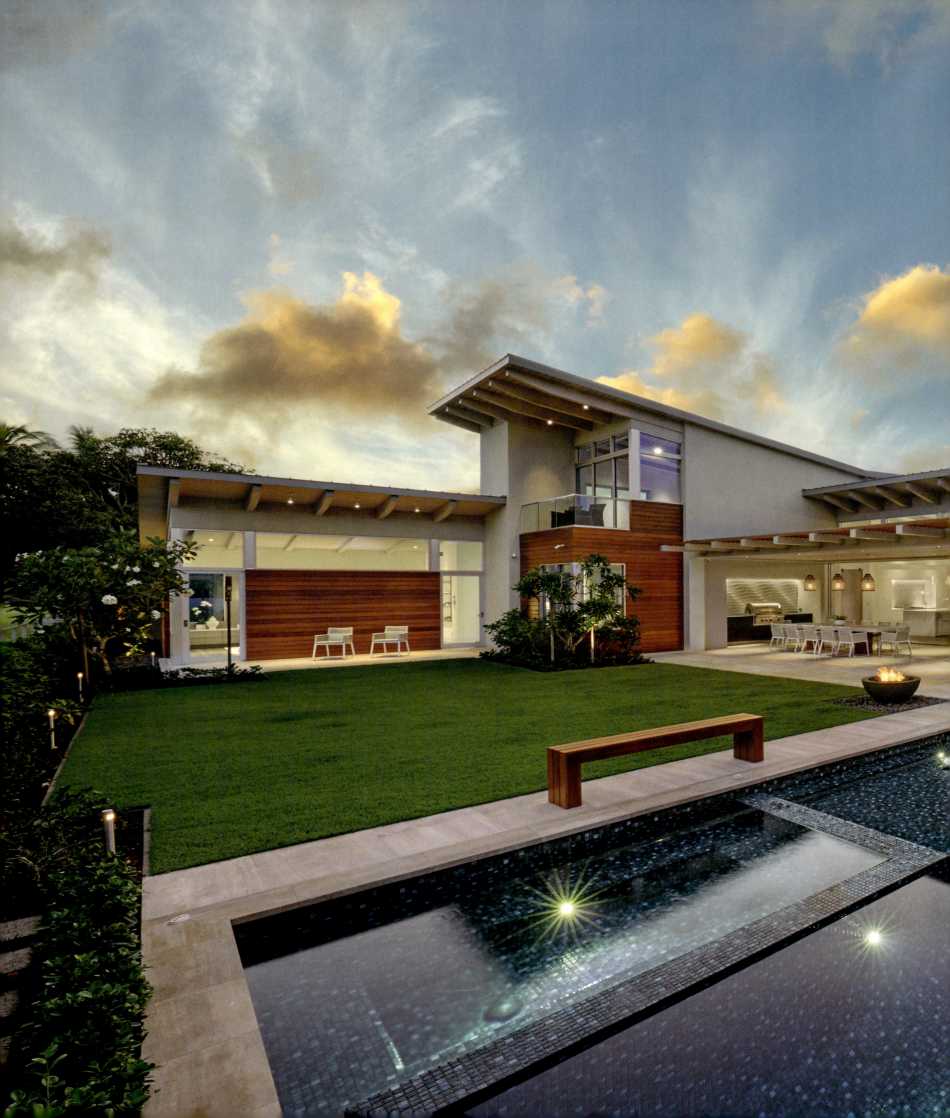

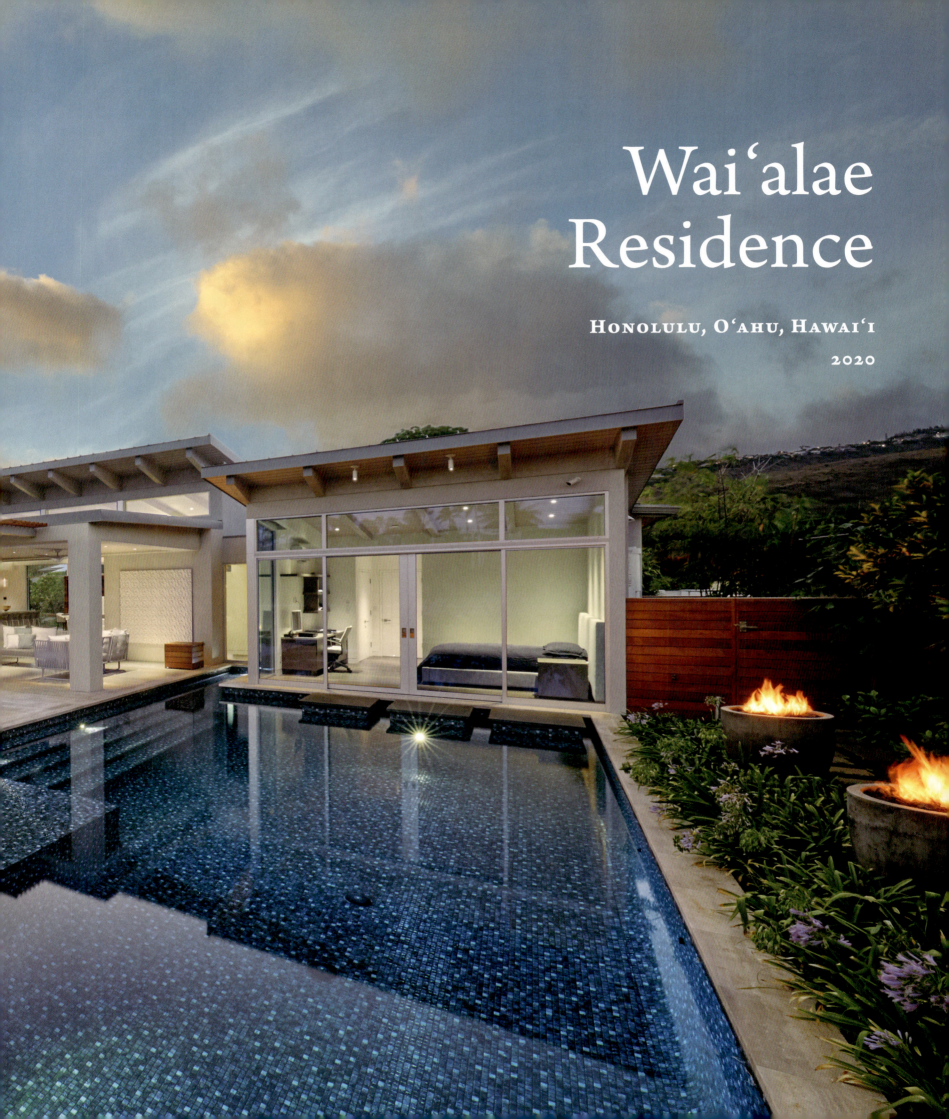

Wai'alae Residence

Honolulu, O'ahu, Hawai'i
2020

From a subdued entry, the Waiʻalae Residence transforms into an expression of openness. "The idea was to have it be more discreet and lower, with less impact on the street, and not really give it away," says Peter, "and then be more of a surprise and a wow as you enter."

Some of this design idea came from the clients, who did not want to build a showy house. Some of it came from community design guidelines, which stated a preference for single-story homes and discouraged opulent houses with grandiose entrances. Much of it came from the project site, which runs from the street to the golf course of the Waiʻalae Country Club, home to the Sony Open in Hawaiʻi.

The street-facing entrance to the house appears as a wall rather than a door. This wall is decorated with Hungarian-made concrete tiles inspired by coral reefs. "This family loves to surf and dive, and ocean living is a big part of their lifestyle," says Peter. "I thought that would make a really interesting reference to the ocean beyond." The square, nondirectional tiles complement the strong horizontals of an adjacent Ipe wood rain screen, and the feature is uplit to provide a dramatic entry at night. To enter the home, visitors turn left to a door, then turn right to take in the view. "A lot of people, especially on an oceanfront, want their entrance to go straight through," says Peter. "Going back to the Balinese influence, we tend not to do that. You come in and turn, so it's private from the exterior."

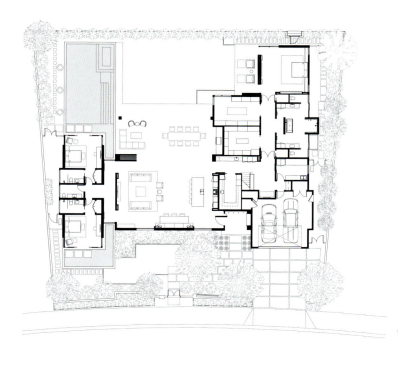

Entry wall features up-lit cast concrete tiles that represent coral reef.

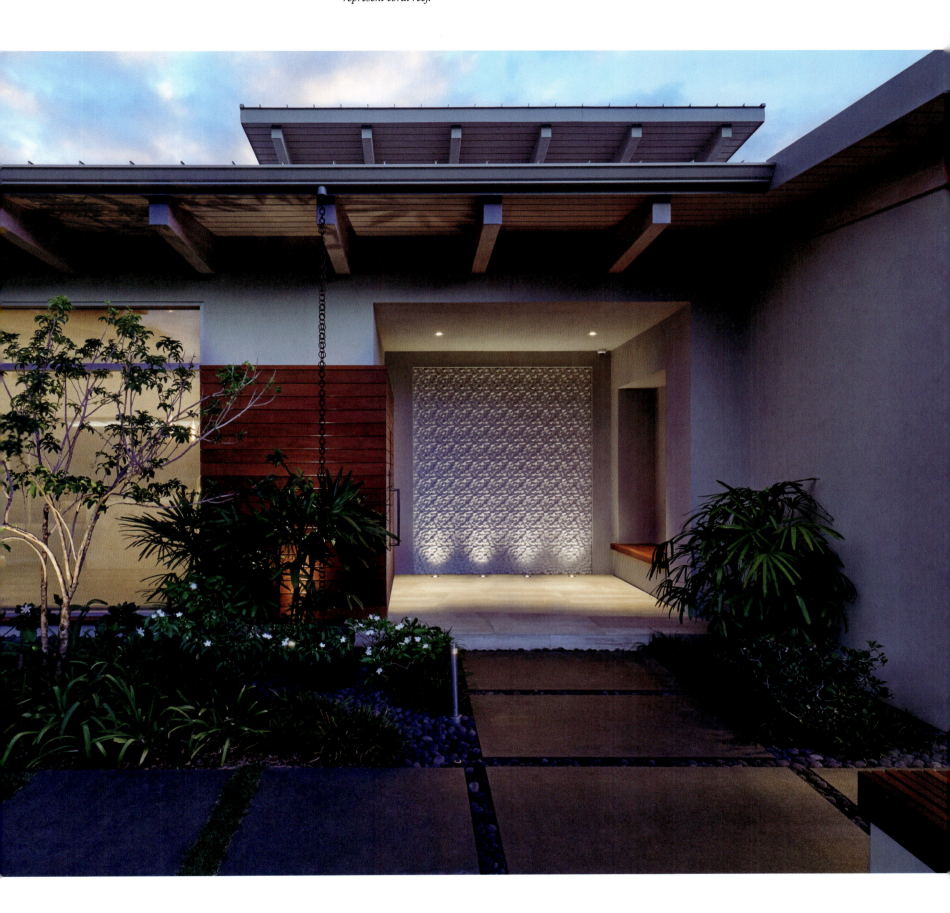

BELOW: *Exterior Ipe rain-screen siding extends into house to frame custom banquette dining table.*

BOTTOM: *View incorporates expanse of golf course beyond.*

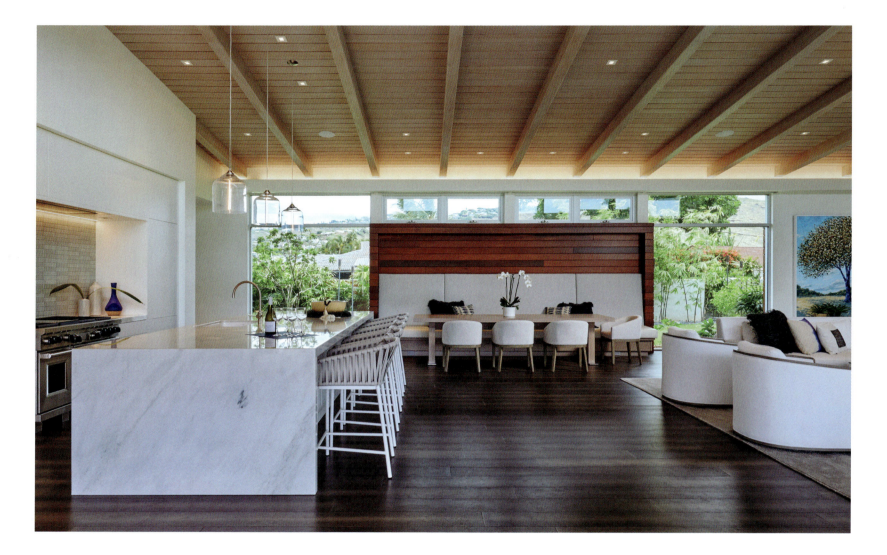

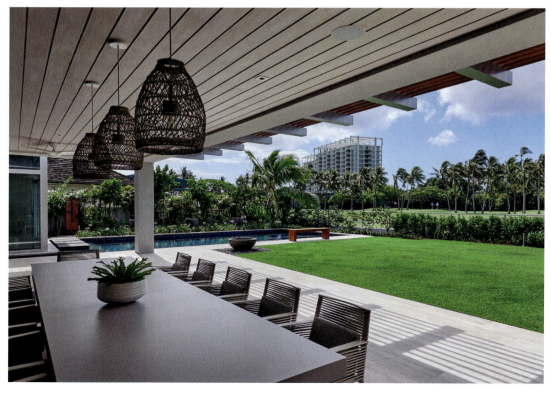

Pocket doors, covered lānai, and trellis provide seamless transition between interior and exterior.

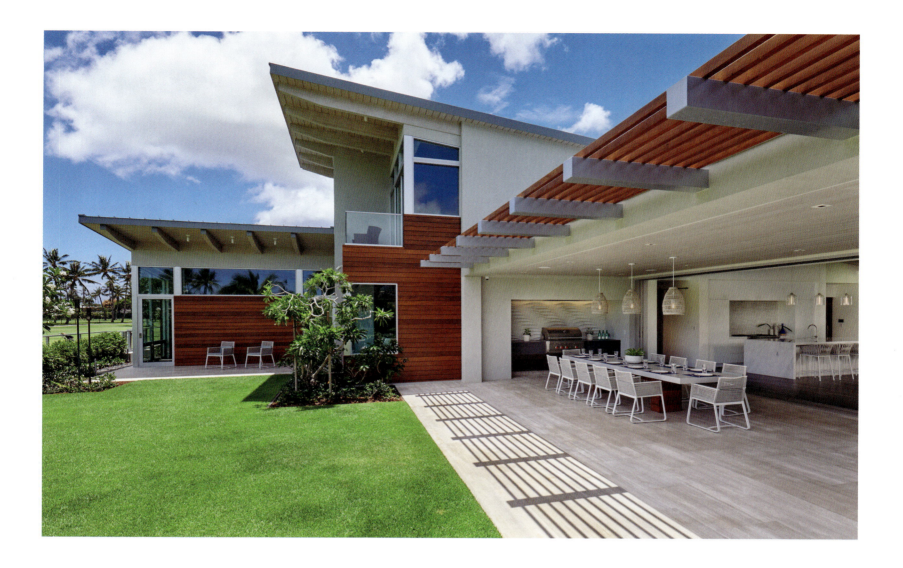

From here, PVA opens the home with the simple but profound architectural gesture of roof lines. Over the main space, a shed roof rises from the entrance toward the yard and golf course beyond. It literally reaches up and over a flat-roofed lānai, producing a clerestory. A hallway leads from the main space to a wing with a butterfly roof; each roof slants over a child's bedroom and toward a pool. On the opposite side of the main room, a shed roof projects over a small second-floor lānai with views to the golf course and the ocean beyond. This thin unit contains a multipurpose recreation room, which also serves as a guest bedroom. Next a shed roof turns ninety degrees to face the lawn and pool and to cover the primary suite. These roof designs not only frame the views, but also separate the building into component parts.

"We're trying to break up the forms into separate pavilions," says Peter, "hearkening back to the days of old Hawai'i, when they would break things up depending on use."

The Wai'alae Residence is a contemporary nod to that Hawaiian tradition. It's in good company with the nearby Kahala Hotel, a 1964 modern building designed by architect Edward Killingsworth and his firm Killingsworth, Brady, and Smith. "It's not like I designed a house around that building," says Peter, "but that's what you do see from here. So, there's a little bit of a connection to that aesthetic because that building is fairly out of character with many buildings in Honolulu." He notes specific characteristics that connect PVA's design of this house to Killingsworth's hotel: weaving indoor and outdoor space, expressing a building's structure, and using trellises to provide shade.

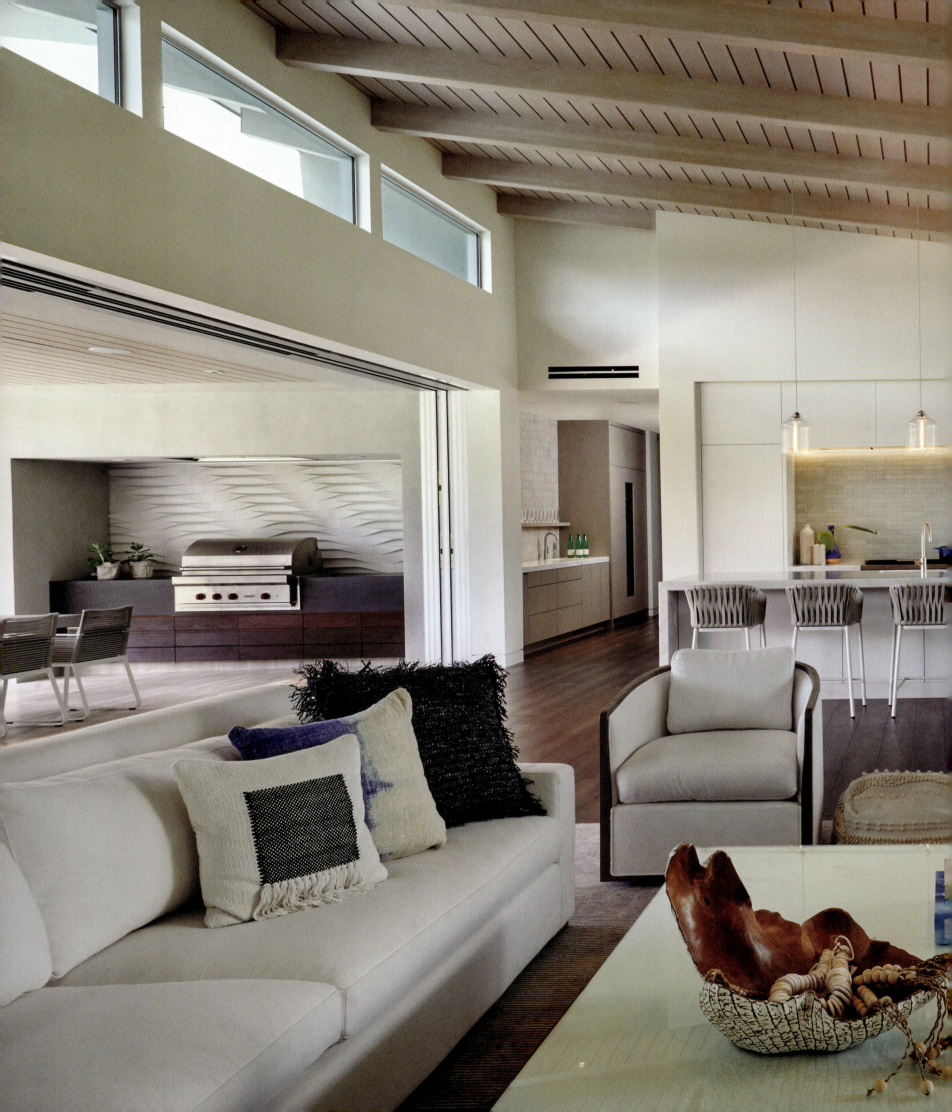

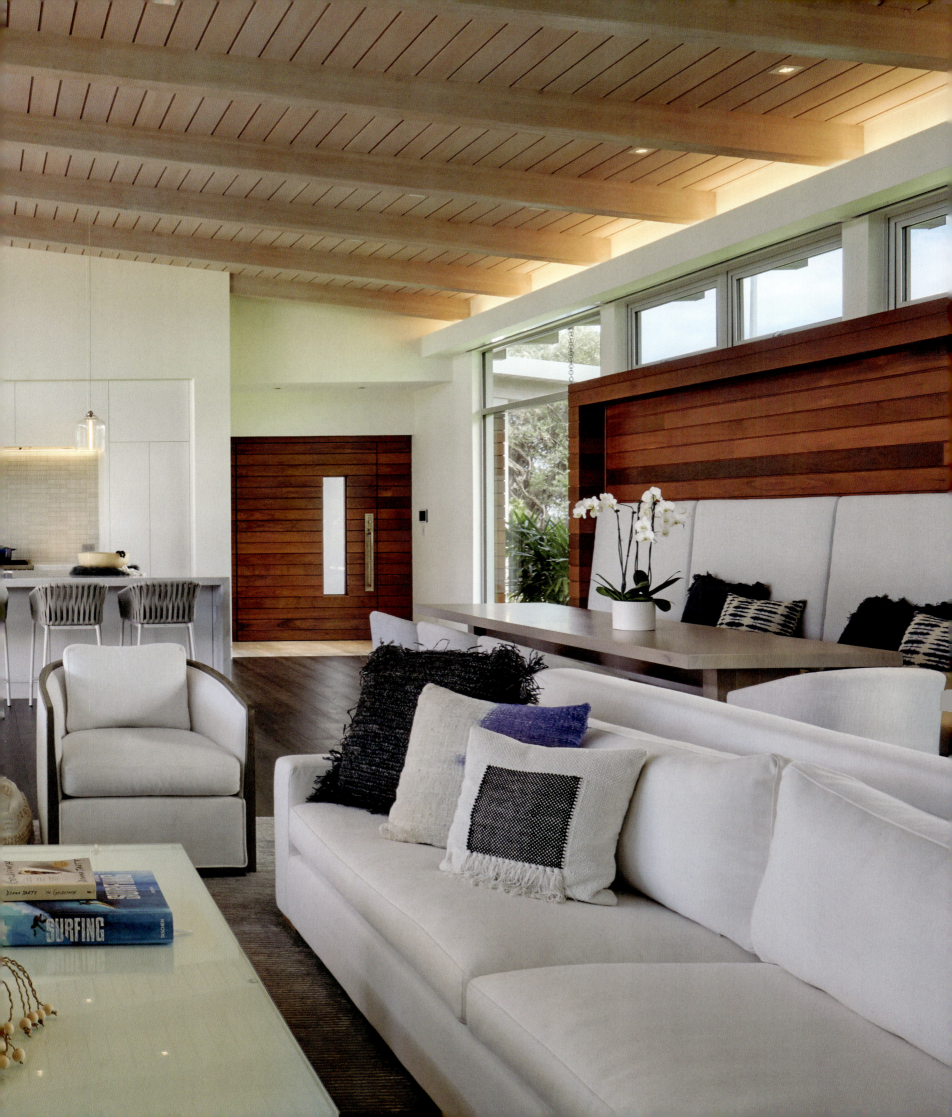

NEW HOMES

Built-in cabinets keep the primary bedroom uncluttered.

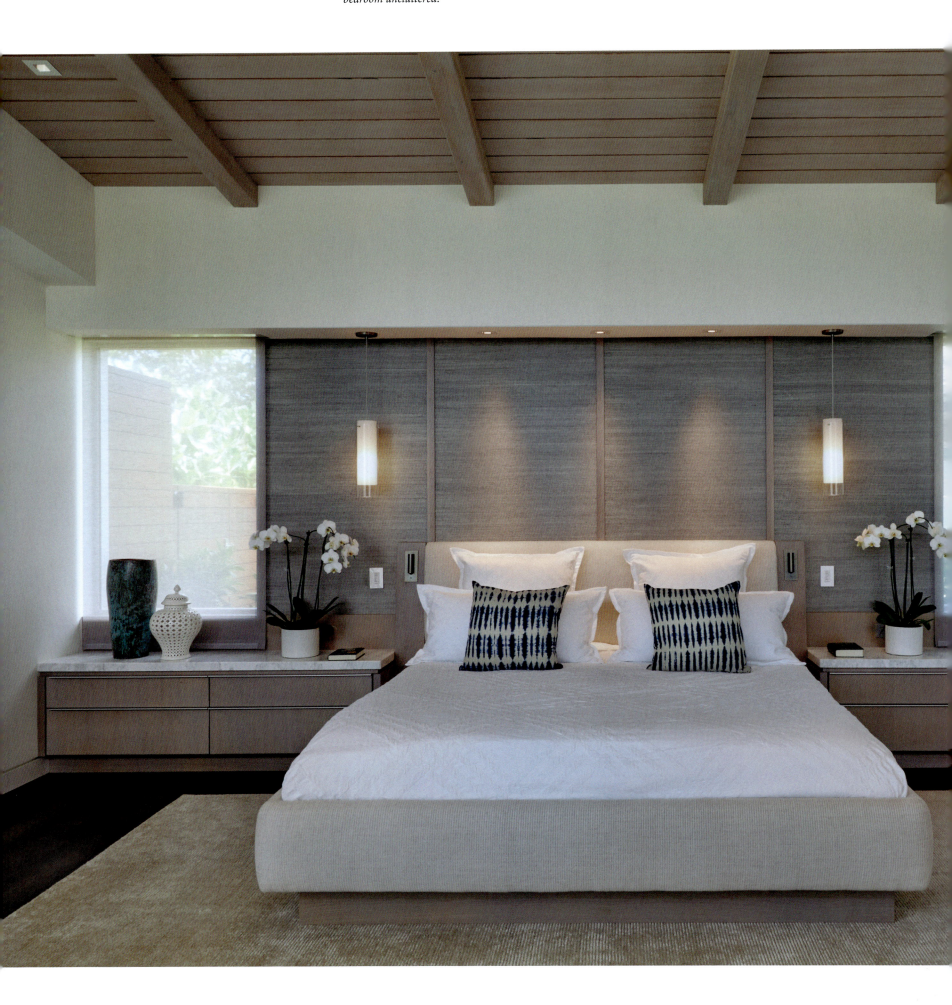

WAI'ALAE RESIDENCE

BELOW: *Stairwell introduces natural light and creates central focal point.*

BOTTOM: *Primary bathroom provides his and hers vanities in an airy setting.*

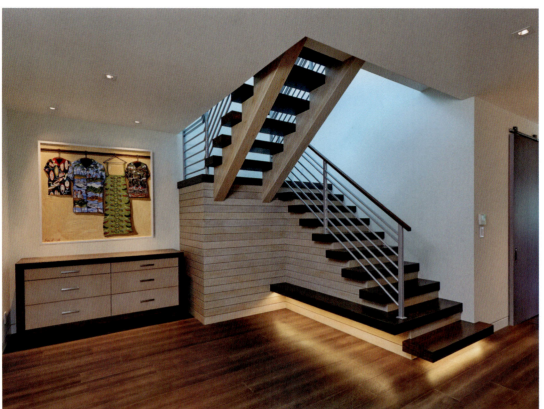

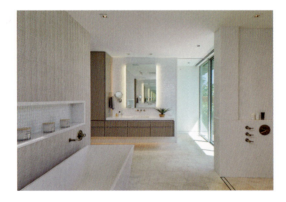

At one point during the design process, the clients rethought this modern aesthetic and considered building a more traditional house with a hip roof. They eventually returned to PVA's original proposal, and its shed roofs—which allow easy installation of continuous insulation and solar panels—were factors in helping their home achieve LEED Platinum, Energy Star, AirPlus, and Net Zero certification. "In Hawai'i, the biggest concern for air-conditioned homes is the heat gain," says Peter. "The roof is far and away the more important element in terms of keeping the heat out." And so, the roofs that express the openness of the building also help define it as a sustainable design.

BELOW: *"Floating" bedroom wing features butterfly roof.*

BOTTOM: *Large covered lānai extends the interior living space.*

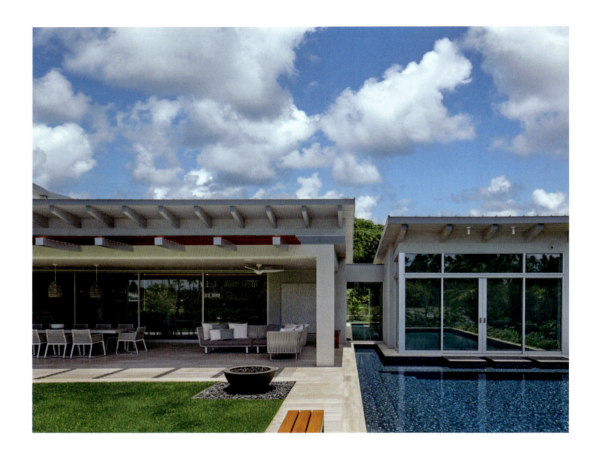

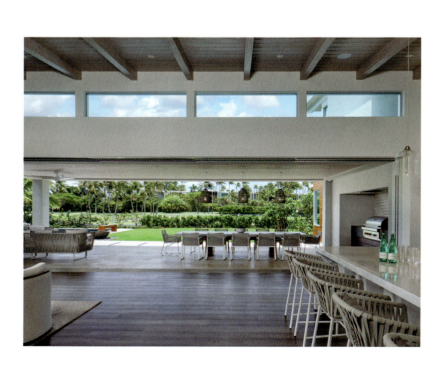

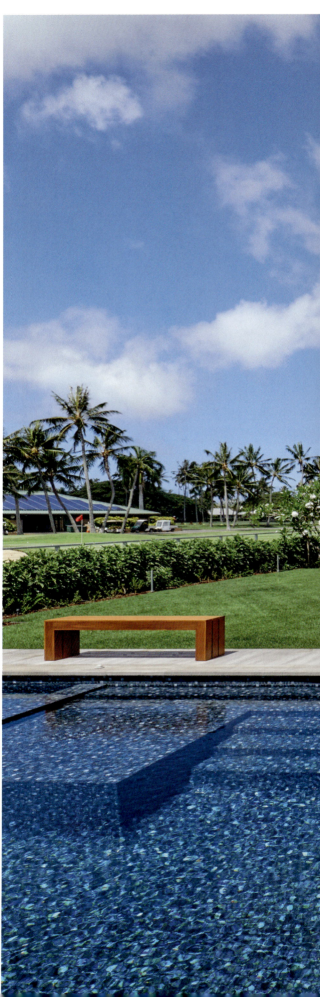

WAIʻALAE RESIDENCE

Soaring rooflines create dramatic focal points.

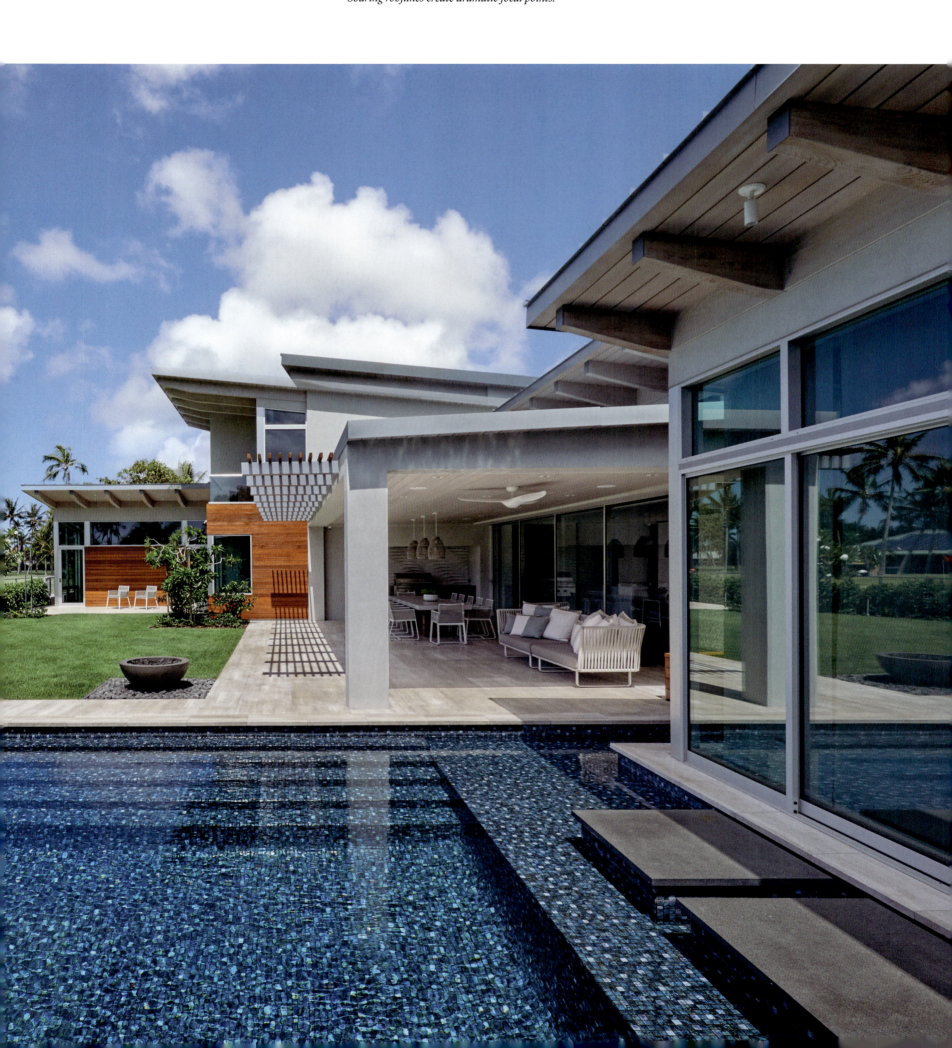

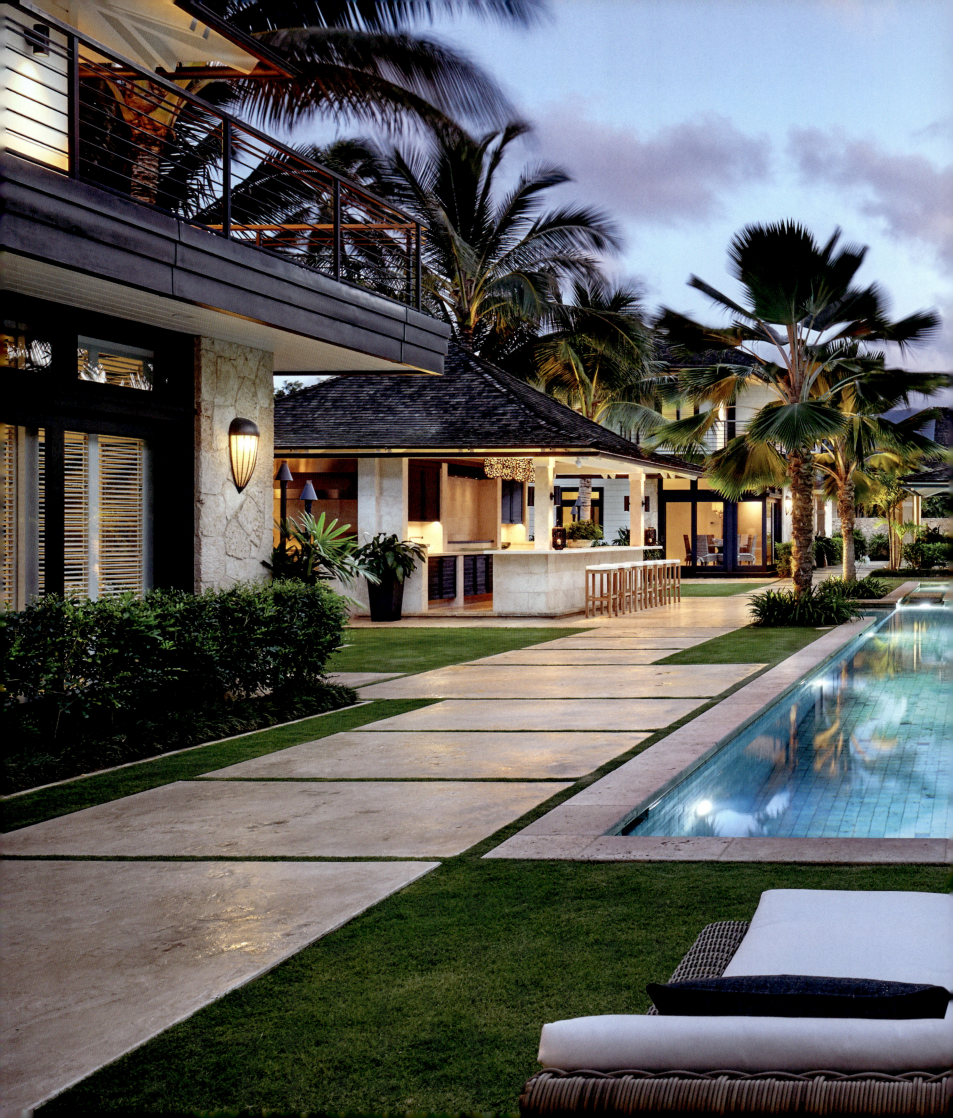

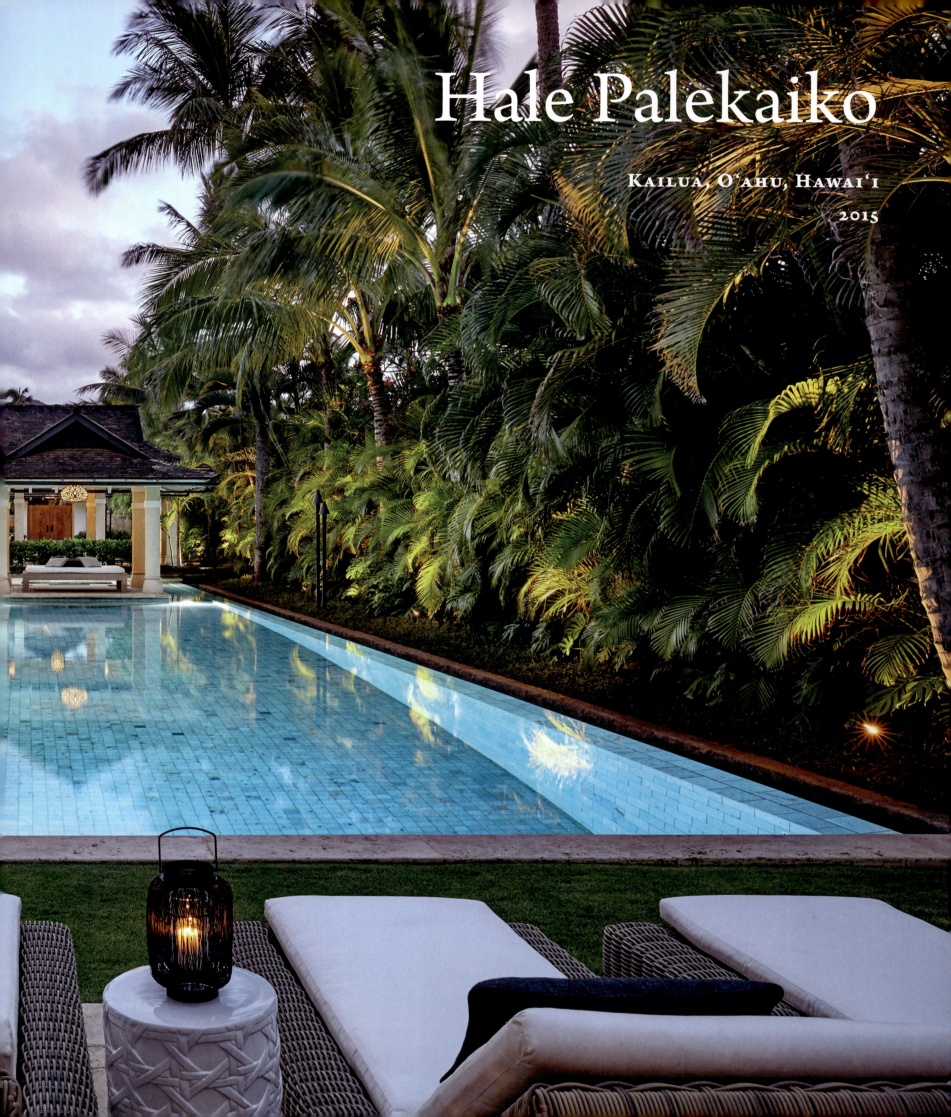
Hale Palekaiko

Kailua, Oʻahu, Hawaiʻi
2015

The story of Hale Palekaiko (House of Paradise) is a bit of an epic. Designed and built over the course of fifteen years for two different sets of clients, the resulting residence could have appeared a mismatch of influences. But by placing architectural concerns over mere aesthetics, PVA created a singular design that can withstand the test of time.

The challenge was not easy. The project's long, thin, 75-by-500-foot beachfront site did not seem ideal for the original clients' request for a "tropical family estate." "You've got seventy-five feet on the ocean," Peter says, "but what are you going to do with this other space?" PVA split the program into two and placed the enclosed buildings—a two-story main house, barbecue pavilion, guesthouse, and garage—on the east side of the property, from ocean to street. This freed up spaces on the west side for outdoor areas, including a hundred-foot pool. The two-story buildings also shield four indoor-outdoor structures—the main living pavilion, pool pavilion, guest pavilion, and entry pavilion—from the trade winds.

This arrangement not only brings order to the project but also allows a visual path through the open pavilions, which met the clients' request for a view from the entrance to the ocean. The view works in the opposite direction as well. "There is the Koʻolau Range in the backdrop—very rugged, gorgeous mountains," says Peter. "The main living pavilion is squared and centered with the pool pavilion, which is reflected in this long pool, and then you see the mountains in the backdrop." The pool pavilion and its poetic reflection—much like that of Doris Duke's Shangri La in Honolulu—was inspired by the Chehel Sotoun in Isfahan, Iran, which Peter studied when working on projects in Saudi Arabia.

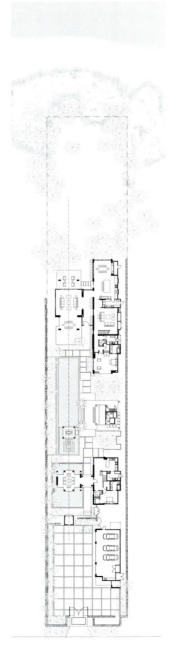

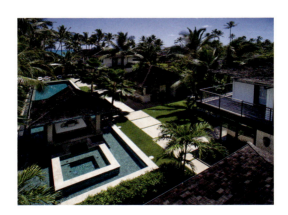

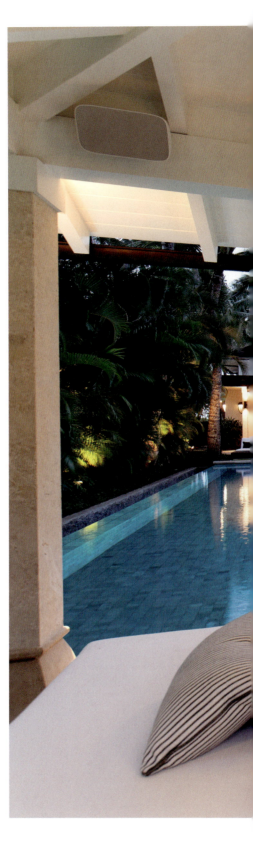

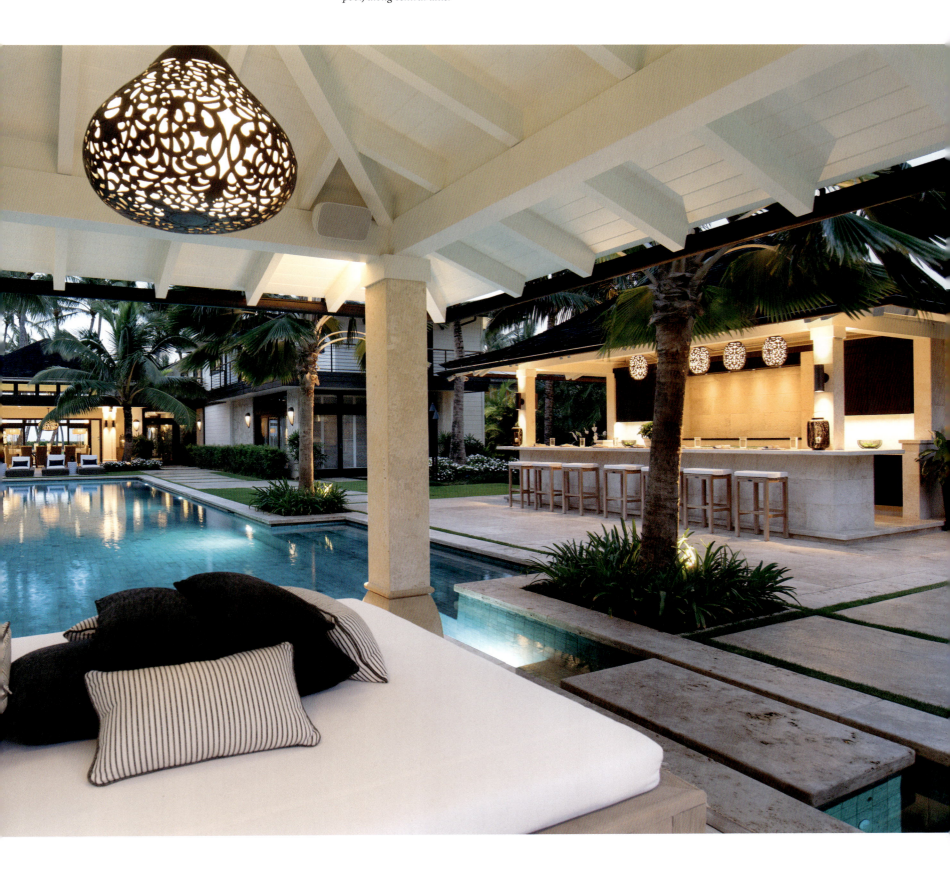

"Floating" pool pavilion sits within hundred-foot-long pool, along central axis.

NEW HOMES

Main living pavilion opens to pool courtyard to provide dramatic focal point.

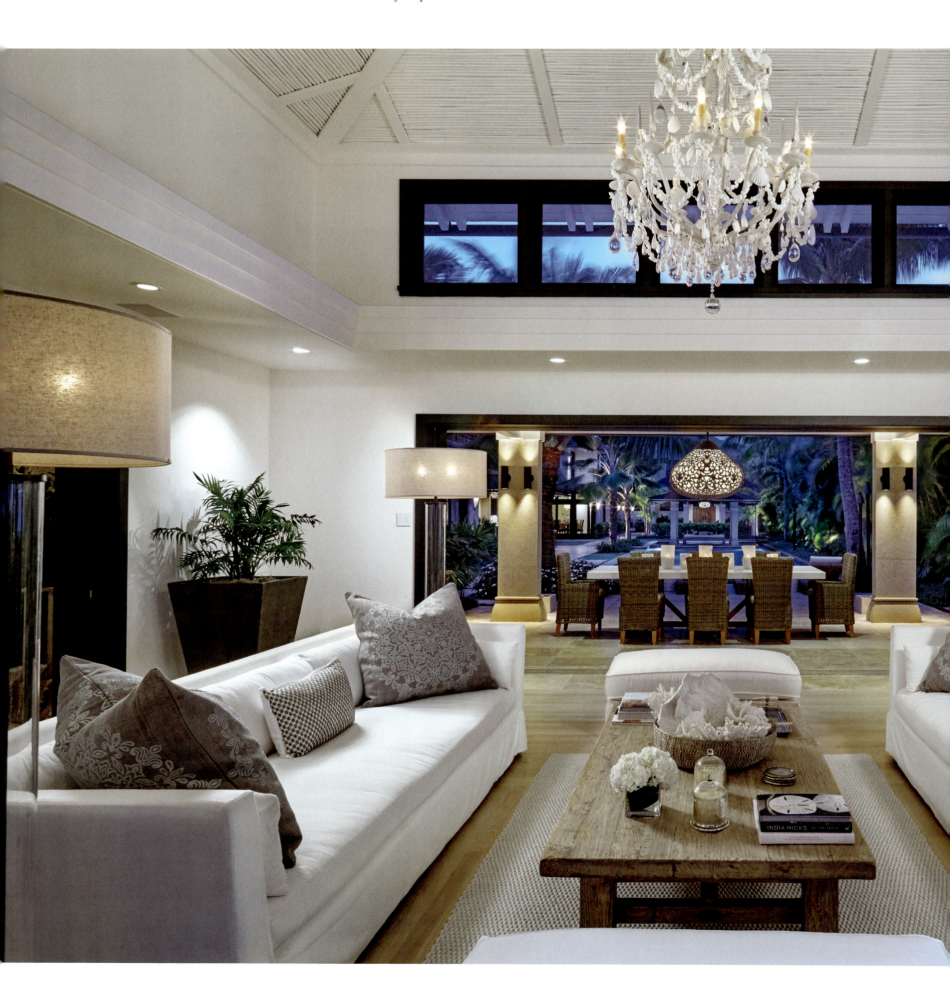

PVA might have made its task easier by spreading Hale Palekaiko's structures over its 36,995-square-foot site. But instead, it respected the building lines of seven neighboring homes, which built 150 feet from the shoreline—much farther than the required 40 feet. The neighbors did not build walls along their property lines, and this combination of borrowed length and width created a sort of open park between families, like that in old Hawaiʻi. PVA also purposely inhibited its buildings' expanse by working around a number of coconut trees that were on site. Some of these provide dappled shade in the long oceanfront park; others are scattered throughout the property.

The initial clients left the construction of Hale Palekaiko with only three parts completed: the guesthouse, the pool, and the shell of the main house completed. The property moved hands from tech workers to fashion designers, and these new owners brought their fondness for white and black to the design. While they kept most of PVA's original scheme, they requested to alter its natural earth tones to a more contemporary look. PVA's redesign of the unfinished buildings also included enlarging the primary suite and adding a second-floor lānai. "Even though the project changed a bit, it was a little more up to date," says Peter. "And the best thing was that they finished it."

The changes to the interior and minor modifications to the original architecture haven't affected the overall success of the work. "The project is very strong," says Peter, "so I think it can undergo various changes and even design fads in the interior and still really pull it off. It's sort of one for the ages."

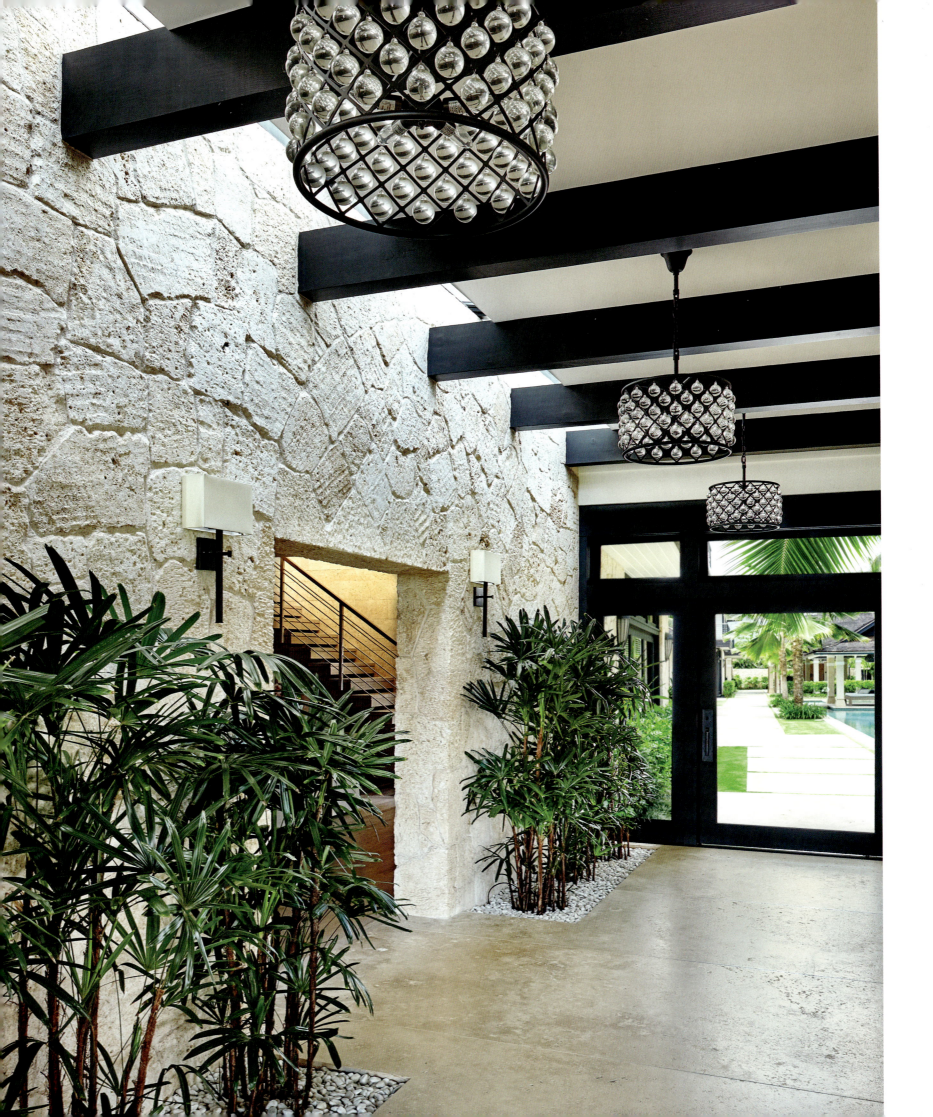

HALE PALEKAIKO

OPPOSITE: *Natural light emphasizes exterior materials, which extend through entry foyer.*

BELOW: *Ma kai lānai opens to park-like setting and ocean beyond.*

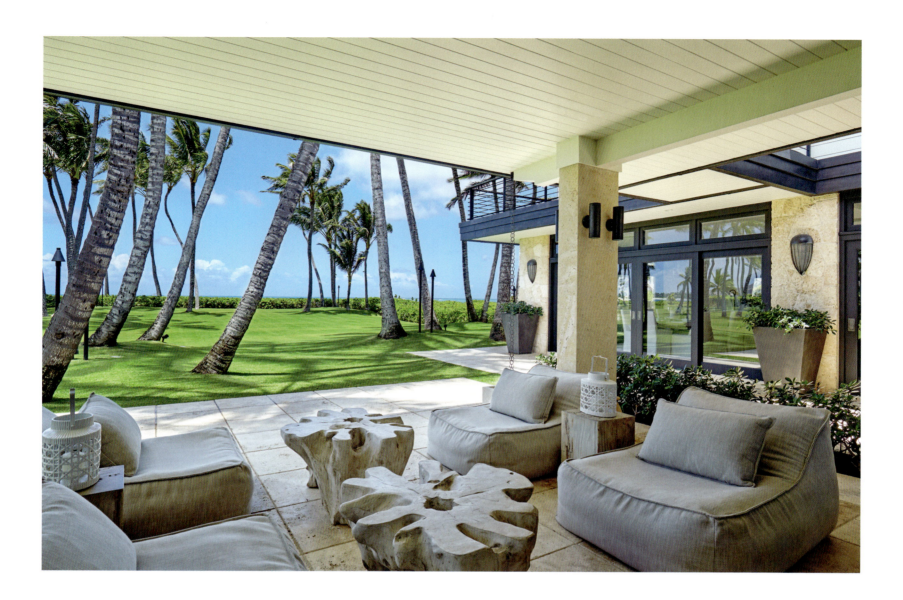

BELOW: *Main house kitchen has chic, beachy aesthetic.* BOTTOM: *Cantilevered stair leads to family bedrooms.*

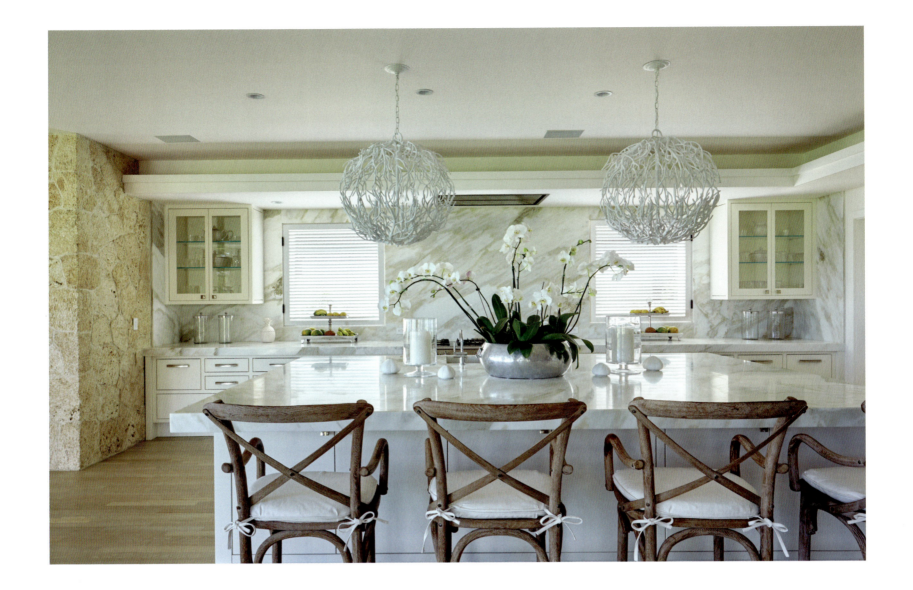

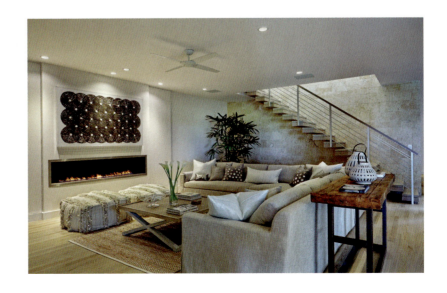

Panoramic view from main-house dining room.

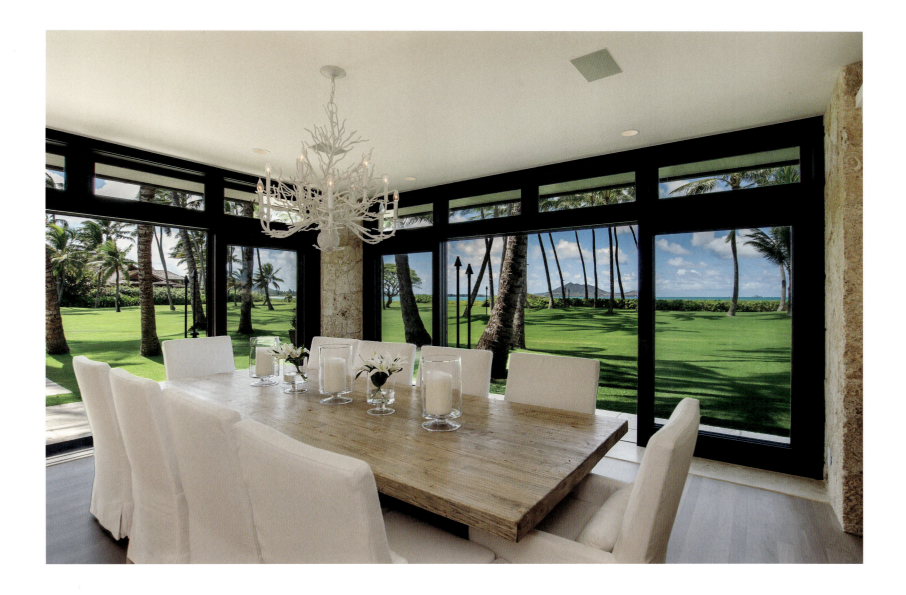

Long pool is buffered from on-shore winds by two-story elements.

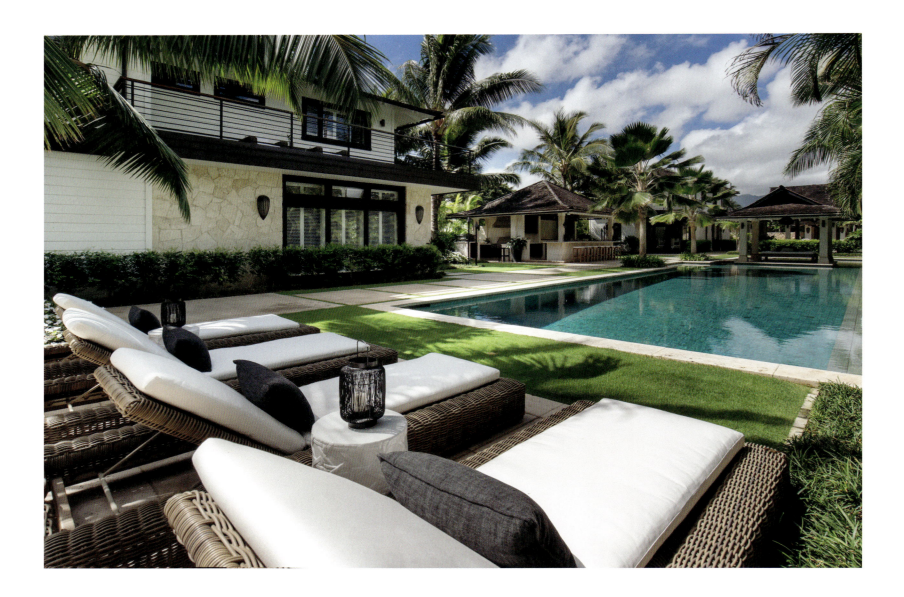

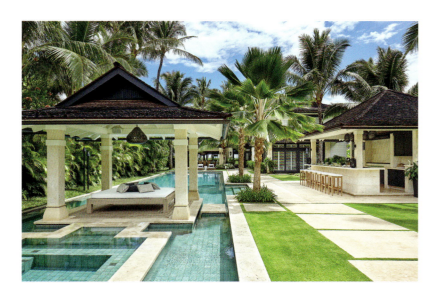

HALE PALEKAIKO

Pool pavilion provides outdoor kitchen, casual dining, pool bath, and storage.

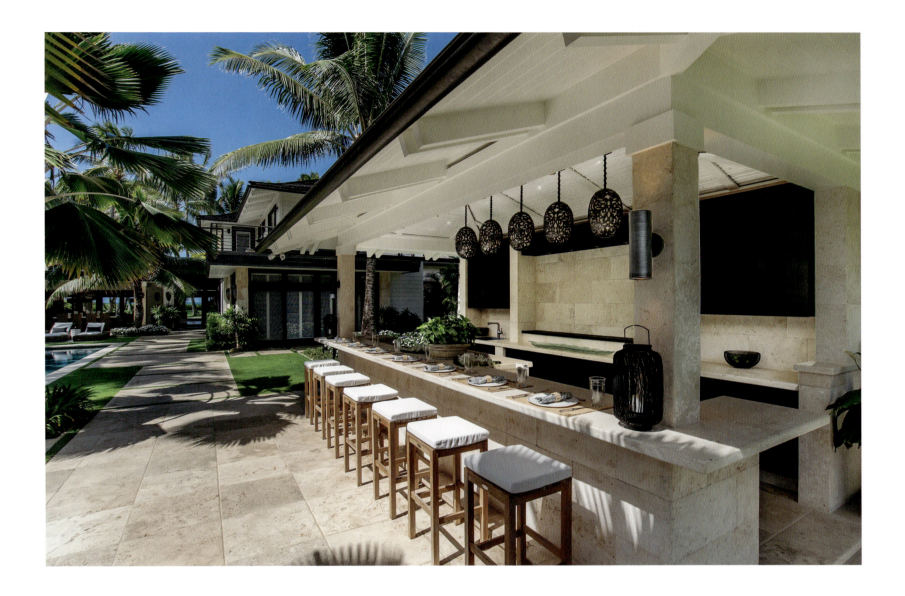

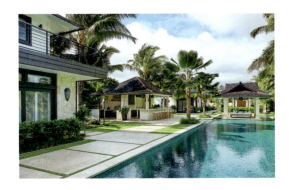

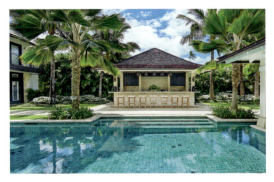

Primary bedroom captures expansive views of coastline.

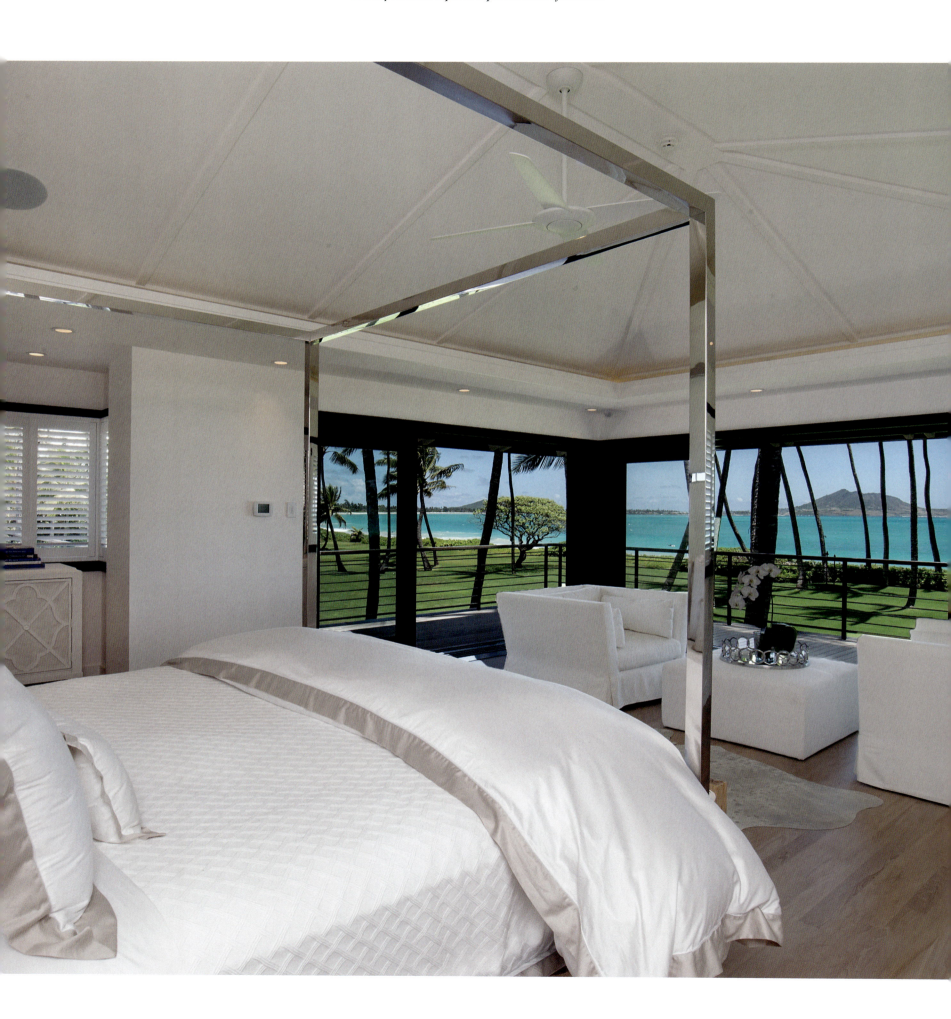

HALE PALEKAIKO

BELOW: *Primary suite includes extensive lānai.*

MIDDLE: *Large auto court buffers living areas from road noise and provides ample parking.*

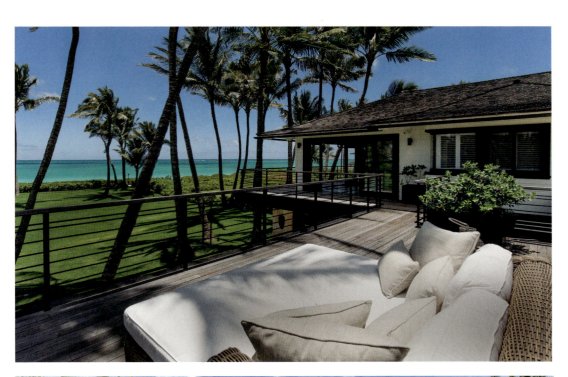

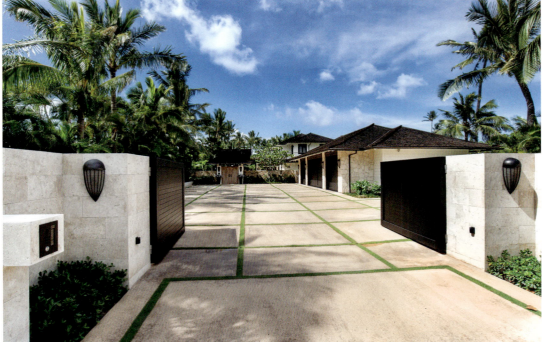

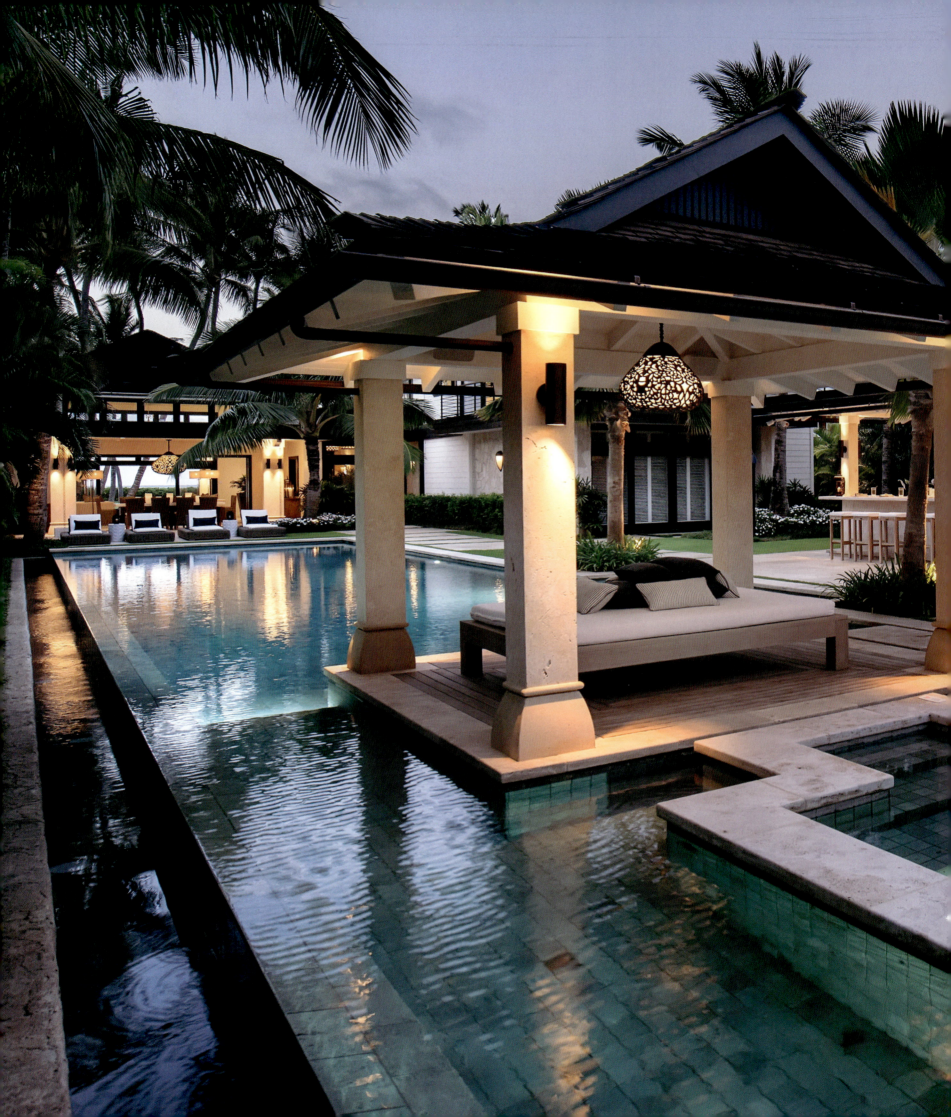

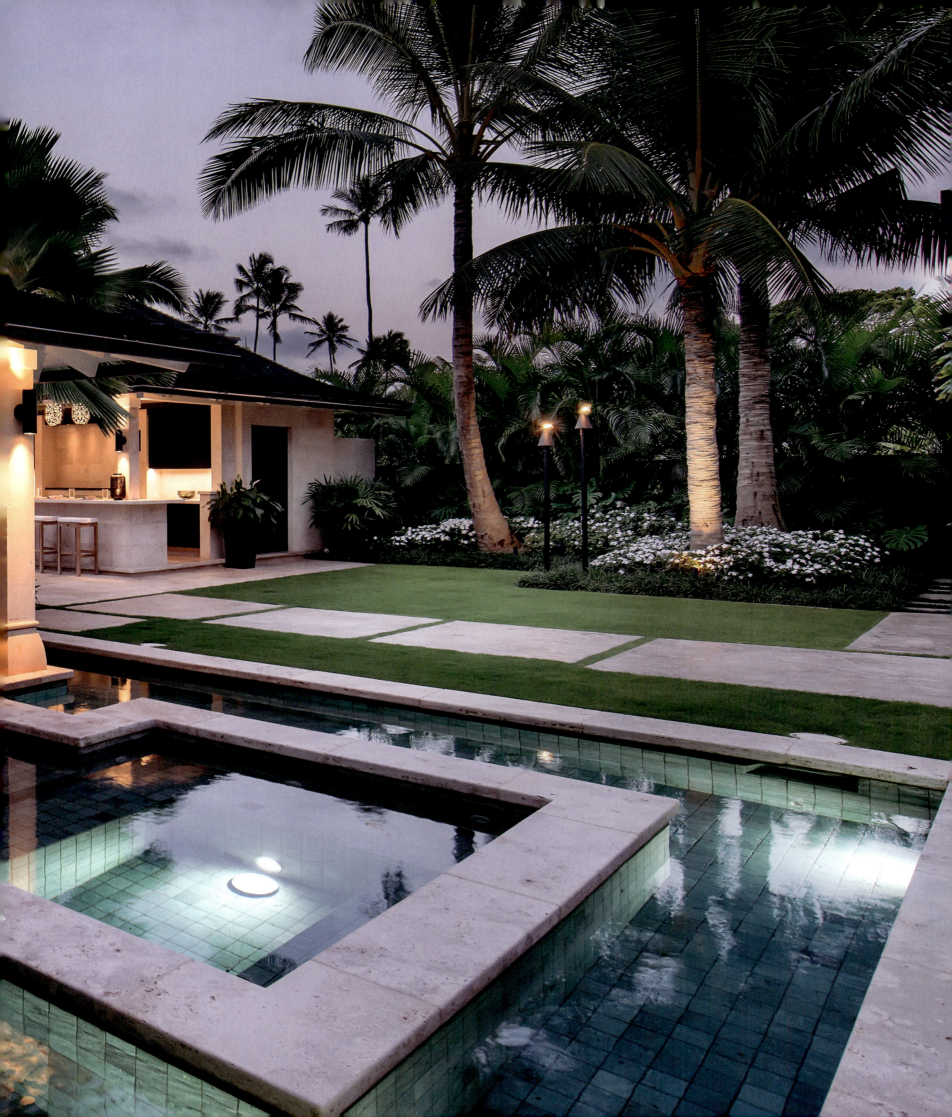

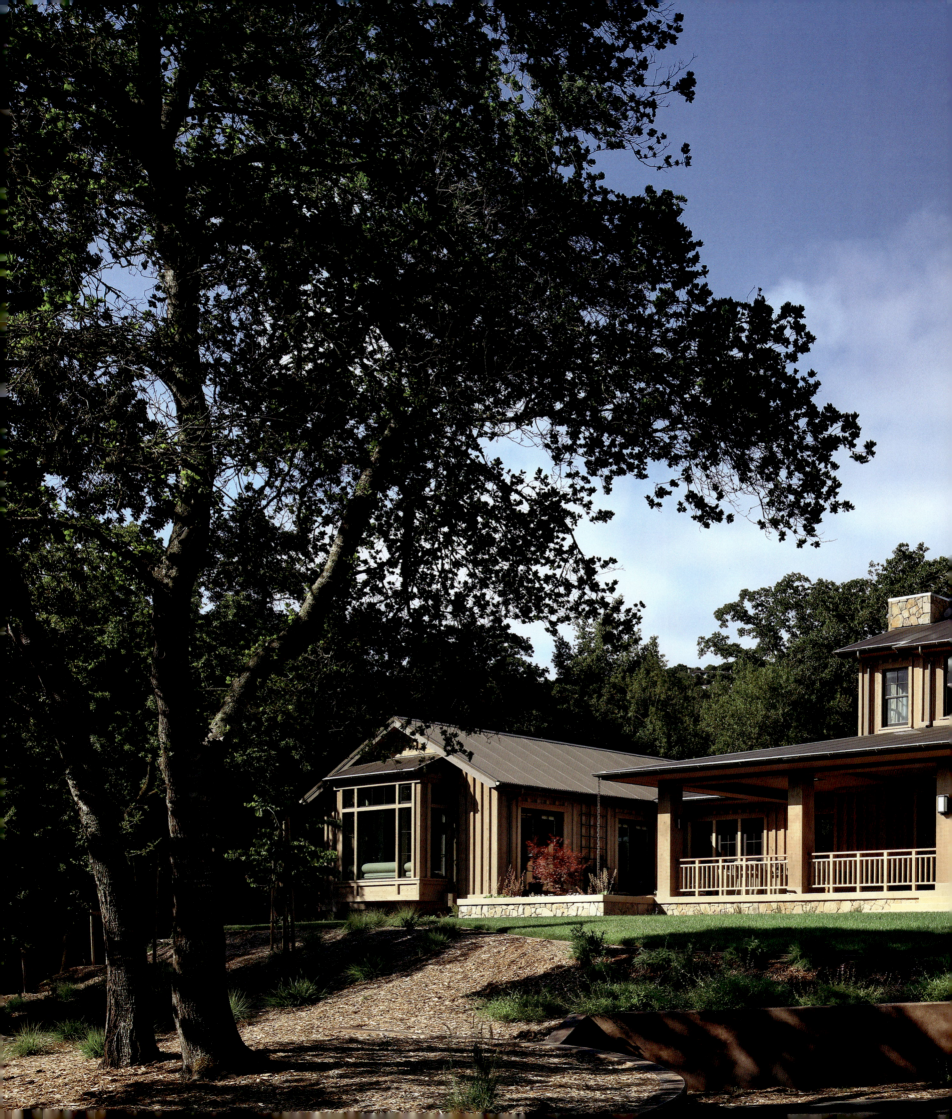

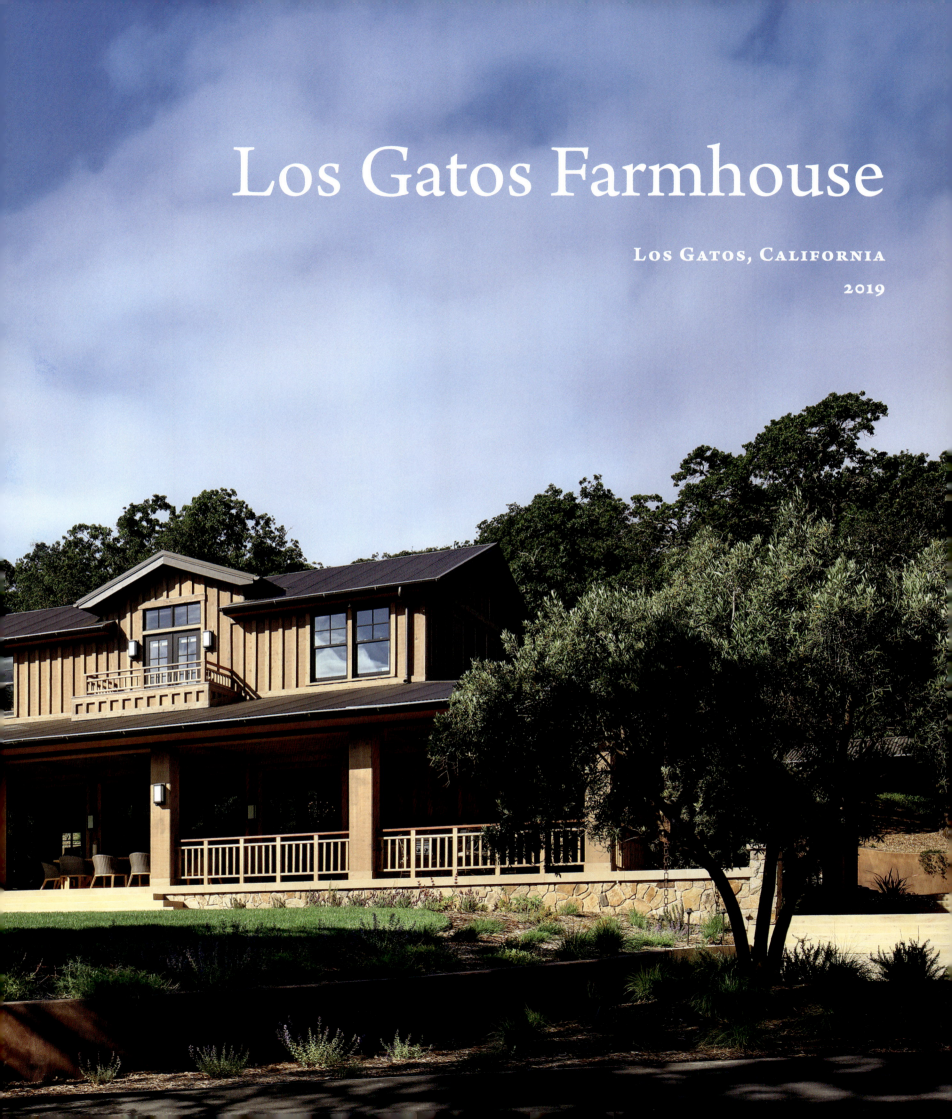

Los Gatos Farmhouse

Los Gatos, California
2019

"I'm a believer that design guidelines don't ensure good architecture," says Peter. "But in Los Gatos, I would say what they're doing works."

Design guidelines—which other firms might see as nuisances—led to opportunities for PVA in its design for a house in Los Gatos, a historic town near San Jose. From site planning to square-footage allowances to materials, regulations became starting points or supported design ideas already conceived by PVA.

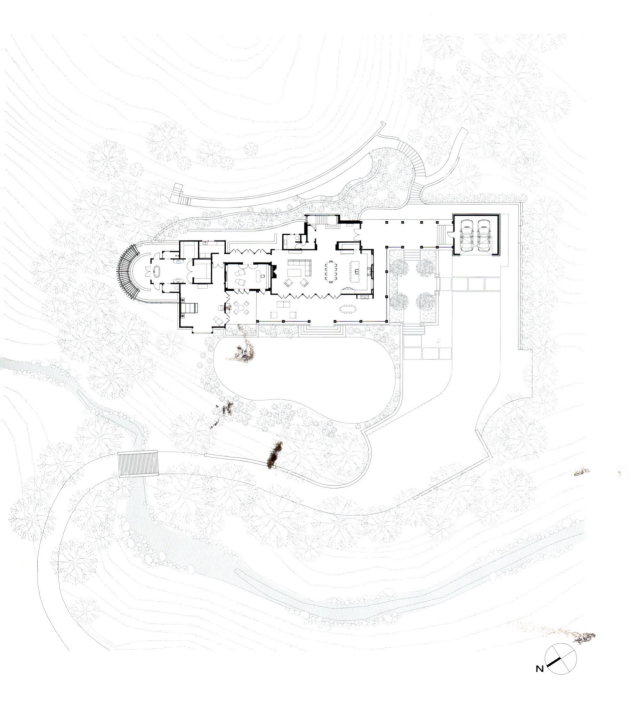

Stone base of house extends to form entry courtyard.

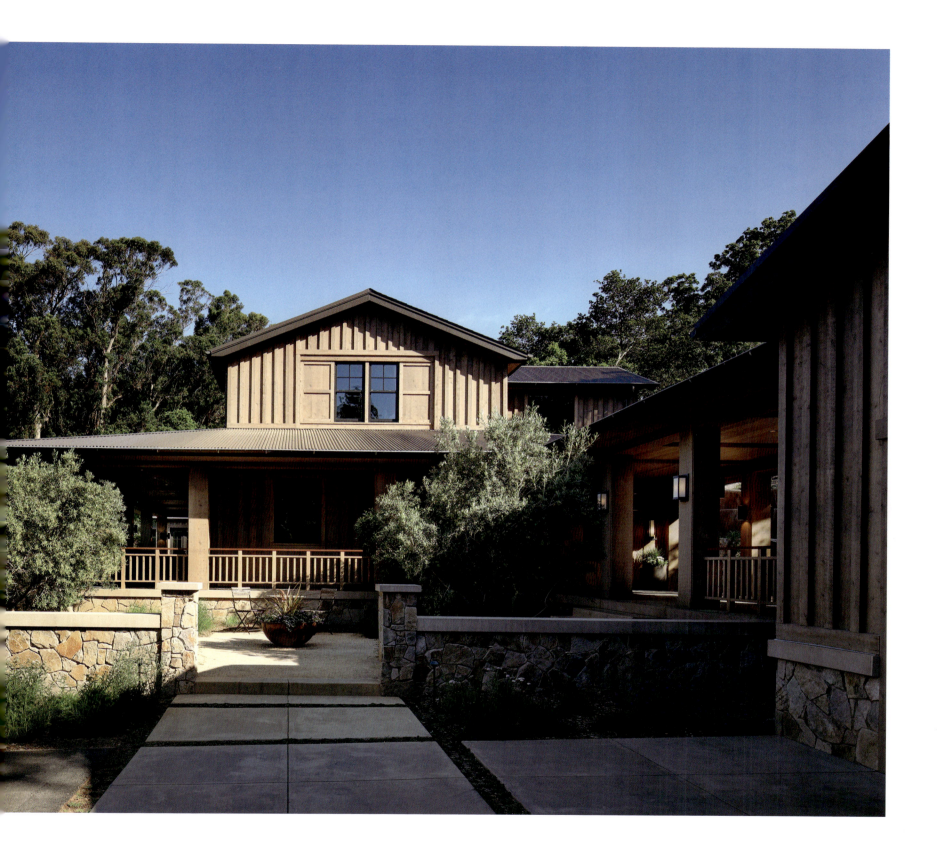

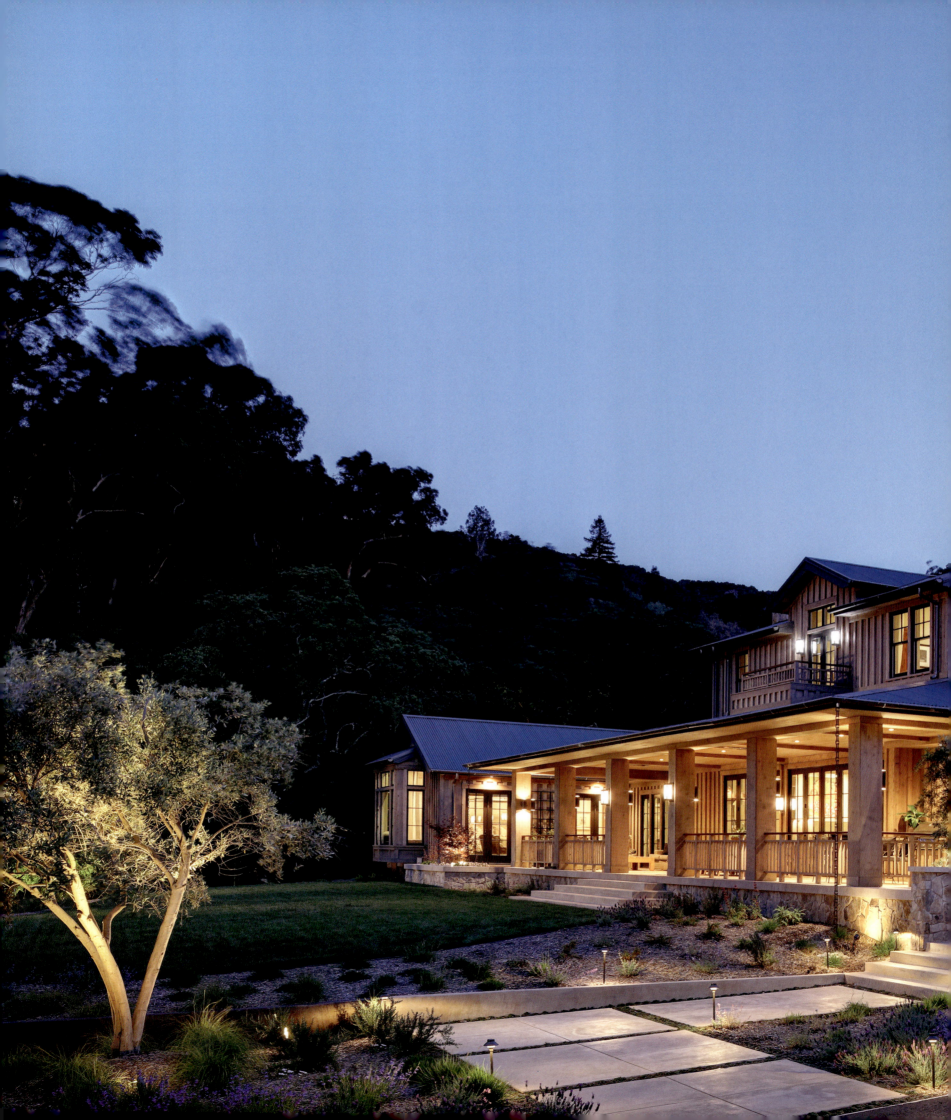

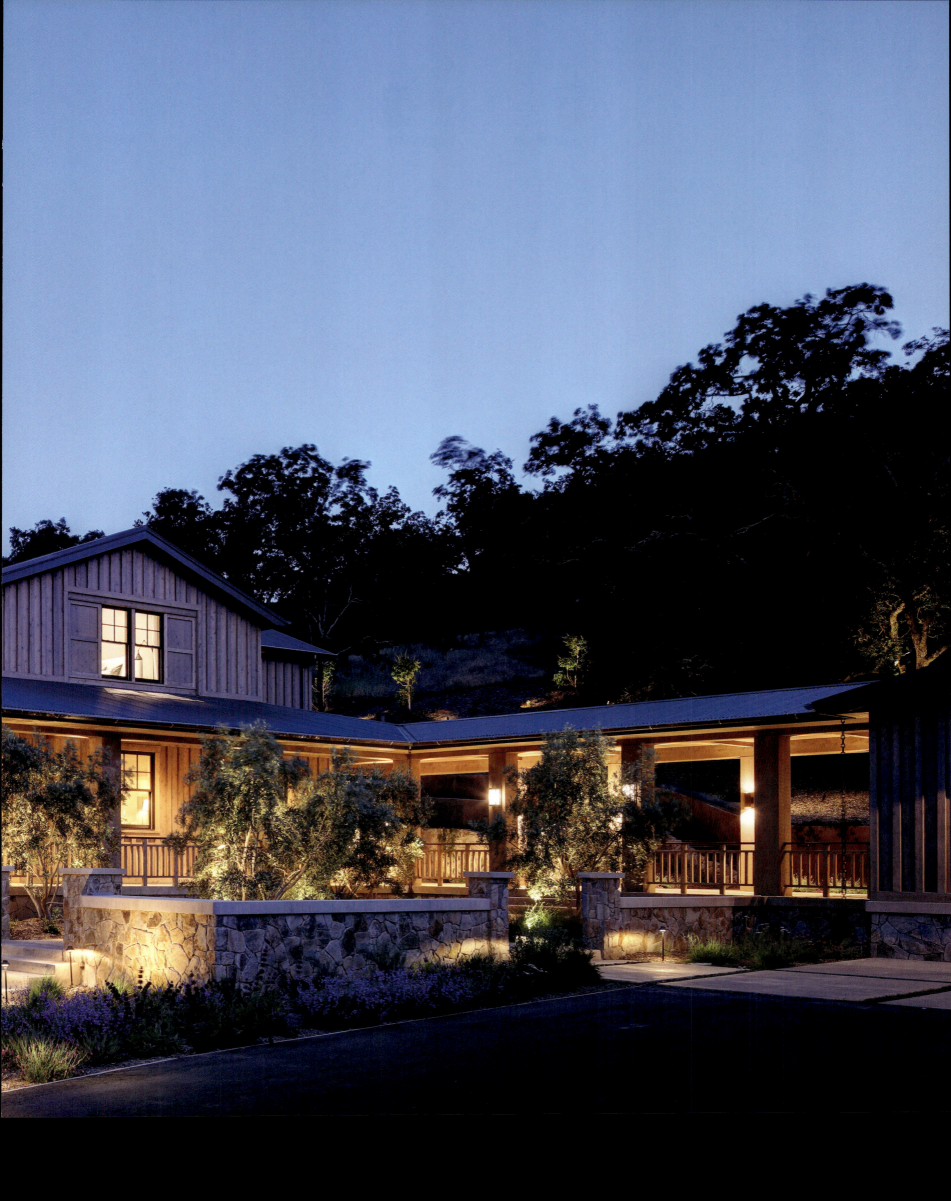

Covered porch creates place for year-round entertaining.

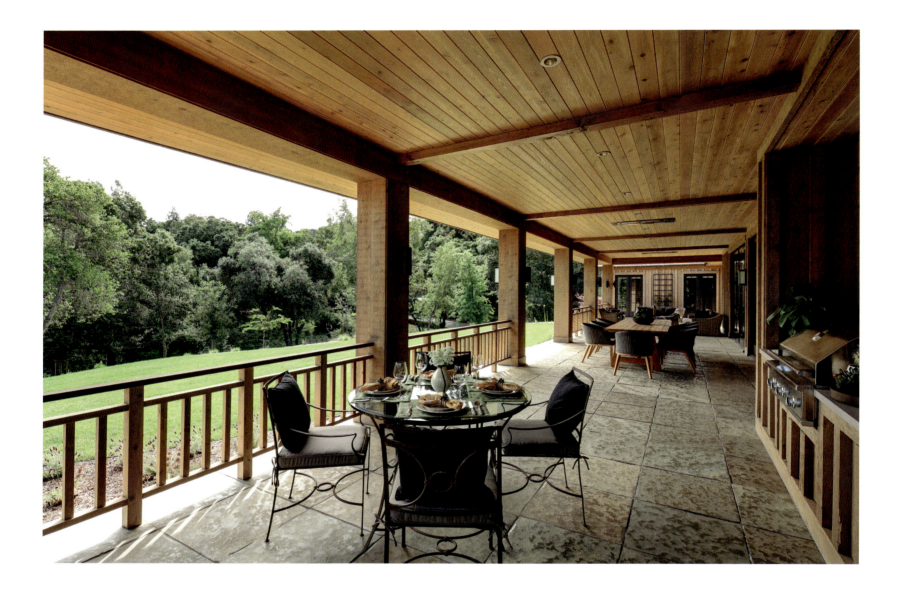

Codes helped determine the siting of the Los Gatos Farmhouse on a steeply sloping, heavily wooded, 4.8-acre site with a stream running through it. Multiple agencies, including the US Fish and Wildlife Service, were involved in the process. "This became really a jigsaw puzzle," says Peter, "to work within the maximum grading allowed because of the steepness." PVA found a spot that, considering all the prohibitions, was the most obvious. Then it decided how to clear a place for the house without upsetting the natural environment. PVA worked with an arborist to determine which trees were reaching the ends of their lives and were more of a liability than an asset to the project. "The town is very strict with tree removal," says Peter, "so new trees were planted for trees that were removed."

A local ordinance set a maximum light reflectance for the house—no bright white paint glaring through the trees. PVA easily met this requirement with warm exterior materials: a stone base and flooring, rough-sawn board-and-batten siding, and corrugated metal roofing. The clients had always had a natural aesthetic in mind—a reference

French doors connect great room to adjacent porch.

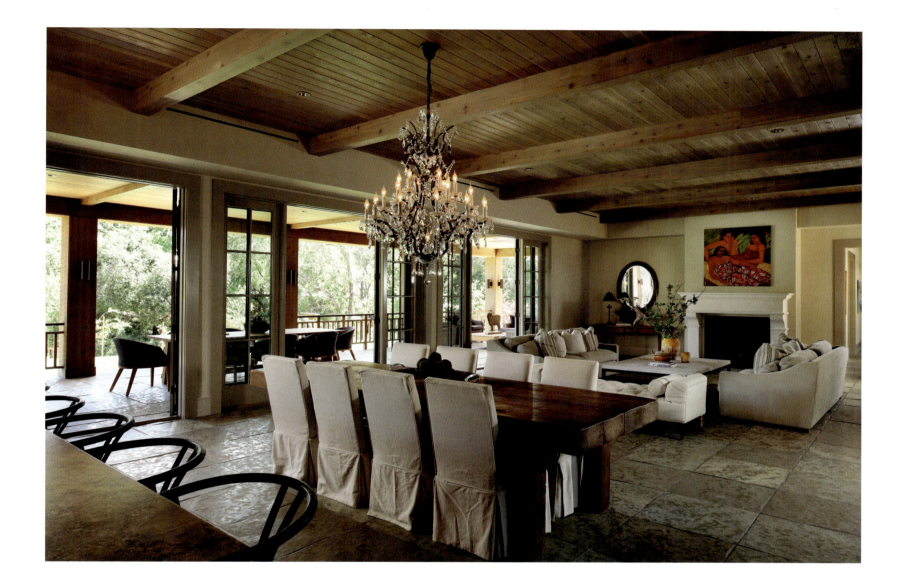

to an old farmhouse and barn that had been on the site. They and Peter visited Napa Valley, located ninety miles north of Los Gatos, to look at local prototypes. "They love Napa's wineries and its modern farmhouse style," says Peter. "This site had that kind of feeling, that sense of the Napa area, and so was influenced by that."

Perhaps most significantly, Los Gatos guidelines allowed PVA to build more usable space. "The guidelines actually encourage design elements like porches," says Peter. "There's a tremendous amount of square footage in the covered walkways and the wraparound porch here, which didn't count against the house." These indoor-outdoor spaces are used for transitions, gatherings, and even seclusion. To ensure privacy of the ground-floor primary bath, PVA designed a small garden and vine-covered fence outside its large French doors.

Fire code guidelines called for less creative—though no less important—design decisions. In this tree-covered area of Northern California, materials needed to be specially selected. "Even though there's wood

BELOW: *Great room features blended entertaining areas.*

OPPOSITE: *Staircase provides hillside views and natural light.*

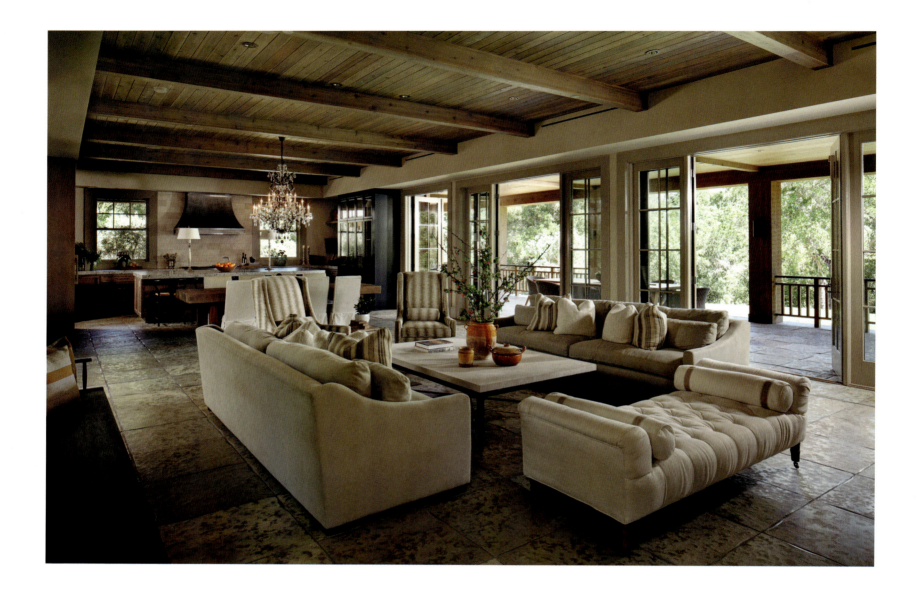

trim on the outside," Peter explains, "everything under that is fire-rated material." Fire codes also determined that the driveway be made of asphalt, rather than the cobblestones or gravel that the clients would have preferred, to allow for fire truck access.

Successful architecture, of course, necessarily responds to clients' design guidelines as well. The retired couple who commissioned the Los Gatos Farmhouse wanted most of their home on the ground floor, so PVA positioned only guest bedrooms on the second floor. The clients' prerequisites included their collections, so PVA designed a fireplace mantel to complement a painting by Hawaiian artist Yvonne Cheng and shelves and niches to support a trove of teapots and other objects. "The clients keep their house looking like an *Architectural Digest* photograph, which is an architect's dream, I suppose," says Peter. "Creating select places for displays but not cluttering—that was a big part of this project." By finding innovative solutions for both the most artistic and most mundane challenges, PVA designs a harmonious project at the Los Gatos Farmhouse.

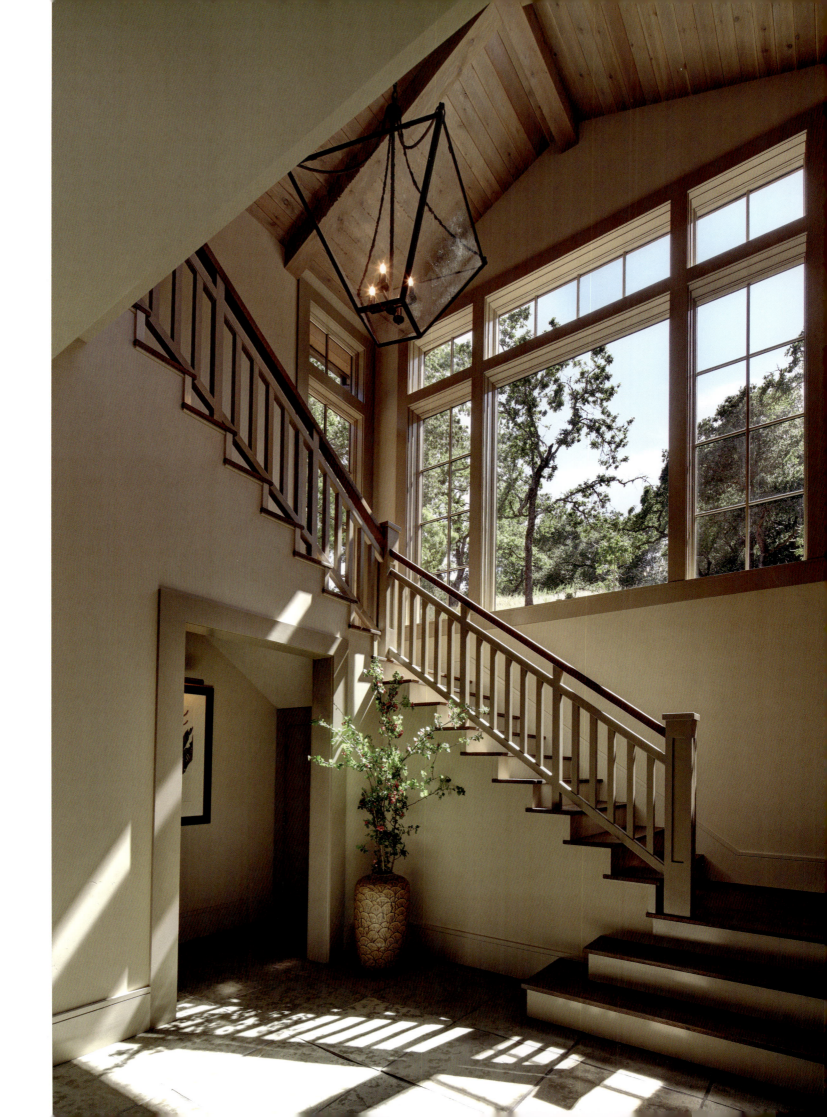

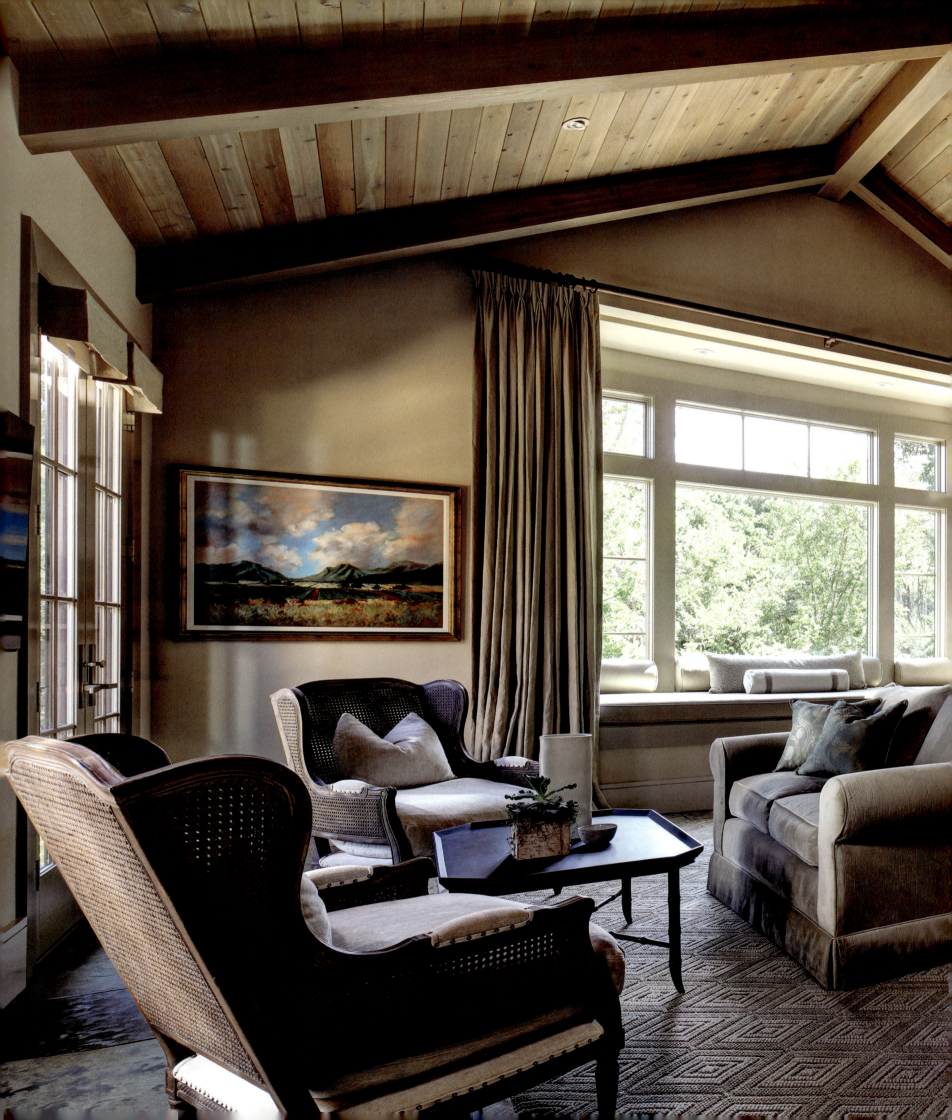

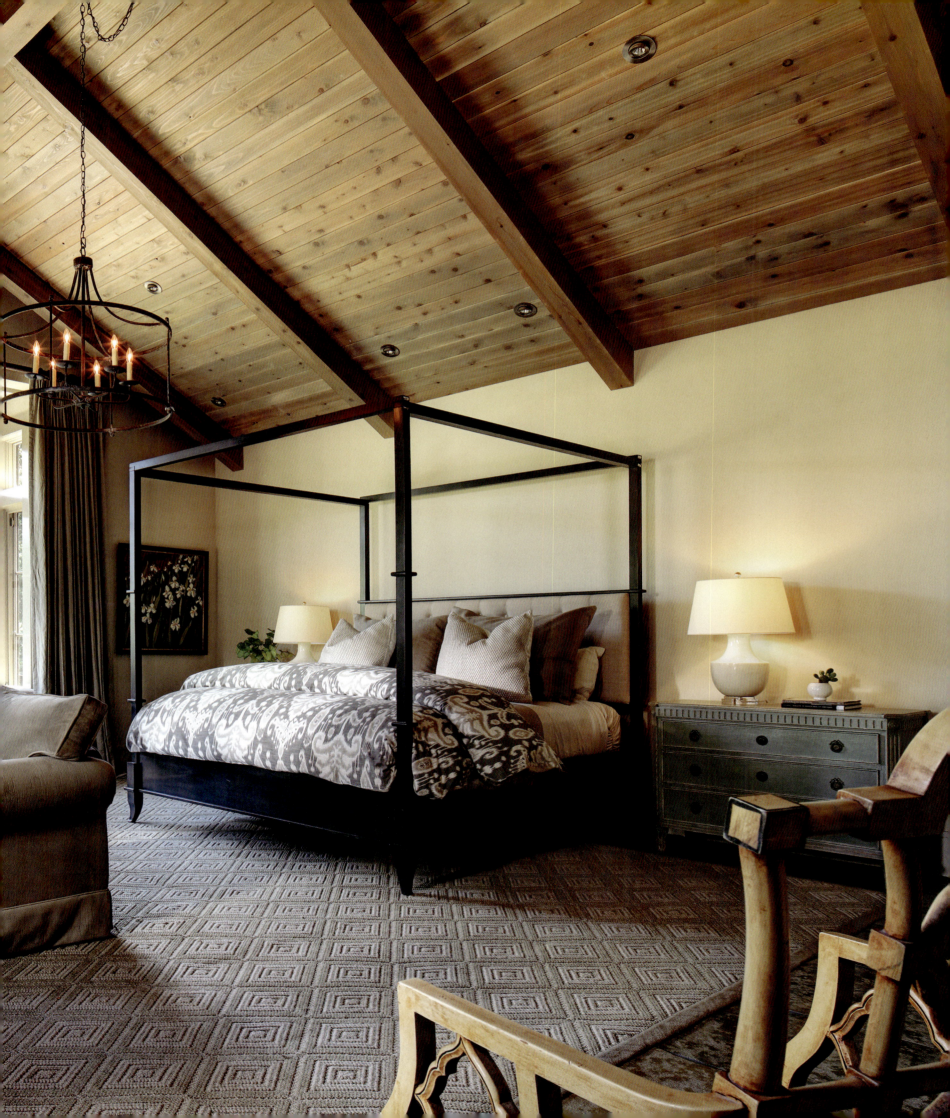

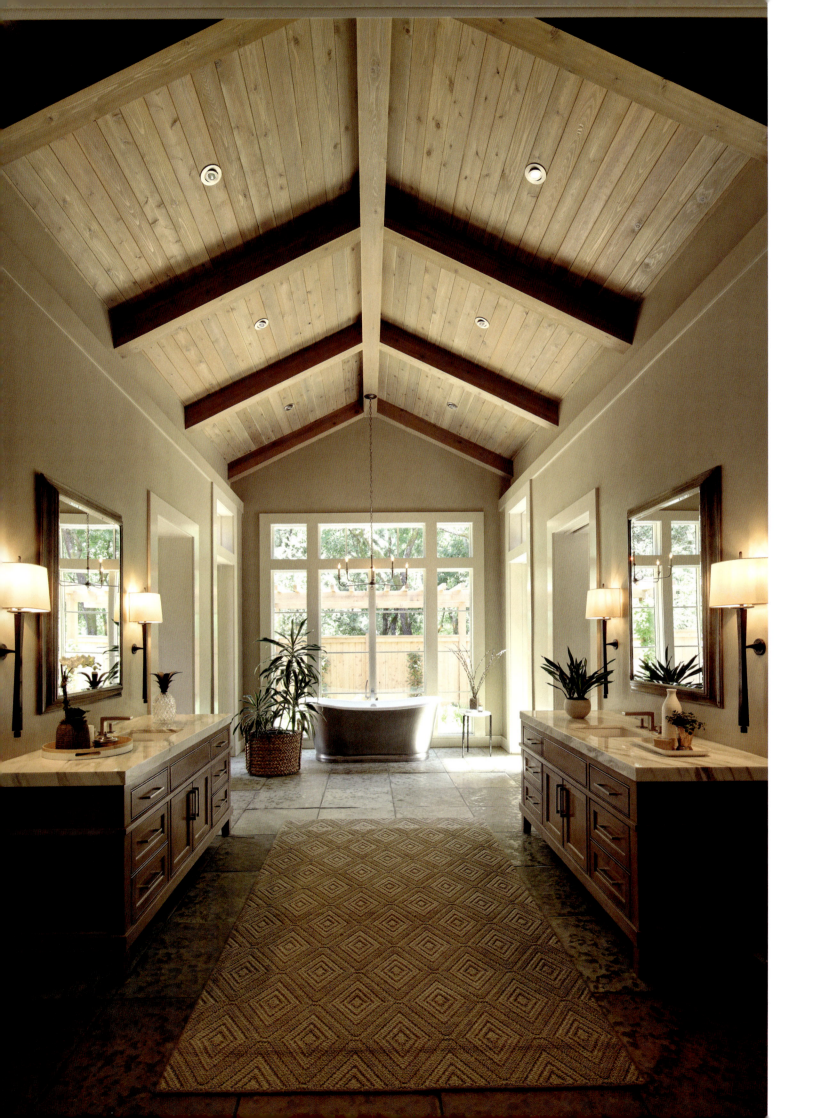

LOS GATOS FARMHOUSE

OPPOSITE: *Custom vanities designed as furniture pieces provide sense of warmth.*

BELOW: *Covered walkway connects to garage and creates inviting entry.*

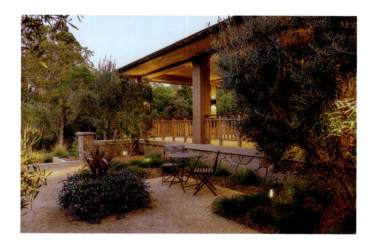

BELOW: *French door–lined gallery leads to study and primary bedroom suite.*

BOTTOM: *Original barn on property provided design inspiration.*

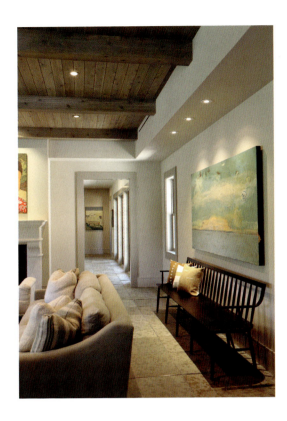

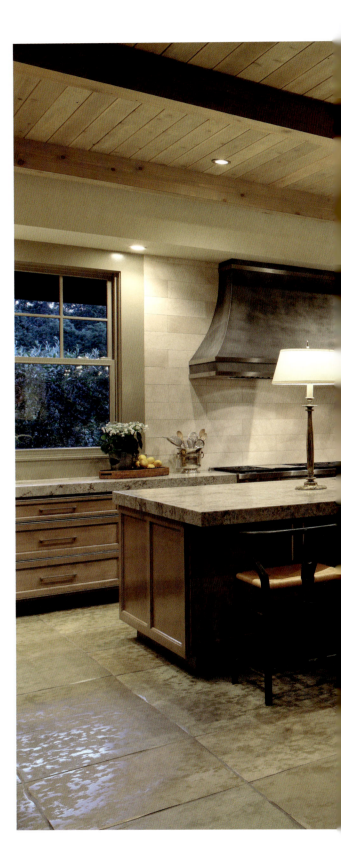

Unique lighting elements create a warm kitchen ambiance.

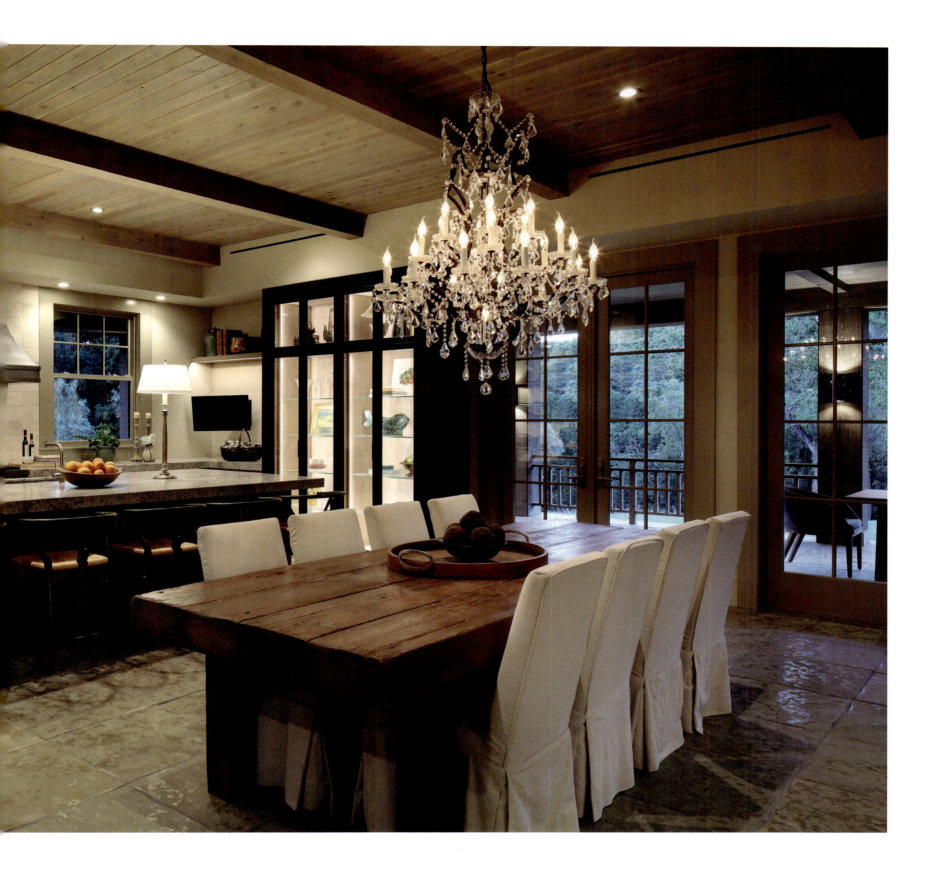

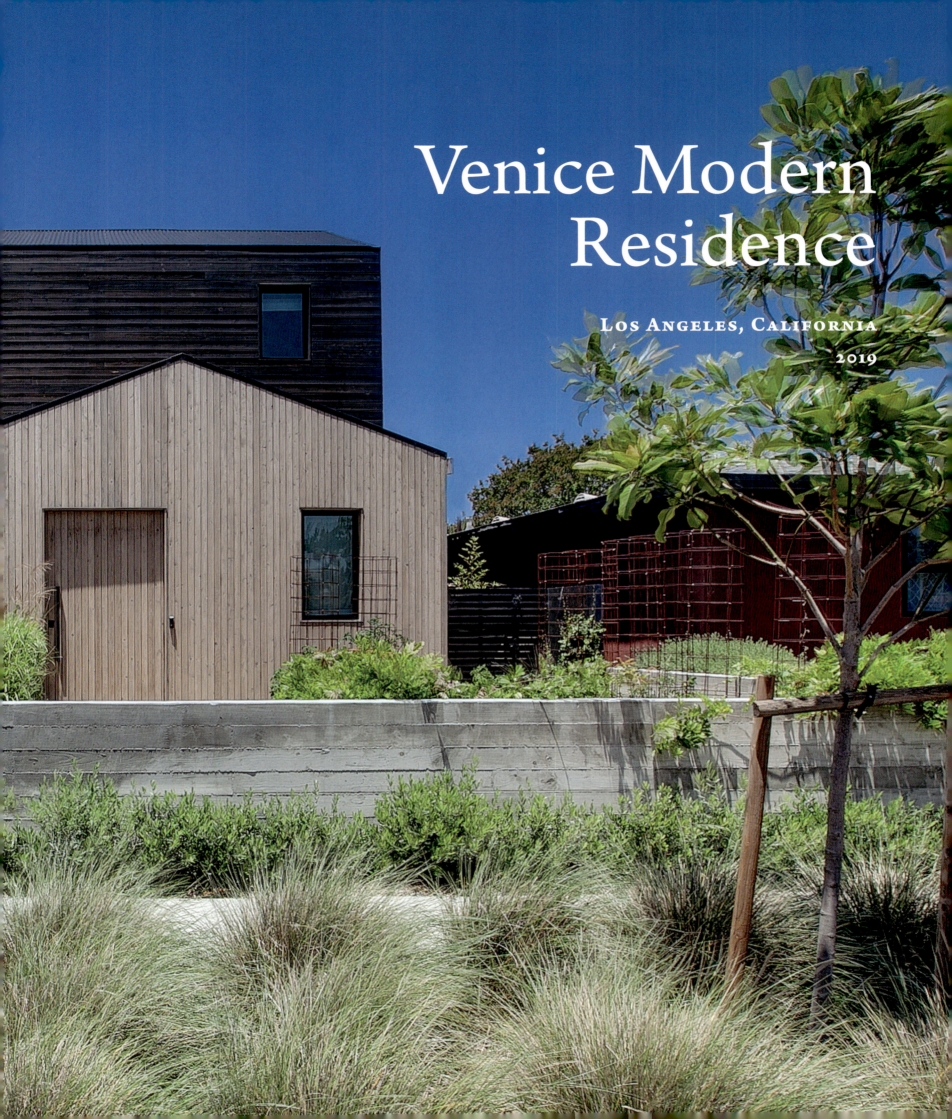

Venice Modern Residence

Los Angeles, California
2019

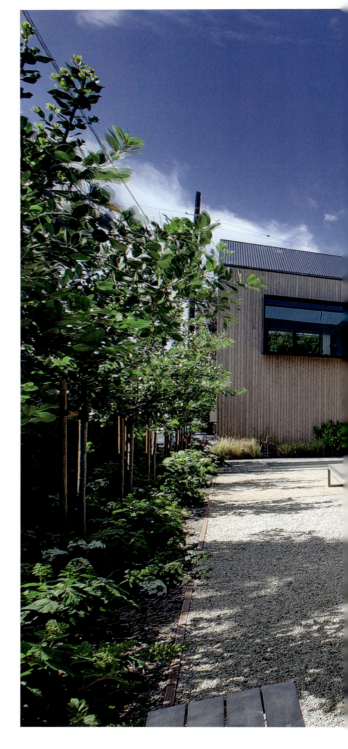

"It's playful," Peter says of the Venice Modern Residence. "It doesn't take itself too seriously. I think that's the influence of Venice, where anything goes."

The Venice neighborhood of Los Angeles is well known for its anything-goes attitude, from its eccentric characters to its quirky buildings. While the immediate neighborhood of the Venice Modern Residence contains mostly nondescript, single-story homes dating from the 1960s, greater Venice, Peter says, has gone through a transformation in recent years, with robust architectural experimentation. This context allowed PVA to design a uniquely Californian home.

The clients' particular interest in a modern farmhouse look and the influence of Scandinavian and Shaker buildings were starting points for the Venice Modern Residence. "Scandinavian and Shaker design boil down to simple, humble forms," Peter says. "Here they work together: simple site plan, simple forms, simple materials of concrete, steel, cedar siding, glass—nothing that doesn't really need to be there." This simplicity may be deceiving. "It's not very simple to make a building look simple," says Peter. "Particularly the flush roof; it actually requires fairly intense detailing." Strict horizontal and vertical siding, large inset glass windows, pocket doors that disappear into walls—all demand precision to create the clean lines that PVA was looking for in this house. And the design had to work within the clients' somewhat limited budget. "We were very cost conscious, so there's a little bit of sparseness," Peter says, "but we still tried to achieve the goal of something that feels pretty substantial."

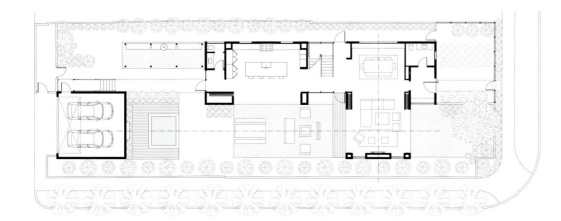

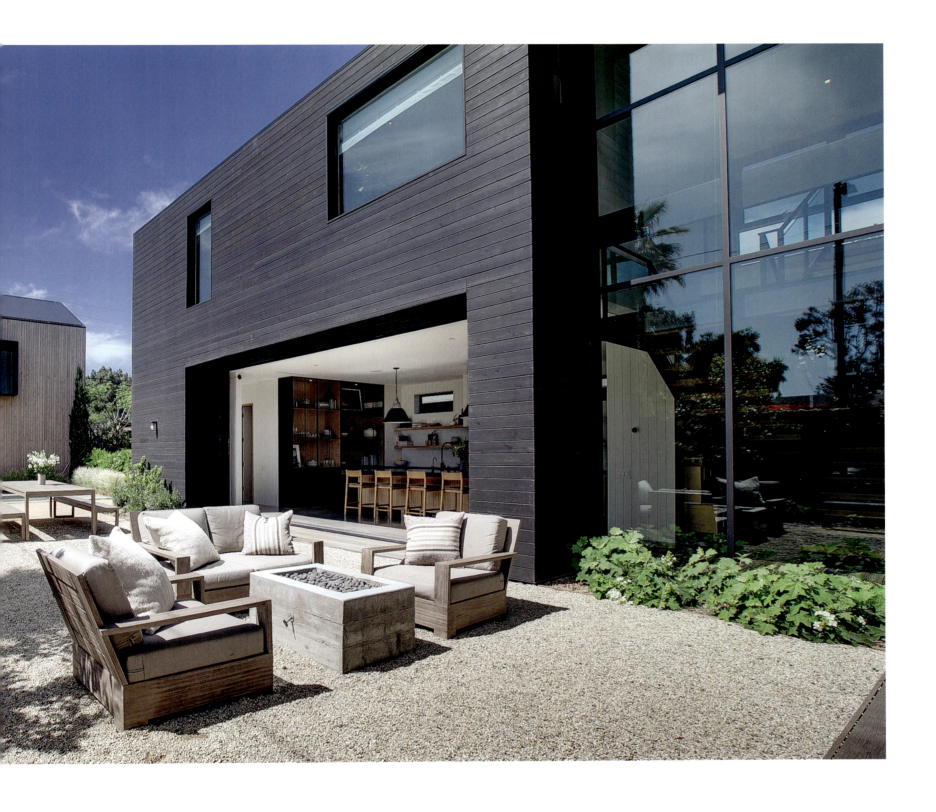

NEW HOMES

Living room opens on both sides and captures borrowed views from corner location.

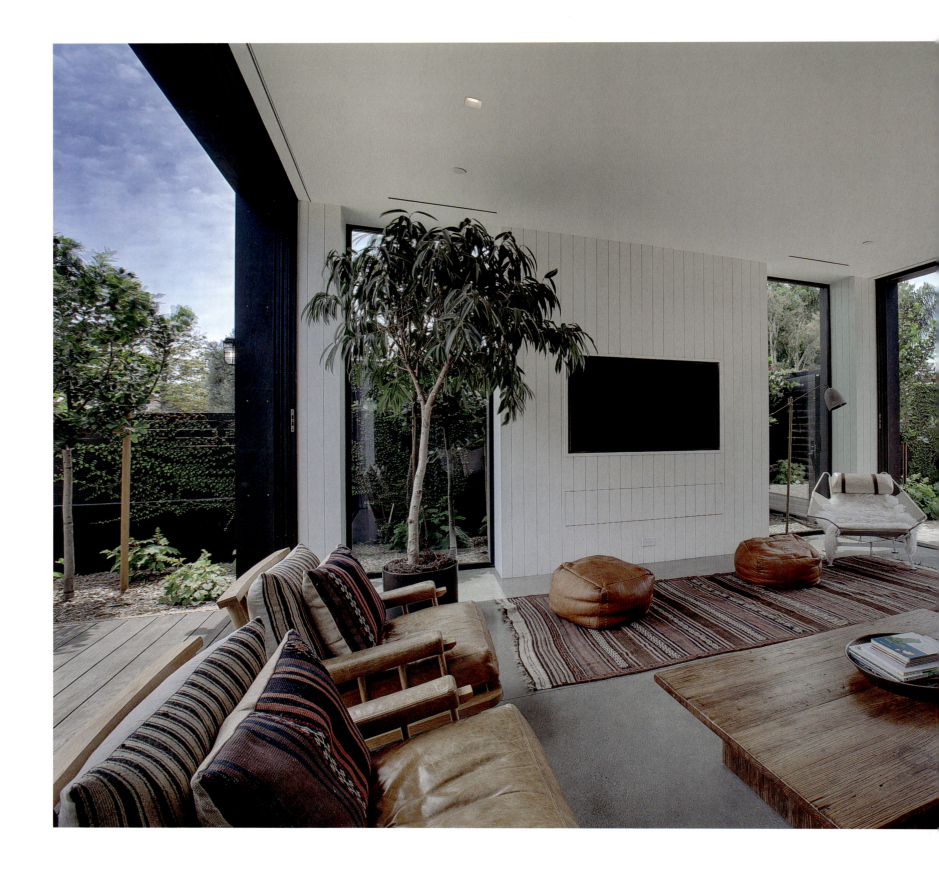

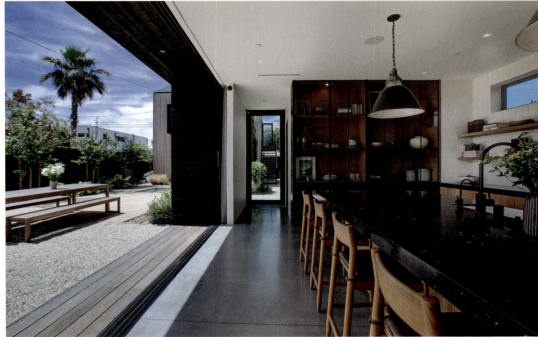

Kitchen fully opens to adjacent courtyard.

Skilled site planning was also necessary to realize the design. On the Venice Modern Residence's long, thin site, PVA designed a collection of contemporary buildings within a patchwork of outdoor spaces, following design principles it uses in its work in Hawai'i. It placed the bulk of the built forms along the lot line. This allows a large courtyard to sit aside the street, which PVA lined with palm trees, and so to gain some additional visual space. Additional open spaces are set around the site to make the best of sunny LA: an ornamental garden and a vegetable garden frame the front entrance, a small garden holds a corner at the rear of the site, and a plunge pool and outdoor kitchen sit in between. "The design became really about outdoor entertaining," says Peter. "The clients do a lot of entertaining; they have friends over and cook out and have gatherings."

When visitors enter the site, they meet a single-story gable roof over the front door. "I tried to respect the scale of the neighboring homes, even though this house was much larger," says Peter. "The front portico brings the scale down to the street." From here a straight line leads to spaces that get progressively more open-air: a dining room, kitchen, outdoor kitchen, and garden. From this main building line bump out two forms: a living room that opens fully onto two side gardens, and a garage with a second floor for an office/guest room. Most of the building exterior is made of stained black wood cedar siding, which met the clients' interest in a modern, Scandinavian farmhouse look. "But then, to break it up," says Peter, "we introduced a lighter siding as well on both the front structure as well as on the garage."

The house fits well into the playful atmosphere of Venice. Yet the complex orchestration of its simple buildings and outdoor spaces sets it apart from some of its improvisational neighbors. More classical than jazz, the design is simultaneously lighthearted and structured.

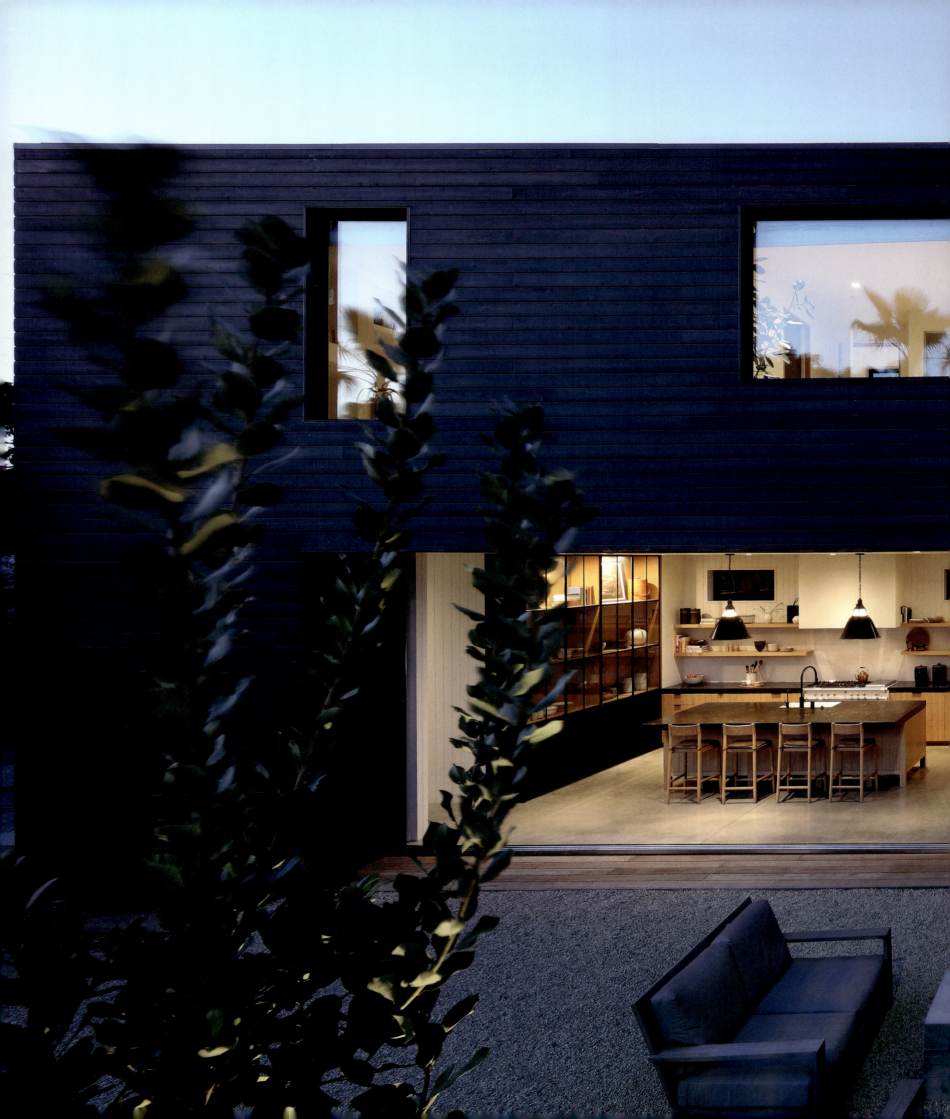

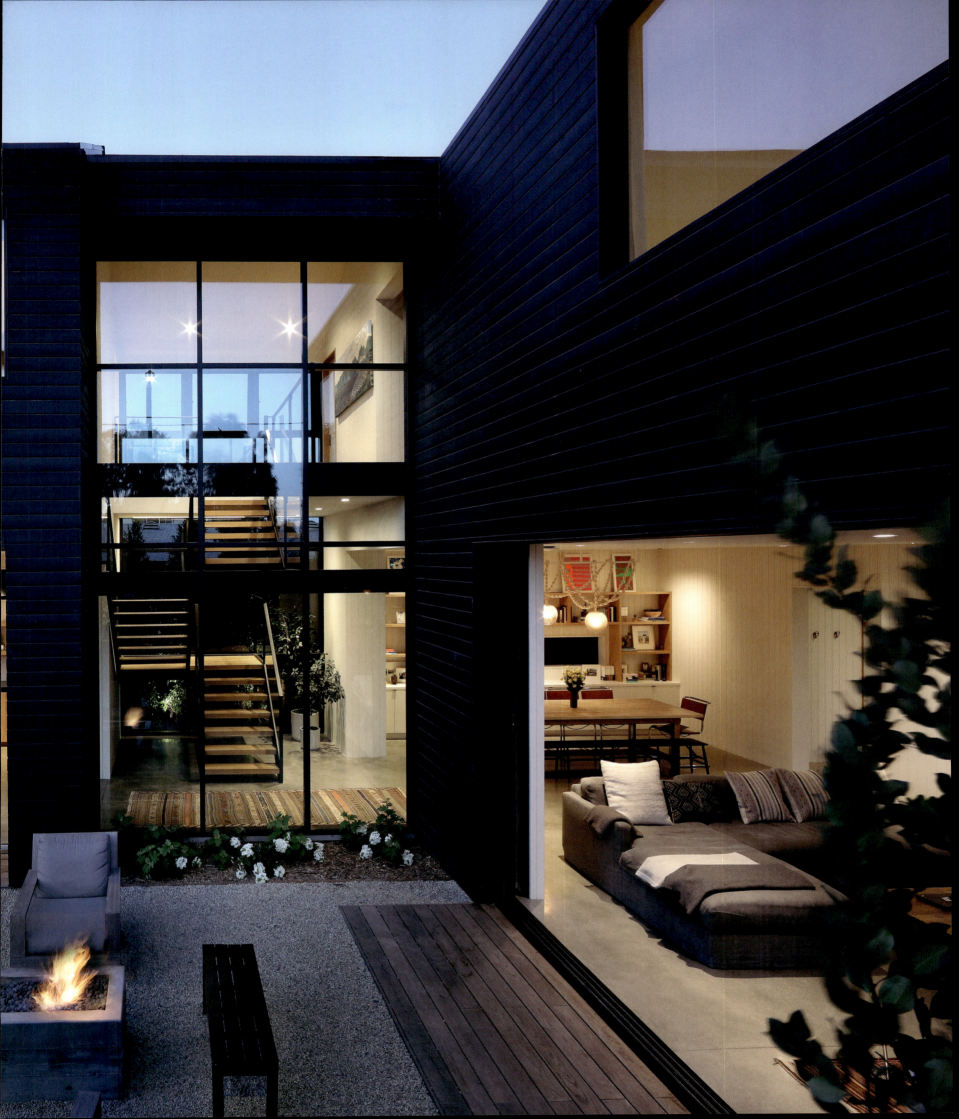

House creates multiple indoor-outdoor exposures.

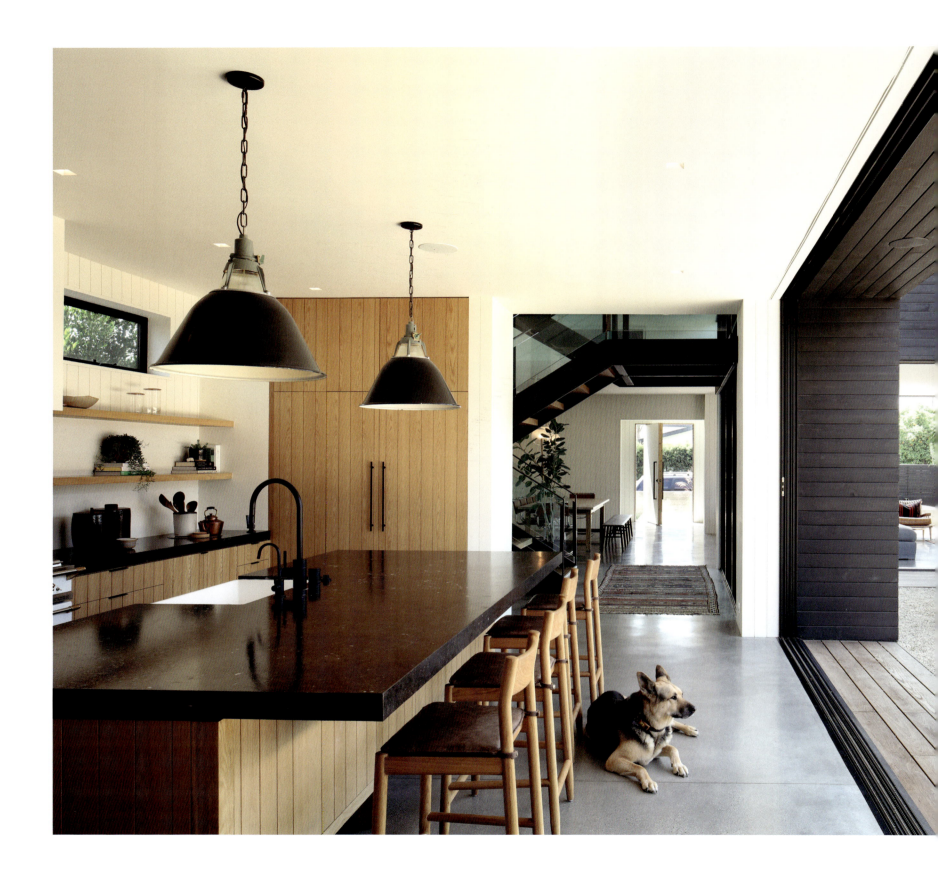

VENICE MODERN RESIDENCE

BELOW: *Multiuse loft space, which includes Murphy bed, overlooks main courtyard.*

BOTTOM: *Concrete, steel, and glass are balanced with soft, playful interior elements.*

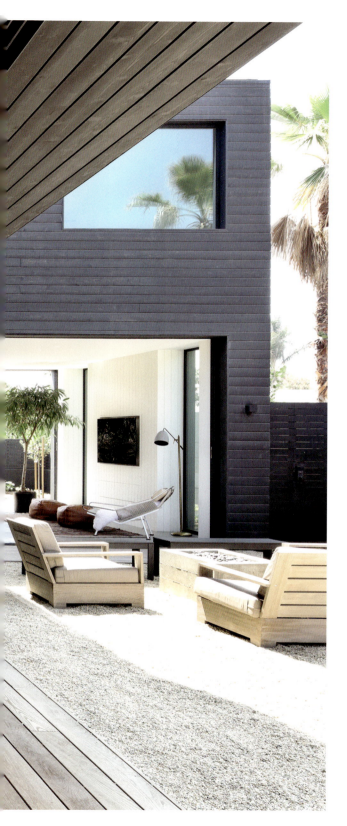
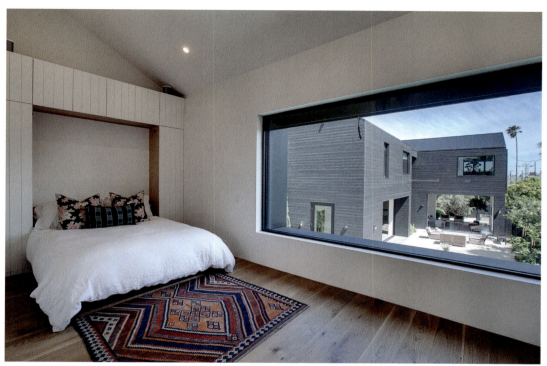
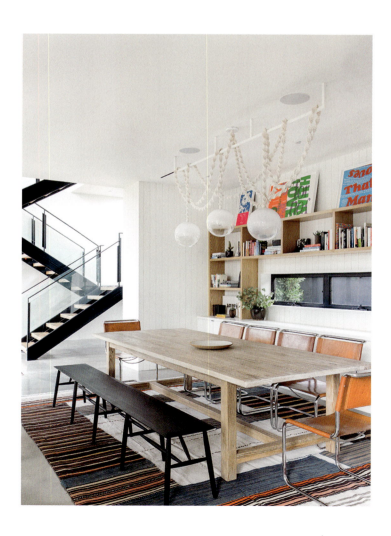

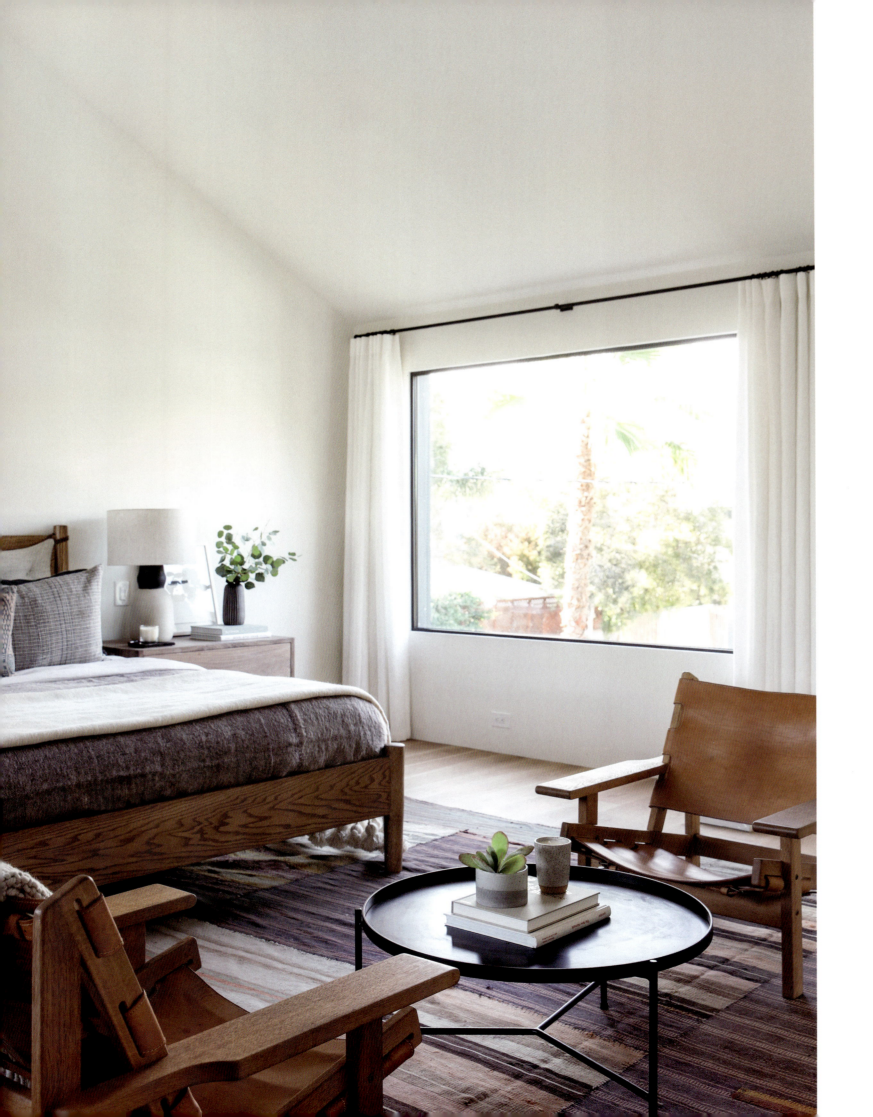

VENICE MODERN RESIDENCE

OPPOSITE: *Simple, clean architectural volume allows view and furniture to take center stage.*

BELOW: *Two-story glass-walled stair separates wings of house.*

BOTTOM: *Section drawings.*

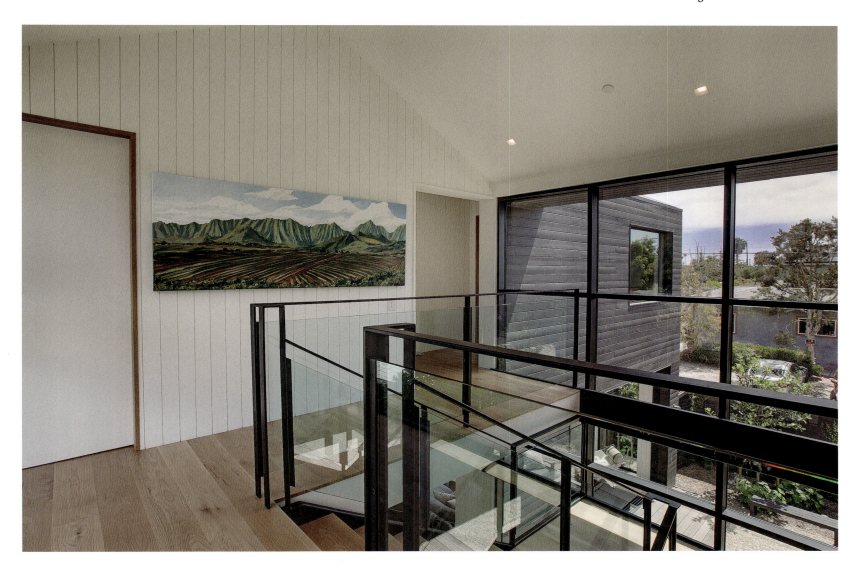

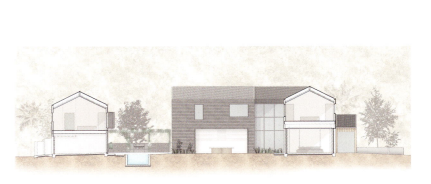

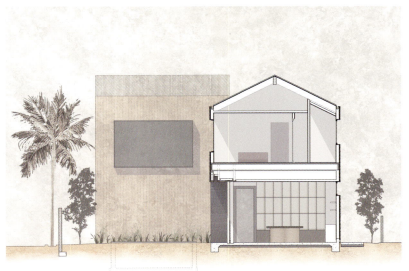

BELOW, LEFT AND RIGHT: *Two children's bedrooms connect to Jack and Jill bathroom.*

BOTTOM: *View through living room.*

OPPOSITE: *Entry foyer provides immediate connection to exterior.*

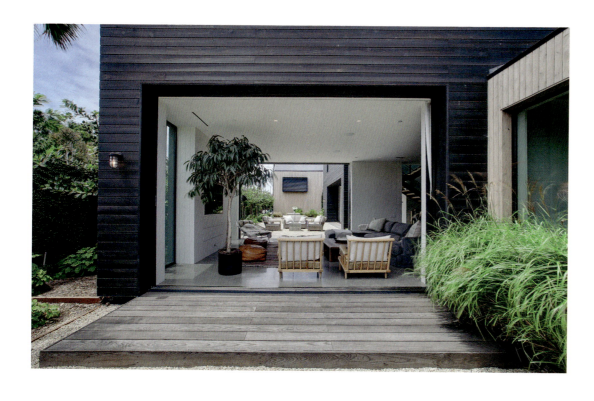

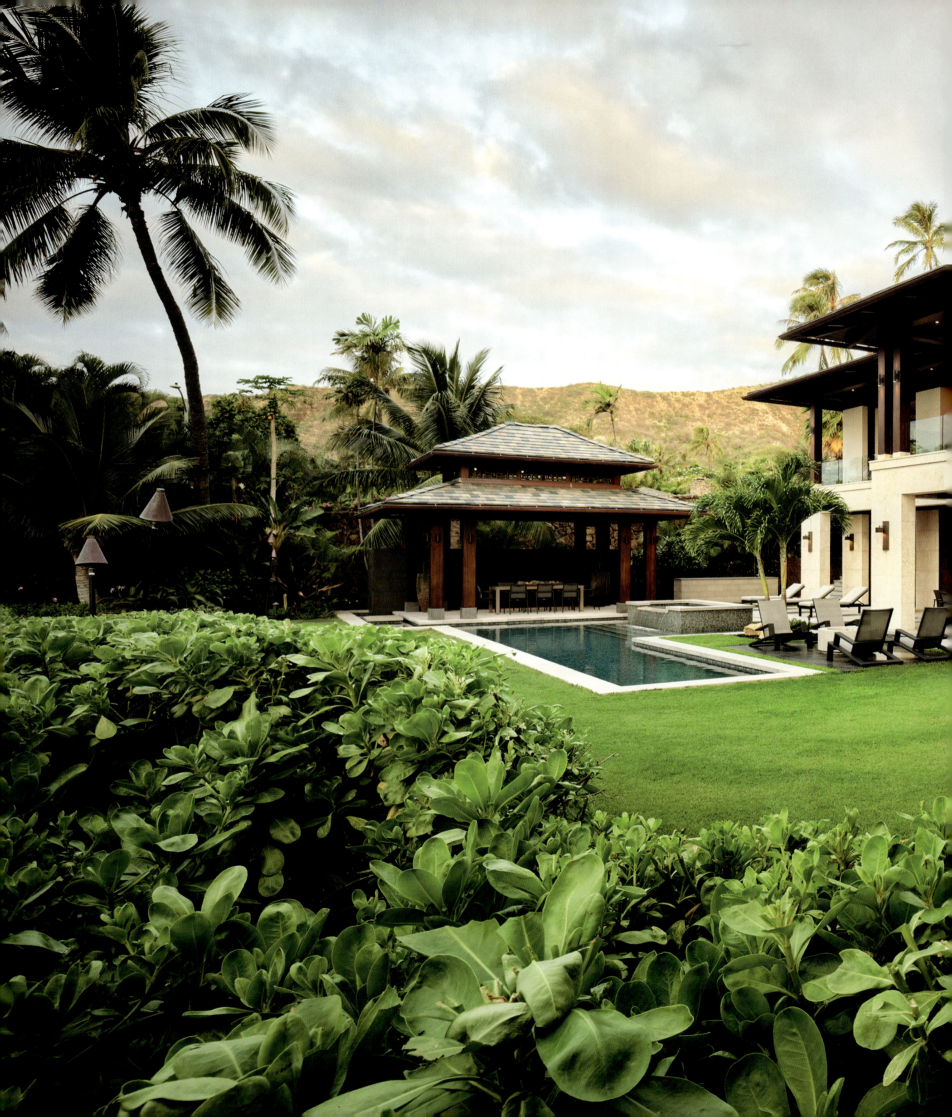

Haleakalā

HONOLULU, OʻAHU, HAWAIʻI

2023

For Haleakalā, a new house on a venerable site, PVA had to decide what to retain and what to let go. "There's a large banyan tree in the middle of the site, and everybody wanted to keep it, of course," says Peter. "It's an epic tree." PVA also kept coconut trees at the ma kai side and plumerias at the entrance.

The basic siting of the house, opening onto Diamond Head oceanfront, was worth maintaining as well. "The site is just fabulous," says Peter. "The views are spectacular."

But much needed to be discarded. PVA investigated renovating the home on the site but found that its layout didn't allow for reworking. "It's a sloping site, and the lower level was kind of a subterranean semibasement with a very small indoor area," says Peter. "And there was no interior connection; you had to go down an exterior stair to get there." Together with the clients, PVA decided to take down the house. PVA worked with the group Re-use Hawai'i to salvage as much of its materials as possible.

The new house replaces the semibasement with a more usable full lower level with ocean views. A glass stairway at the entry connects the two floors and brings daylight below. "And then we actually pulled the floor away on the upper level from the entry wall," adds Peter, "so there's a few feet of space that allows light down into what would otherwise be a dark lower-level area." The entrance is a sort of bridge made with wood planks; gaps between the boards allow views to the lower level.

HALEAKALĀ

Aerial view showing the property's relationship to the mountains (uka) and the sea (kai).

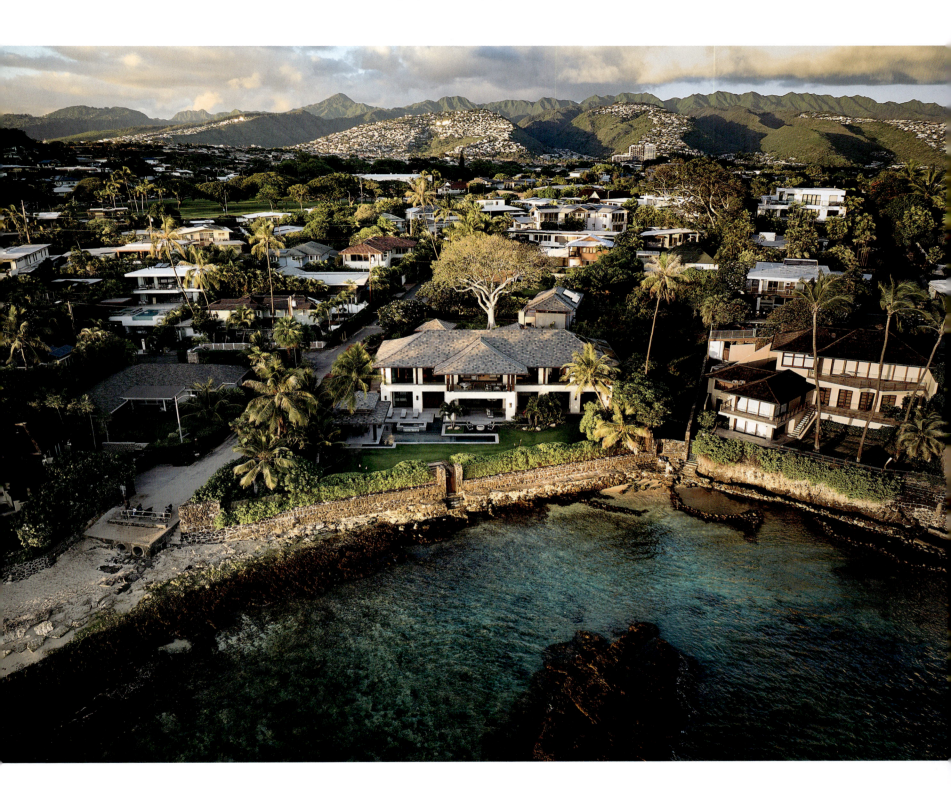

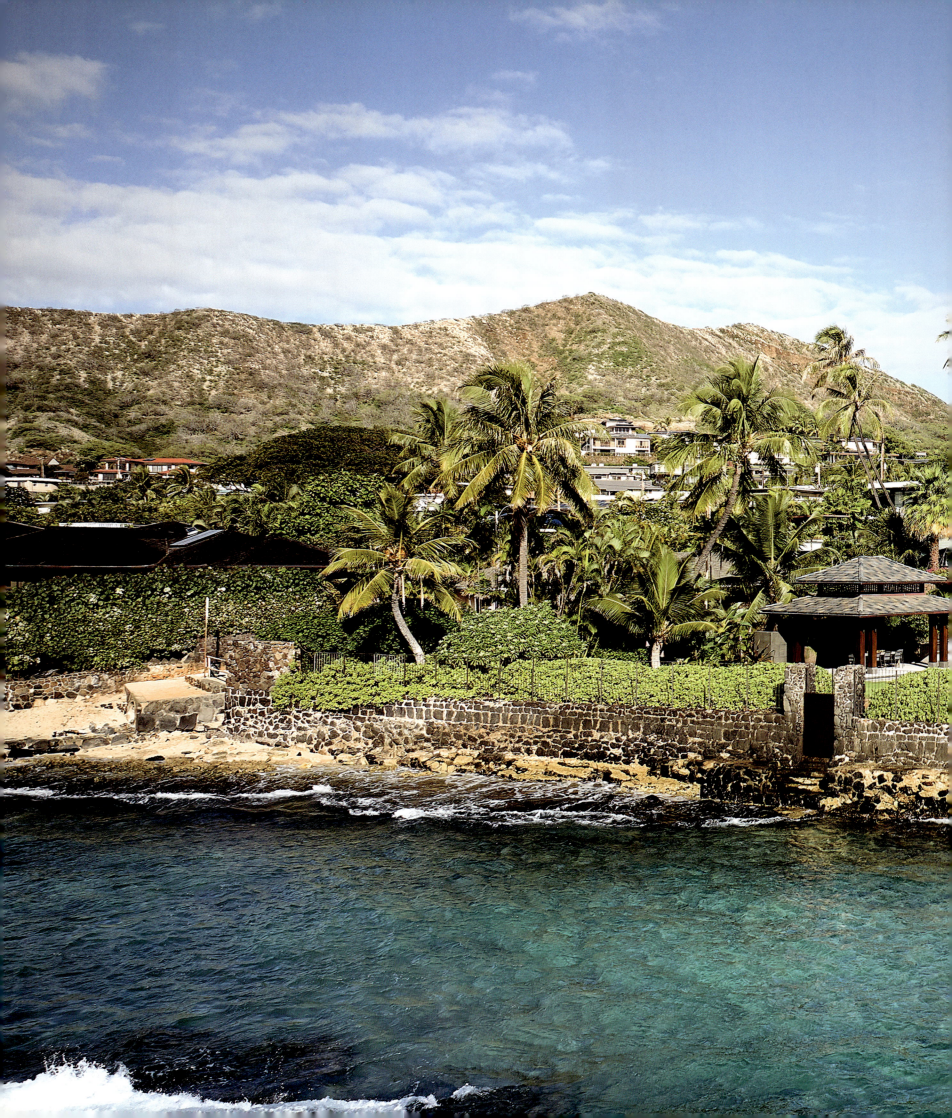

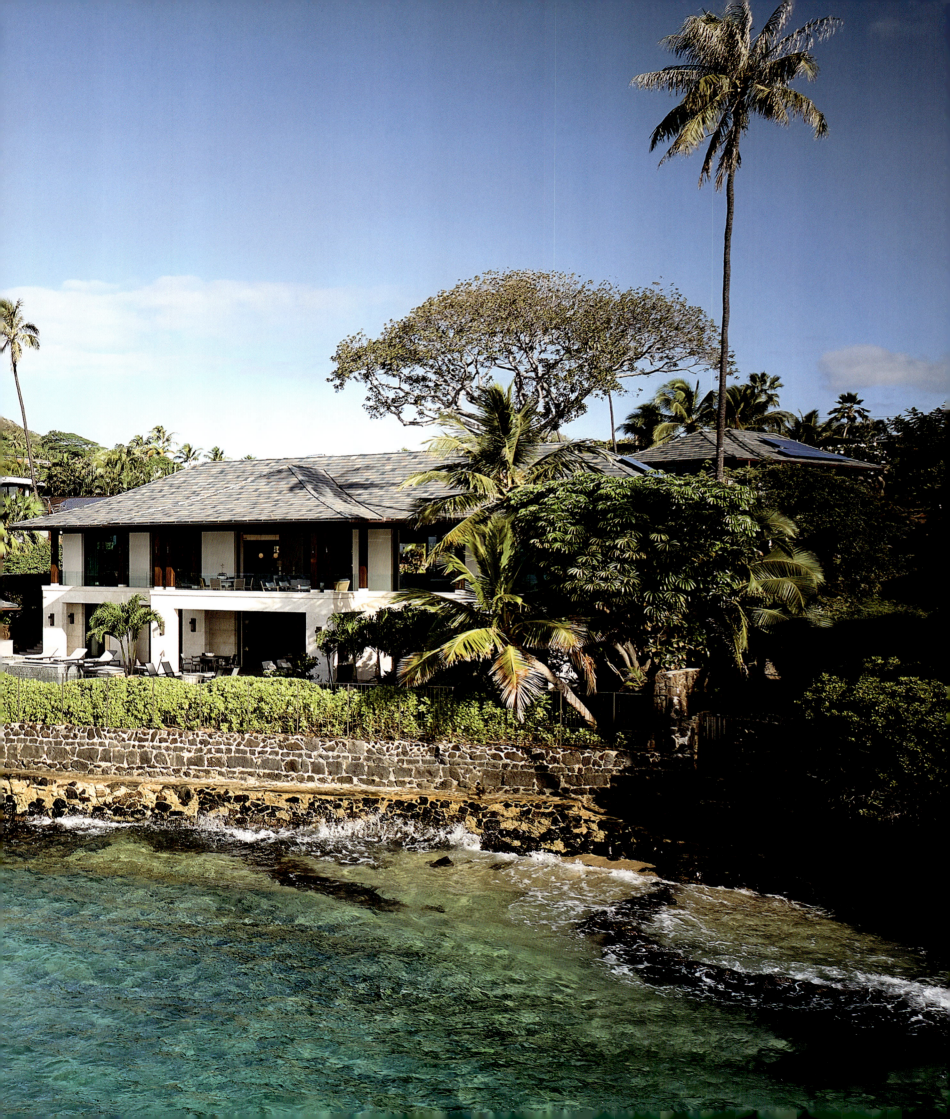

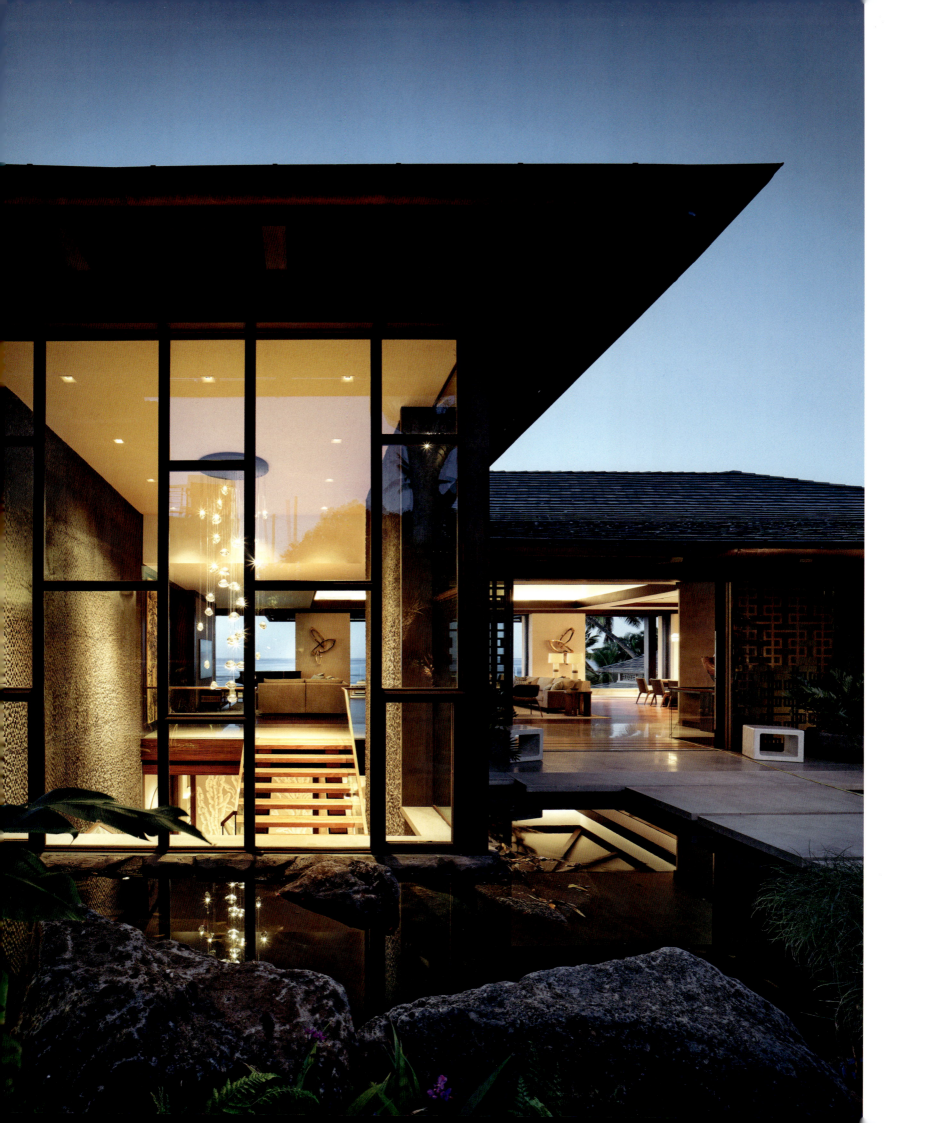

LEFT: *The entry pond at the upper level symbolizes the ma uka side.*

BELOW: *At the lower level, the pool and spa reflect the ocean's color palette.*

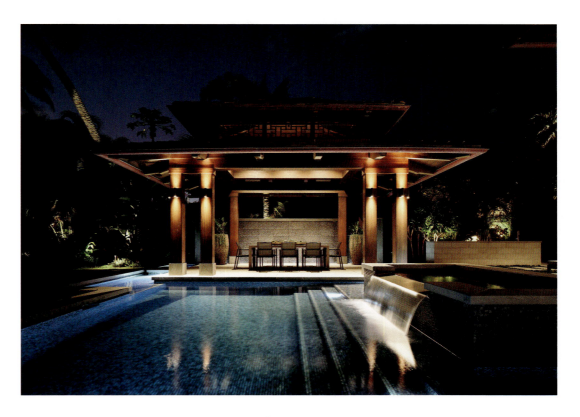

The design of Haleakalā—named for both the prominent, sacred volcano on Maui and the clients' family—also required a bit of give and take between the contrasting interests of its clients, a married couple. One preferred a darker, more traditional aesthetic and the other a lighter, more contemporary one. For example, the classically shaped Hawaiian double-pitched roof is made with more contemporary, flat clay tiles, and fossilized stone on the lower floor facade is complemented by thin mahogany columns and champagne limestone walls on the upper floor. For a screen at the entrance, PVA used a "King Waves" pattern that Peter found in the book *Chinese Lattice Designs*. The 1875 motif from Chengdu, Sichuan, has "three horizontal bars—heaven above, man between, and earth below—connected by a vertical—the one who joins heaven-earth-man." The pattern references the clients' cultural heritage, while its squarish forms offer a contemporary look. The wave design also seemed perfect for a site that has a great wave break and surf spot just off the shore.

The new house incorporated some items—personal possessions of the site's former owner—into its design. "I was more enchanted with the memorabilia than anything else," says Peter. "He had just a plethora of photos of Hollywood stars, and he had so many friends in the industry." The "he" Peter refers to is Jim Nabors, famed comic actor and beloved resident of Honolulu. Peter and the clients visited his home on the site before beginning work on Haleakalā. While they couldn't reuse his house, they found they could reuse some of its objects.

One memorable item that the new clients chose to keep was a piano that comedienne Carol Burnett had given to Nabors. PVA designed a room to accommodate it. Another was *Le Cirque*, a circus-themed wall mural painted by Honolulu artist John Chin Young in 1954. It was there when Nabors bought the house, according to his widower, but a second signature suggests it was updated during Nabors' time there. As the sixteen-by-eight-foot acrylic work was painted directly on the house's drywall, not on a canvas, it was tricky to save. PVA managed to demolish the exterior wall and access the work from behind it. After expert restoration, the mural was relocated to the back wall of the lower level. "Anybody that will have been to the old house will see that and they'll recall that," says Peter. "It's quite interesting."

BELOW: *Haleakalā (house of the sun) rays are depicted in the auto court's paving pattern.*

MIDDLE: *The entry pavilion features foo dogs, retained from the site's prior residence.*

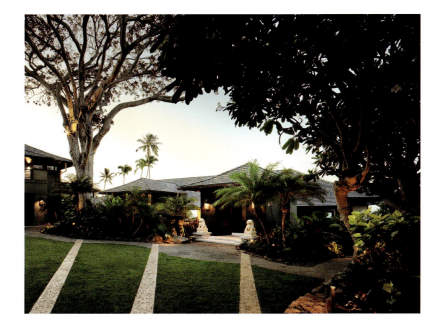

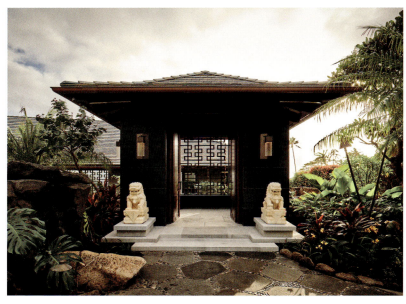

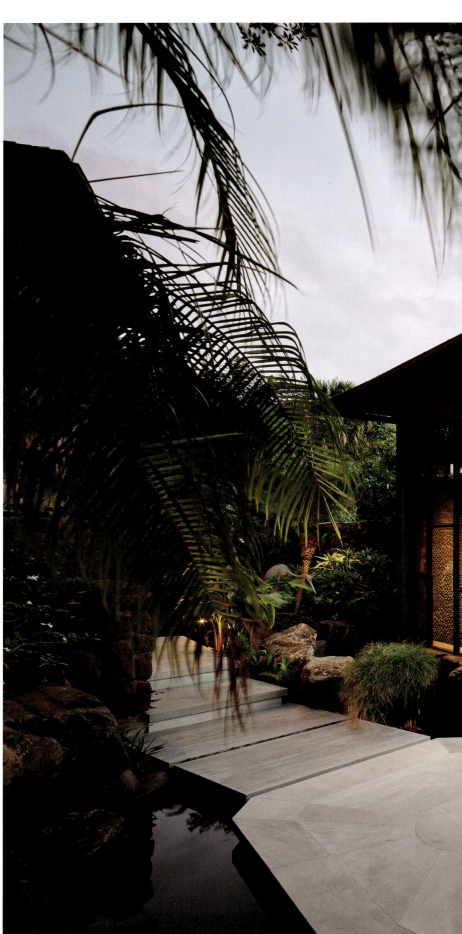

"King Waves" screen doors act as veils and suggest the ocean beyond.

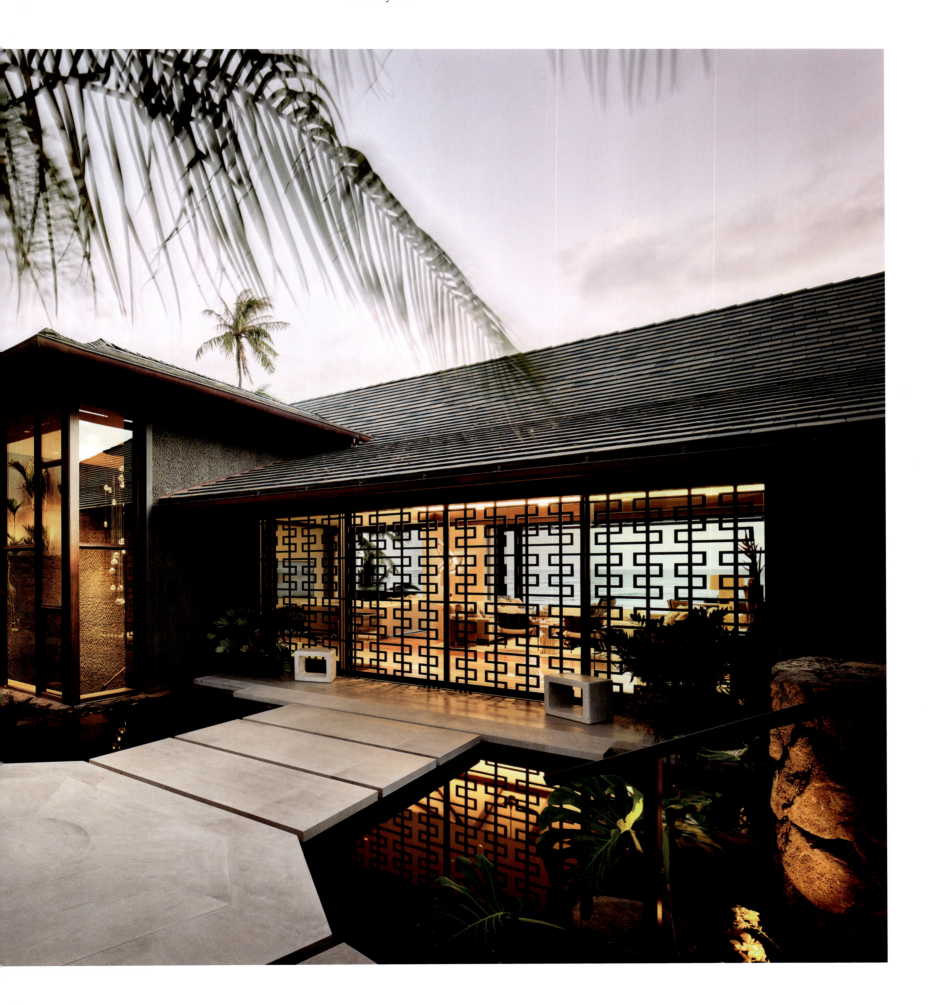

A stone base accommodates the sloped site and breaks up the two-story ma kai facade.

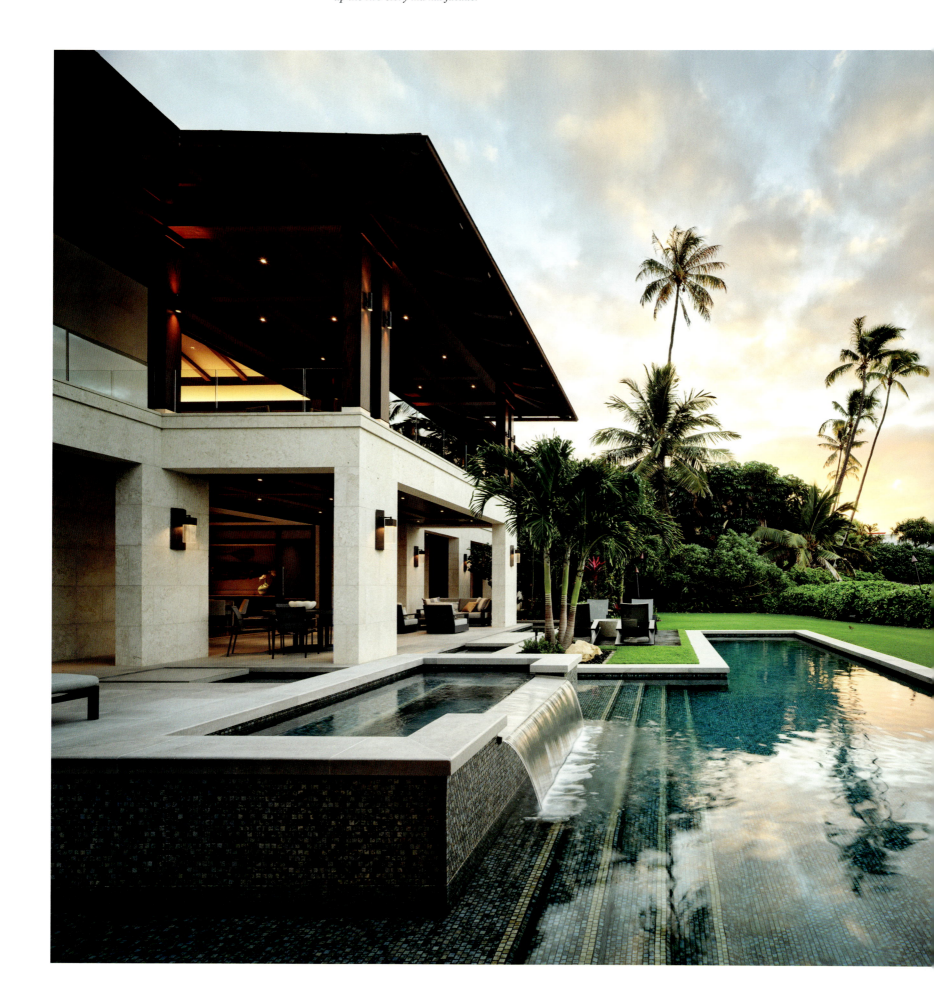

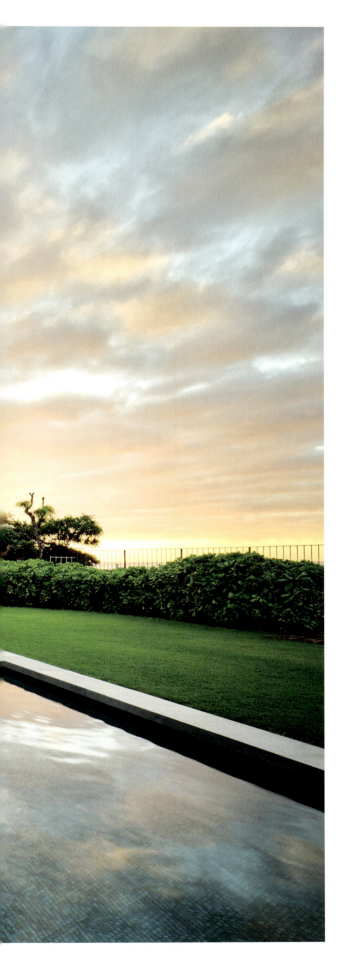

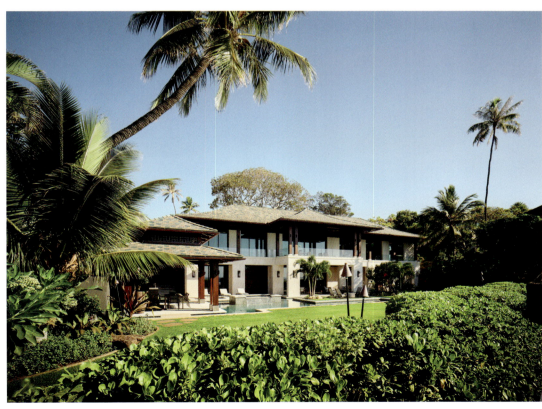

An exterior gallery provides views and protects the doors to the interior from the weather.

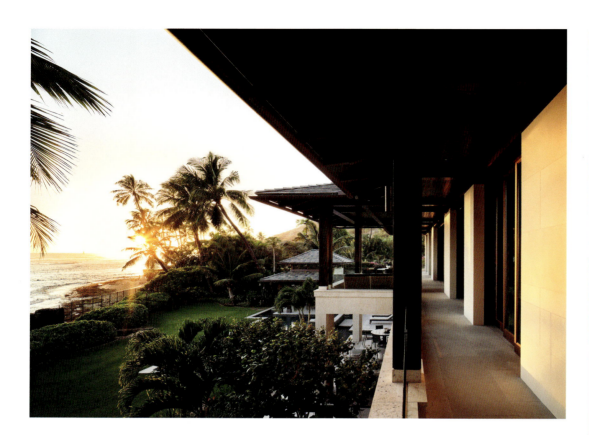

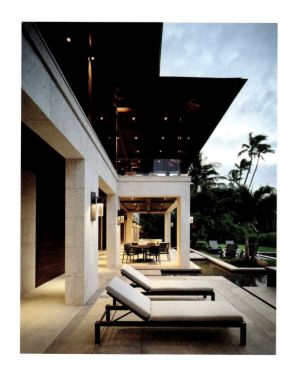

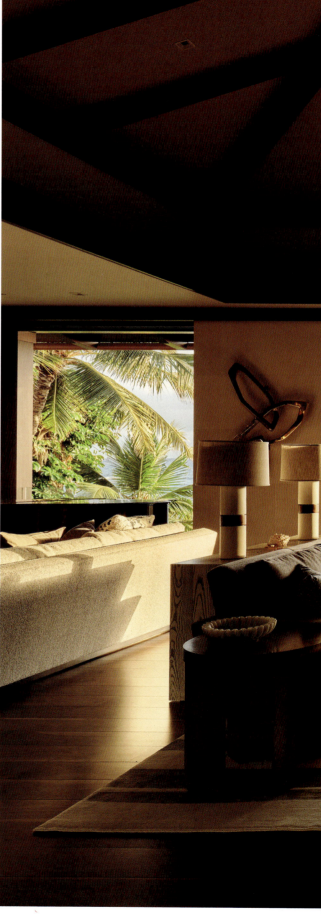

The great room.

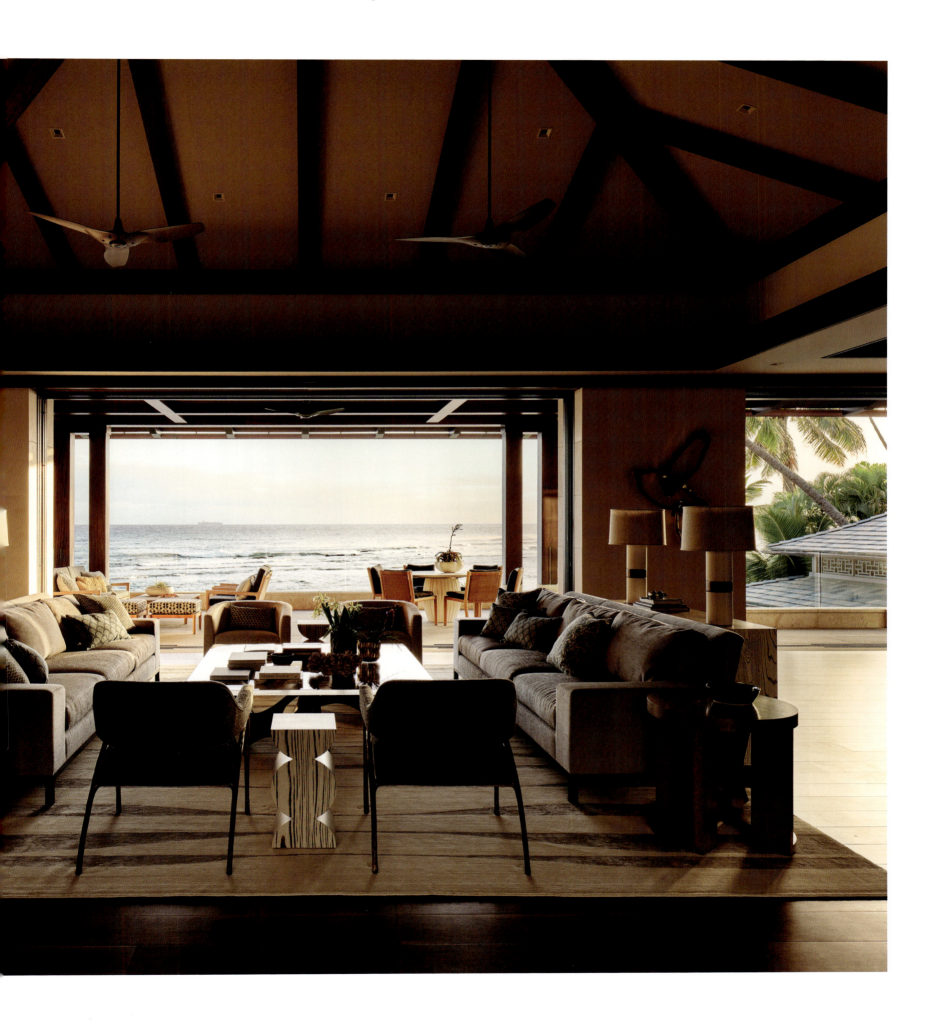

BELOW: *The entry pond and garden provide a lush backdrop to the great room.*

BOTTOM AND OPPOSITE: *Both the kitchen and the main dining room feature framed views.*

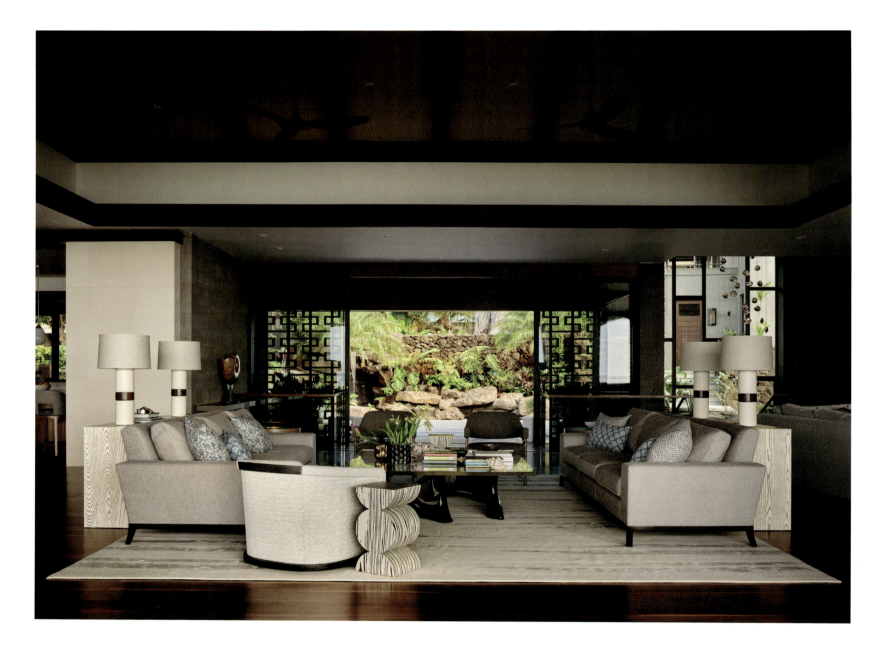

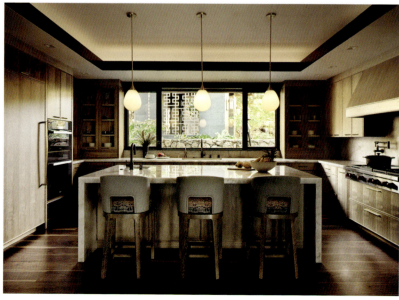

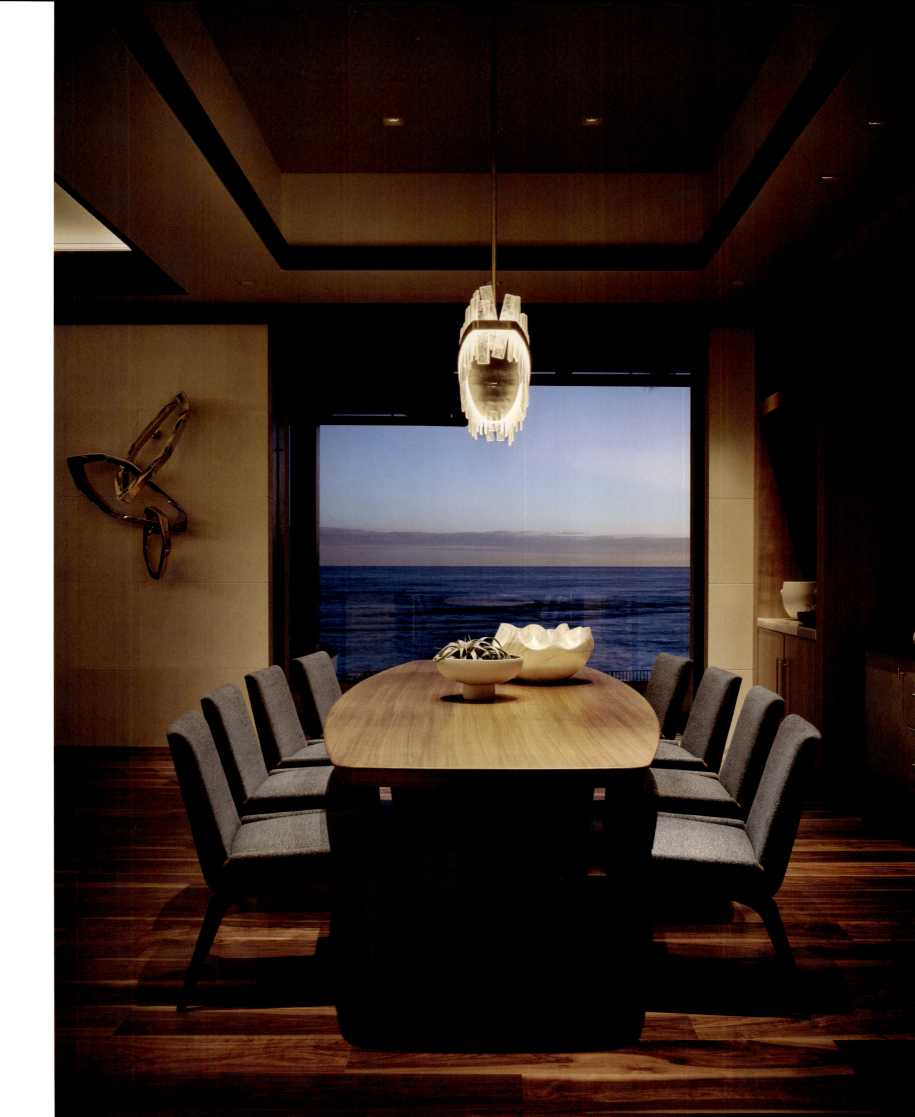

The primary suite provides a tranquil oasis.

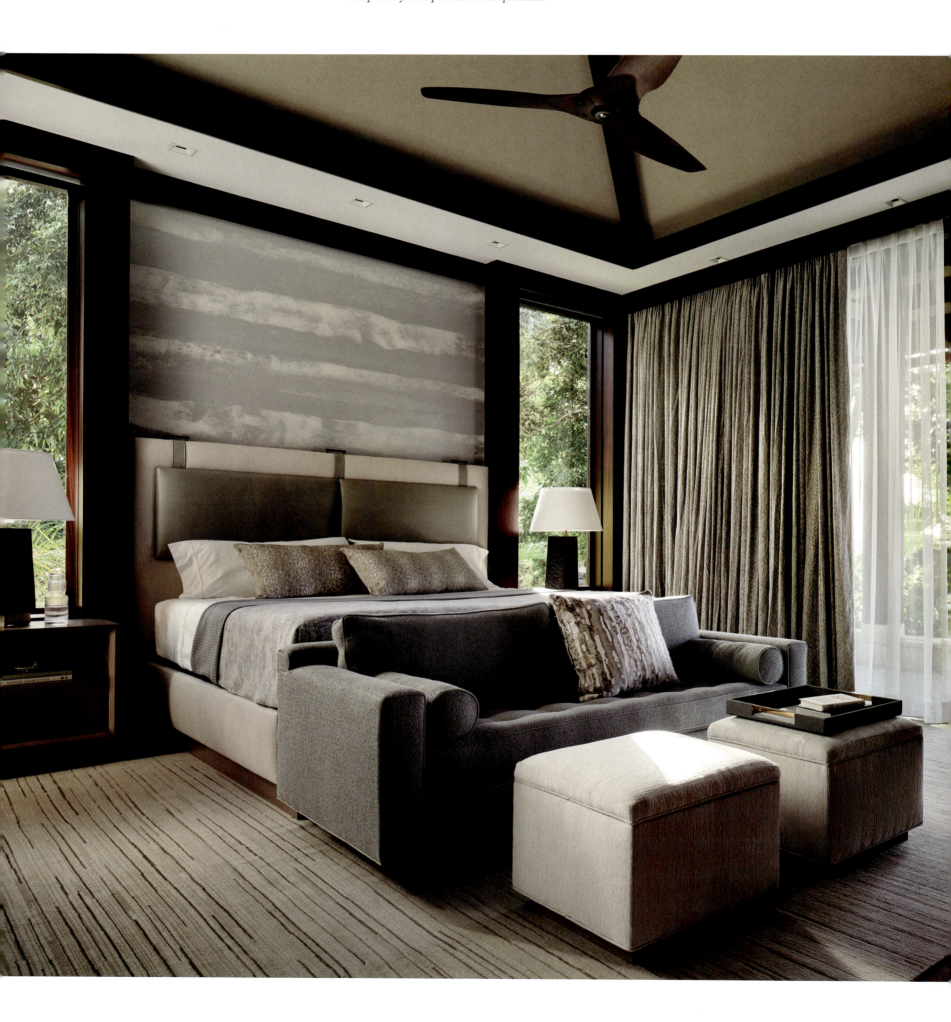

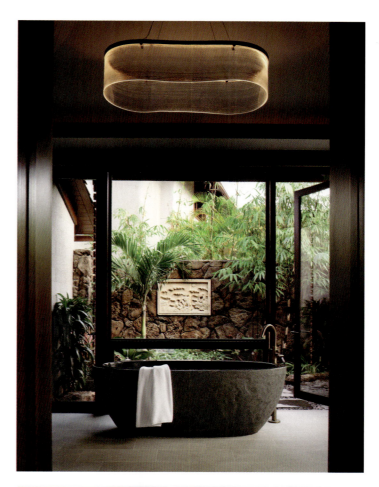
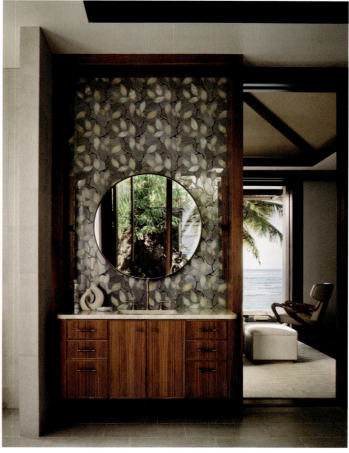

BELOW LEFT: *The powder room features a backlit onyx countertop.*

BELOW RIGHT: *The wine cellar employs dark wood like that used throughout the house.*

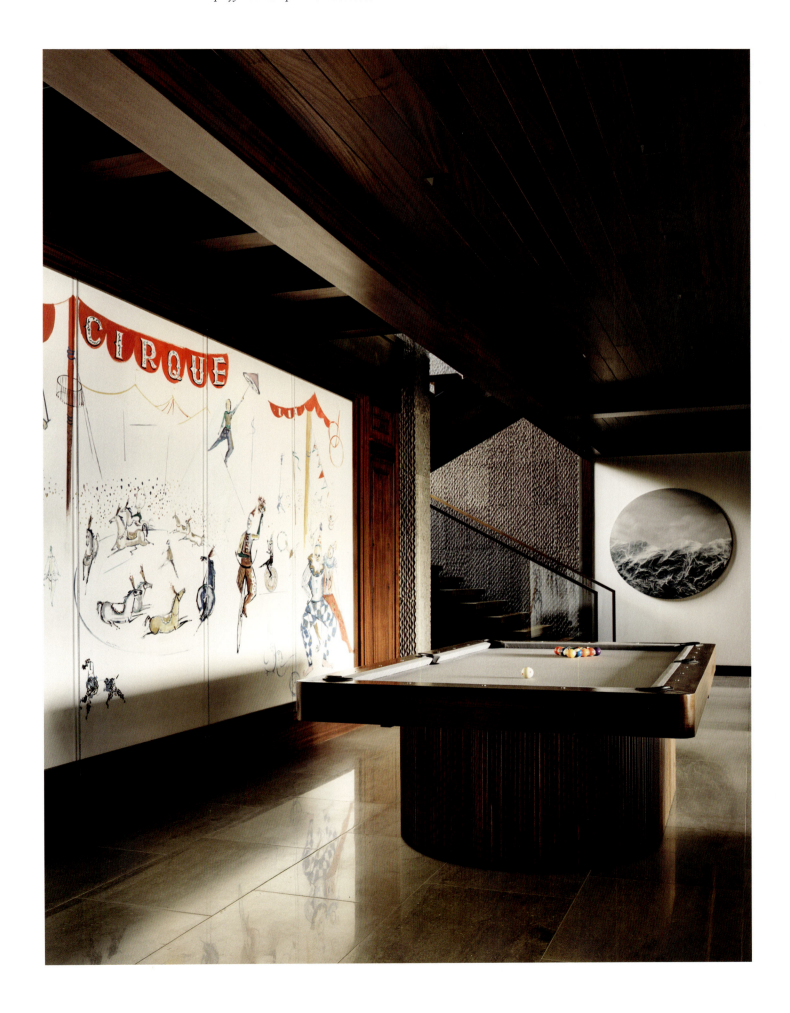

Le Cirque *mural by John Chin Young provides a playful backdrop in the lower level.*

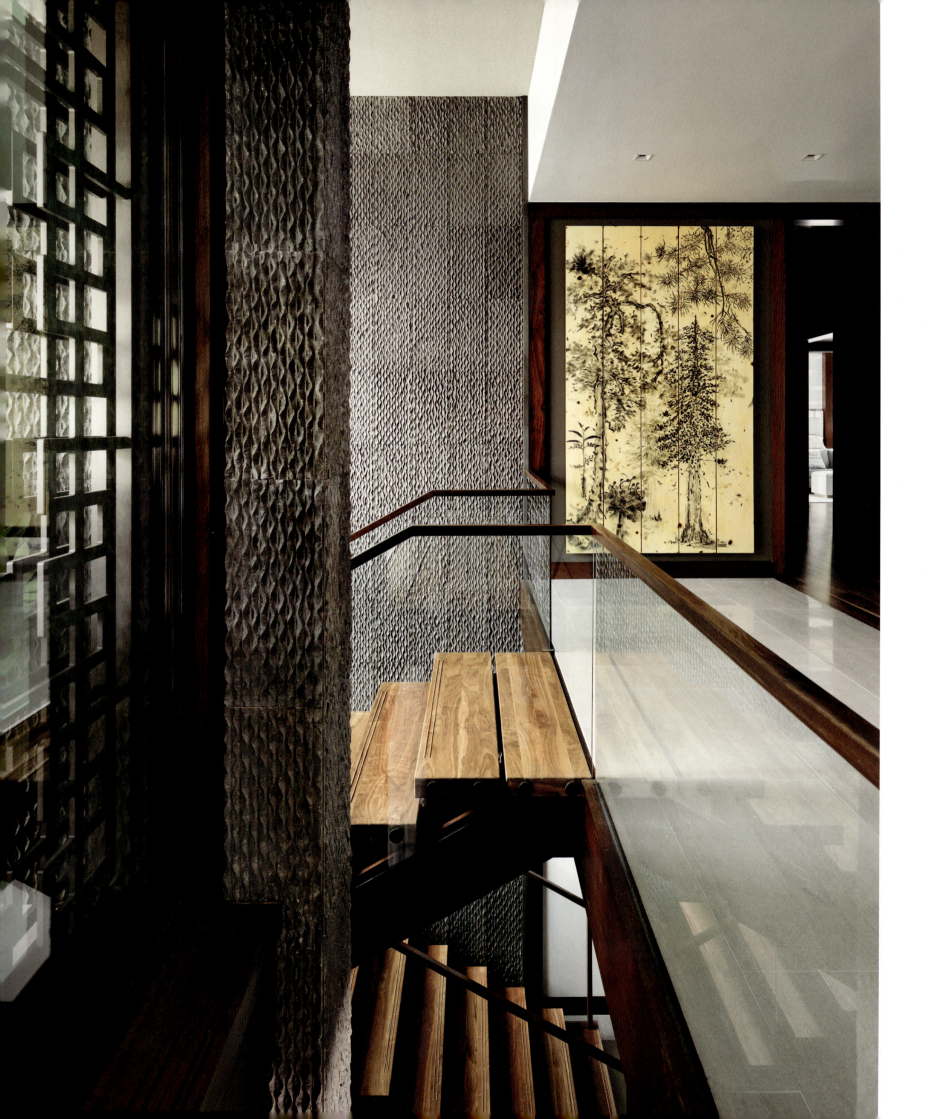

HALEAKALĀ

LEFT: *The stairway, as seen from the entry bridge, brings natural daylight to the lower level.*

BELOW LEFT: *The entry pavilion showcases a 180-million-year-old fossil of sea lillies.*

NEW HOMES

The great room lānai provides casual outdoor seating areas from which to enjoy the view.

RIGHT: *A floating pavilion anchors the pool.*

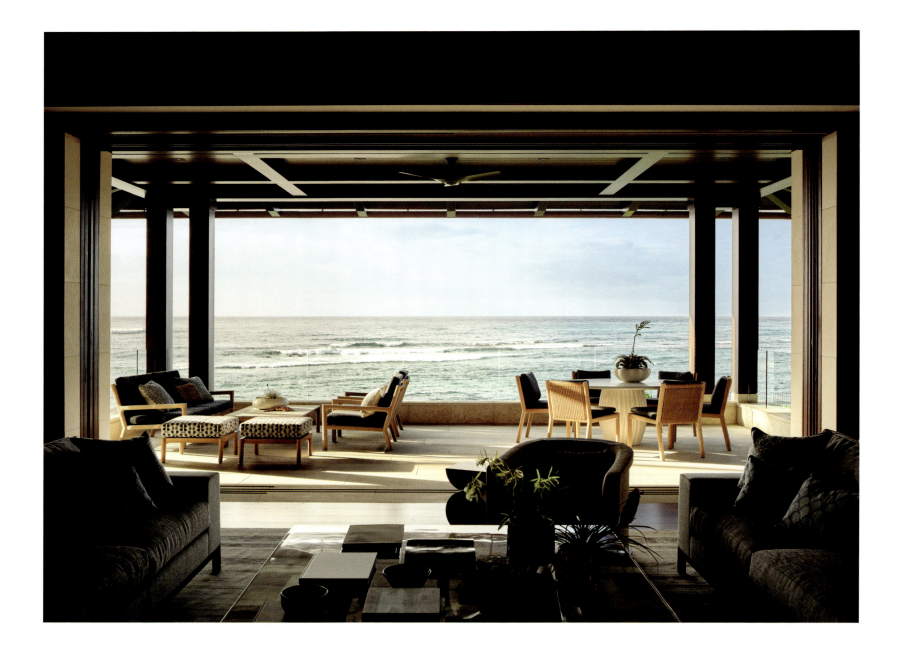

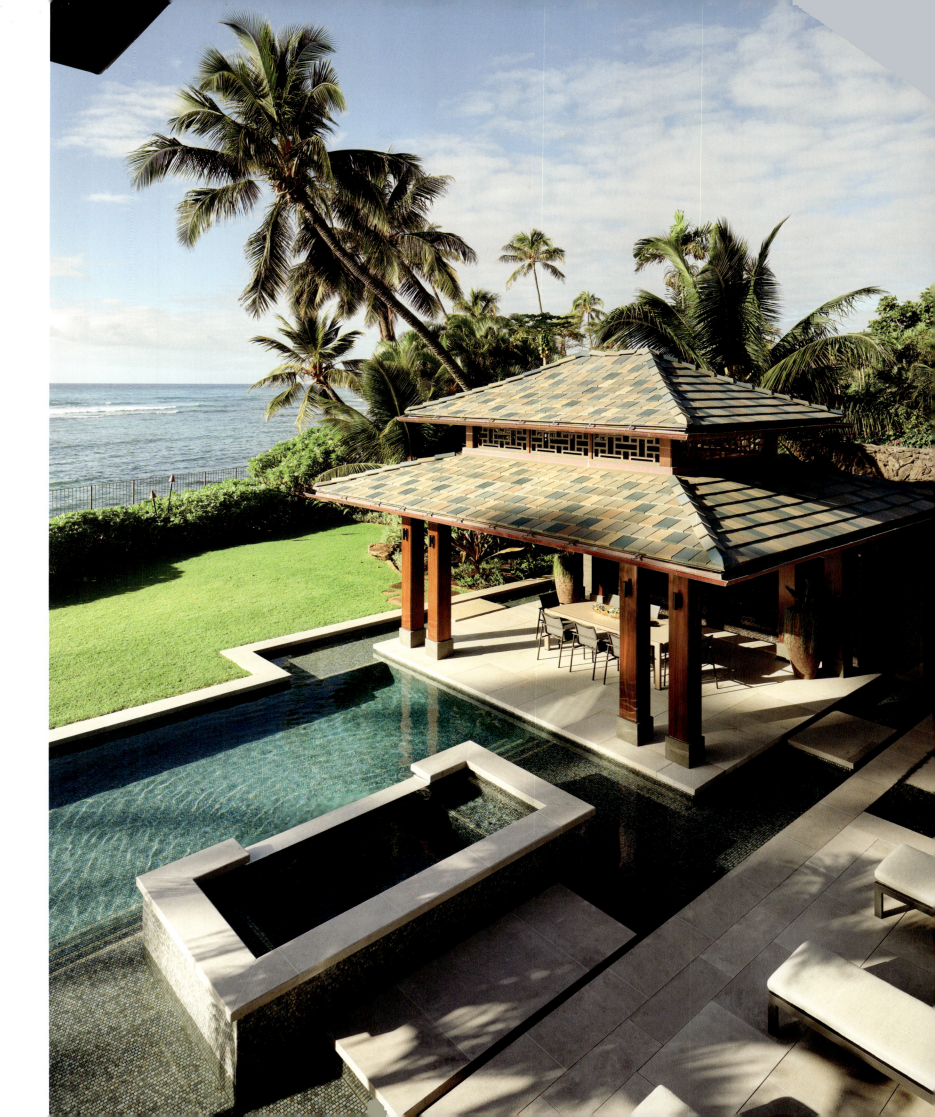

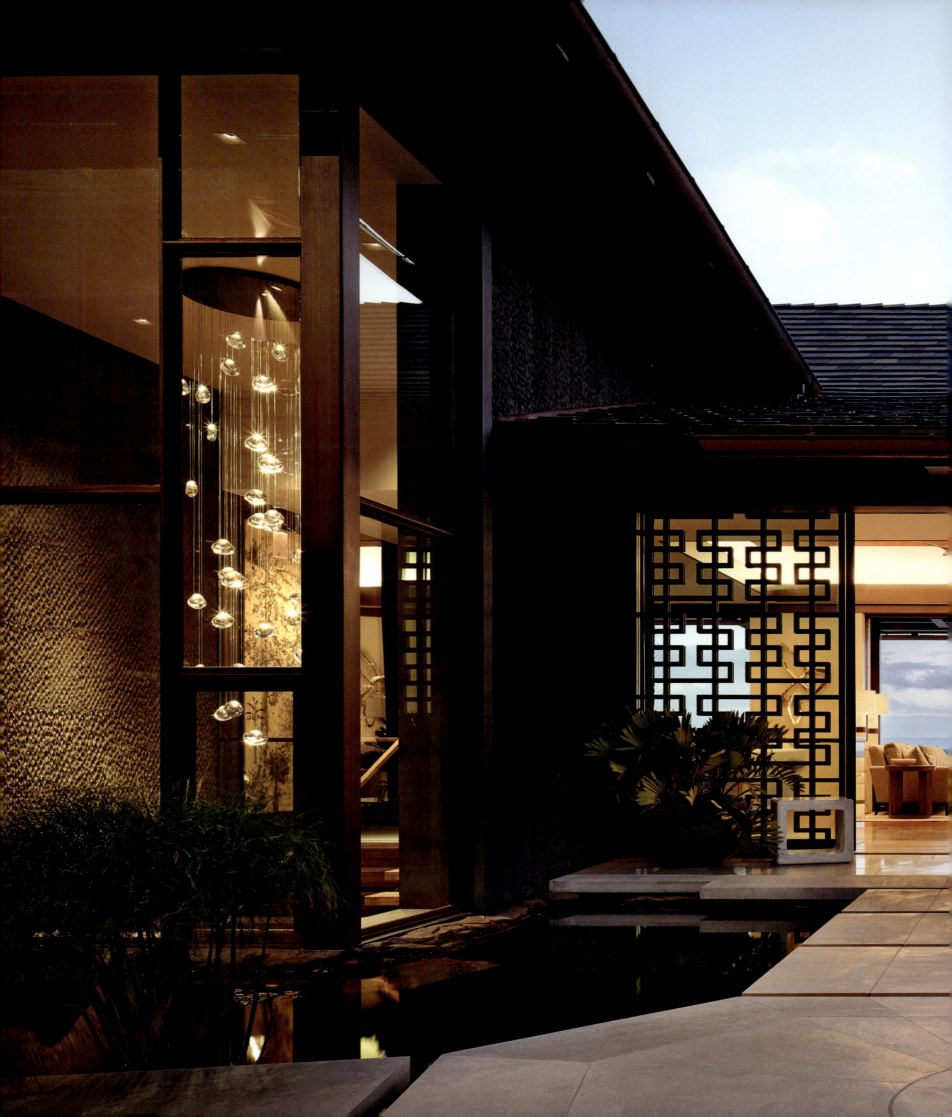

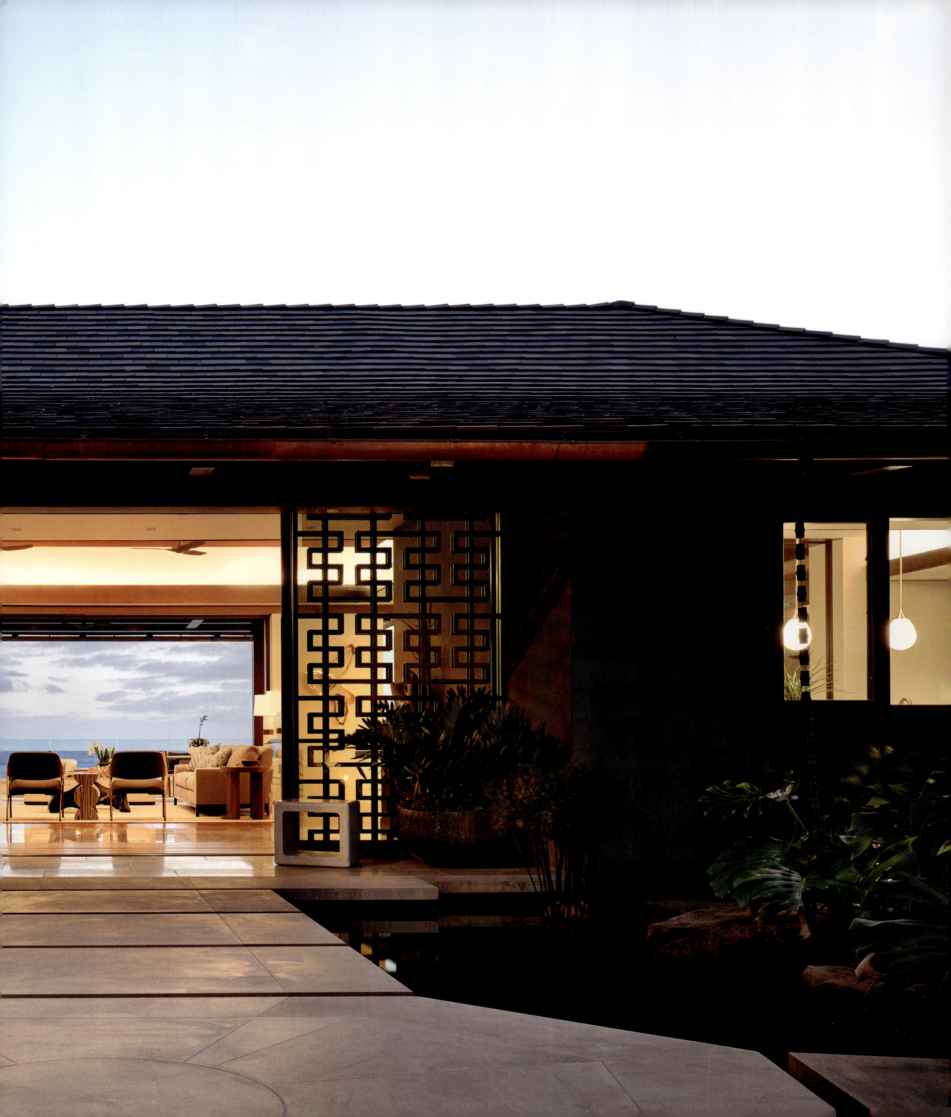

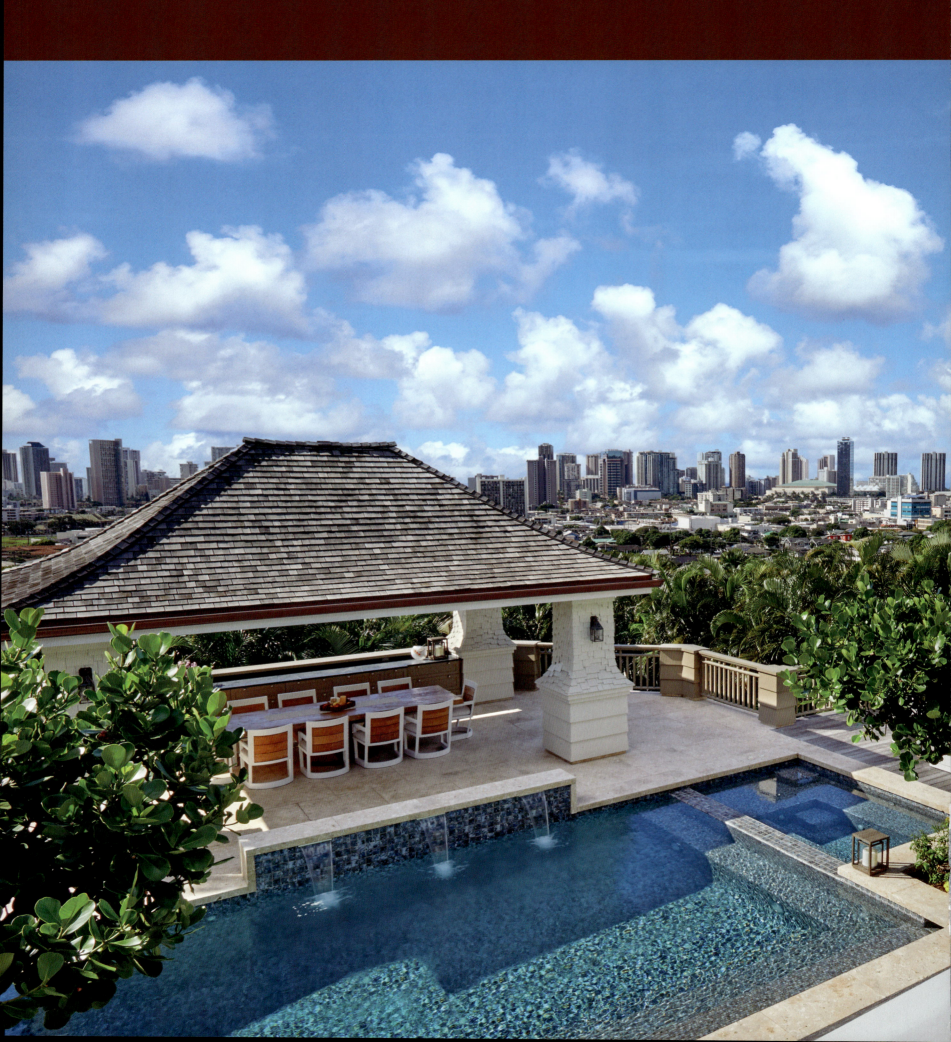

RENOVATIONS

"I've always embraced renovations," says Peter, "but I think the important thing for me is that there be some redeeming architectural quality, character, charm—something to make a building worthy of renovation." The houses featured in this chapter have that something, that spark that makes the time, effort, and cost that go into renovating worthwhile.

PVA preserves a project's best parts—be it a masterful layout, a well-designed feature, or a unique aesthetic—then uses them as springboards for new design interventions. In so doing, each renovation resolves inherited problems and brings the home into the twenty-first century.

Peter's experience documenting older buildings informs PVA's current renovation work. While at Boston Architectural Center, he spent a semester drawing a kyōmachiya, a traditional wooden townhouse that Kyoto had gifted to Boston. He drew every inch of the house and so came to understand Japanese joinery and the proportions of the space, which were based on the size of a tatami mat. Peter studied European architectural precedents as well. During a break from school, he worked with a group documenting an eleventh-century castle in Tuscany. "Because I had the most drafting experience, I got adopted as the chief draftsman, if you will," he says. "I set up a little shop with a makeshift drafting table inside. I would look out through this little arched window to the Tuscan hillside, and I'd draw away."

These drawing exercises came in handy when PVA began to renovate residential buildings. "Sometimes we would have access to original drawings, but oftentimes not," Peter says. "We would just have to measure and draw, which is a painstaking process but, in a way, a good one. There's no better way to get familiar with a building than to draw it."

One of Peter's first jobs out of school was the renovation of nineteen buildings in Maynard, Massachusetts, converting what had been the Assabet Woolen Mill into the headquarters of the computer company Digital Equipment and creating a set of design standards for subsequent work at the site. "They were three- and four-story buildings and just huge, and pretty much all brick with arched windows and heavy timber beams," Peter says. "They were really beautiful." As part of his work, he renovated Digital cofounder Ken Olsen's office and conference rooms. Repurposing nineteenth-century structures for a new-technology company necessarily required a careful blend of respecting the old while providing for the new.

DIAMOND HEAD RESIDENCE
Honolulu, Oʻahu, Hawaiʻi, 2001

"In the case of the Diamond Head Residence renovation," says Peter, "the design was great as it was." The building, designed in 1940 by the well-regarded Hawaiʻi-based architect Vladimir Ossipoff, was an ideal project for PVA to take on as its first significant residential renovation. Peter especially liked its double-pitched roof with wide overhangs. "It really makes a lot of sense in Hawaiʻi, with our intense sun," he says. "It's like having a good hat on." But over the years, the original house had undergone some unfortunate transformations, including, at one point, the inclusion of a makeshift wedding chapel. Peter says his goal for PVA's renovation was simple: "Get back to the original quality of the Ossipoff design, get rid of all that stuff that hadn't made sense, and then start to impose my own new aesthetic." That aesthetic included some contemporary elements—light wood interiors, clean stone paving, and corner glass windows—that complement the Ossipoff building. PVA replaced the old kitchen, designed as a back-of-house servant area, with a twenty-first-century kitchen to be used as a gathering place. It opened up rooms that had been divided into smaller spaces, and it built a pavilion to connect the Ossipoff home to a newer structure on a lower level of the property. Now, twenty years after PVA's renovation, the clients continue to live in the Diamond Head Residence. They recently contacted Peter, saying, "We think we're ready to give it a refresh." PVA now has another opportunity to give the Ossipoff home a new life.

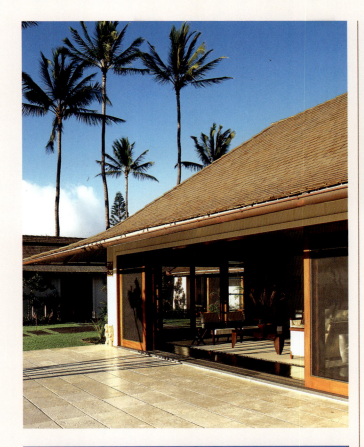

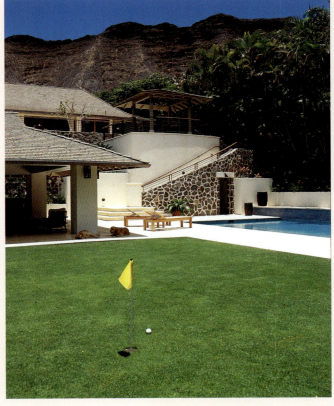

Peter worked along similar lines in the renovation of a Boston townhouse, "one of the projects that really helped form my early years," he says. The five-story house is in Beacon Hill, an old neighborhood with very strict design guidelines: "You can't even paint the color of your front door without town approval," Peter says. The job entailed managing a historically correct exterior restoration and designing a more contemporary interior. Combining old and new looks is something that PVA does today in projects such as the Honolulu Hillside Residence (page 184).

"So, I was pretty well versed in working with old buildings and renovations before I got to Hawai'i," Peter says. "I was no stranger to that." In Hawai'i, PVA renovates projects that are much younger than the Japanese and Italian models that Peter documented or the New England buildings he helped to refurbish early in his career. Still, the buildings come with history—a well-known architect, a family backstory, even a previous renovation, as seen in the Koko Kai Cliffside Residence (page 166). Each history needs to be valued and integrated into PVA's new design.

There are times when, after much research and consideration, PVA determines that an older home cannot be renovated. (See the story of Haleakalā, page 106.) "When we find that a house or property is just not worth saving, then we try and save as much as possible rather than just crunch it up and put it in the landfill," Peter says. "We're very heavily involved in reusing what we can."

Peter cites the example of the single-wall redwood boards used as exterior walls in many Hawaiian homes. These walls, built in the 1950s and 60s, do not meet current structural codes or provide an adequate thermal barrier for air-conditioning, and so architects had deemed them unusable. "For years, many of these homes were demolished," says Peter. "They'd come in with an excavator and then, in two or three hours, the house would be a pile of rubble." But Peter saw the value in that wood. "It's clear, vertical-growth redwood. No knots, pretty much—beautiful wood." So PVA works with a company that dismantles the walls, board by board, and saves the planks.

"It's much more painstaking, and it's more costly, of course," says Peter.

Knowing what to keep and what to change is a hallmark of PVA's residential renovations. Whether preserving a simple redwood plank, a lovingly produced detail, or a multi-building complex, the firm sees the value in this work. "I really enjoy doing renovations," Peter says, "and trying to do it more sustainably now is important as well." As the houses in this chapter attest, a well-designed renovation is not only a sustainable choice, but also well worth the extra effort.

LANIKAI HILLSIDE RESIDENCE
Kailua, Oʻahu, Hawaiʻi, 2002

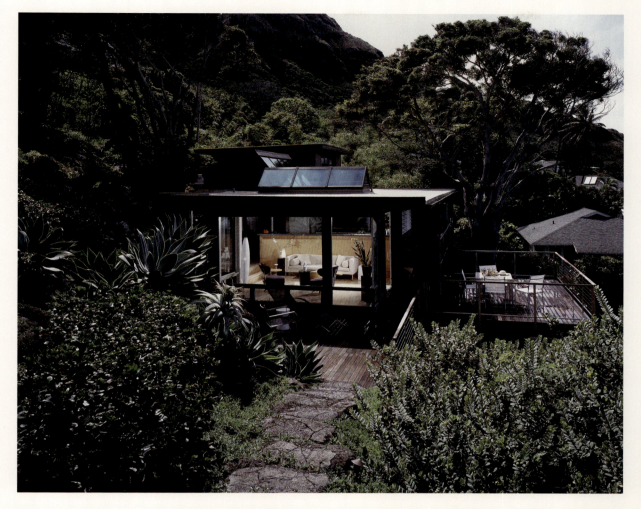

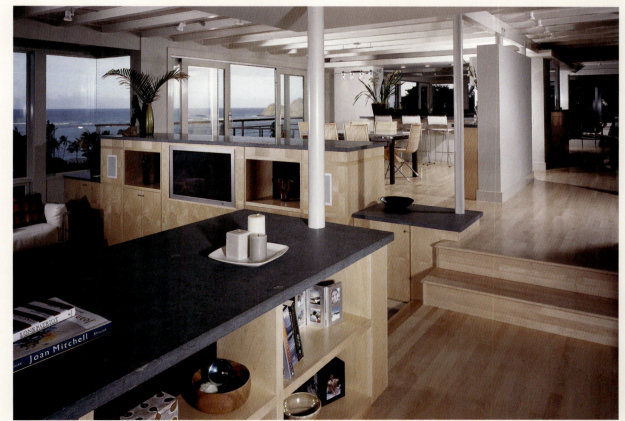

"It had this Bohemian, almost hippie-esque quality," says Peter. "Probably in the sixties it would have been pretty fabulous." The 1969 house designed by Alvin Badenhop, a former Taliesin Fellow, showed both a Bohemian spirit and the influence of Frank Lloyd Wright. A battered rock wall, which Wright typically used for a house's fireplace, here anchors a skylit stairway and serves as an entry feature. Some of the other, funkier, aspects of the house—such as burlap-covered ceilings—were less worth keeping. This burlap was emblematic of the dark interior of the house, which contrasted with the bright view afforded by the hilltop site. "So, we tried to lighten things up," says Peter, "to keep the cool character of this Wright-inspired house by Badenhop that had this great indoor-outdoor, built-into-the-rock, panoramic-view quality, but to neutralize the balance between the bright and the dark." PVA replaced the burlap with whitewashed tambour panels, painted the beams a light earth-toned color, and replaced darker flooring and cabinetry with maple. This gave the renovation a light monochrome base, to which PVA added grayish-green limestone countertops, whose color connected to the ocean view. PVA replaced the old doors, windows, and skylights, which leaked and rattled in the wind, with high-quality fenestration. "It wasn't built to high standards," Peter admits, "and so trying to keep that cool of-the-earth character and yet seal it up a little better was what we did."

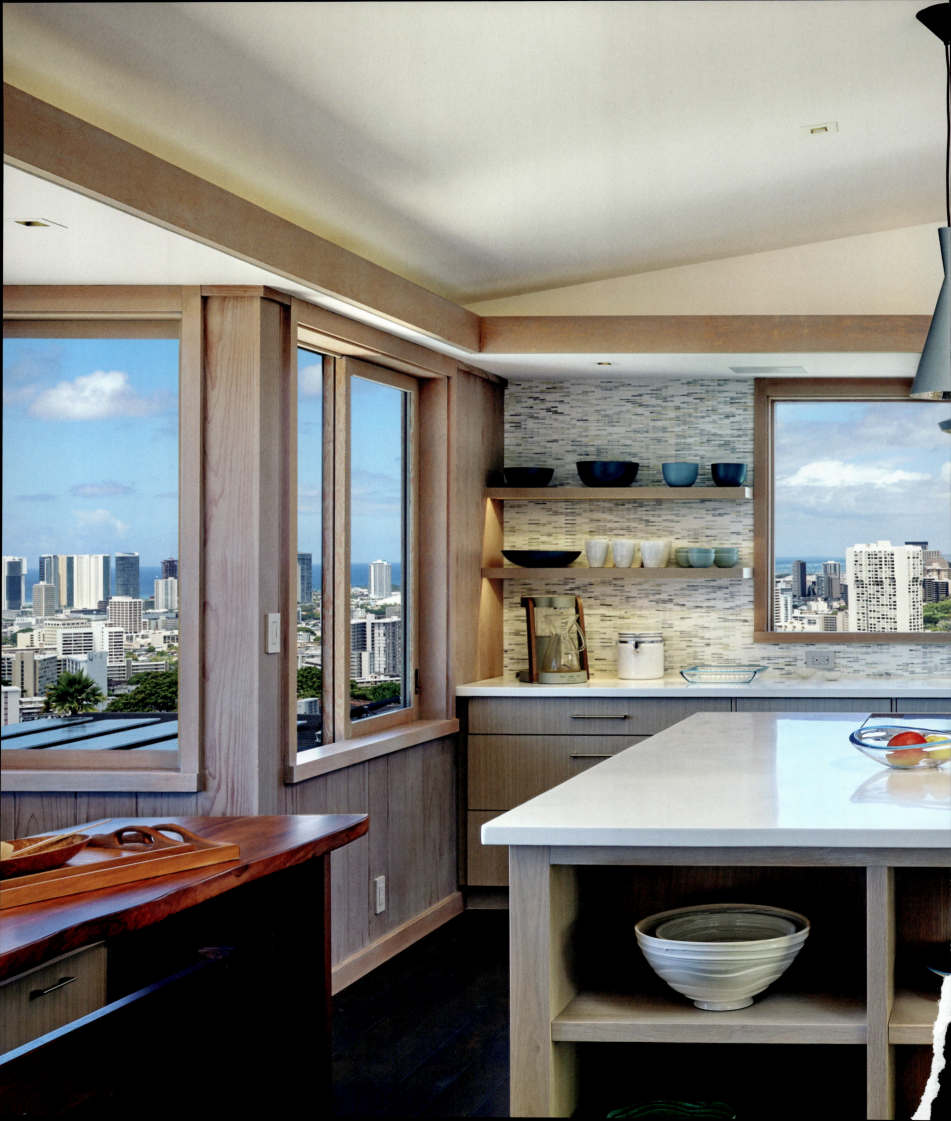

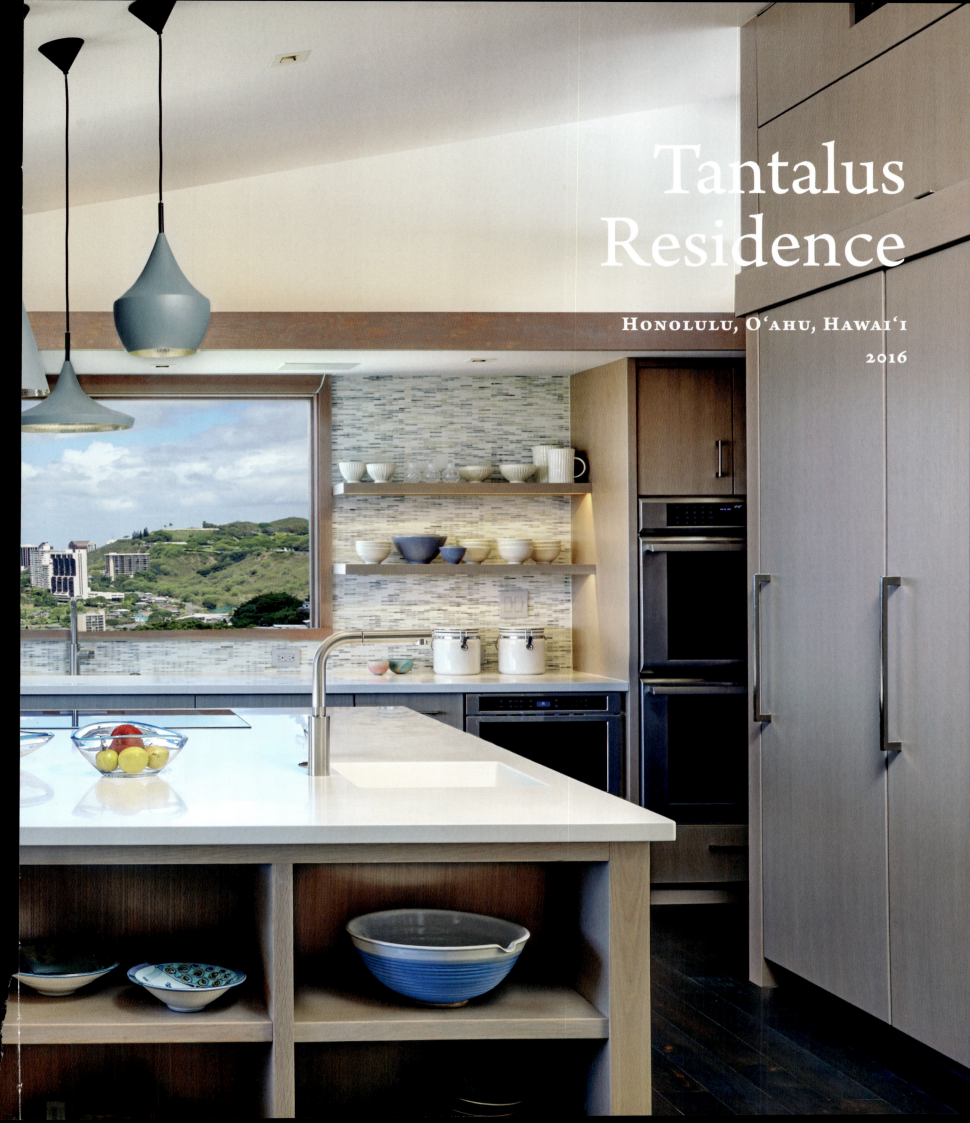

Tantalus Residence

Honolulu, Oʻahu, Hawaiʻi

2016

"It's a sort of quiet approach to a renovation," says Peter, "not a big fancy, you know, let's blow it all out." The quietness of the Tantalus Residence renovation matches the character of its owners, Peter says. The couple are kamaʻāina (people who have lived in Hawaiʻi for a long time) and were very respectful of local culture. "The renovation really fits the personality of these people," Peter says. "They're very down to earth, not showy, not glitzy."

The placidity of the Tantalus Residence stands in sharp contrast to its dramatic views. Its entrance faces the towers of Honolulu and the towering Diamond Head, while its back has a view up Tantalus Mountain. The original home—designed by famed Hawaiʻi architect Vladimir Ossipoff—is tucked into this sloping site, its simple shape subdued. The house's midcentury-modern style may have appeared somewhat radical in 1952, when it was built, but by the time the new owners acquired it, its clean lines and single-slope shed roof were not uncommon to Honolulu.

"We obviously wanted to retain the character of the Ossipoff house," Peter says, "and yet do pretty extensive renovations." These improvements included expanding the kitchen, opening it up to the living area, and adding an elevator from the lower-level garage to the upper level. "It was pretty ambitious to do that kind of work without really impacting much of the existing space," Peter says. PVA's additions were, then, more like subtractions—removing walls that had compartmentalized the kitchen to allow for unobstructed twenty-first-century living. Peter says of his clients' request: "They said, 'We love it, but it doesn't really fit our current lifestyle needs. So how do we change this without making it feel like we changed it?'"

TANTALUS RESIDENCE

Kitchen changed from closed, back-of-house area to inviting open space.

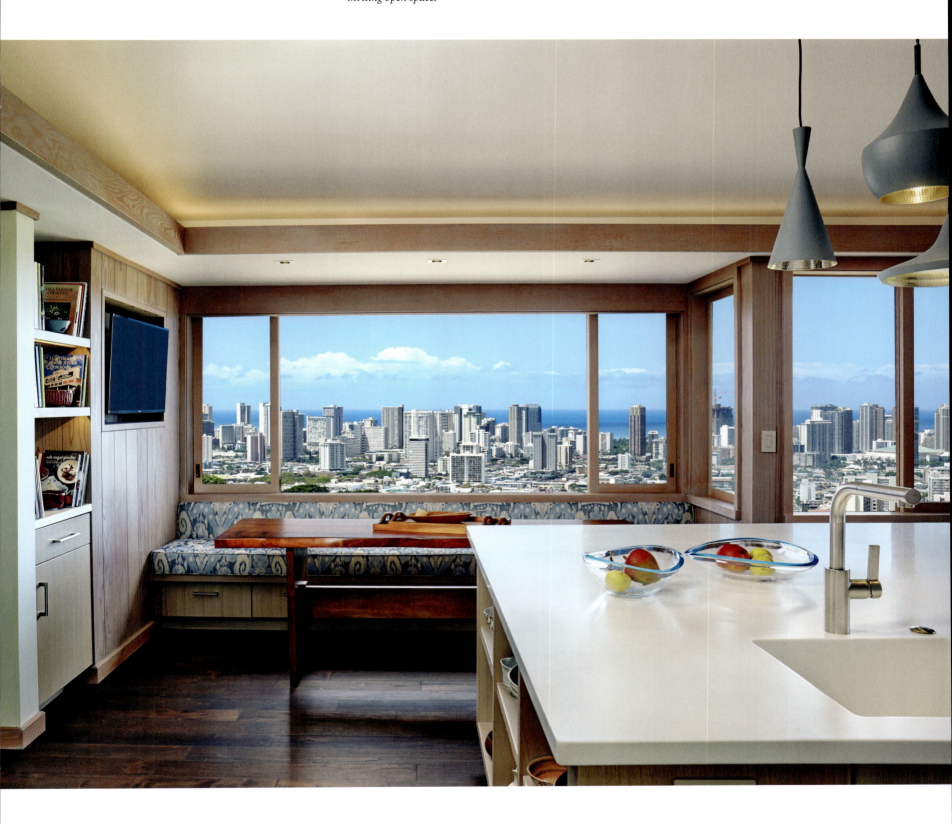

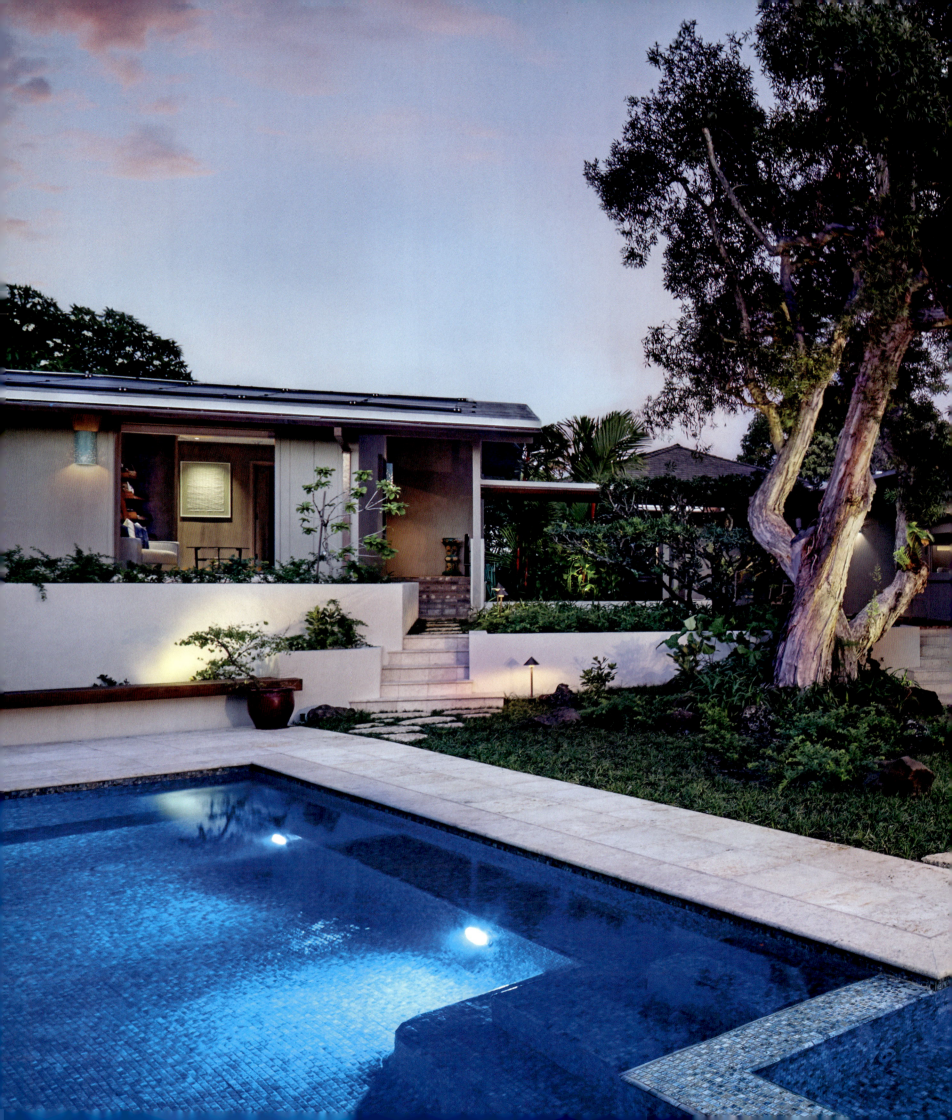

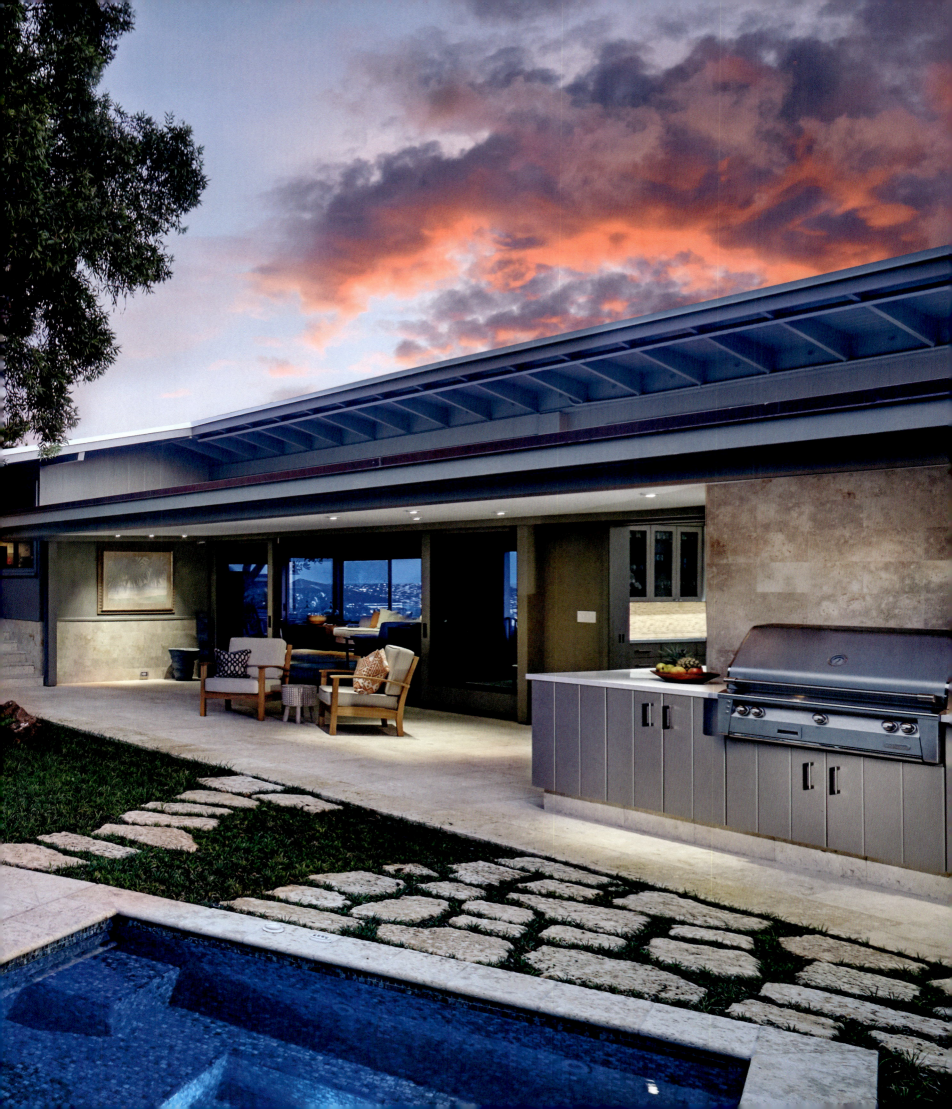

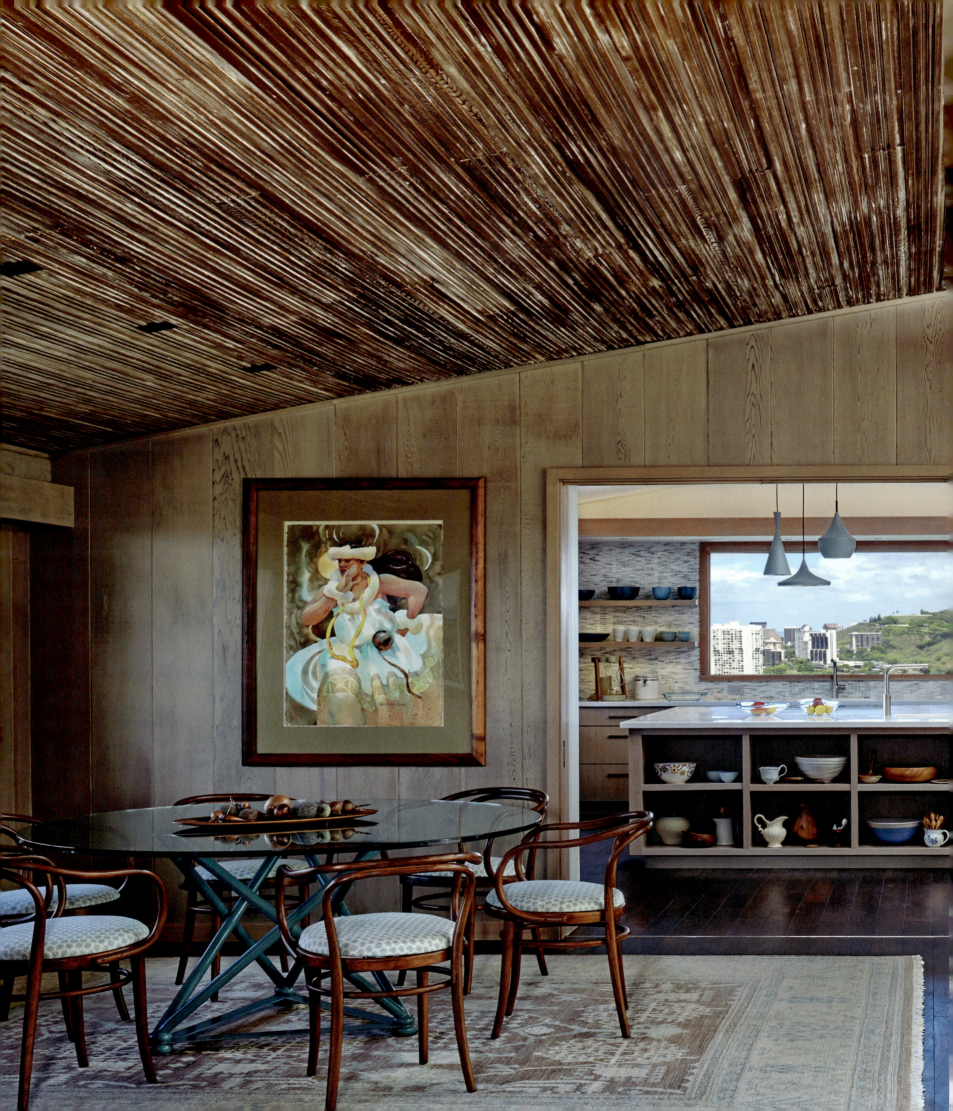

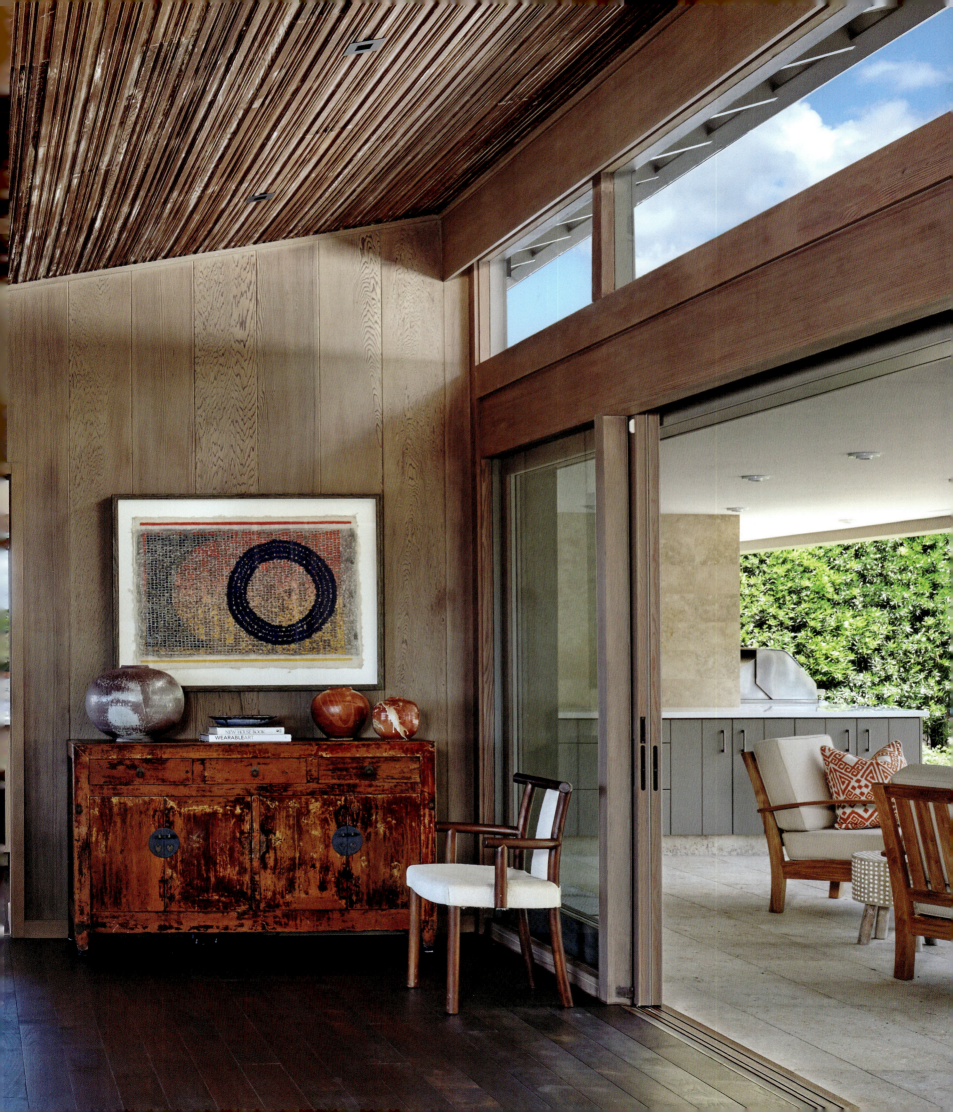

One focus of the renovation was to preserve the central living area and its big, sloping, grooved-wood ceiling—a noteworthy feature of Ossipoff's scheme. PVA was charged with adding lights in that ceiling and keeping the fixtures discreet, so as not to disturb the original design. "We inserted square housings," Peter says, "very small-aperture downlights with a light bronze trim so that they pretty much blend in." PVA maintained the footprint of the single-slope shed roof over this ceiling, then extended the flat roof over the living room's adjacent lānai to make for greater indoor-outdoor space. A new pool—which required some creative thinking to bring large construction equipment onto the tight site—offered additional outdoor space.

At the Tantalus Residence, PVA also renovated an on-site guesthouse. Though it was built after the main house and was likely not designed by Ossipoff, it was connected to the home by a covered walkway. It was important to integrate it as well to the new aesthetic of the renovation, so some of its materials, such as its linoleum floors, were updated. PVA and the clients wanted to retain the bleached redwood walls of the guesthouse, walls that were like those in the main building. "Ossipoff had this special recipe for bleaching it because, otherwise, it's quite dark," says Peter. "On this renovation we worked with a contractor who used to build a lot of Ossipoff's homes, so they actually had that formula for bleaching redwood."

All these modest moves—carving out new spaces within existing exterior walls, hiding small light fixtures in a big ceiling, faithfully re-creating a wall finishing—add up to a new home that respects the clean lines of a mid-century look and adds a contemporary twist. "Our intent was that we do this pretty significant renovation," says Peter, "yet it feels like it was always that way."

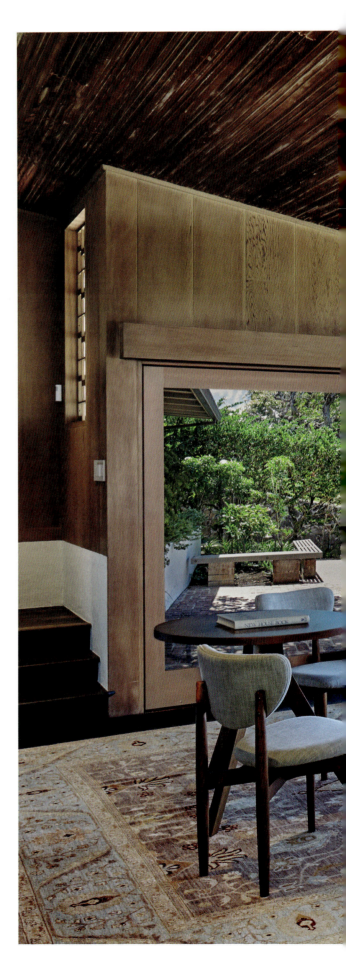

TANTALUS RESIDENCE

Subtle improvements do not detract from character and view of original space.

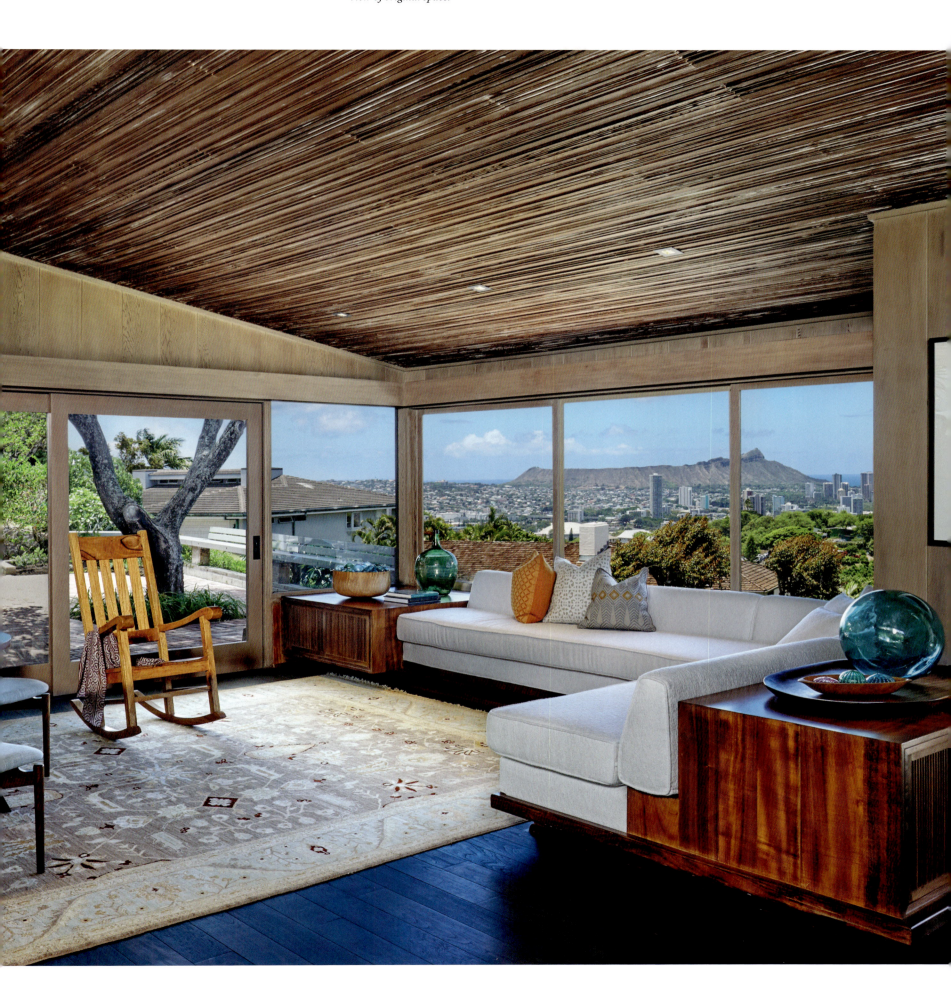

BELOW: *New design elements are sensitively incorporated into house aesthetic.*

OPPOSITE: *Ma uka lānai was extended to provide outdoor kitchen adjacent to new pool and spa.*

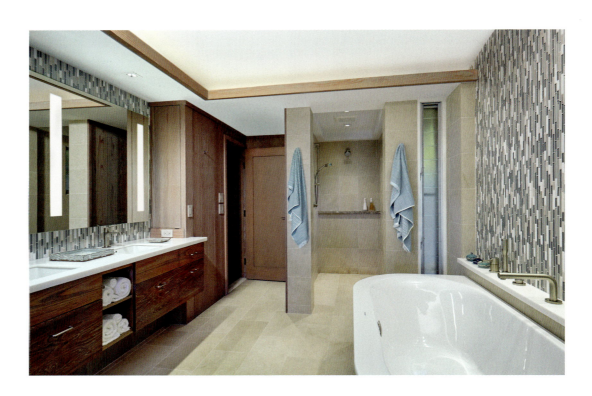

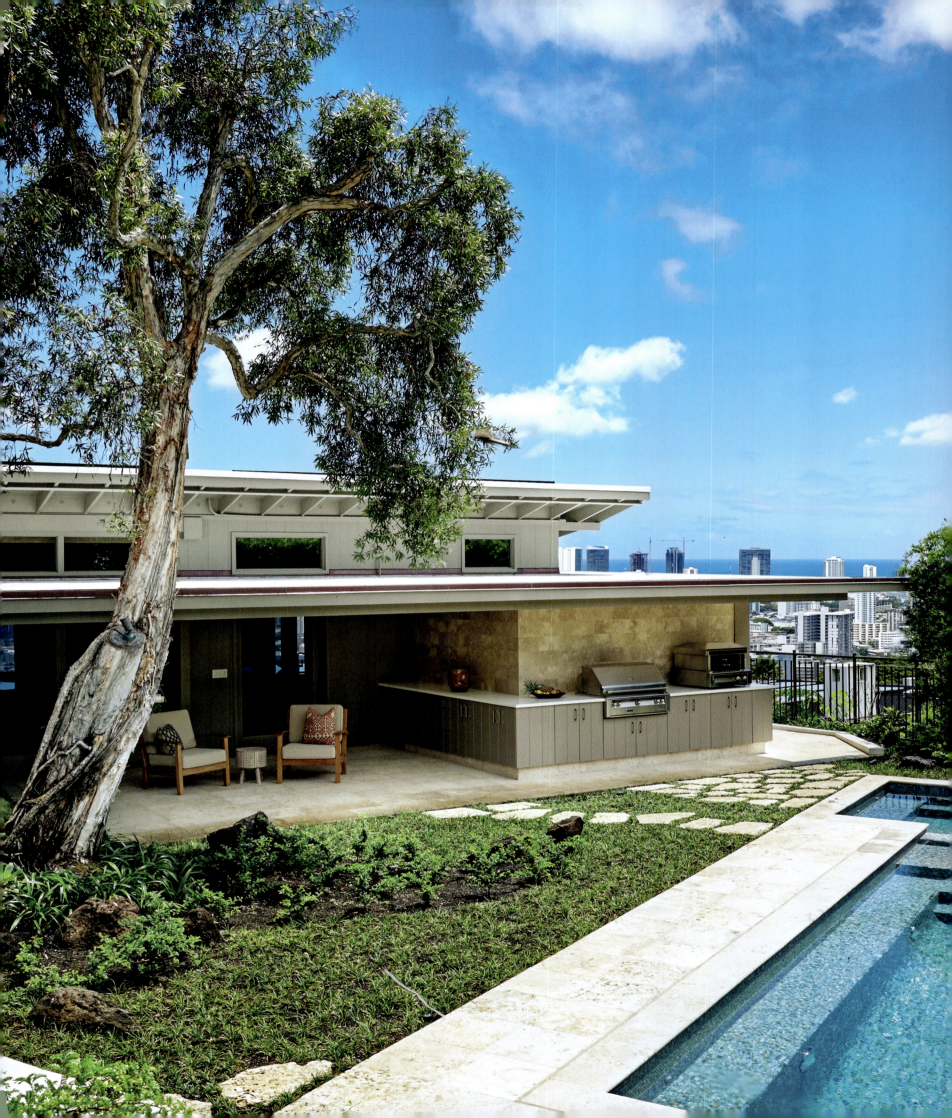

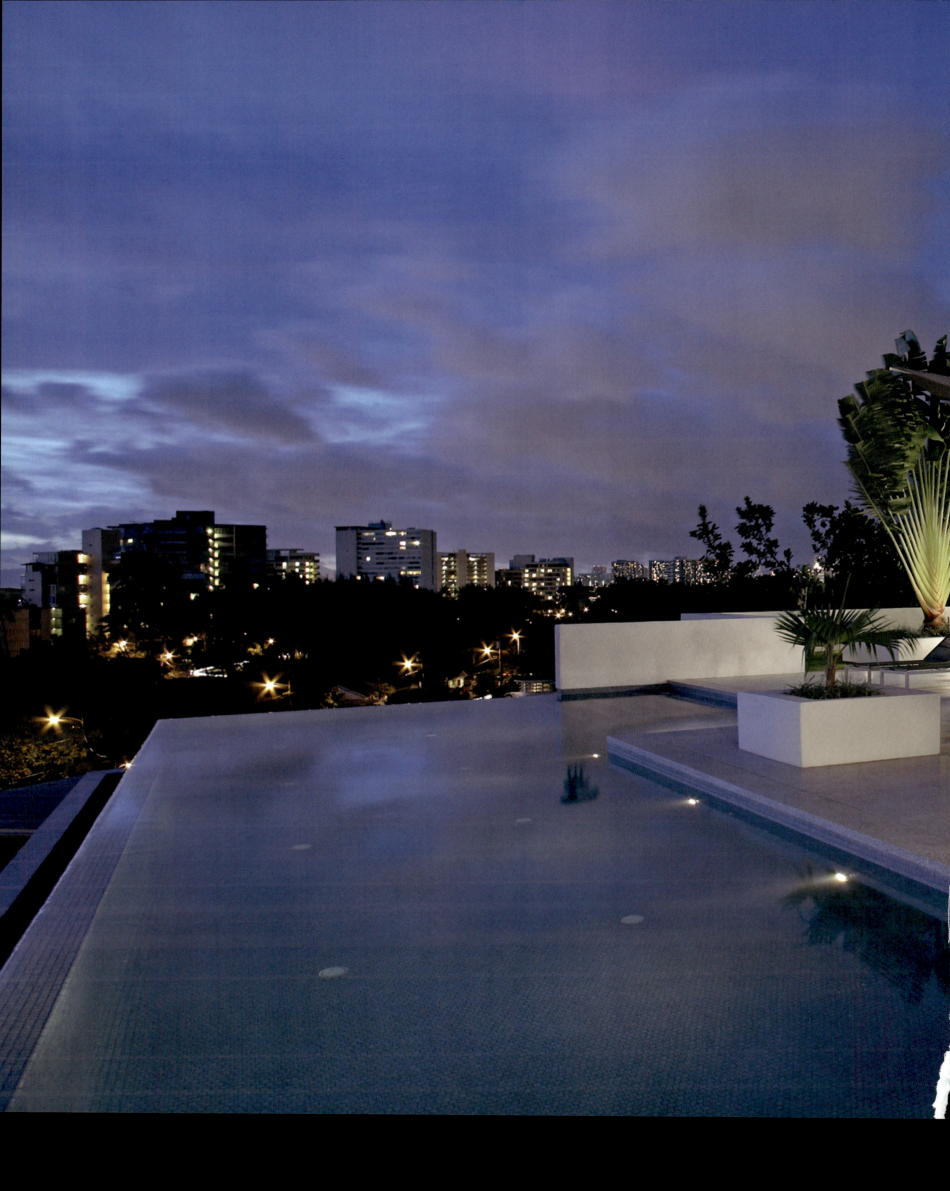

Nā Manu ʻEhā Residence

Honolulu, Oʻahu, Hawaiʻi
2007

In its renovation of the Nā Manu ʻEhā Residence, "We took the elements and the style from the house," Peter says, "and carried that through." Albert "Bert" Ely Ives designed the 9,500-square-foot house in 1938 for his wife, Kīnaʻu Wilder, who gave it the name Nā Manu ʻEhā (four birds).

In her 1978 book *Wilders of Waikiki*, Wilder describes the house as "a combination of Hawaiian, Oriental, and Mediterranean." While one might still see these motifs after nearly seventy years (and at least one major renovation), the house's modern look predominated. The building's flat-roofed white forms; thin, round, steel columns; windows with horizontal muntins; and railings with circular embellishments united the modern design, and PVA incorporated these themes into the renovation.

To complement the round columns and railings, PVA included new, circular, stainless-steel designs—from cabinet pulls to a hot tub—in the gut renovation. When the architects added new windows, they added new horizontal muntins to promote the modern look. And they replaced the ceramic tile flooring (added during a 1990 renovation) with terrazzo. "We liked the idea of a monolithic, very simple floor that would run from the inside to the outside and be durable," says Peter, "and then create this simple base for this white structure and these stainless-steel elements." PVA also used terrazzo for a custom-designed four-birds emblem at the entry of the Nā Manu ʻEhā Residence.

The sprawling house is located on a steeply sloping rocky parcel on Diamond Head. "I couldn't visualize how anyone, genius or no, could build a house on what seemed to be a ridiculously small plot," Wilder wrote in her book. "I did not know Bert!" Ives backed the house into Diamond Head and centered its rooms around a cliffside courtyard. In an early photo, this court is landscaped. In 1990, it accommodated a swimming pool. In PVA's redesign, in association with landscape architect Randall Monaghan, it became a sculpture garden—home to the owners' collection of bronze figures and a newly commissioned rock work by local sculptor Donald Jones. The untitled art piece is made of more than thirty sections of basalt (some weighing over a ton) from the Kapaʻa Quarry in Kailua. "If you were in that courtyard, you'd look up the slope of Diamond Head," Peter says. "So, it feels like Diamond Head comes down into this courtyard." The courtyard can be fully open to the interior, shielded with motorized screens, or closed off with large pocketing glass panels.

NĀ MANU ʻEHĀ RESIDENCE

New pool, deck, and spa overcame technical challenges of steep slope.

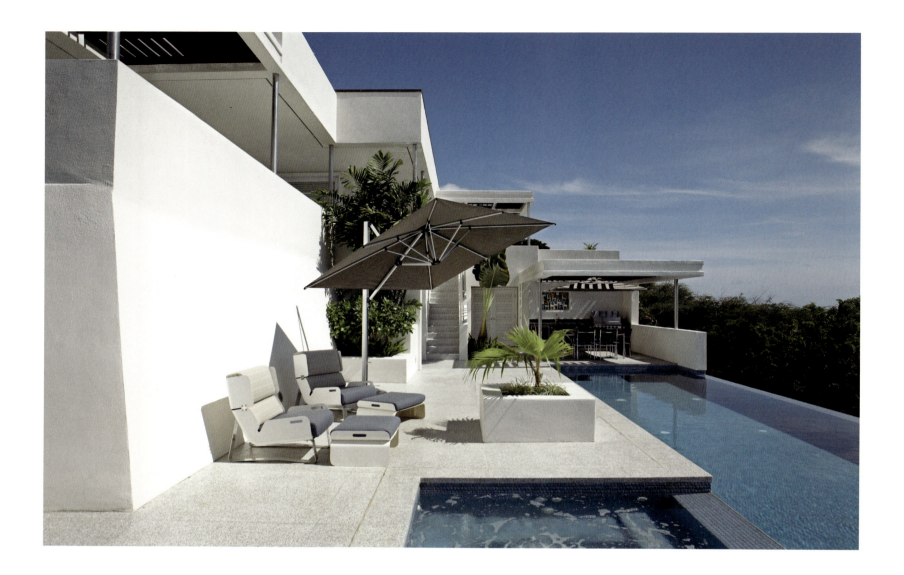

The owners' large collection of artworks suggested the design direction of not only the courtyard, but also other parts of the house. PVA built a niche at the entry for a statue called *The Guardian*. It created chairs to complement an artful table. It centered a portrait of Princess Victoria Kamāmalu, which resided in the original home and was refurbished by experts from the Honolulu Academy of Arts, in satin finish ʻōhiʻa, a wood used in the original interior.

In the middle of construction, the owners requested a place for a newly acquired painting, by the Swiss artist Pia Fries, on four five-by-eight-foot panels. "That's a big consideration," Peter says, "but it worked out perfectly in the dining room." PVA added recesses to hold the panels and lighting to accentuate it. The diverse art finds a comfortable home in Nā Manu ʻEhā Residence, as it all resides within PVA's unified, modern palette.

NĀ MANU ʻEHĀ RESIDENCE

Central courtyard features bronze statues set against cut-basalt backdrop.

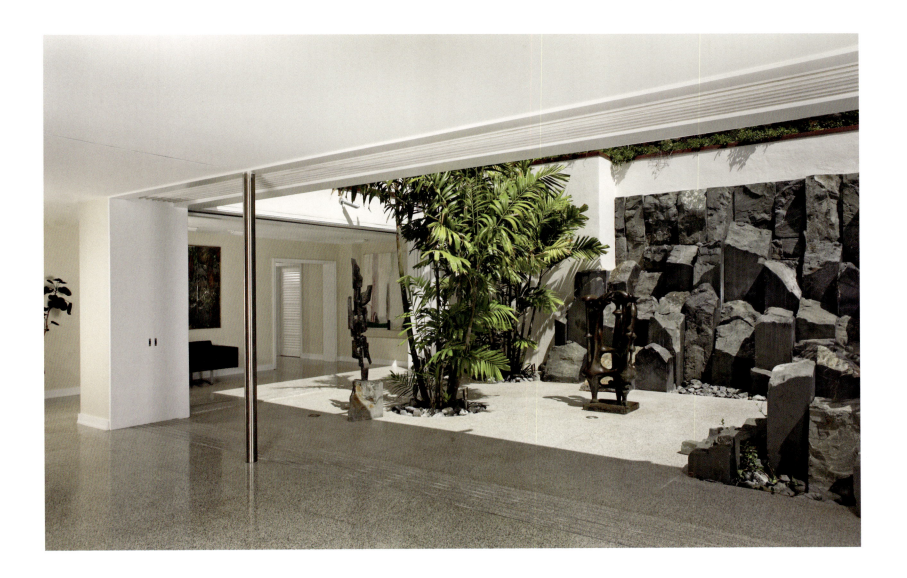

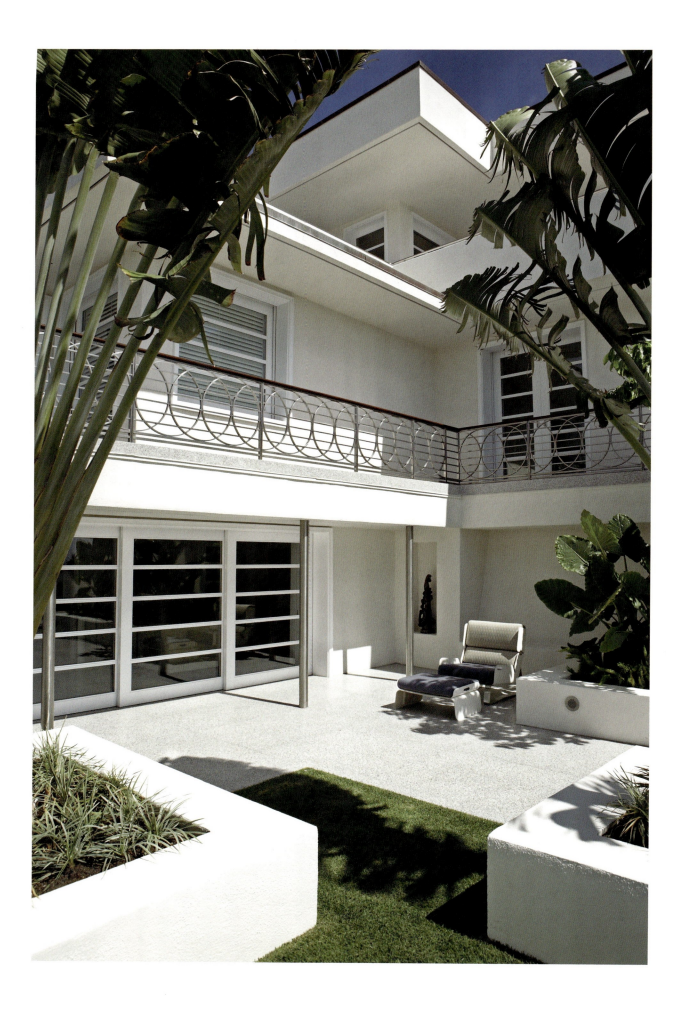

NĀ MANU ʻEHĀ RESIDENCE

OPPOSITE AND BELOW: *Extended areas of house form garden terrace.*

BOTTOM: *Custom-designed logo in terrazzo flooring represents Nā Manu ʻEhā (four birds).*

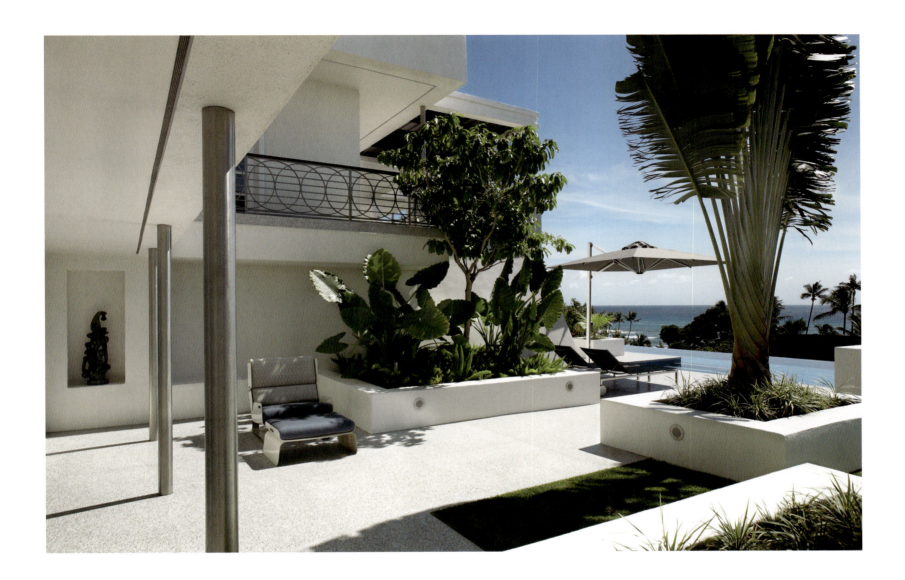

NĀ MANU ʻEHĀ RESIDENCE

Removing kitchen walls allowed for expansive ocean views.

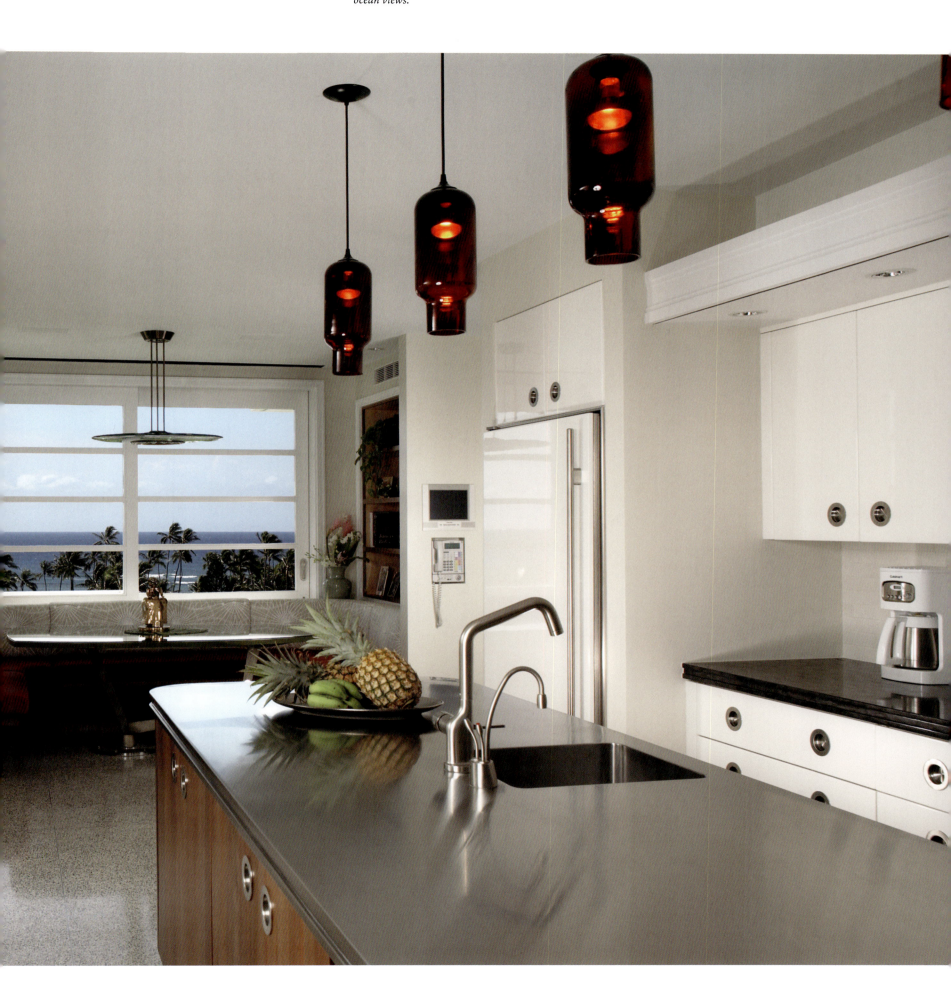

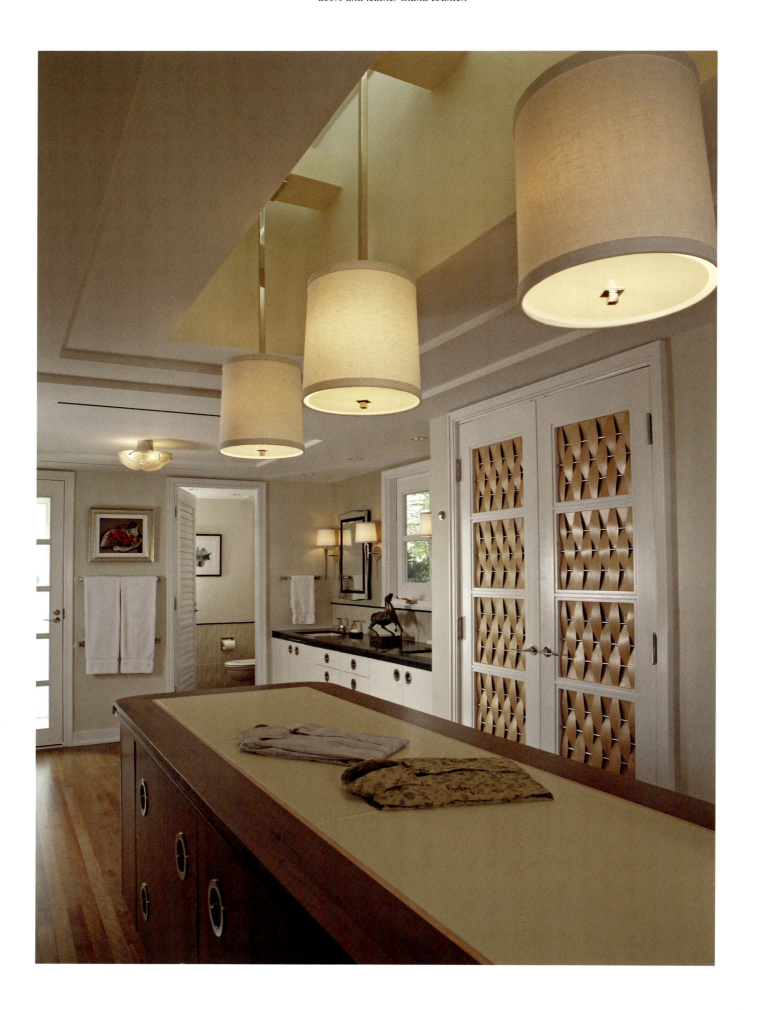

Skylit dressing room features maple basket-weave closet doors and leather island counter.

NĀ MANU ʻEHĀ RESIDENCE

Elevated primary suite takes advantage of sweeping ocean and city views.

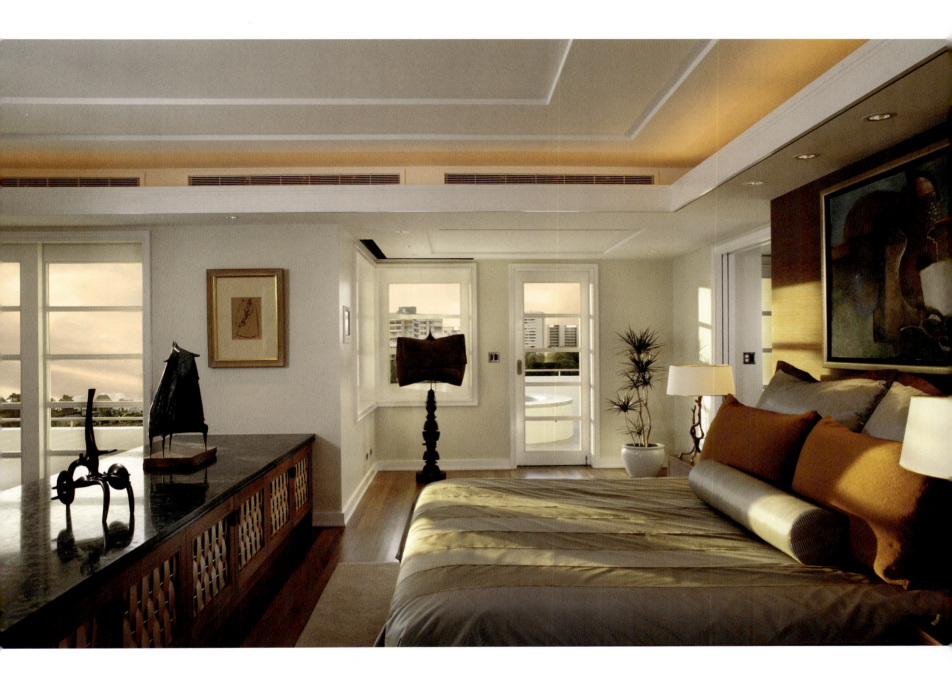

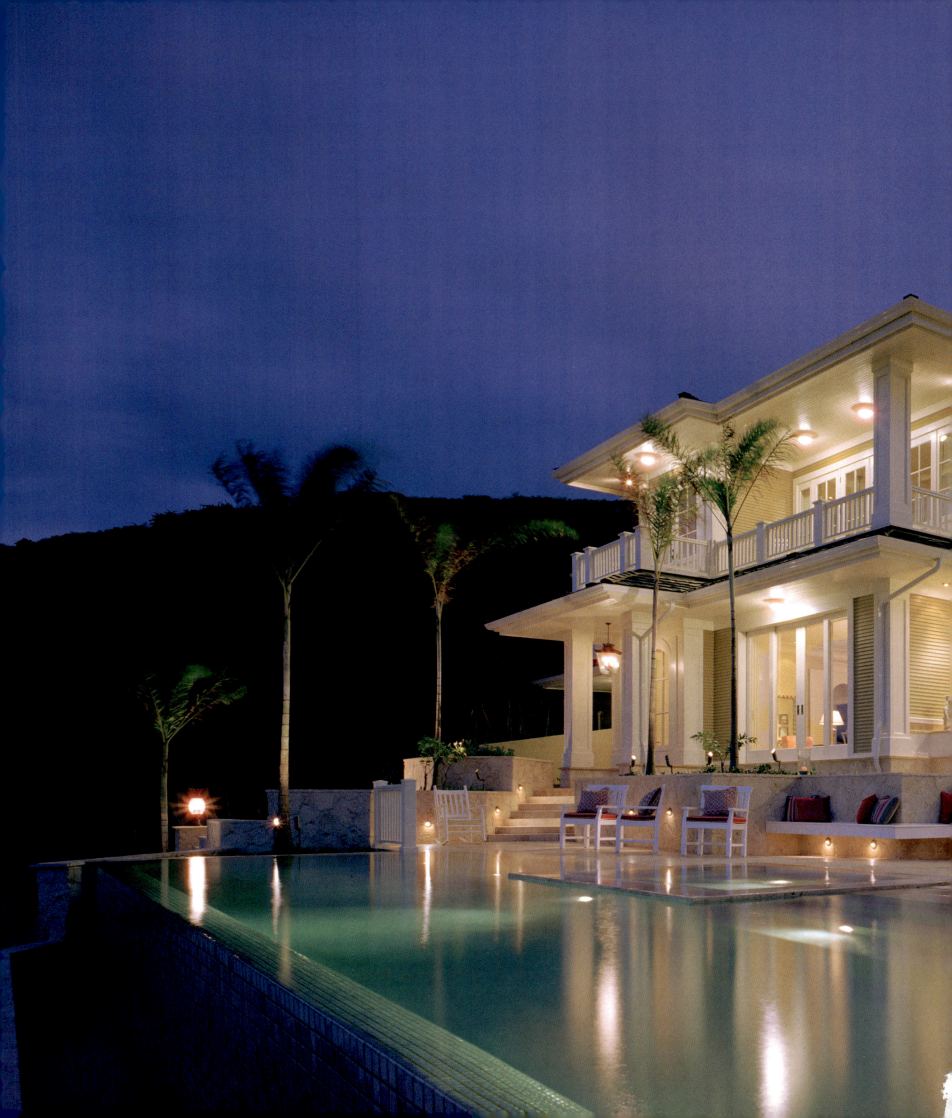

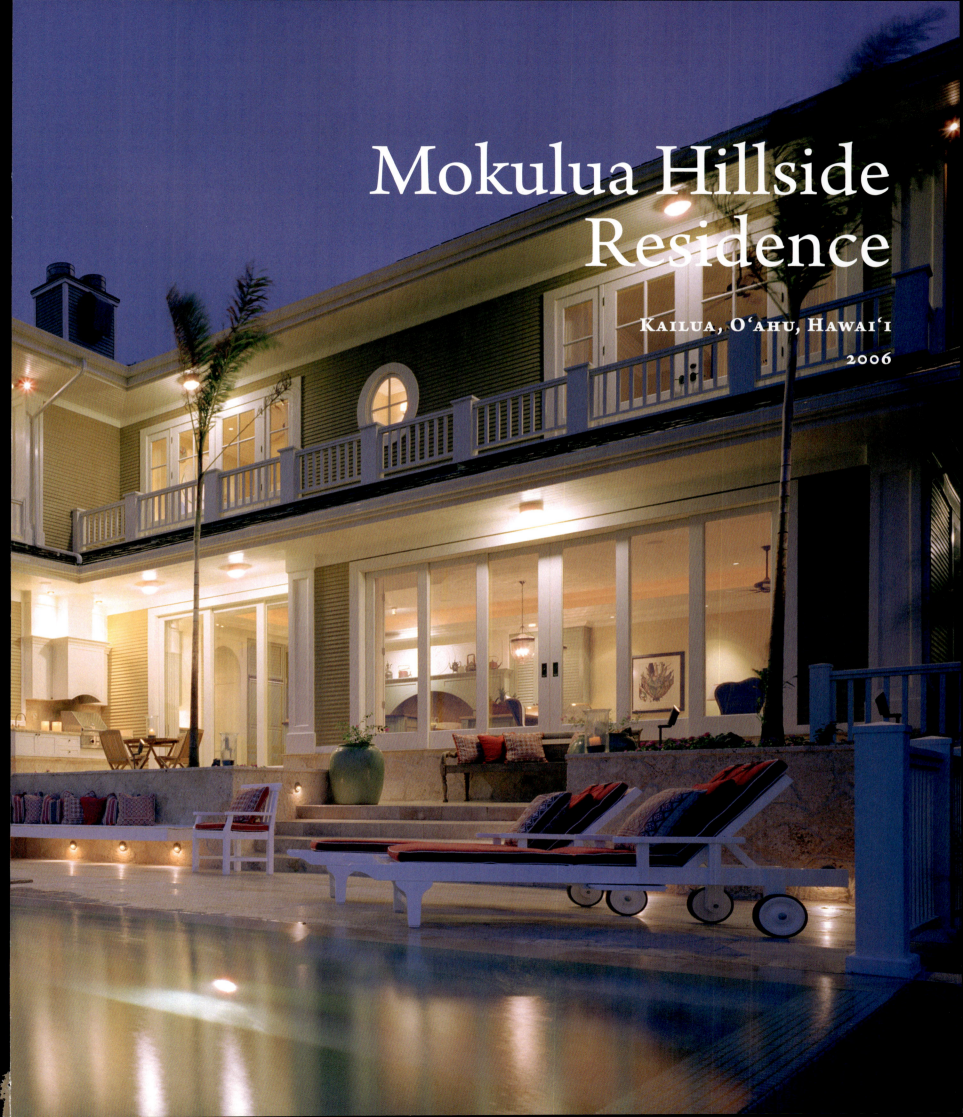

Mokulua Hillside Residence

KAILUA, OʻAHU, HAWAIʻI
2006

For some renovations, PVA works off the themes of the existing building. For the Mokulua Hillside Residence, that was not so easy. "It was sort of a little bit of everything," says Peter. "There was clapboard siding painted sea foam green, stainless-steel cable railings, Balinese teak furniture, a lot of ziggurat forms, Tuscan columns, and an awkward roof (I call it the flying nun). It was like, what are you going for?"

The original home, built in 1990, may have been poorly designed or may have suffered some bad renovations. But when PVA took it over, "It was a lot of different looks jumbled together," Peter says.

PVA united the Mokulua Hillside Residence with a single approach. "It's a Hawai'i plantation look," says Peter. PVA added white shutters and wide-board trim and extended the flying-nun hip roof with a more familiar (and useful) overhang. It replaced the sea foam green exterior paint with a muted green and the stainless-steel cable railings with white wooden ones. The interior uses similar light-toned walls with white trim. "Fairly substantial crown moldings give it a sense of grandeur," Peter says. Craggy flagstone flooring was replaced with dark, distressed wood, which complemented the clients' oriental rugs. PVA removed the ziggurat shape from the fireplace and installed an antique cast-iron surround.

The large size of the two-story house allowed for more substantial renovations as well. PVA removed a drop soffit and an island from the kitchen and connected it to the family room as one space. It replaced a simple stairwell (and its adjacent Tuscan column) with a grand stairway lit with a large hanging lantern. Peter designed its newel post finial in the shape of an oversized pineapple. The pineapple—a symbol of both Hawai'i and hospitality—is repeated elsewhere in the renovation. "We had a lot of square footage to work with, so we were able to make very gracious spaces like the primary bath, which feels more like a room than a bathroom," Peter says. "It has a bay window where a pedestal tub sits, looking out to a little private landscaped garden." The house's high ceilings and material choices had made the previous interiors somewhat cold looking.

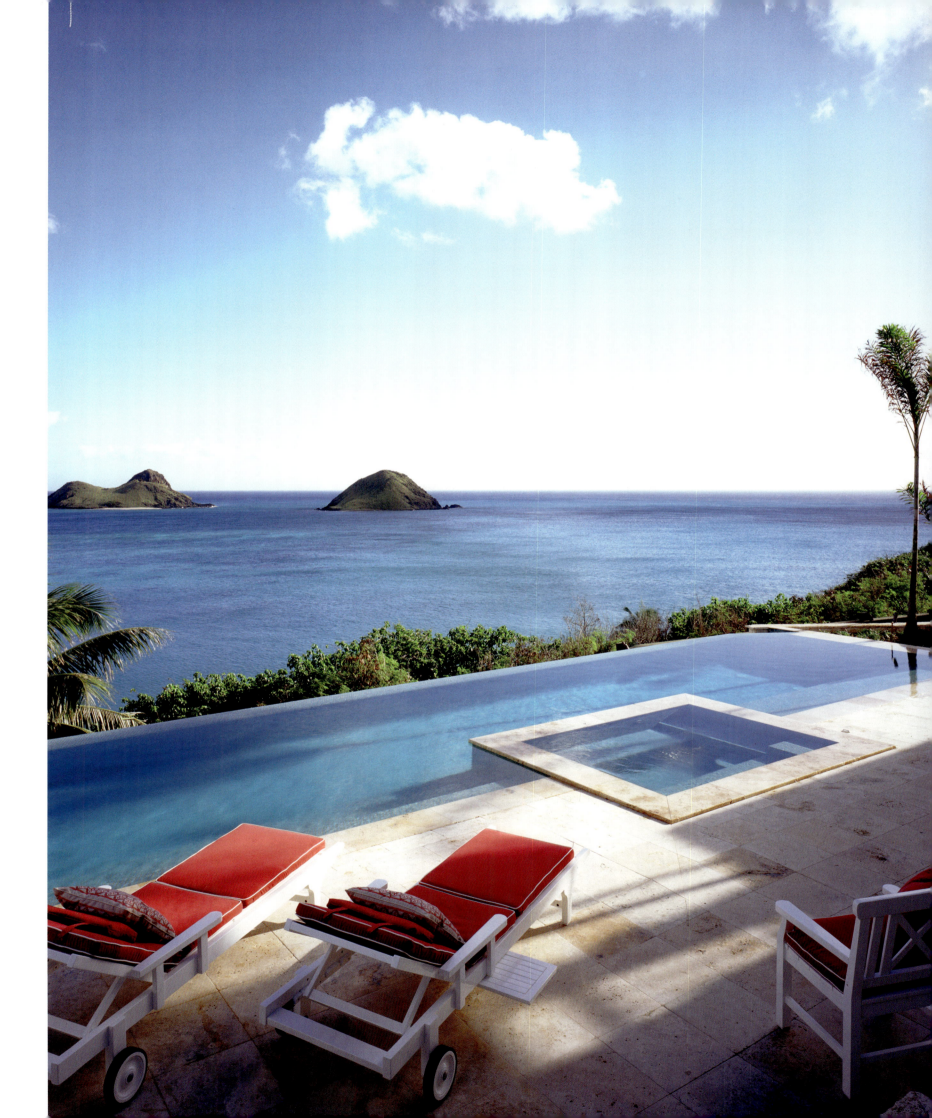

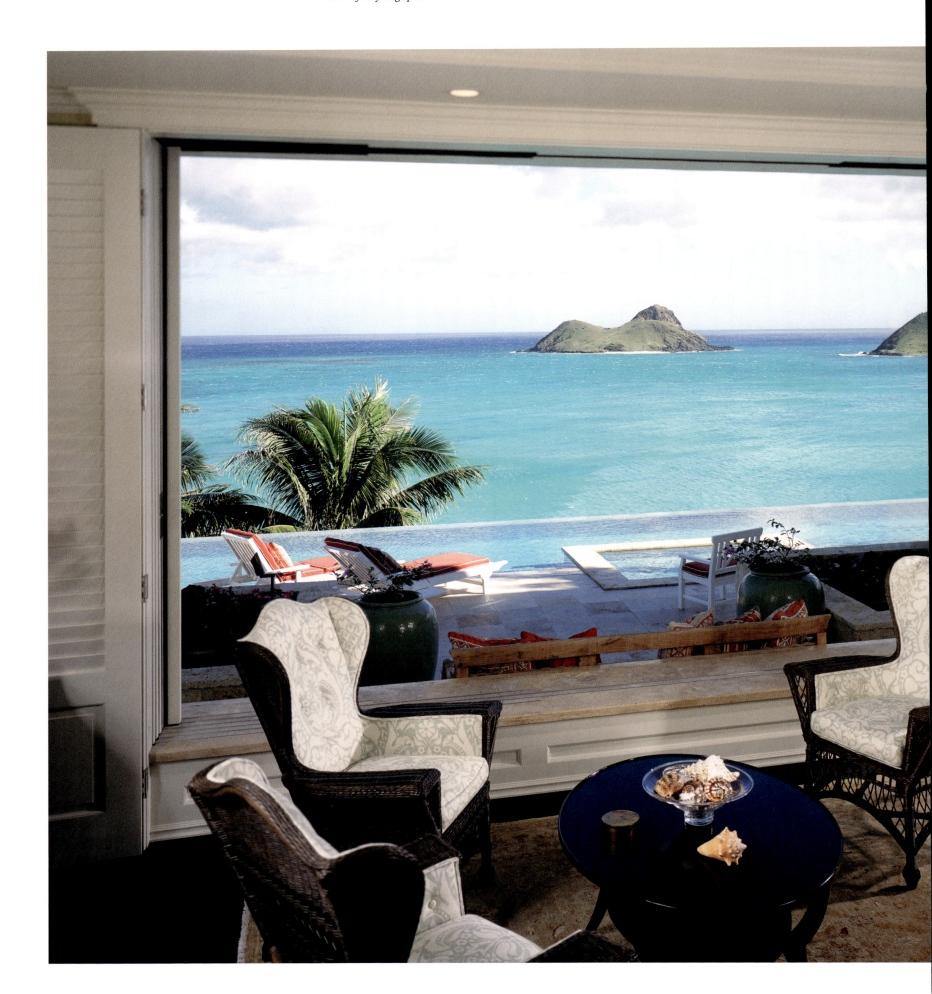

View of Mokulua Islands from family room overlooks new infinity-edge pool.

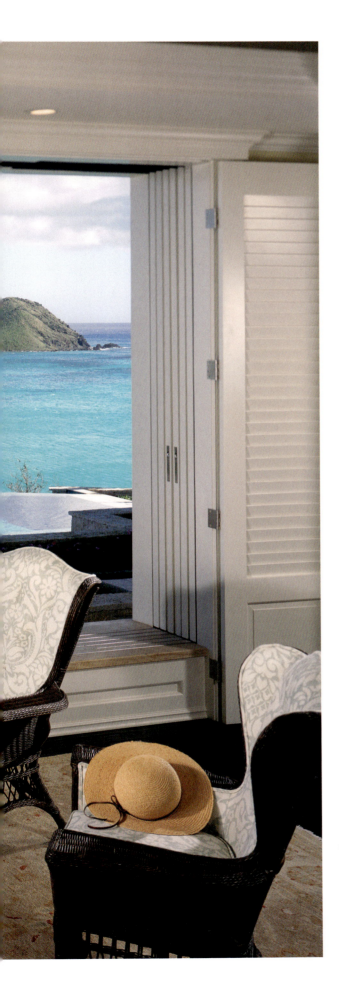

"I could see that we could transform this and really bring a sense of scale to it by using large trims," Peter says. "I think that's where both my Italy and New England design experiences came to bear on this project—bringing that sense of scale and the proper proportions."

While the pre-renovated house was a bit chaotic, its site in Kailua was pristine. "It has an incredible view, not just of the ocean and the Mokulua Islands (the Mokes), but also looking back at Lanikai," Peter says. "You're just high enough where you see a lot of foliage, particularly coconut trees in the foreground. The view is just absolutely magnificent." The house was built into the hillside yet did not take best advantage of the views. The renovation aimed to correct this. On the exterior, PVA expanded the pool and gave it an infinity edge. "It was the perfect pool to do an infinity edge," Peter says, "because it just drops off against the water." On the interior, PVA opened up spaces and reoriented rooms toward the view. "Having the cool sky and the ocean" Peter says, "and then having this warmer interior, the dark floors, and this rich furniture and nice art creates this warm, cozy kind of feeling."

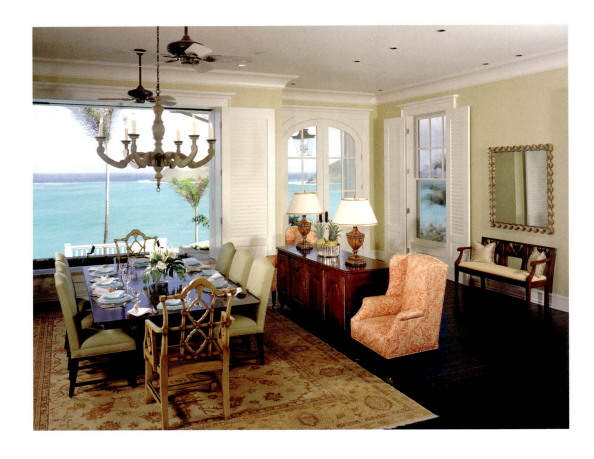

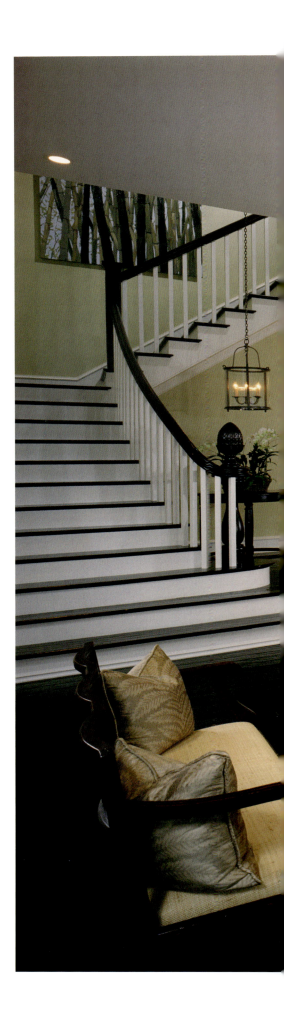

MOKULUA HILLSIDE RESIDENCE

OPPOSITE AND BELOW: *Renovated entry foyer, dining, and sitting areas take on cohesive, unified sense.*

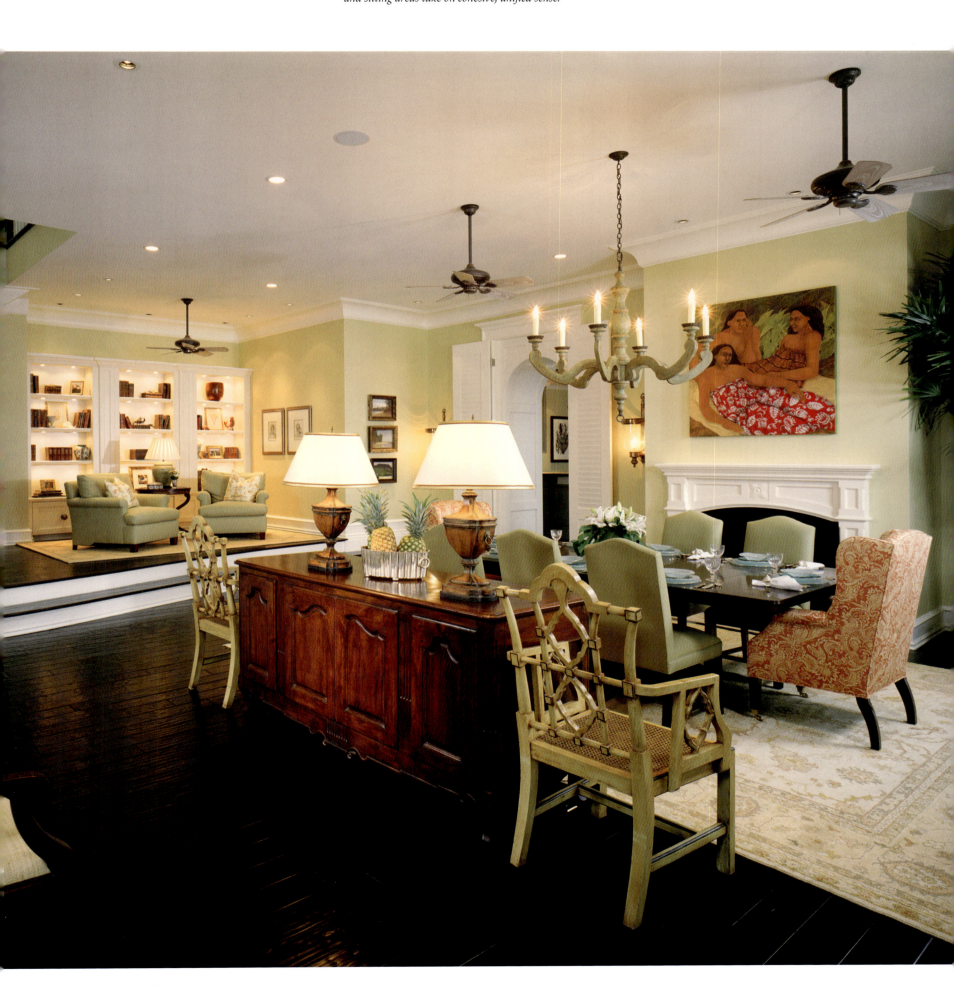

RENOVATIONS

Primary bedroom's sitting area provides secluded space with spectacular view.

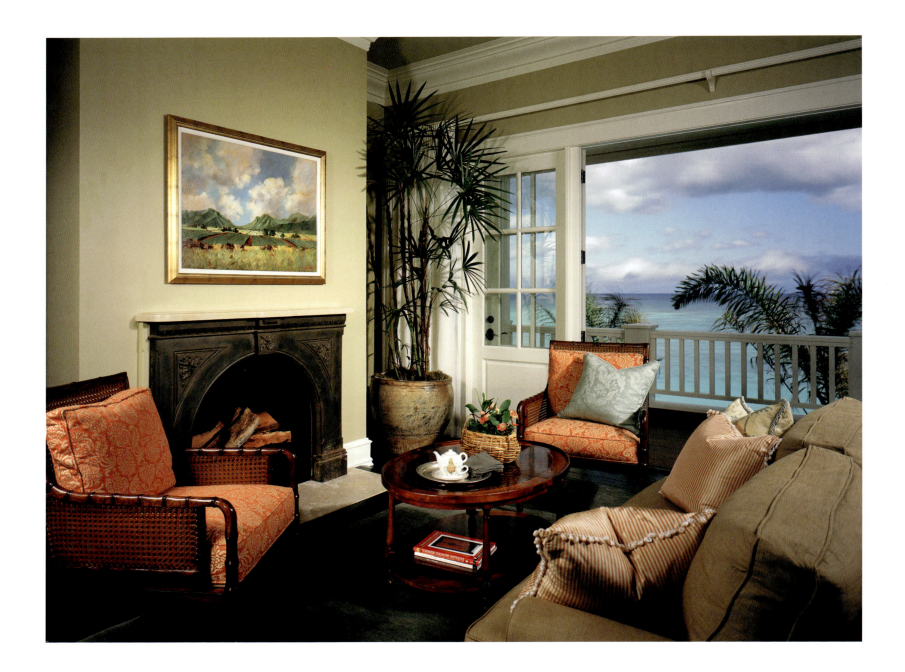

Arch-topped windows were replaced with French doors.

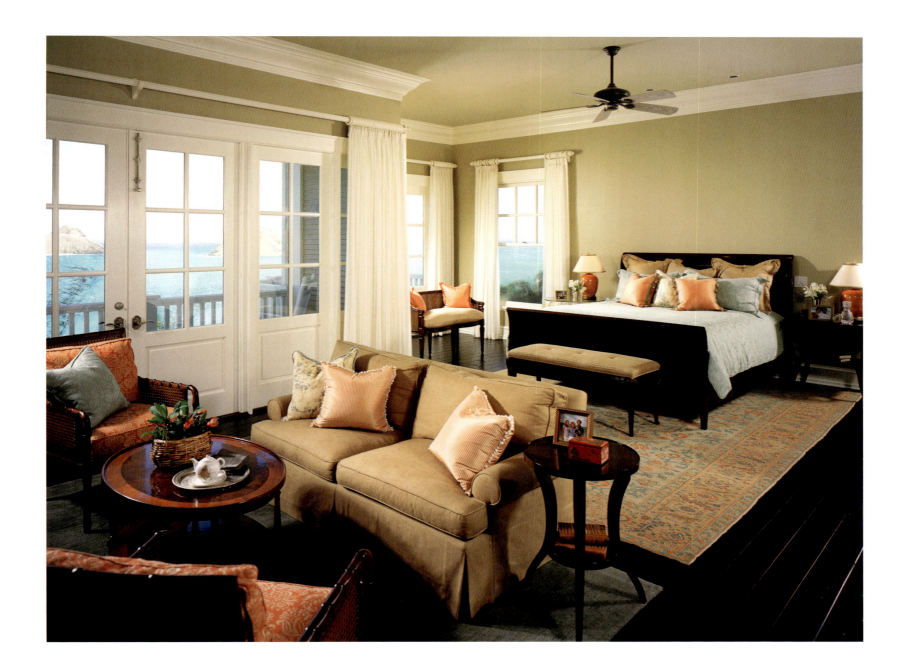

Guest bedroom suite maximizes ocean view and breeze.

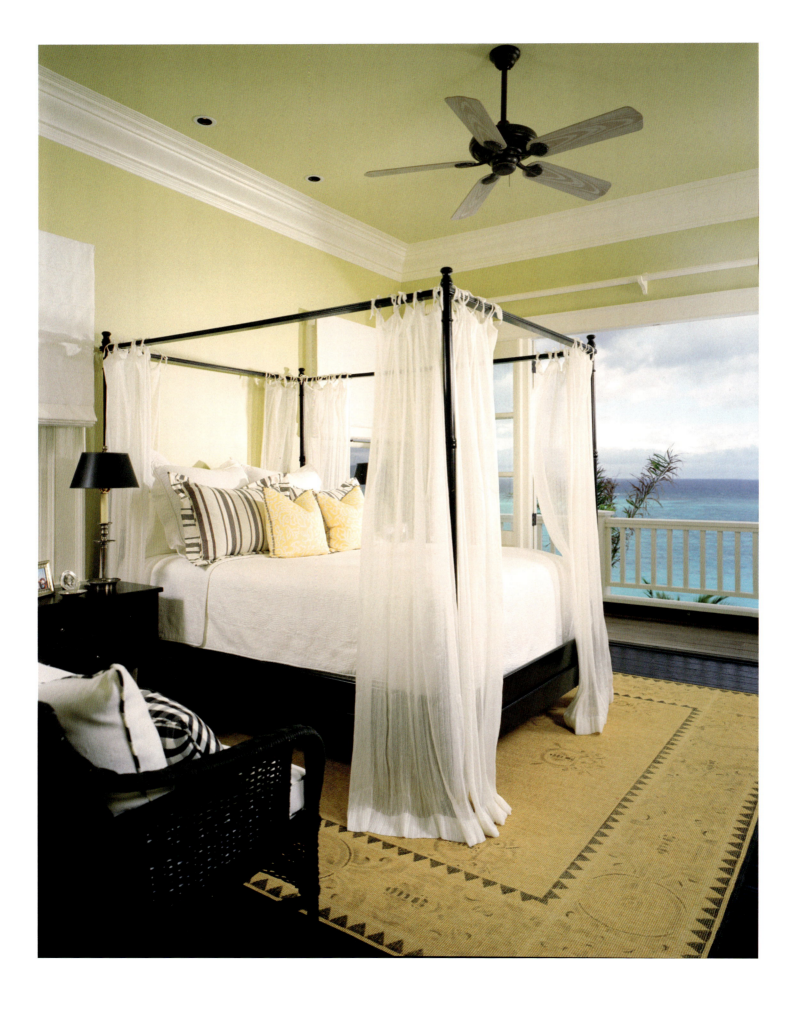

MOKULUA HILLSIDE RESIDENCE

Monkey chandelier provides levity to study.

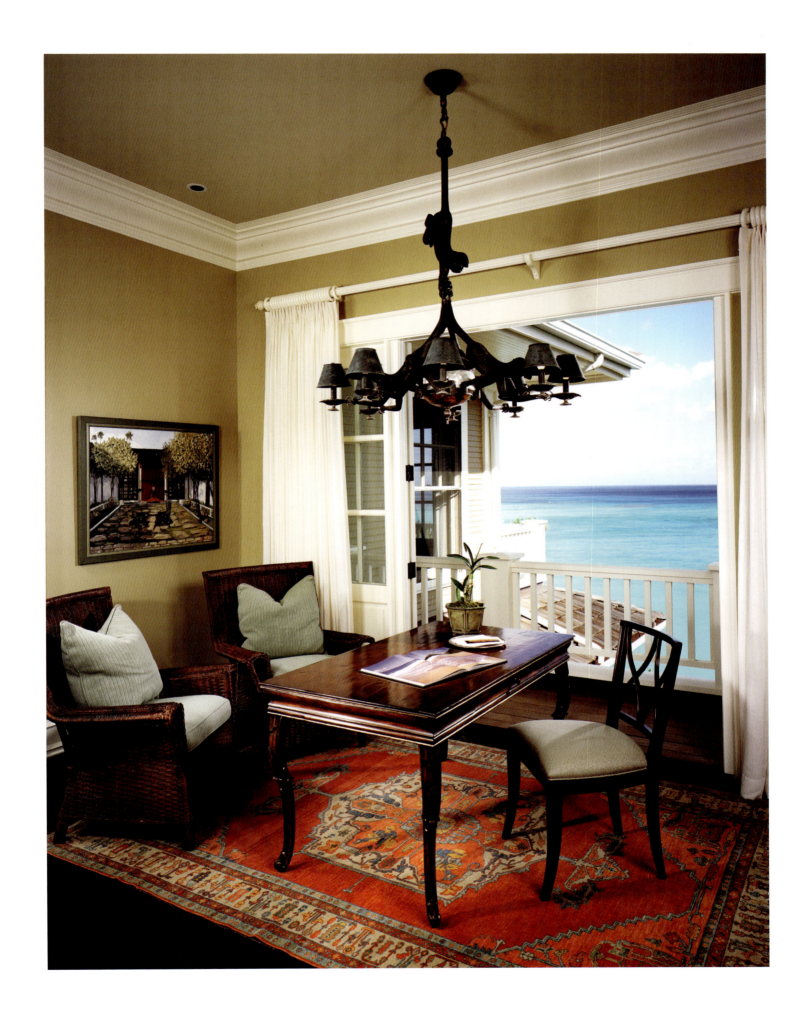

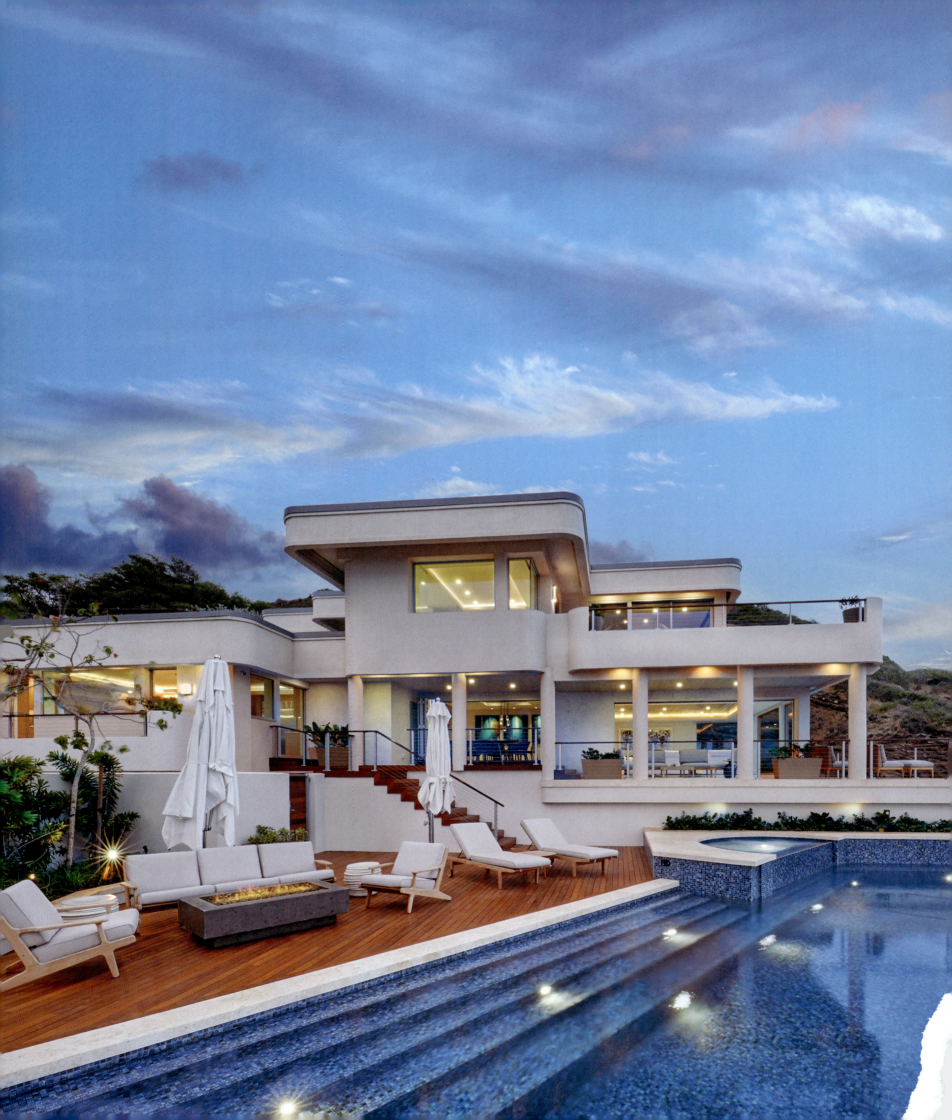

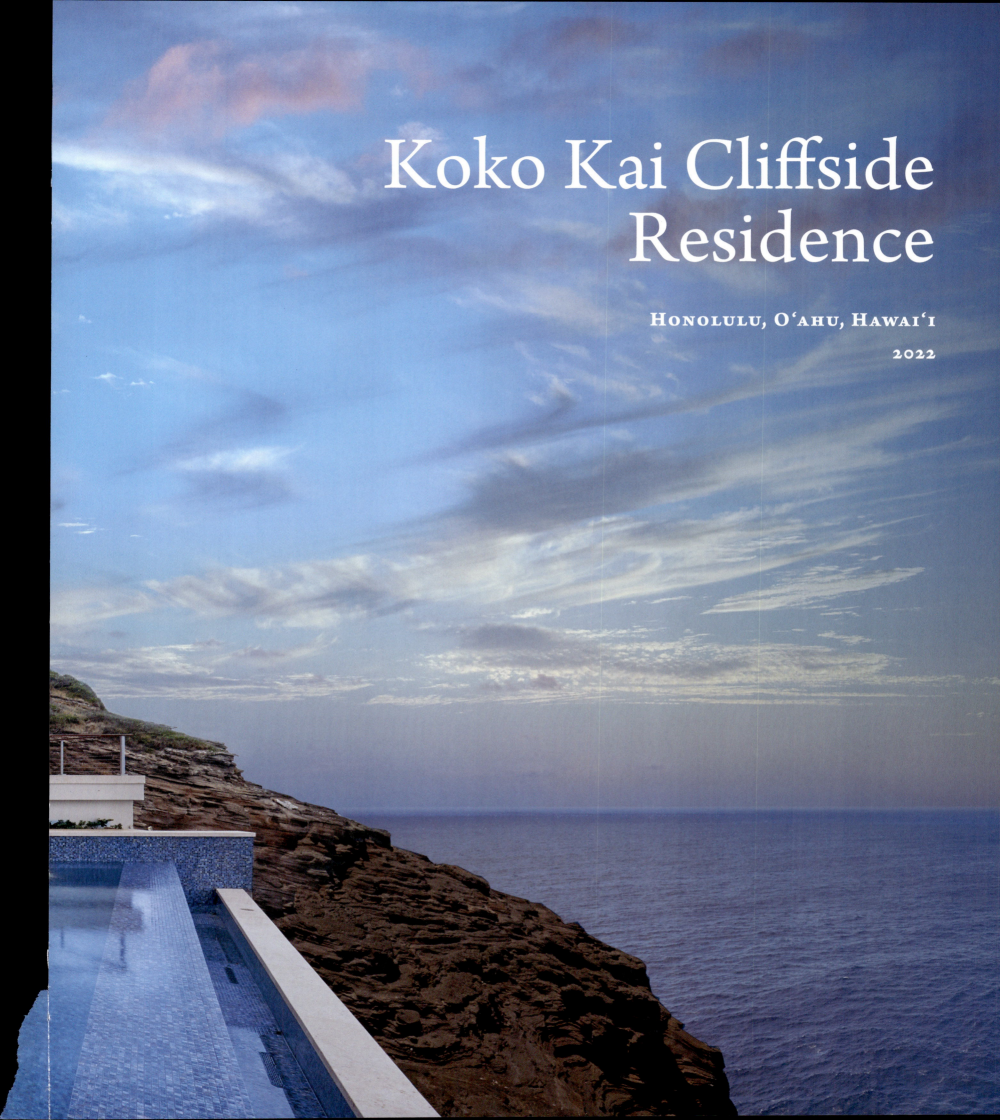

Koko Kai Cliffside Residence

Honolulu, Oʻahu, Hawaiʻi

2022

At the Koko Kai Cliffside Residence, an interim renovation had greater influence on PVA's work than the original design did. The house, as built in 1978, had been a heavy building with brick arches and pavilion roofs. In 1994, the building received a flat-roofed second floor and its facade was wrapped in white curving forms, a motif popular in 1980s postmodern architecture. The interiors, too, took on a 1980s look—"a lot of angles," Peter says.

"The game plan was to keep what was there and yet transform it into something radically different," Peter says. "We kept the curves but tried to clean up the lines." This game plan may have been born of necessity more than desire, as the clients' budget and local building codes discouraged major exterior renovation. Yet the look offered PVA a unique mode to work with.

The theme of clean lines and curves plays out with a modified deck. "We used stainless-steel railings with an Ipe wood cap, so it has kind of a ship aesthetic," Peter says, "because from the primary bedroom and even the living room below, you really feel like you're on a ship." The bedroom interior continues this theme with a boat-shaped soffit in the ceiling, "just to make you feel like you're almost moving along with the deck outside," Peter says.

The entrance to Koko Kai Cliffside Residence needed some cleaning up as well. "You'd come in on this narrow path, scraping by some bushes, under a very low, roughly seven-foot ceiling, and then the ceiling disappeared, and the path was open to the air," Peter explains. "And then you went in, and right in front of you was the stair going up. So, the sense of entry was absolutely dismal." Visitors now arrive via an uplit path to a large glass pivot door. Once through the door, they face a five-by-five-foot niche; PVA moved the stair off to the side to allow for this more pleasant arrival. The niche, lined with a soft fabric wall covering, contains a colorful ceramic work from Japanese-born artist Jun Kaneko's Dango (dumpling) series.

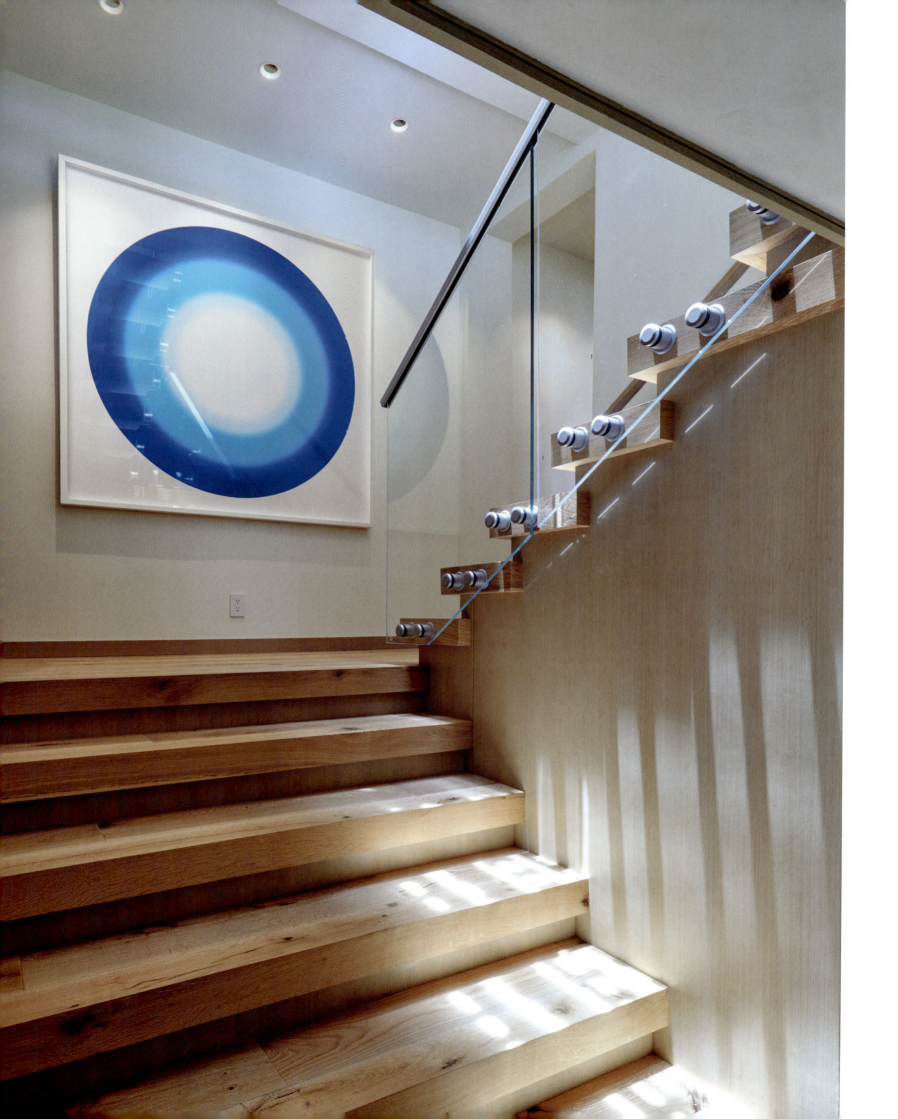

KOKO KAI CLIFFSIDE RESIDENCE

OPPOSITE: *Relocated main stair creates welcoming entry experience.*

BELOW: *Expanded kitchen provides gathering space and opens to family room.*

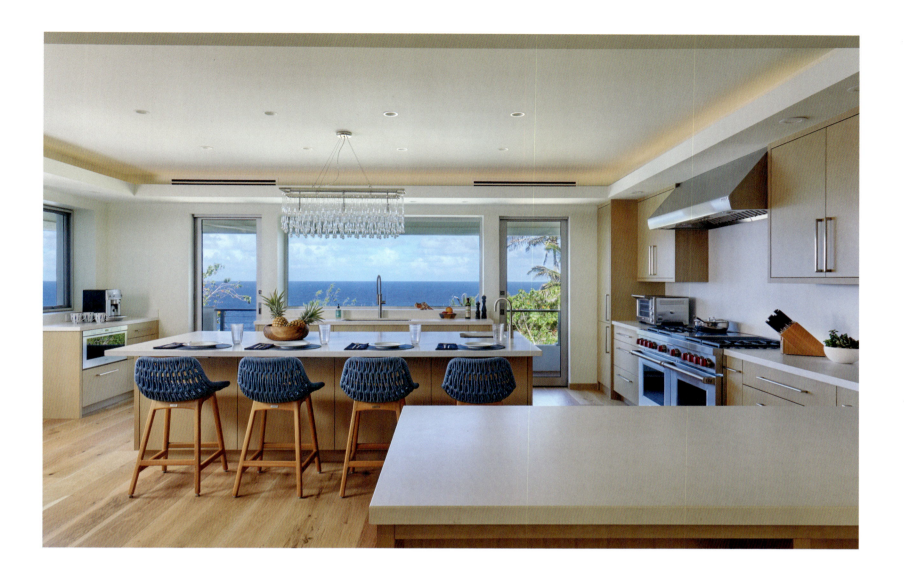

RENOVATIONS

Bleached wood bulkheads, reminiscent of those on ships, offer open transition between spaces as well as storage and display.

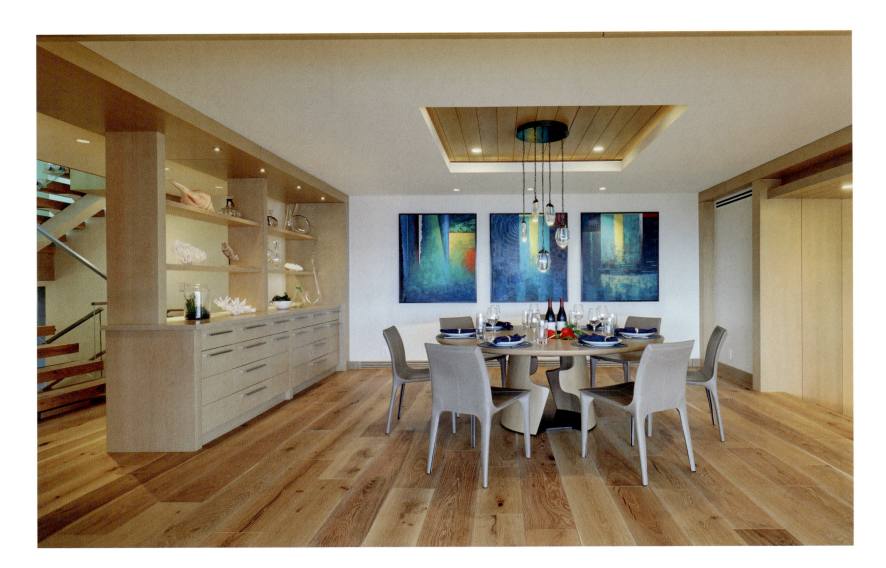

Living room uses neutral pallette to let view be center of attention.

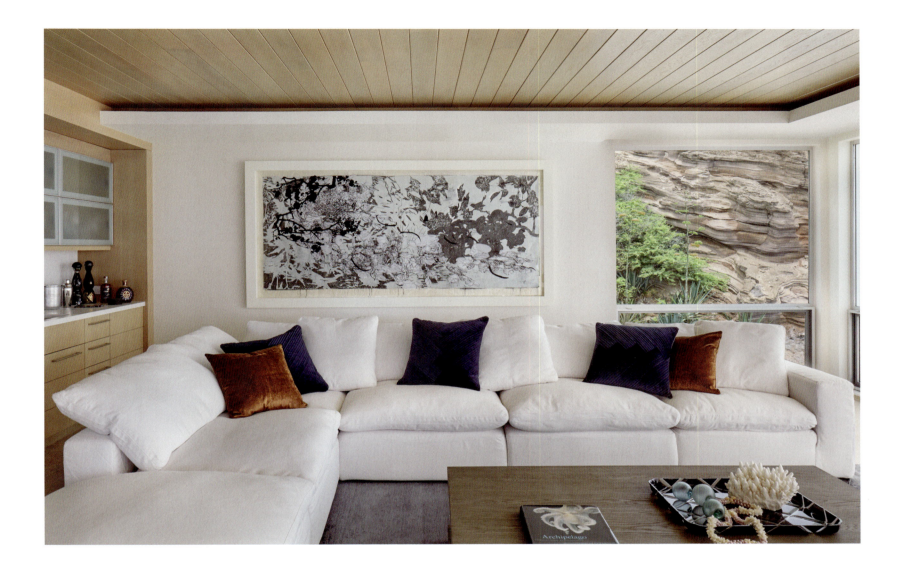

PVA, working with art consultant Kelly Sueda, guided the effort in acquiring the dango and most of the art and furniture in the Koko Kai Cliffside Residence to complete its clean, contemporary look. "The art is more abstract, but in ocean-themed colors," Peter says. "We didn't want to use ocean paintings and scenes when we've got that scenery." "That scenery" is an unobstructed view to the Kaiwi Channel, the twenty-six-mile-wide waterway between Oʻahu and Molokaʻi. "In the winter months, you see whales off the coast," Peter says, "and all year you see green sea turtles."

This view, more than the extant bright white house, likely convinced the clients to purchase the property. Yet PVA could see something in the 1994 house remodel that was worth pursuing. "It's really just clean lines," Peter says. "We stripped it all and went with much more contemporary interiors, all unified."

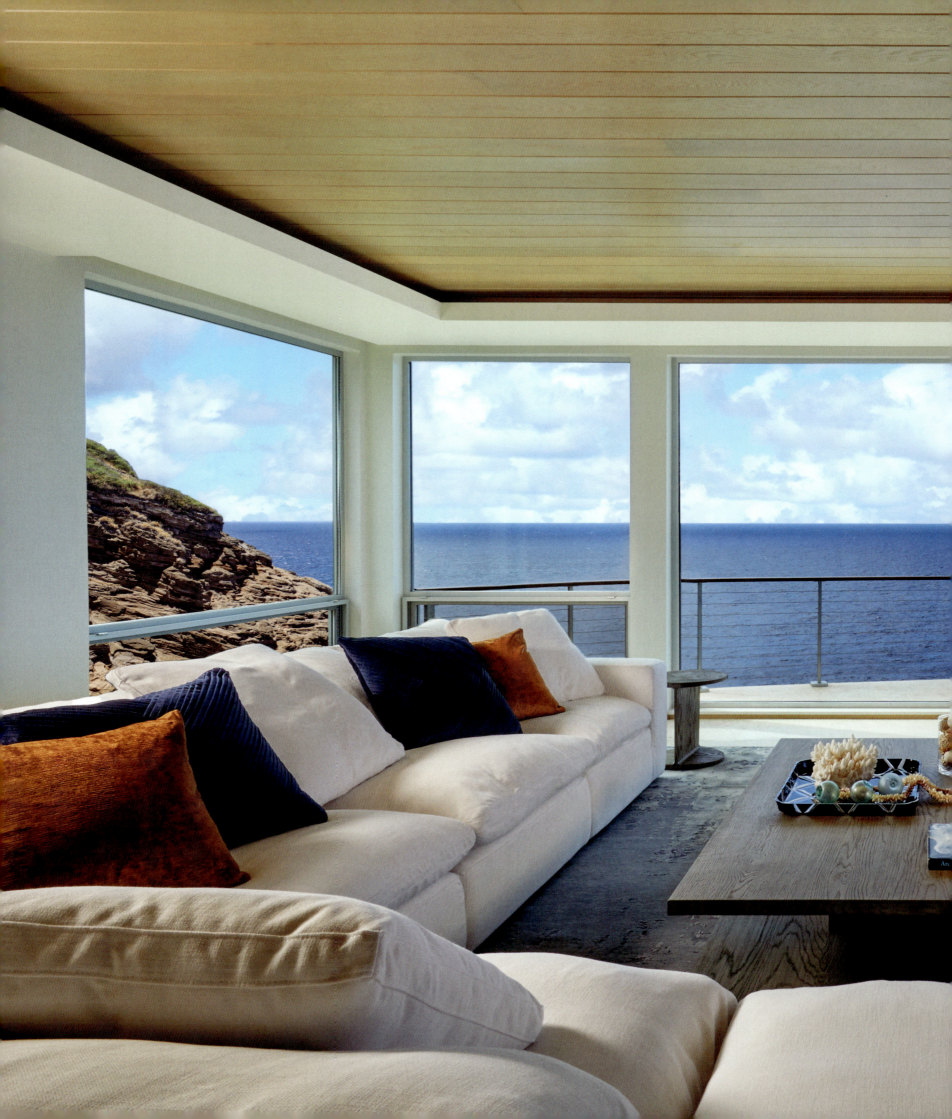

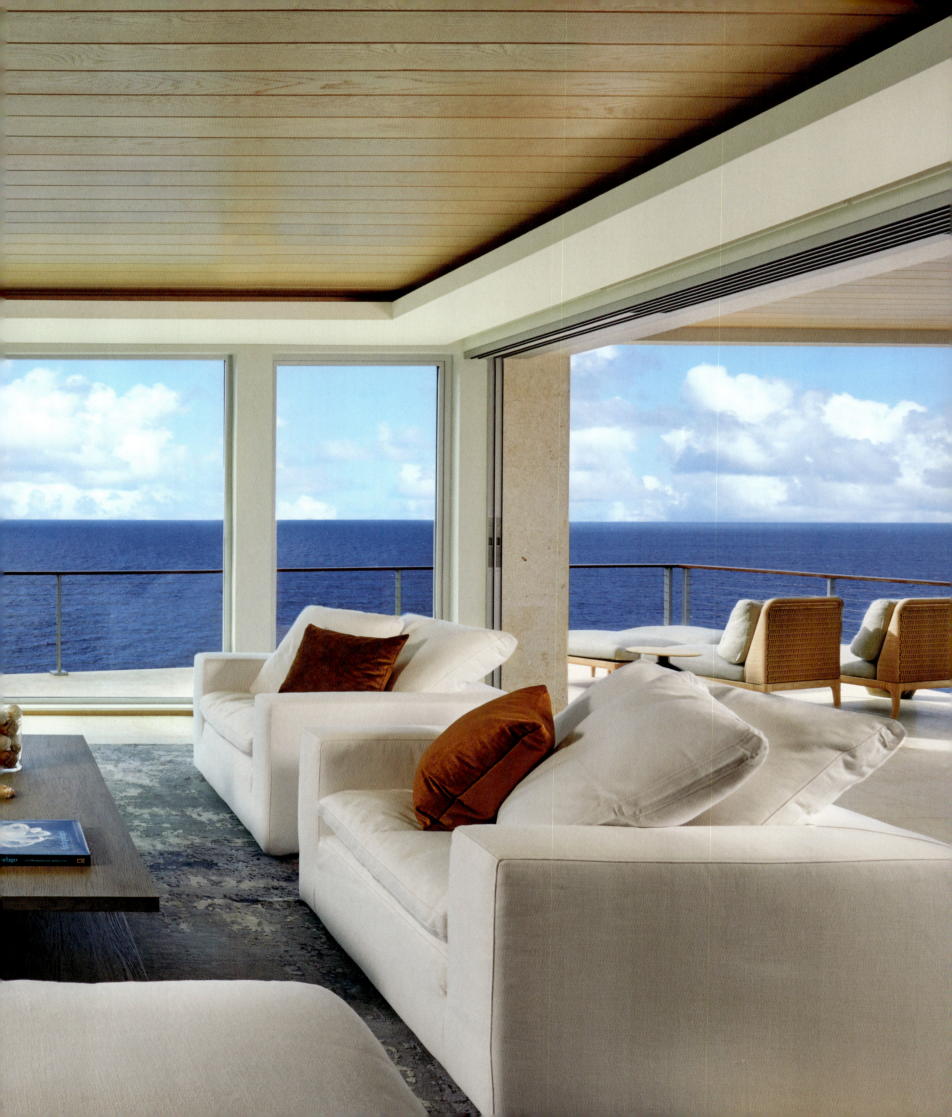

BELOW AND OPPOSITE: *Skylit stair provides transparency and light throughout house.*

BOTTOM: *Occulus skylight brings natural light into powder room, which features sea urchin pendant lights.*

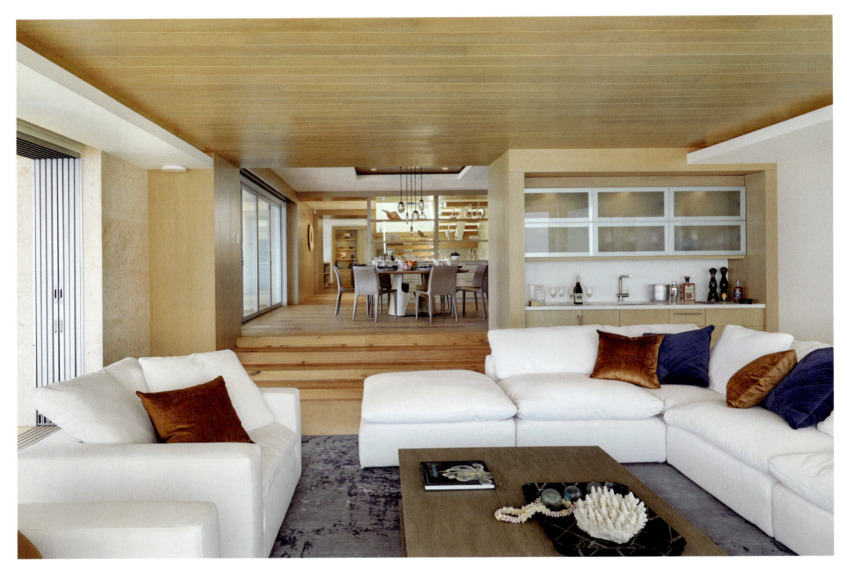

Boat-shaped soffit in primary bedroom enhances ocean-themed experience and conceals flip-down TV.

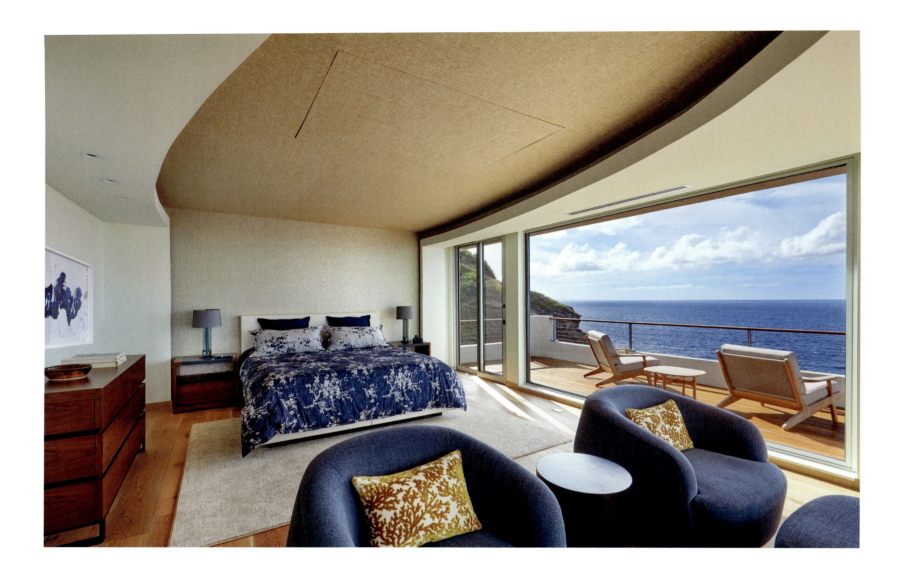

KOKO KAI CLIFFSIDE RESIDENCE

BELOW: *Glass tile connects primary bath to ocean view.* BOTTOM LEFT AND RIGHT: *Skylit stair and primary bedroom foyer bring light to lower level of house.*

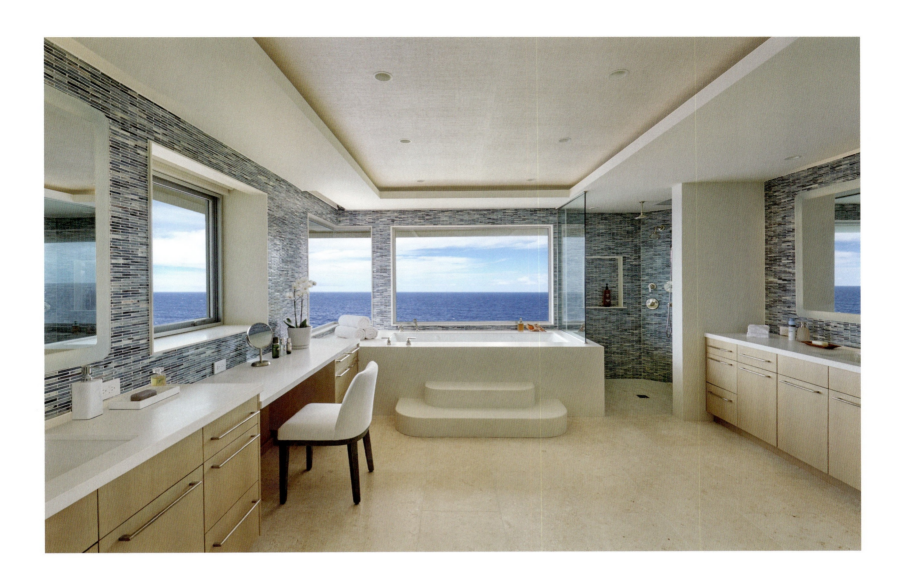

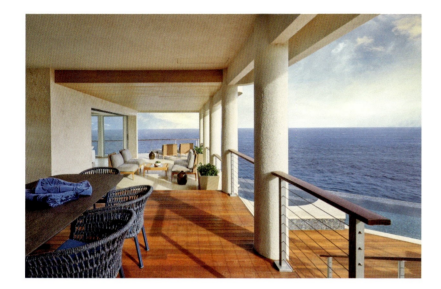

KOKO KAI CLIFFSIDE RESIDENCE

Wrap-around lānais open to view and take on appearance of ship's deck.

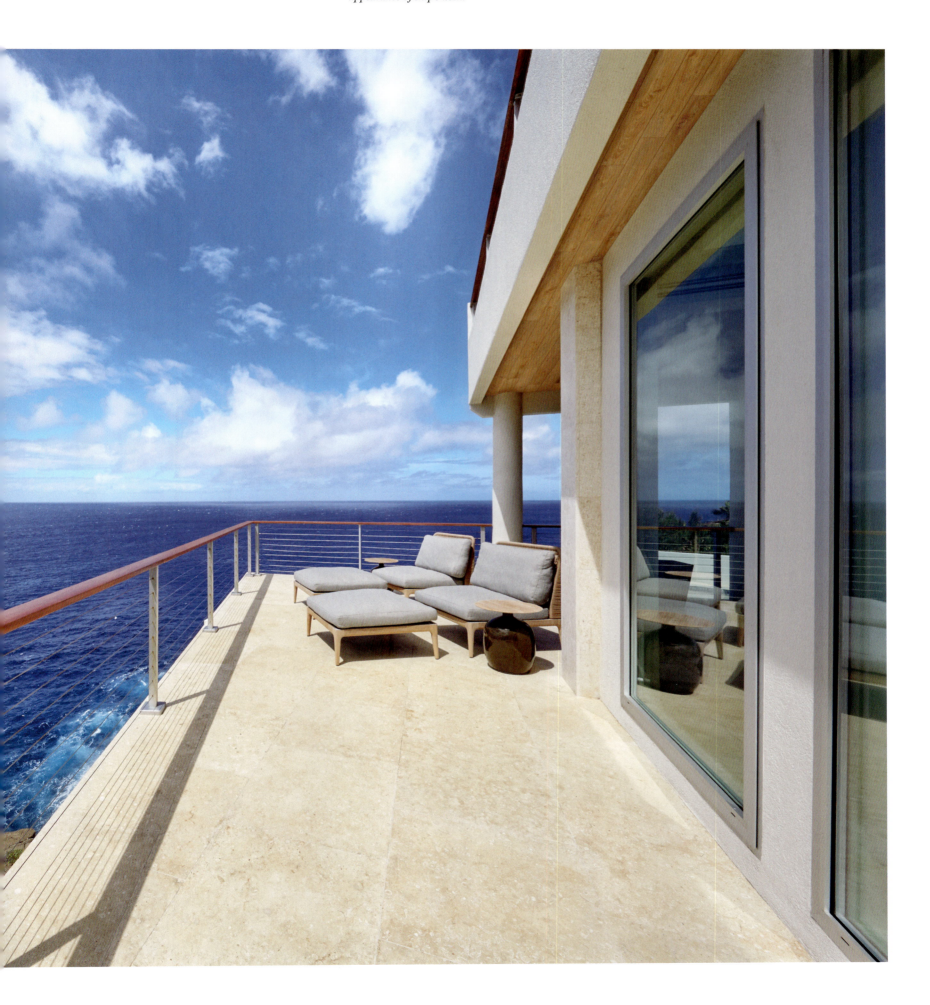

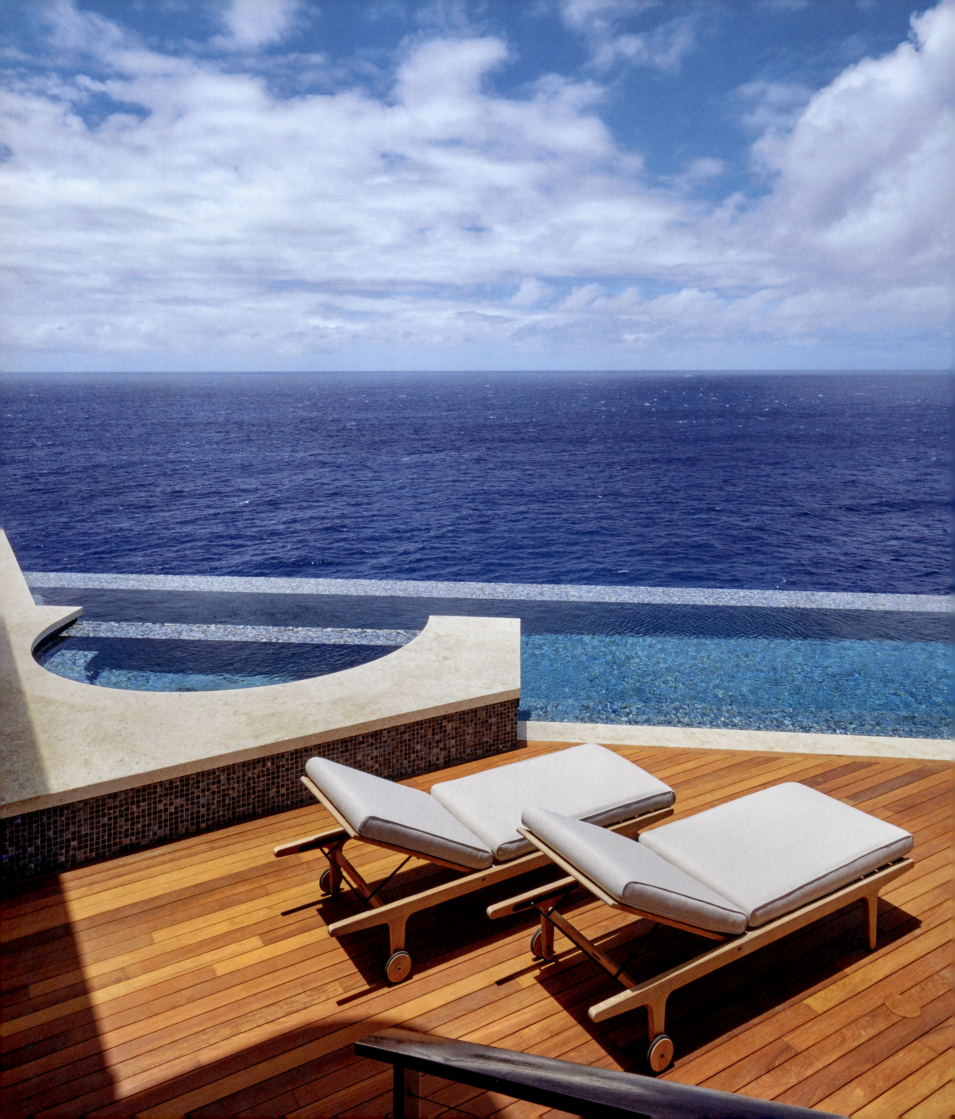

KOKO KAI CLIFFSIDE RESIDENCE

Opposite: *New pool deck with infinity-edge pool overlooks Kaiwi Channel.*

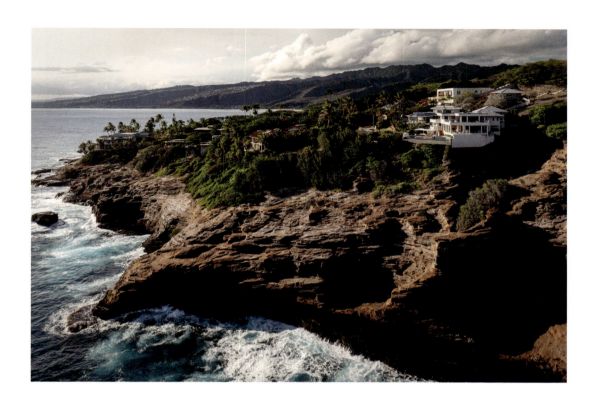

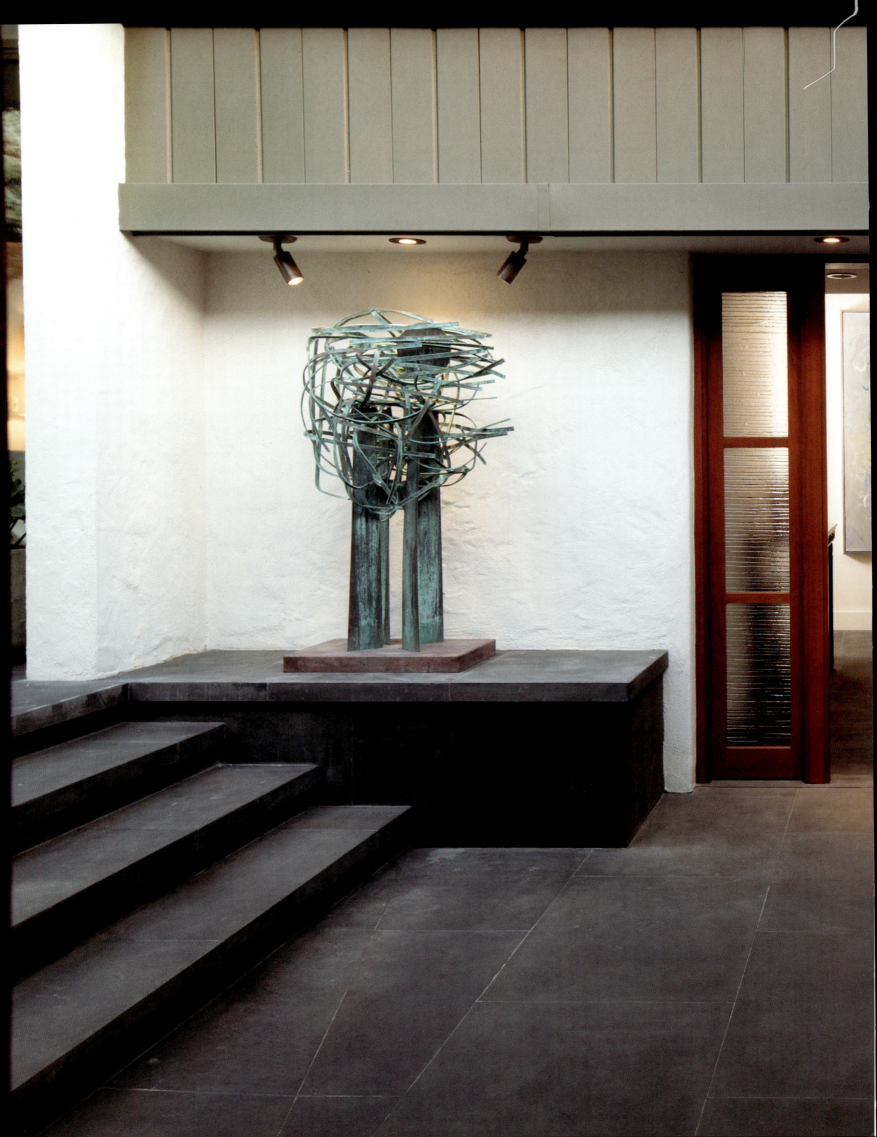

Honolulu Hillside Residence

Honolulu, Oʻahu, Hawaiʻi
2012

The clients of the Honolulu Hillside Residence had a personal connection to the property. "The wife grew up in this house," Peter says. "Her father was a contractor and built the house. And it was built very well in terms of being solid."

The dense construction of the two-story building on the slopes of Diamond Head was an asset to PVA's renovation—a proven framework on which to work. Yet at the same time it was somewhat of a detriment. Built of concrete block in 1972, the home was divided into many small rooms, reflecting how families—including the family of the father/builder—lived at the time. Yet when the clients came to PVA to renovate the house, they were not tied to nostalgia. "Their guiding request was to de-compartmentalize the house," Peter says. "They wanted more modern living."

To open up the house, PVA selectively took down walls and enlarged windows. This required putting in new beams and doing a fair amount of structural work. Because the clients were aging, they wanted to live primarily on the street level. "So, while we renovated the lower level," Peter says, "the emphasis was on creating their main floor where they could really exist day to day."

HONOLULU HILLSIDE RESIDENCE

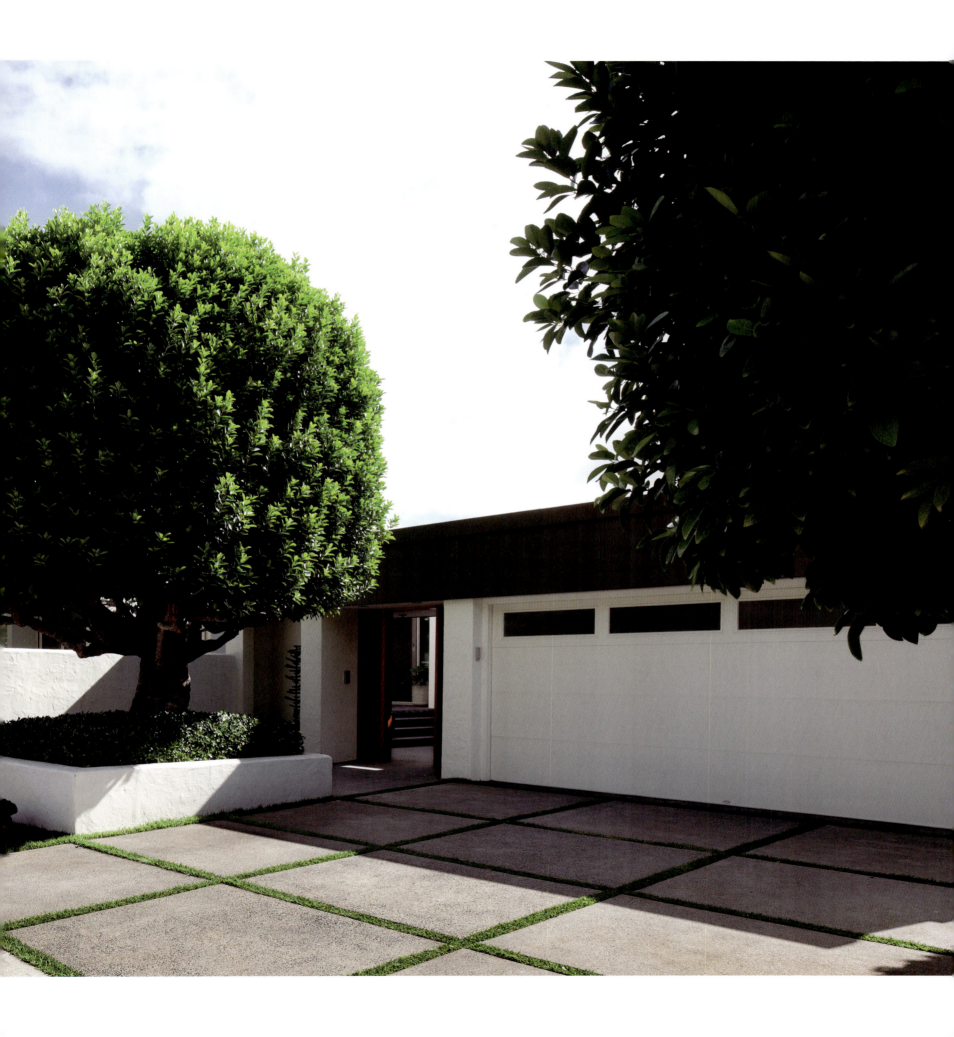

RENOVATIONS

Reworked kitchen opens to view and uses ocean color scheme.

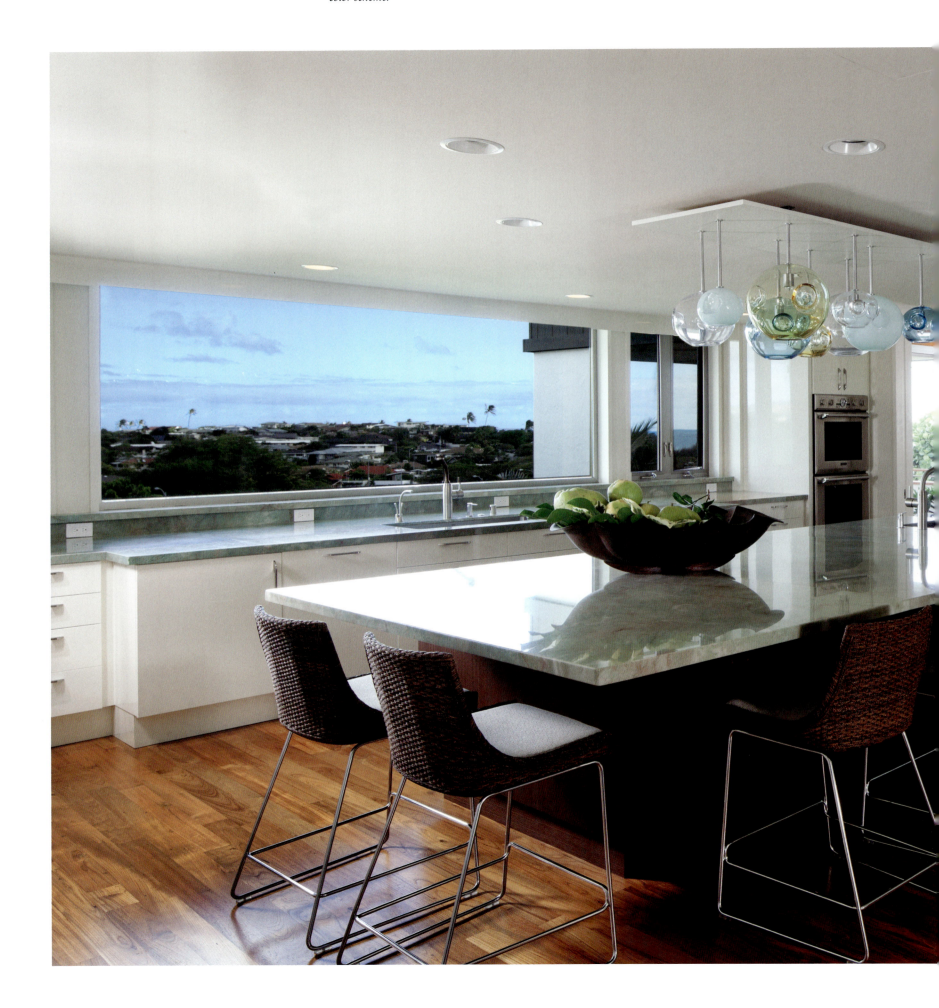

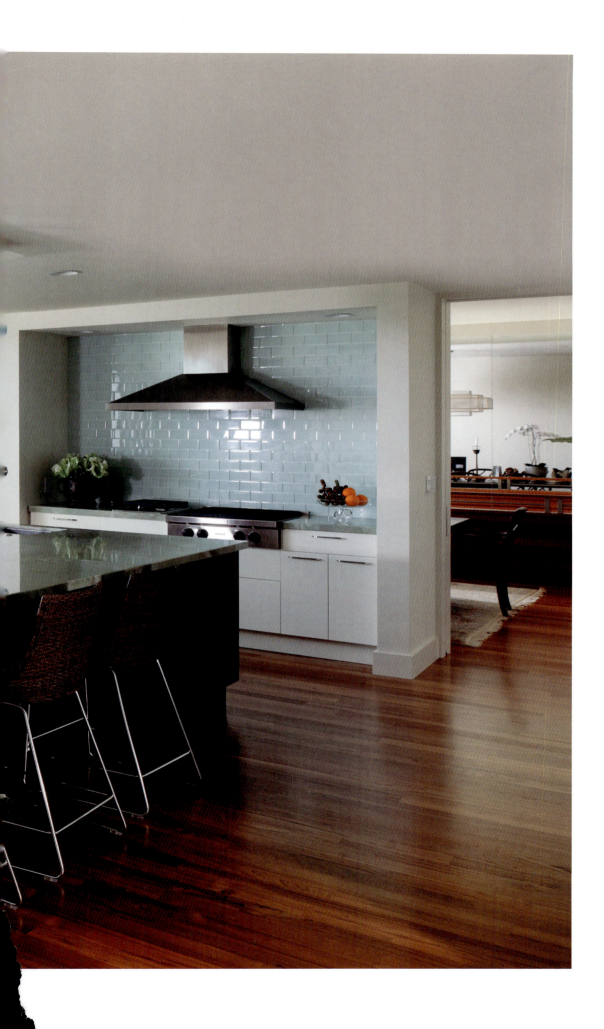

The kitchen was a focus of PVA's renovation of the Honolulu Hillside Residence. Peter says the female client loves to cook and entertain; she even brought her home cooking to weekly Owner/Architect/Contractor (OAC) meetings. "Nobody missed that meeting," Peter recalls with a smile. So PVA converted the small kitchen and dining room of the original house into one space centered on an expansive island. "Then we just opened the wall up to the view," Peter says. "They have an ocean view in the distance, and that became the hub of the house." The kitchen's color scheme—including white cabinets, marble countertops, a pale blue backsplash, and a multicolored blown-glass chandelier by jGoodDesign—is meant to bring the distant ocean into the house

To further open the house, PVA managed the clients' collection of objects. "They traveled extensively," Peter says, "and they had a lot of art and antiques—pieces from all over." Displaying all this work at once could make the home appear cluttered. So PVA focused its design on a few of the pieces, creating a good amount of white space around each in order to showcase it. For example, the architects designed a pedestal to support a bronze sculpture by Satoru Abe at the outdoor entry and a wall recess to perfectly frame a painting in a powder room. To highlight an antique Chinese tomb figure from the clients' collection, PVA used a unique material—the house's former front door. The door was in disrepair, its dark wood veneer peeling, but its custom-designed interlocking pattern was worth reusing. PVA restored the door, painted it white, and used it as a backdrop in a niche containing the antique. A skylight and spotlighting show off both the art and its familiar backdrop.

PVA reinterpreted other items inherited from the original home. It designed a raised planter/seat around an existing ʻopiuma tree in the courtyard, making an open-air sitting area. It covered a plywood soffit with aluminum panels that complement the house's blocky exterior while adding protection. It set solar panels on the flat roof because, as Peter says, "There are probably few places on earth that get more sun than Diamond Head." By both incorporating the rich patrimony of the Honolulu Hillside Residence and changing it to meet the client's current needs, PVA injected new life into the family home.

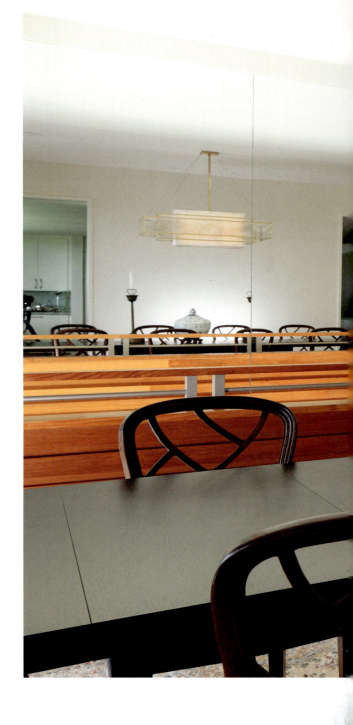

HONOLULU HILLSIDE RESIDENCE

Reclaimed teak wood adds warmth to dining room.

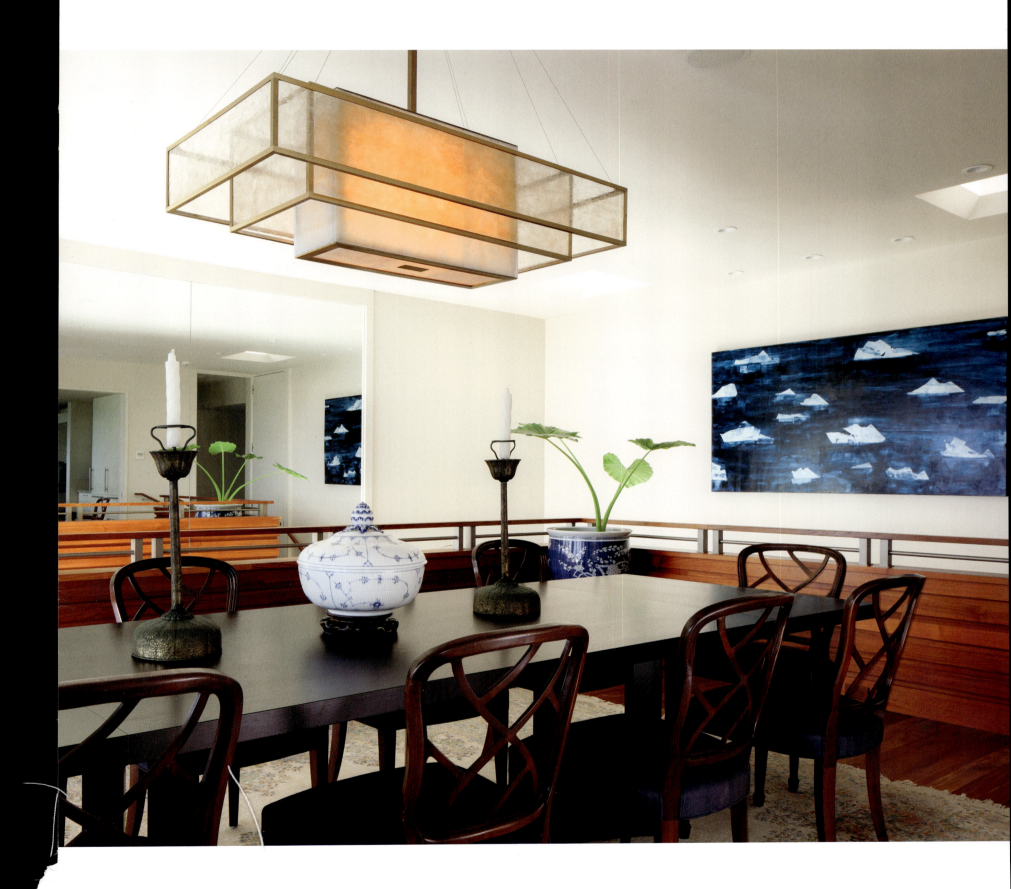

RENOVATIONS

Lower level is opened by removing dumbwaiter that bifurcated space.

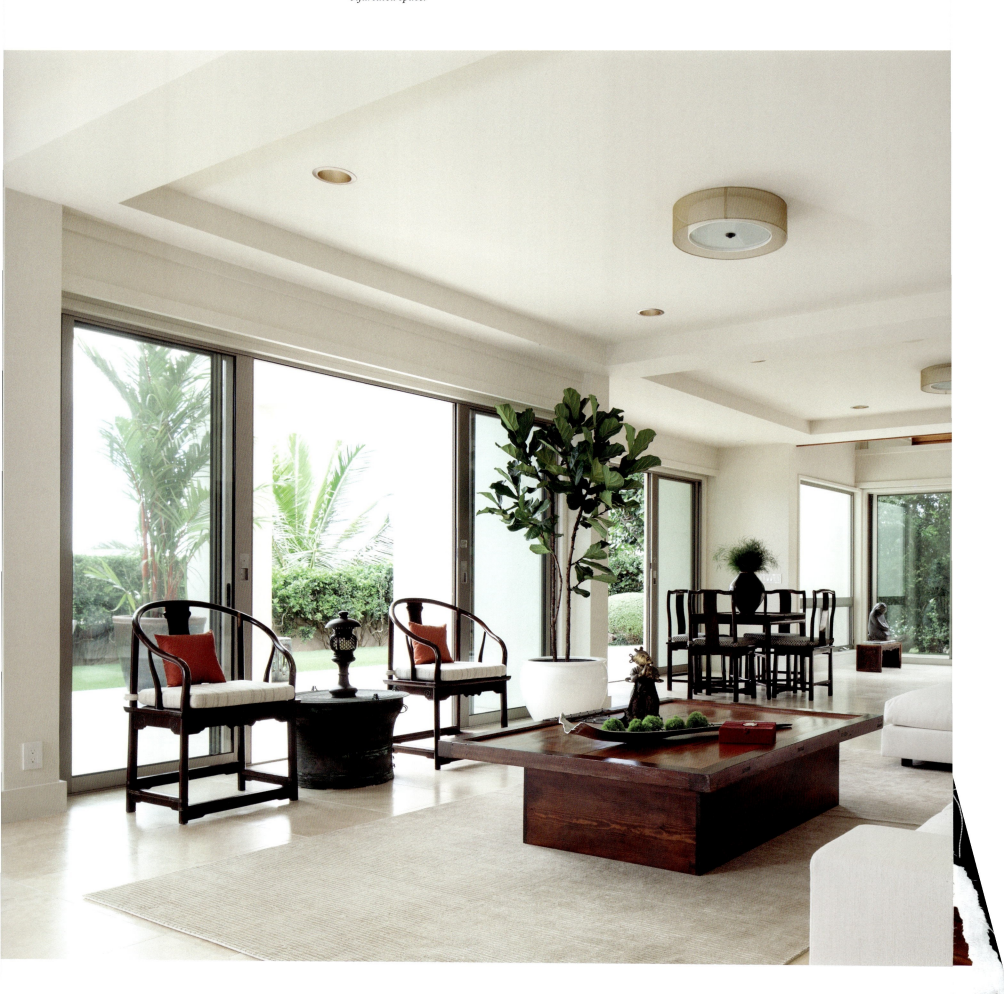

House's original front door is repurposed into backdrop for sculpture.

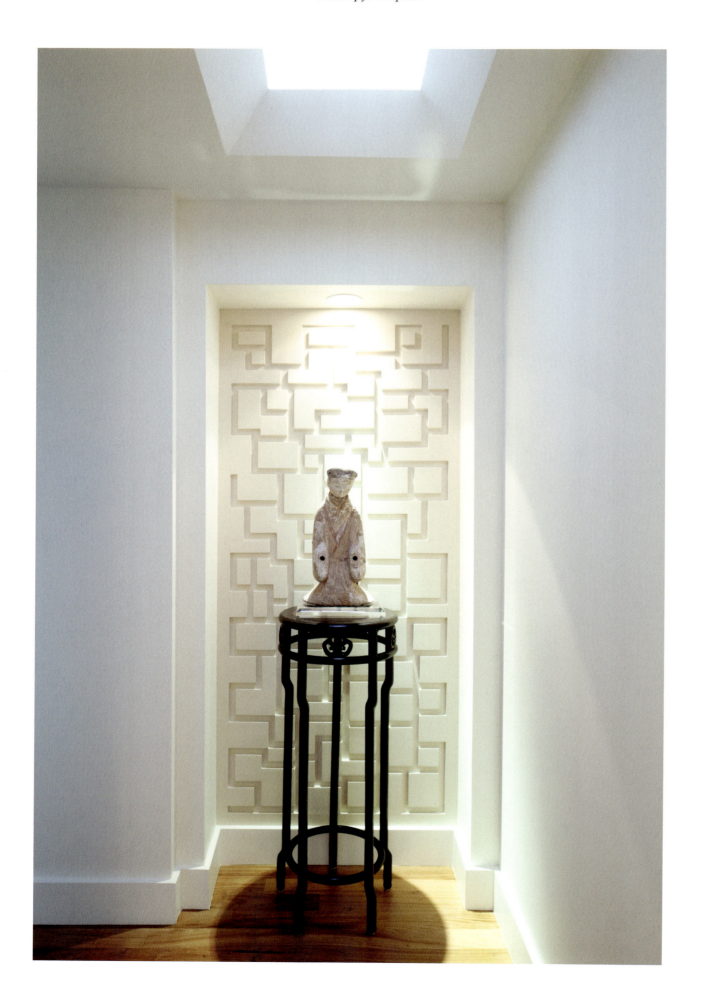

Powder room designed to feature owner's fanciful vessel sink.

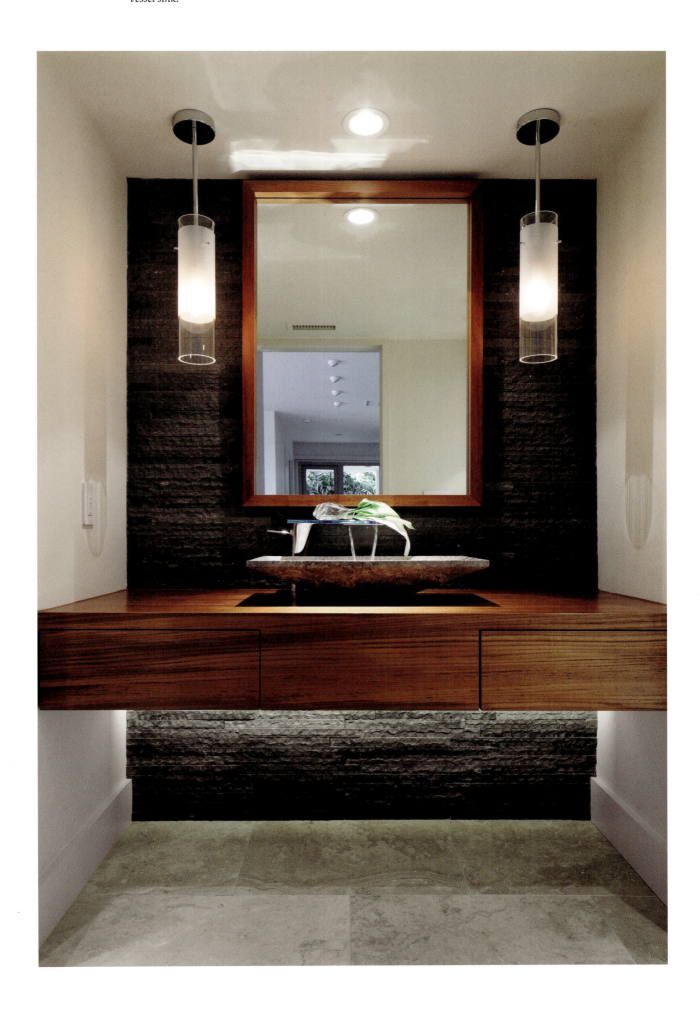

Mirrored wall provides concealed hamper drawer to laundry room behind.

HONOLULU HILLSIDE RESIDENCE

Family room built-ins display owners' collection of celadon pottery.

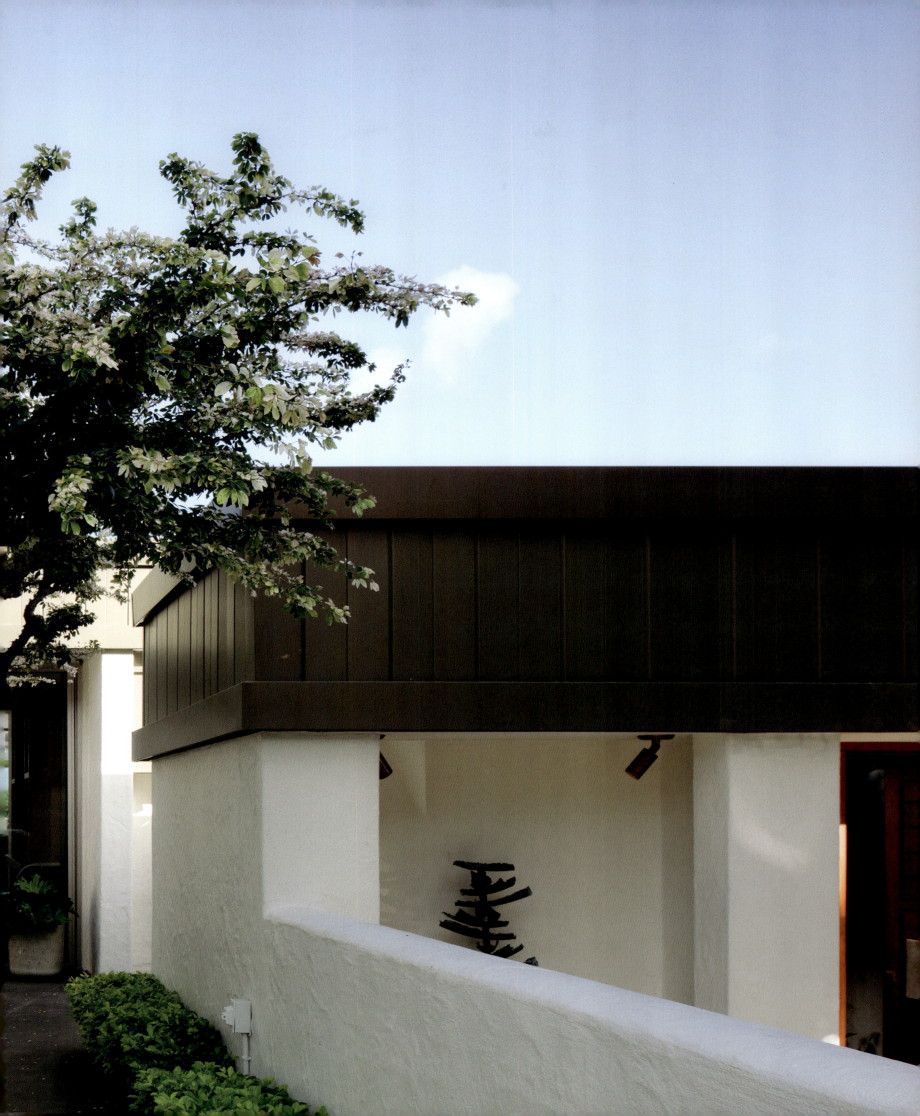

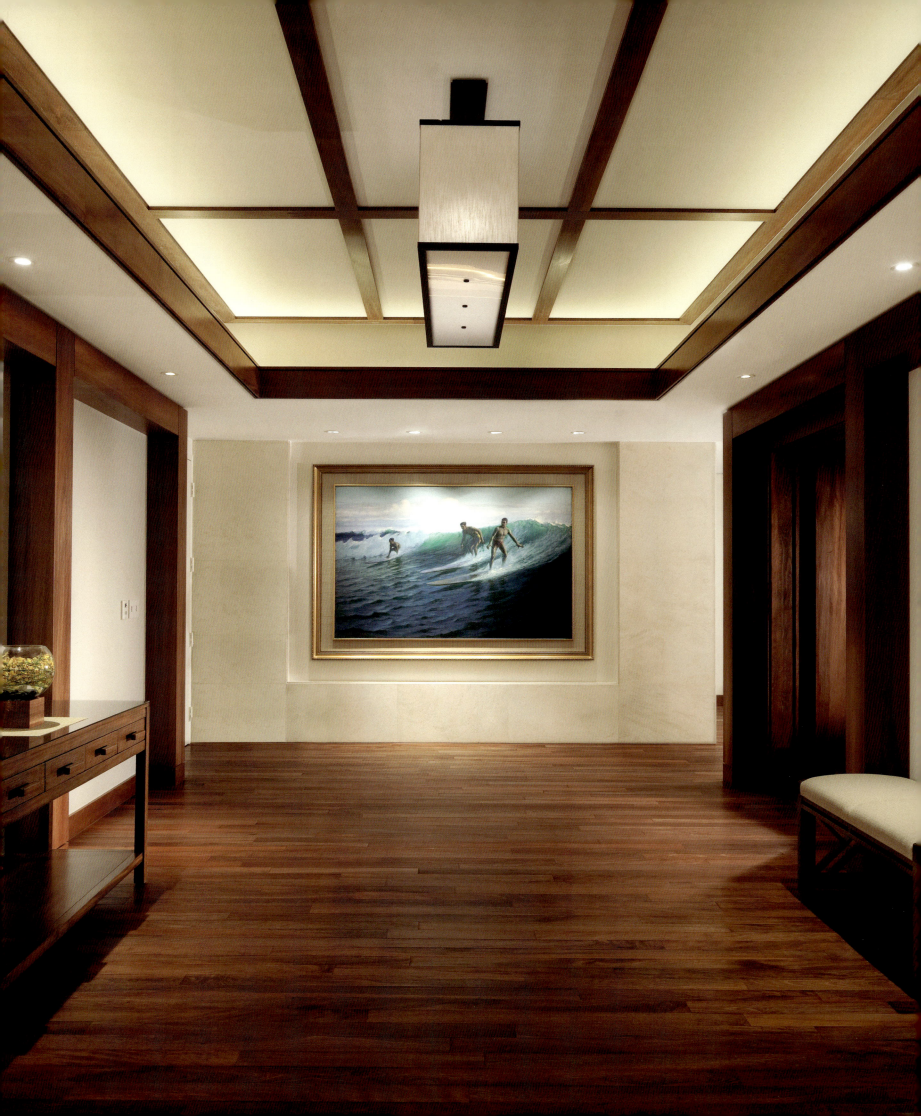

PUBLIC SPACES

"I've always been very comfortable with residential and nonresidential design," says Peter, "and really could never see myself specializing in one or the other." In a field of specialists, this comfort is difficult to find. Architects tend to work in narrowly defined areas where they can repeat conventions and clients.

Yet PVA not only designs both residential and nonresidential work, but also tackles many sectors within the latter. The four projects featured in this chapter show PVA designs for the healthcare (see page 206), leisure (see page 212), hospitality (see pages 205 and 218), and banking industries (see page 224), and PVA's services go well beyond these categories.

A variety of work has long been a part of Peter's portfolio. He began his architectural education at Phoenix Institute of Technology, taking classes in the evening while simultaneously finishing high school. "We learned how to do working drawings of commercial projects," Peter says. "It gave me a very good technical education." After completing PIT's twelve-month program, he worked in Arizona for the Maricopa County Planning Office, then as a landscape designer for a developer of apartment complexes.

Peter moved east to attend the Boston Architectural Center and simultaneously worked on the headquarters for Digital Equipment (discussed on page 126). "I'd draw it, and then they would go build it within a short timeframe, and then I'd go see it," Peter recalls. "So early in my career, I had a fairly good command of technical know-how in commercial work." Other early work included facilities design for a plant in Mexico, a racquetball club for the Athenaeum House in Cambridge, Massachusetts, office buildings along Boston's Route 128, and work for L.L.Bean. His boss recommended him to a friend for a condo renovation, which Peter worked on in the evenings. "Even back then, it was kind of this mix of commercial work during the day, and then moonlighting and doing a residential project," says Peter. "And both were a lot of fun."

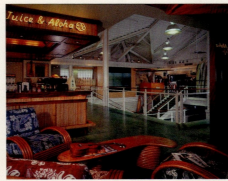

LOCAL MOTION FLAGSHIP STORE
Waikīkī, Oʻahu, Hawaiʻi, 1998

"At the time, there was more of this—I don't know what to call it—grandiose design that had gotten away from island style," says Peter. "This client really wanted to bring that back." Island style made good sense for PVA's Local Motion surf shop. Located on the site of a former gas station near the new Hawaiʻi Convention Center, a gateway into Waikīkī, the project called for a compelling design. Its clay-tiled pitched hip roof, earth-toned colors, and playful wave-roofed tower (a nod to the neighborhood's surfing legacy) identified it as Hawaiian from the street, while its interior, including ocean-colored concrete floors and a second-story lānai, repeated the theme. The commission faced several challenges: its site's history as a gas station, a large sewer easement running through it, and a low budget. PVA did some creative planning to manage these issues. It pulled the sidewalk into the site, floated the lānai above the sewer easement, and set the wave-roofed tower on axis with a major road heading into Waikīkī. "It was like the waves coming into Waikīkī," Peter says, "and it points in that direction." The Local Motion Flagship Store was both a critical and popular success, garnering a Members' Choice Award from the Hawaiʻi AIA and commendations from Hawaiʻi Senator Fred Hemmings and George S. Kanahele, author of *Restoring Hawaiianness to Waikīkī*, as well as a regular spot on MTV's *Real World* season 8. More importantly, it was PVA's first major nonresidential project. "It was a springboard project," says Peter, "and it will go down as one of my favorites. It was kind of heroic."

Eventually Peter relocated to Hawai'i to take a job designing resort and hospitality work. "Then the Japanese bubble burst, and they laid me off," Peter says. "That's when I got this little retail shop to do." That shop set PVA in motion.

The works featured in this section share the same priorities as PVA's residential work: attention to proportion, inclusion of indoor-outdoor spaces, working with traditional Hawaiian forms in a contemporary manner, and emphasis on clean lines and quality construction. PVA brings the same attitude of casual elegance to both types. "In hospitality work, in medical work—clients are looking for a sense of home and warmth and comfort," Peter says. "And having the custom residential experience, it's easy for us to bring that into settings that may have been more sterile before."

PVA also brings a desire to make all its architecture not just casual but memorable. "I think even with our custom residential work, even though it's casually elegant, it still needs to pop and have some drama to it," Peter says. "And we bring that to our commercial projects, too. They need to be inviting, places where people are comfortable. But they're also not too fancy or glitzy."

PVA's residential work took off before its nonresidential practice. But after a dedicated effort to expand the latter, the firm now splits the two parts of its practice roughly half and half. "I guess we're certainly well recognized as one of the leaders in residential design in Hawai'i," says Peter. "But we've fulfilled our goal of being more recognized for our design of commercial projects." While commercial work typically has, Peter notes, "generally smaller budget and tighter timeframe," he finds enjoyment in it. "I feel really fortunate," Peter says, "that when we're able to do the more customized work that we do and it comes out right, then everybody's really happy. There's that sense of fulfillment."

ROKKAKU AUTHENTIC JAPANESE CUISINE
Honolulu, Oʻahu, Hawaiʻi, 2006

In designing a high-end restaurant for Honolulu, PVA turned to a Japanese residential form for inspiration. "The client was looking for a design that was both homey and refined," says Peter, "and a modern version of the traditional *machiya* was a good model for this." The machiya, a townhouse popular in historic Kyoto, had the cultural connection and the clean lines that made a good match for Rokkaku Authentic Japanese Cuisine. And PVA's interpretation of the form made it both familiar and unique. The typically long and narrow plan of the machiya matched that of the restaurant's space, which had previously been used as a furniture store. The center of a traditional machiya would often have been home to a garden, but here it is occupied by a prep kitchen to celebrate the restaurant's specialty, *kamameshi* (kettle rice). Bar seating adjoins this kitchen, giving diners an intimate view of the creation of the dish. Table seating surrounds this hub and includes a private dining area. A limited palette of colors—light seating, dark tables, neutral walls, and a red fascia that highlights the prep kitchen—gives the space a warm and natural look. Rokkaku Authentic Japanese Cuisine incorporates several Japanese materials to suggest its design inspiration. These include maple posts, tatami mat floors, *washi* paper pendant lamps, and both Japanese cedar and silk wall coverings. Throughout the project, PVA made design choices to reference the machiya and to appeal to the restaurant's sophisticated clientele. "We look for inspiration from many areas in our design for commercial work," says Peter. "For this restaurant, using a traditional type in a contemporary way worked wonderfully."

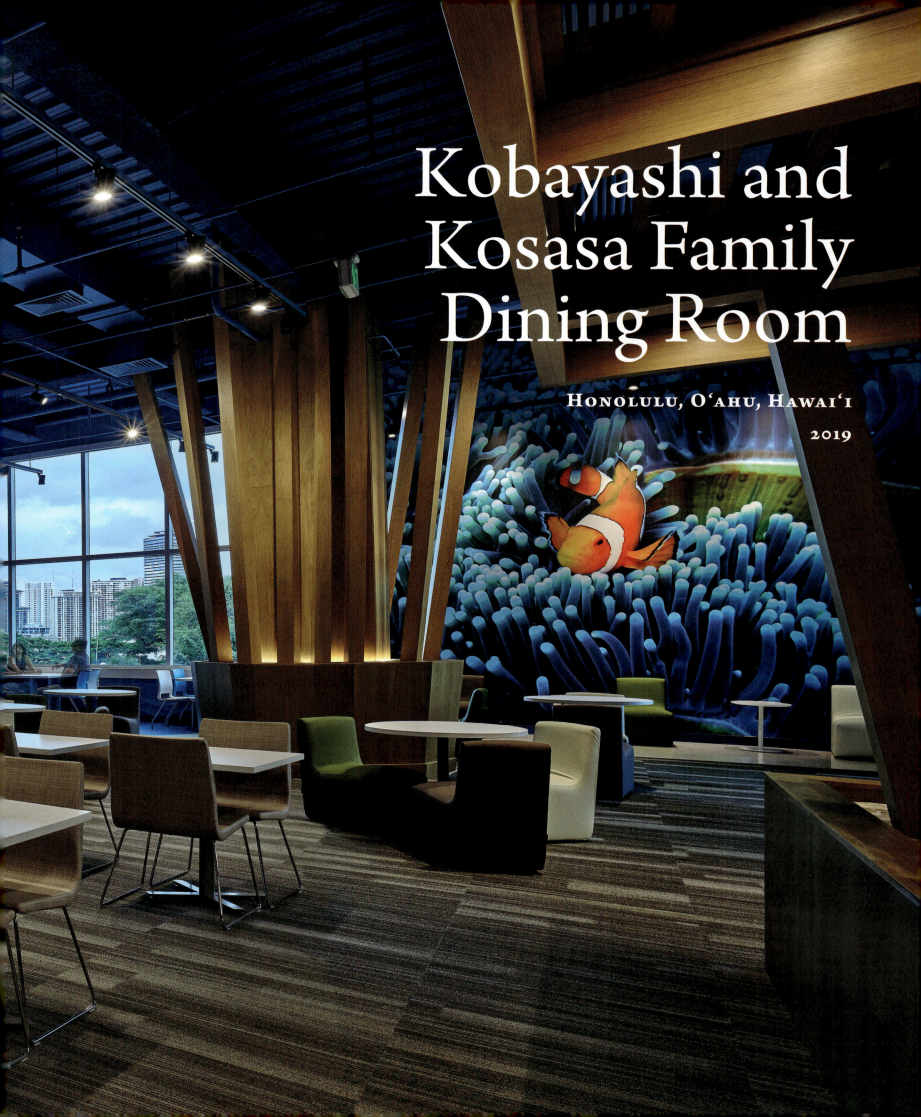

Kobayashi and Kosasa Family Dining Room

Honolulu, Oʻahu, Hawaiʻi
2019

BOTTOM: *Ahupuaʻa—traditional Hawaiian land division—inspired organization of dining room.*

For a complex program for Honolulu's Kapiʻolani Medical Center for Women & Children, PVA focused on one thing. "When we went for the interview and CEO Martha Smith said it should be a place of respite," Peter recalls, "that's the one thing I wrote down."

PVA would center the project—a 9,000-square-foot kitchen, 14,000-square-foot dining room with 227-seat capacity, 1,800-square-foot lānai, three conference rooms, and an interactive children's zone in a new building tower—on that single idea of respite. It would be a place where staff and patients, some of whom would travel from long distances across the Pacific Rim to access the hospital's services, could rejuvenate.

"That became the whole design concept," Peter says. "We're in Hawaiʻi, and people here generally like to rejuvenate outside. So, I thought, let's make it feel like an outdoor space. And then I thought, well, as an outdoor space, let's represent an ahupuaʻa." Ahupuaʻa is a traditional Hawaiian land division. Each headman oversaw a wedge-shaped section of an island running from the mountain to the sea, providing each group with access to the benefits of all land and water types.

PVA represented three elements of the ahupuaʻa—uka (mountain), kula (plain), and kai (sea)—in its design for the Kobayashi and Kosasa Family Dining Room. The position of the project determined the arrangement of these parts. "We imagined that the kitchen and servery, which are on the mountainside, are the mountain region, and the dining area in the middle is the plains," Peter says. "And then we'll have our ocean zone facing the ocean."

The mountain is manifested at the entrance to the dining room with battered gray basalt walls, a waterfall, and a bamboo forest. While the bamboo is real plant matter, painted in shades of tan and green, other forms of nature are represented abstractly so as to ensure the health of the patients. These include cloud forms, so typical to Hawaiian mountains and used here to conceal mechanical equipment.

The plains are rendered with earth-toned floors and furnishings. PVA camouflaged large columns that march down the space with uplit, abstracted tree branches. "In making them bigger," Peter says, "we actually made them go away more." A children's area contains an interactive floor; when kids step on it, colorful fish appear, as if from a Hawaiian reef. The colors here and throughout the dining room are brighter than those in most PVA designs. "Because the children are our key

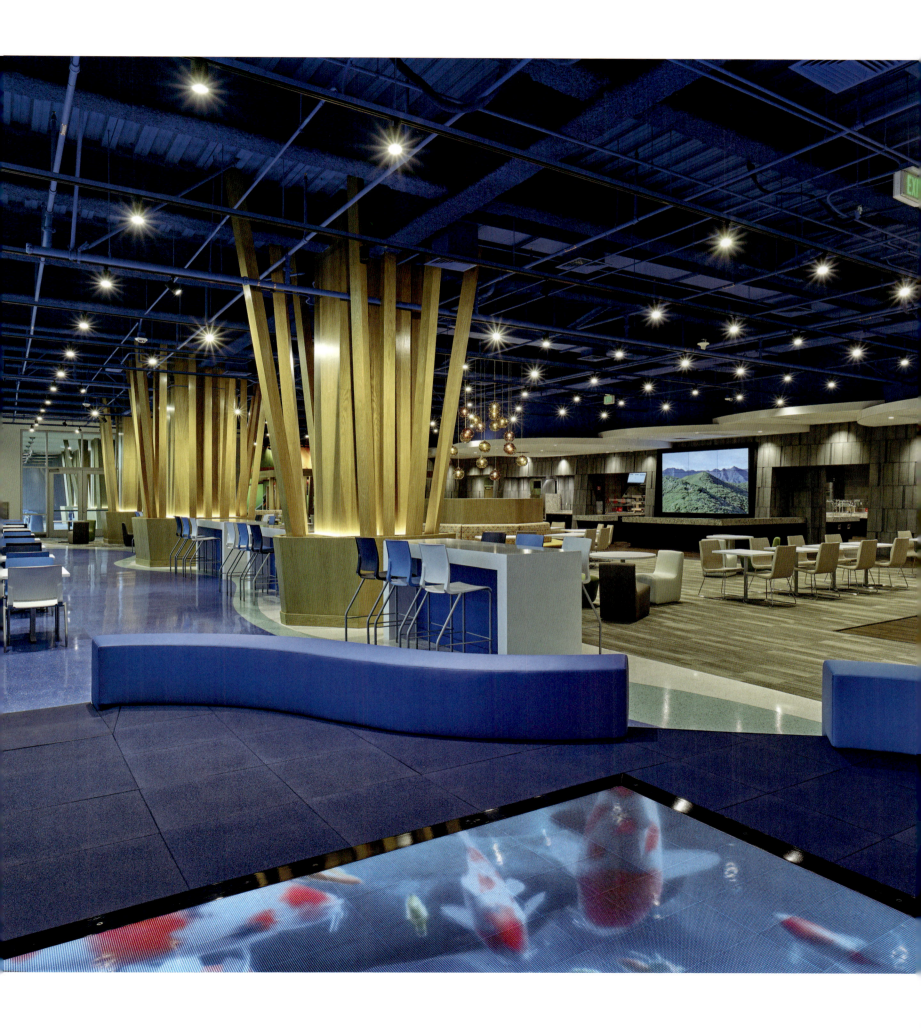

PUBLIC SPACES

View across kula (plain) zone, with cloud-capped uka (mountain) wall on right.

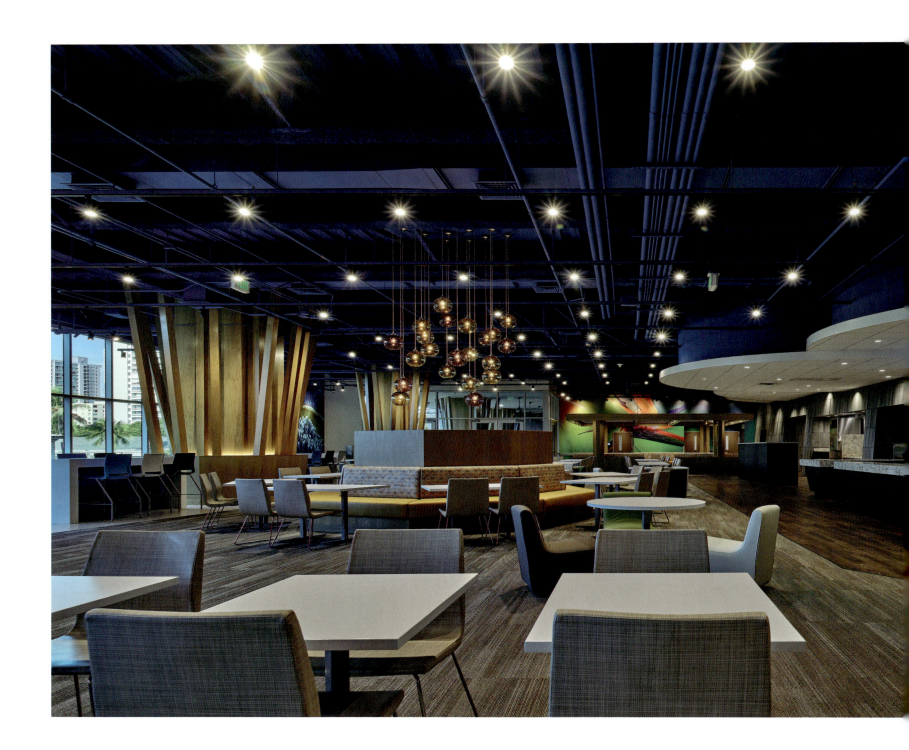

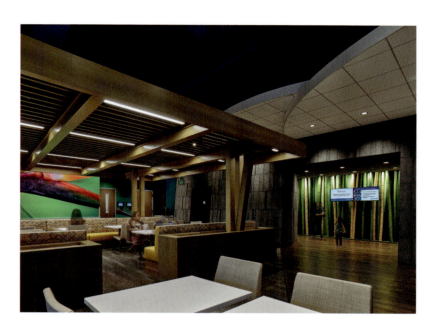

Wood trellis enhances indoor-outdoor effect and provides intimate seating area.

component," Peter says, "we wanted it to be playful." The colors also pleased at least one adult, who posted on Yelp, "Very colorful and eye-catching to make you feel at ease even with whatever visit you just had."

PVA connects the project to the ocean with a large lānai filled with blue chairs. "People are in the hospital for long periods of time," Peter says. "I think they really love the opportunity to go outside, warm up, and get some fresh air." PVA needed to redesign the given space to optimize the indoor connections to a garden view. The tower designers had used opaque glass on the upper section of windows and had sprayed fireproofing on the ceiling structure, expecting the dining room to have a dropped ceiling. PVA convinced the client to replace the opaque windows with clear glass and keep the high ceiling, painting it over with a deep sky blue to create a sense of the outdoors. "It just transformed the space," Peter says.

PVA met other obstacles in working within the new tower. The hospital's emergency department, located one floor below, was scheduled to be completed just months after PVA was awarded the project. "We had to design a kitchen and identify all the penetrations through the floor slab within weeks," Peter says. "It was a fire drill." Peter credits the restaurant experience of PVA partner Michael Subiaga with getting the job done. "He's really skilled at coordinating all of that mechanical and electrical work," Peter says. "That really helped us."

The clients were pleased with PVA's coordination of so many complex elements. "When they're so happy with it and it feels like it fulfilled their mission and provided a place of respite," Peter says, "then you get that same level of satisfaction that you do when a house comes out well and people love it."

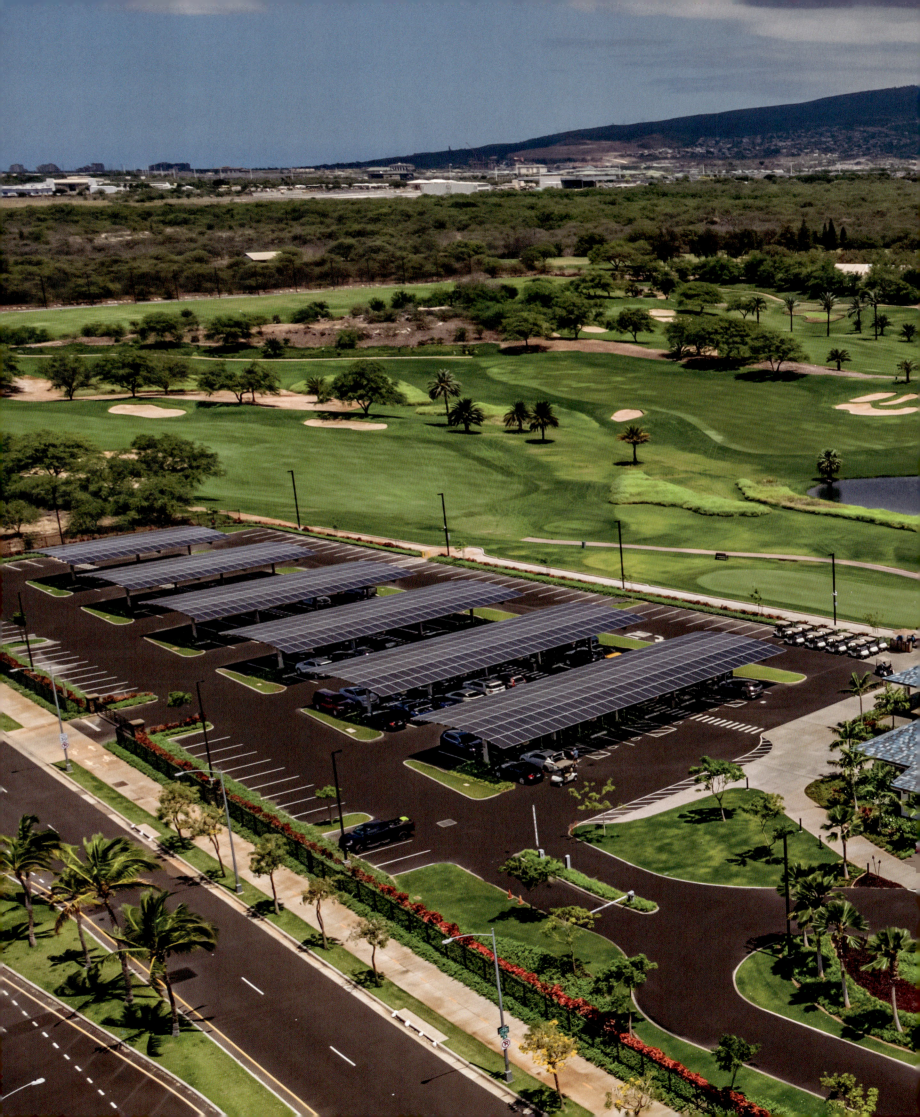

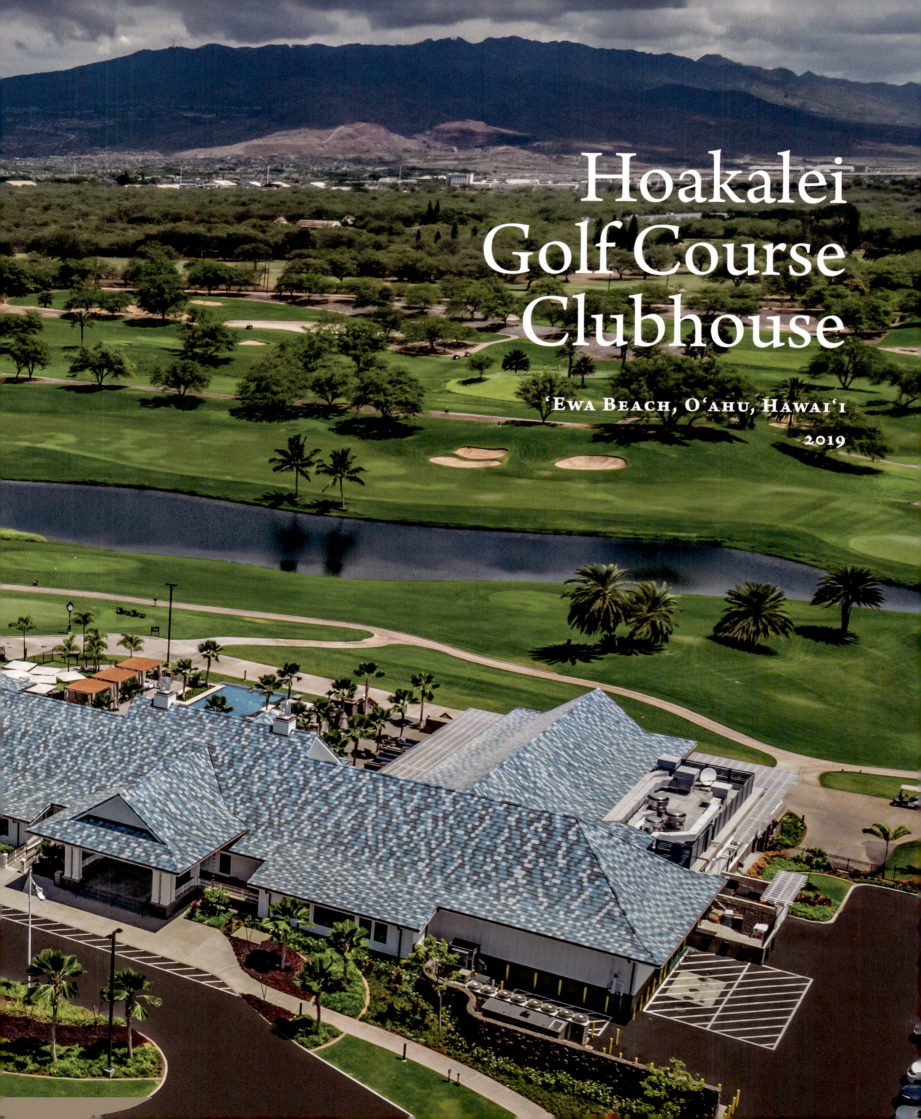

Hoakalei Golf Course Clubhouse

'Ewa Beach, O'ahu, Hawai'i

2019

Building new architecture calls for a good amount of creativity. And, as seen at PVA's Hoakalei Golf Course Clubhouse, it can also call for responsibility.

This comprehensive project—which includes a three-hundred-seat restaurant, two bars, locker rooms, lounging areas, a pro shop, a pool, and a spa—responds to the particularities of the site, the precedent of an existing aesthetic, and the need for building sustainable architecture.

The site is on the southern edge of the Hoakalei Golf Course at Oʻahu's ʻEwa Beach. The 248-acre golf course, designed by "The Big Easy" Ernie Els, was completed in 2009. But its members had been using a trailer for their clubhouse for years. "The new building really filled in this need on this beautiful golf course," Peter says. The clubhouse is positioned to open to views of the fairways and the mountains beyond. Its placement also responds to strong winds coming from the northeast. "The shape of the building became an L," Peter says, "with the restaurant extending out to create a little bit of a lee of the wind for the pool and deck area."

The aesthetic of the Hoakalei Golf Course Clubhouse might best be described as plantation style. This style had been set by the golf course's developer, who built adjacent residences along the same lines. PVA was comfortable working within this aesthetic for the clubhouse. "This is former sugar cane area—a former plantation." Peter says. "This style goes with the history of the area. So, we just took that and ran with it." PVA partner Todd Hassler assumed primary day-to-day responsibility for the project.

With its hip roof, white board-and-batten exterior, and classically proportioned interiors, the design is a contemporary update of the plantation look. Yet the building takes the plantation model only so far. "Most of the older plantation homes were built on post-and-pier foundations," Peter says. "The posts would come down and sit on a rock, or they would sit on a little square of concrete that affectionately gets referred to as a tofu block." Here PVA built a basement, an uncommon foundation in Hawaiian architecture. The basement—which houses golf cart storage, member locker rooms, an employee lounge, and utility areas—sits a half level up, allowing the clubhouse to perch a bit higher on the

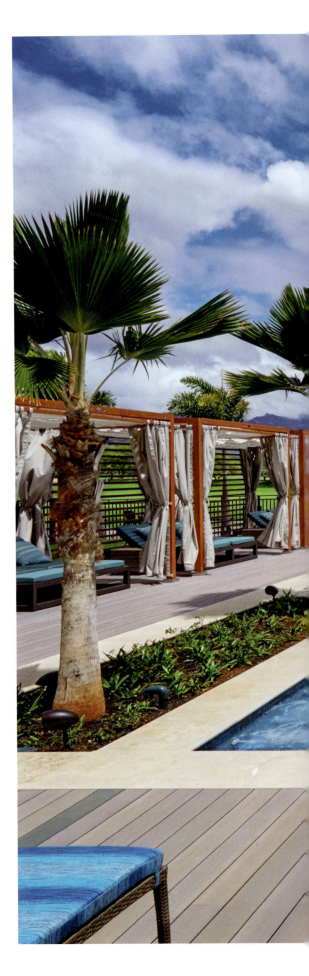

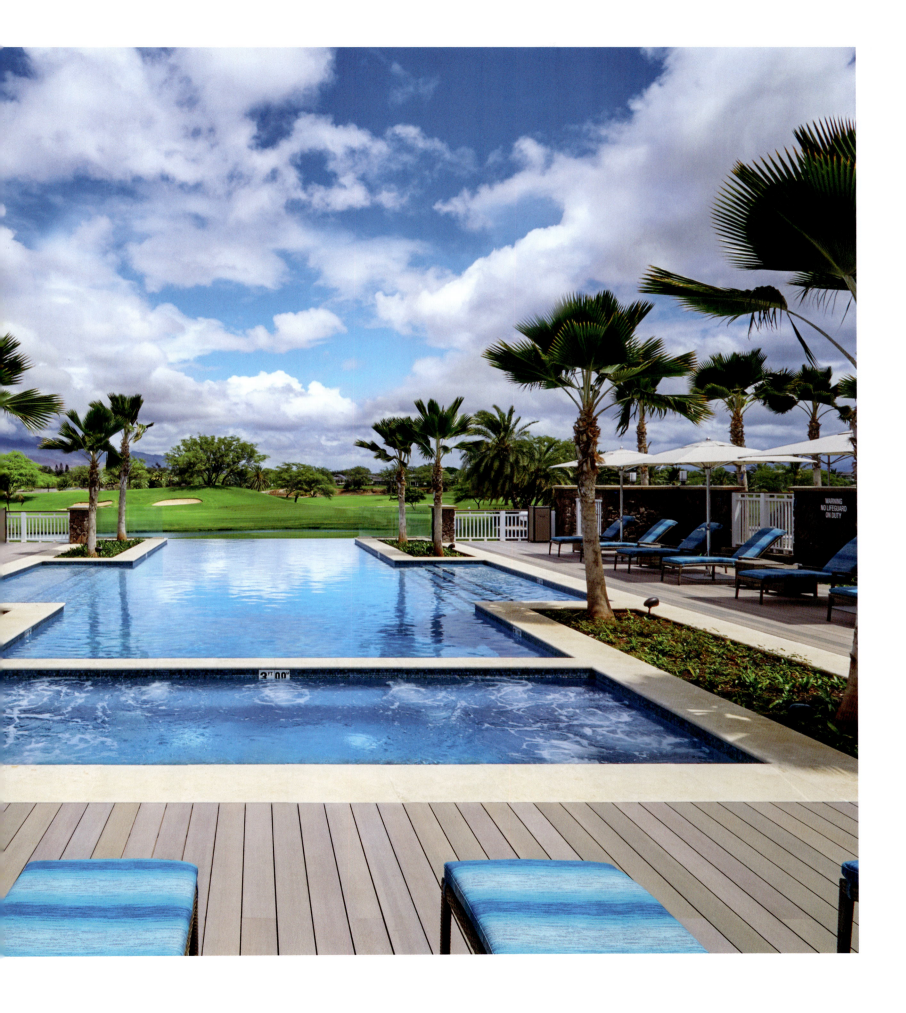

BELOW: *Restaurant features seating for three hundred, private dining room, and temperature-controlled wine room.*

BOTTOM: *Clubhouse is elevated to make it visible from 248-acre golf course.*

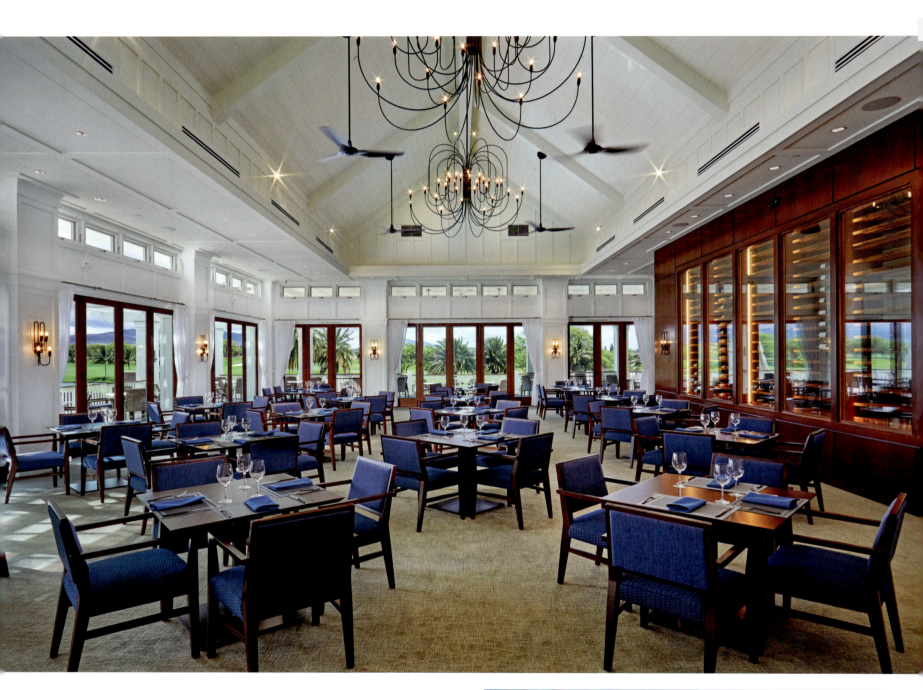

HOAKALEI GOLF COURSE CLUBHOUSE

Section showing project's sustainable features.

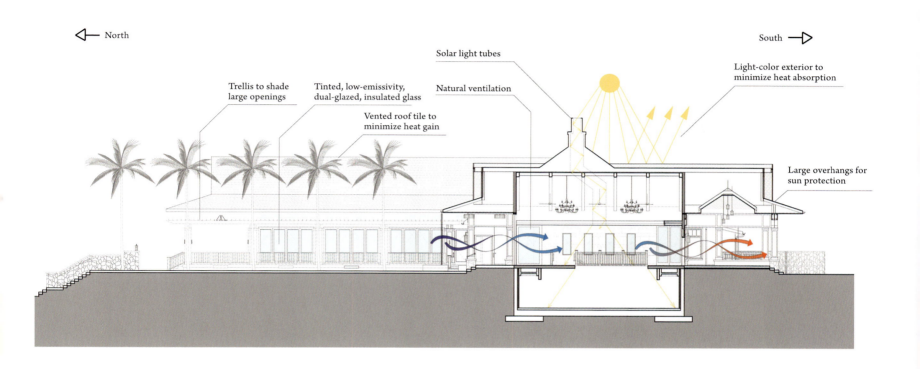

landscape. "It has prominent views," Peter says. "And also, from the golf course you want to see the clubhouse in the distance."

Hoakalei Golf Course Clubhouse responds to the need for building sustainable architecture in several ways. PVA used one green feature—tubular sunlight collectors that bring natural light from the roof into the lobby and lower level—to emphasize the plantation style. "Rather than trying to hide them, we embraced them," Peter says. "We put them up and made them chimney-like, so they have that classic traditional golf course look." The project's other sustainable design features include natural ventilation, trellises and large overhangs for sun protection, and tinted, low-emissivity, dual-glazed, insulated glass. "And then we put in a very large solar photovoltaic array, which is a freestanding, post-mounted array," Peter says. "The photovoltaics have a dual use of providing shade for the car parking and all the electricity not just for the building but also for the electric golf carts." PVA's efforts earned the clubhouse the Hawai'i Award for Excellence in Energy Efficient Design from the AIA Honolulu.

Finally, PVA's clubhouse design responded to less-discussed yet no-less-important issues—those of ownership transition during the design process and the changes this affected. "I don't know if that makes an interesting story for the reader," Peter concedes. "Probably only for architects." What is undoubtedly interesting is PVA's ability to respond to this and other disparate requirements and create a clean design that hides all the complexities.

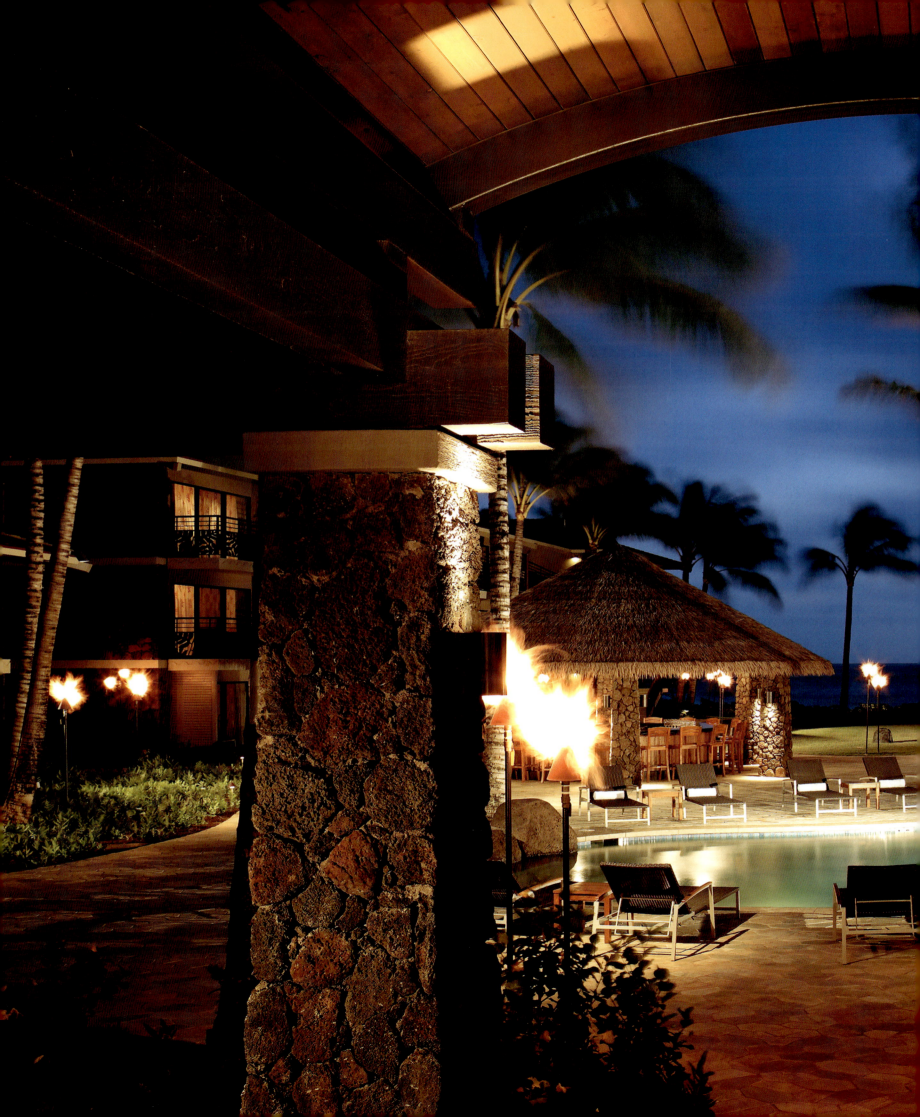

Ko'a Kea Hotel and Resort

Po'ipū Beach, Kaua'i, Hawai'i
2010

"This was a feel-good project that came out really well," Peter says, "just finally bringing it back to life after that massive devastation." The project is the Koʻa Kea Hotel and Resort, five-star accommodations on Kauaʻi's stunning Poʻipū Beach. "That massive devastation" is Hurricane ʻIniki, which stormed through Hawaiʻi in 1992. "Kauaʻi was just ruined," Peter recalls. "It's the lushest of all the Hawaiian Islands, and all the leaves were stripped. The island was just bare."

ʻIniki tore into what was then called the Poʻipū Beach Hotel—a family hotel that had been around for decades. "It was a wonderful place for a Hawaiian holiday," Peter recalls. "The beach out there and the waves are spectacular. And you can just imagine people in the sixties sitting down in their lawn chairs." Some of the hotel's characteristic details—including walls covered in rough lava rocks and steel railings with leaf patterns—survived the storm, but the five buildings that comprised the hotel complex were mostly gutted.

Peter first encountered the hotel as part of a group hired by the Federal Emergency Management Agency to manage rebuilding Kauaʻi. "The mission of the office was twofold," Peter says. "To enforce new strict regulations and to provide a high level of customer service, because people were in such difficult situations." Peter had opened his own firm just months before ʻIniki, and so split his time between this work on Kauaʻi and establishing his office on Oʻahu. "Some six months after I started, I got a call from people that were involved in the Poʻipū Beach Hotel," Peter says. "It was the original architect who had designed the facility and the owners and operators. And they wanted to understand all the code requirements."

Peter gave his assistance, but no work was done on the hotel; a variety of legal issues kept the building stagnant while much of Kauaʻi gradually rebuilt. When new owners acquired the property many years later, they consulted with Peter, who knew its history firsthand, and eventually hired him to redesign the property as the Koʻa Kea Hotel and Resort. "Long story short, we ended up getting the job to do the renovation," Peter says. "And so, it's a significant project for us. We're happy to have brought the hotel back and to have made it even better for the community."

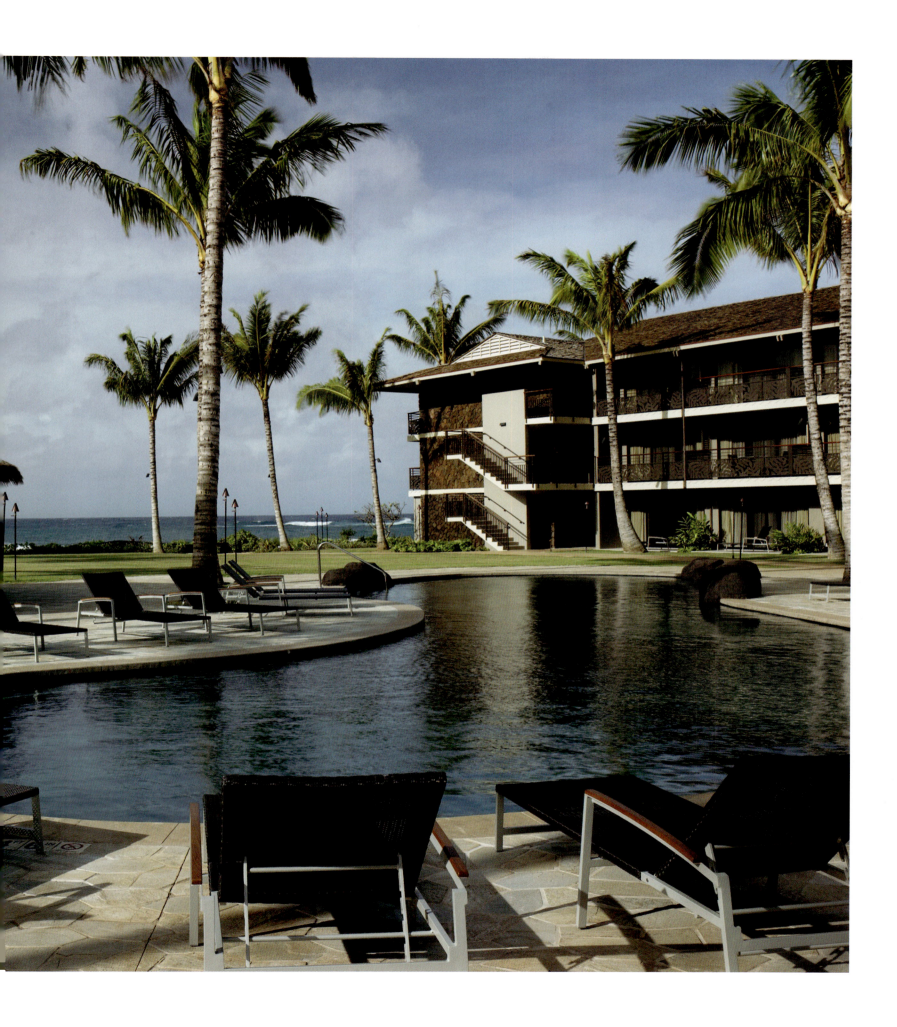

PUBLIC SPACES

Lobby provides dramatic sense of arrival to hotel.

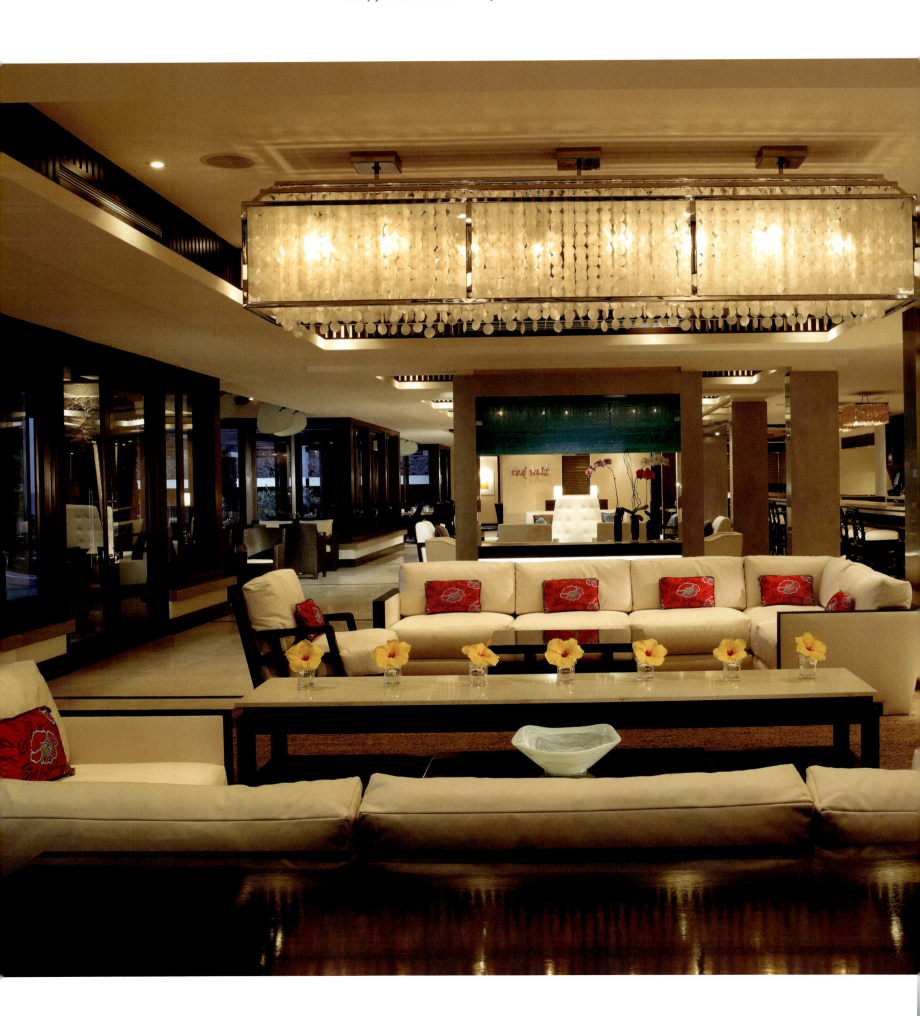

KOʻA KEA HOTEL AND RESORT

Upper-floor guestrooms feature vaulted wood ceilings.

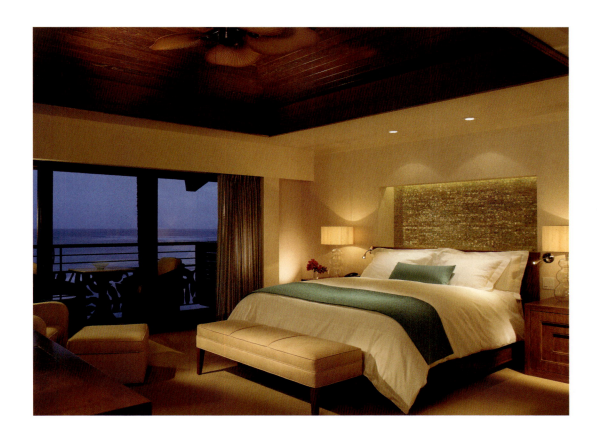

PVA was charged with retaining the charm of the old building while bringing it up to code. The well-loved leaf railings, for example, were topped with new straight bars to make them regulation height. PVA was asked to upgrade the hotel into a luxury boutique hotel. The guest rooms were updated, and a new spa, pool, and beach bar included. The latter replaced what had been a little shack with what Peter calls "a bit of a sophisticated tiki hut," with lava rock columns to match the older design. "Everybody, including the owners, wanted to maintain the history and the kitschy character," Peter says. "But then, again, trying to bring it up to code without destroying the character." Its work on the hotel earned PVA several awards, including an AIA Honolulu Award of Merit and an NAIOP Kukulu Hale Award.

As PVA was beginning work on the Koʻa Kea Hotel and Resort, it had recently completed another hotel project, the renovation of a major Waikīkī hotel with 1,500 guest rooms and 150 suites. The size of that project, its tight budget, and the number of decision makers involved were challenges to the work. "We got that one done, and it came out nicely, but kind of designed by committee," Peter says. "Whereas the Koʻa Kea Hotel and Resort was a much more streamlined process, much more fun."

As meaningful as the creative process of designing the Koʻa Kea Hotel and Resort was, it was the personal connection that makes it so important to PVA. "There was just such a long involvement with the property," Peter says. "It was quite an undertaking—so much had to be redone. And then we finally completed it, and we couldn't be prouder of the result."

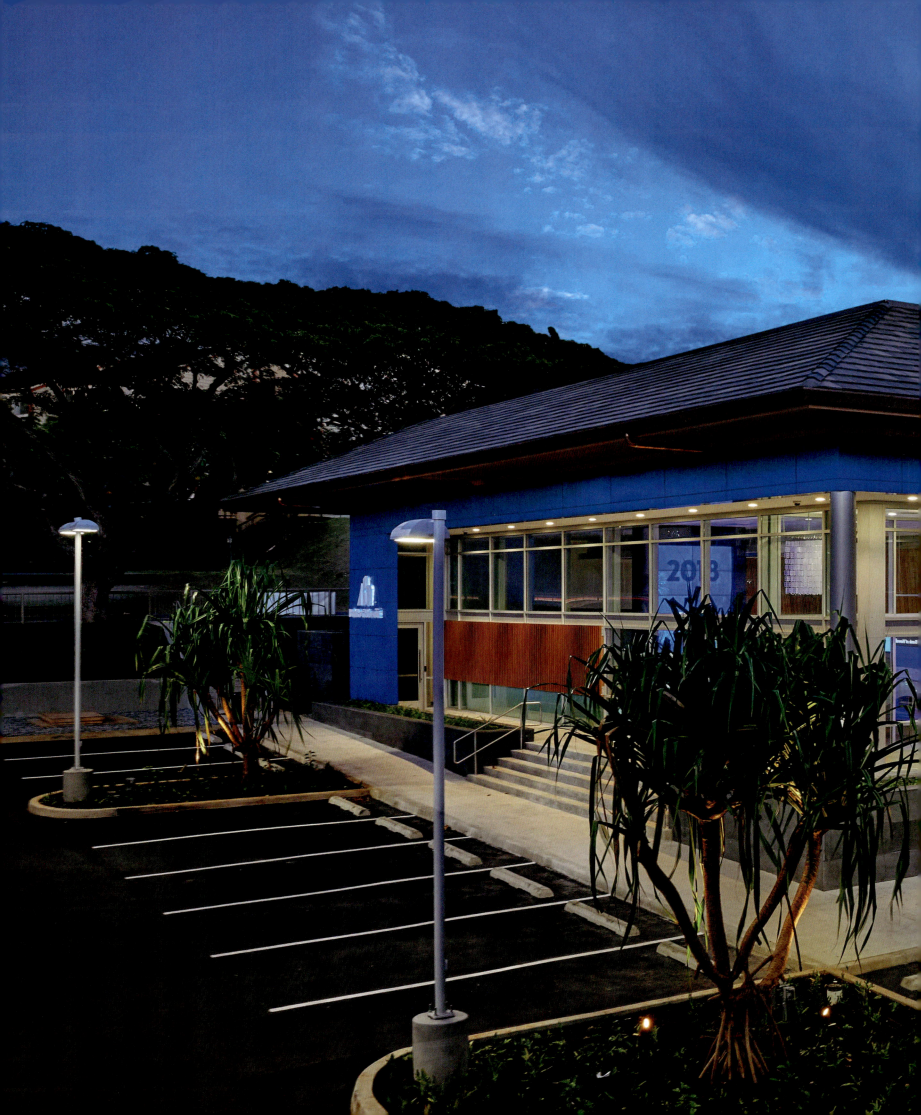

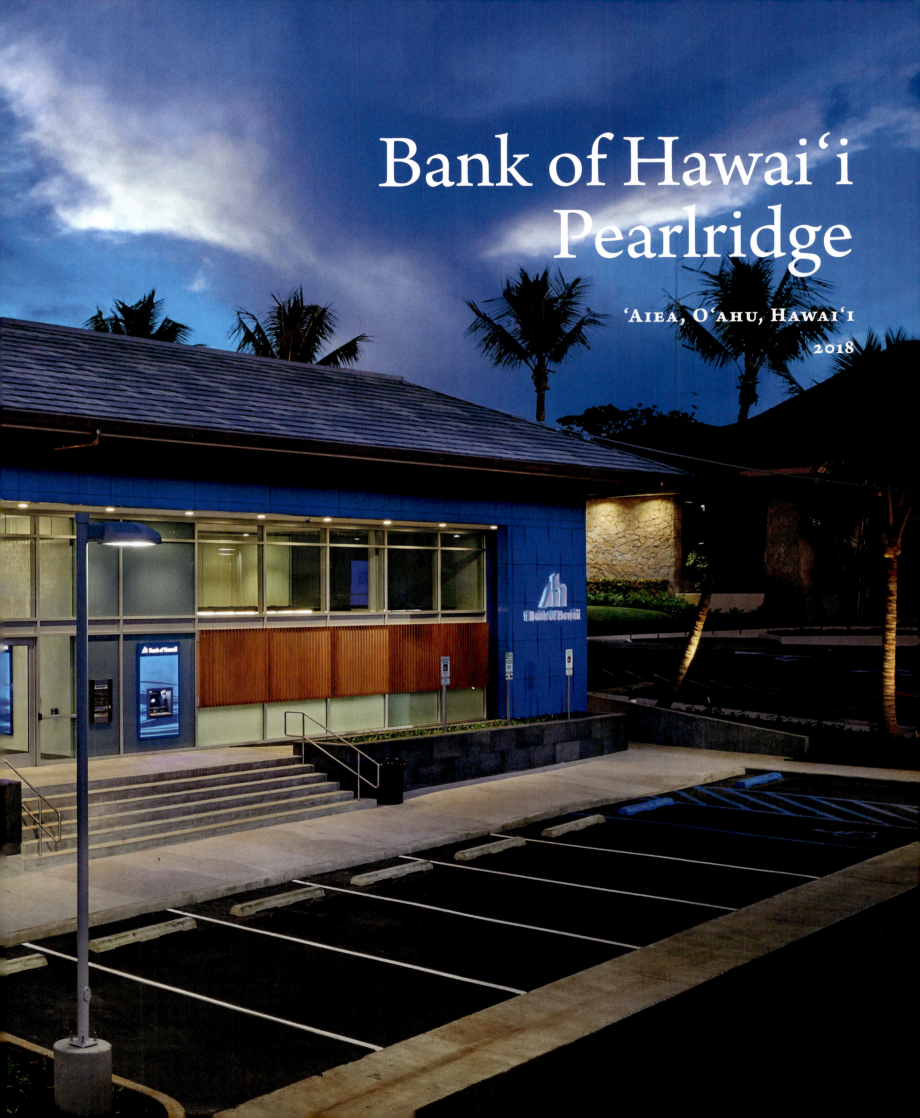

Bank of Hawaiʻi Pearlridge

ʻAIEA, OʻAHU, HAWAIʻI

2018

The Bank of Hawaiʻi Pearlridge is designed to send a message— one of welcoming, openness, and community. This is a much different expression from bank buildings of the past, which were made to look like fortresses.

Bertram Goodhue's 1927 Bank of Hawaiʻi headquarters at South King and Bishop streets in downtown Honolulu had the solid walls and tiny windows of an Italianate palazzo. The building that replaced it, Leo S. Wou & Associates and Victor Gruen Associates' 1968 Bank of Hawaiʻi at the Financial Plaza of the Pacific, used the brutalist aesthetic— "dark concrete, massive, heavy, extreme proportions," as Peter describes it—to suggest its sturdiness. "Architecturally it's interesting. I think most people would be impressed by it," Peter says of the brutalist icon. "But today we're looking for a much more open, much more transparent appearance. This design, when you look at Bank of Hawaiʻi's past, it's 180 degrees from that."

The Bank of Hawaiʻi Pearlridge is part of the bank's "Branch of Tomorrow" initiative. Peter describes the new approach: "The bank becomes less about a fortress. Obviously, it's still a safe place to put your money, but it's more of a retail-type environment." As electronic banking and personalized banking experiences have grown, he explains, bank architecture needs to change to accommodate. PVA's design of Bank of Hawaiʻi Pearlridge provides for traditional bank features, such as consumer and commercial tellers and safe deposit vaults, but it also includes updated features, including a concierge station, a lobby/waiting area, semiprivate and private financial advisory rooms, and conference space. At just under 6,000 square feet, it is one of Bank of Hawaiʻi's largest Branch of Tomorrow. And with a start-to-finish time of only six and a half months, PVA was tasked with designing and constructing a large project in a little time.

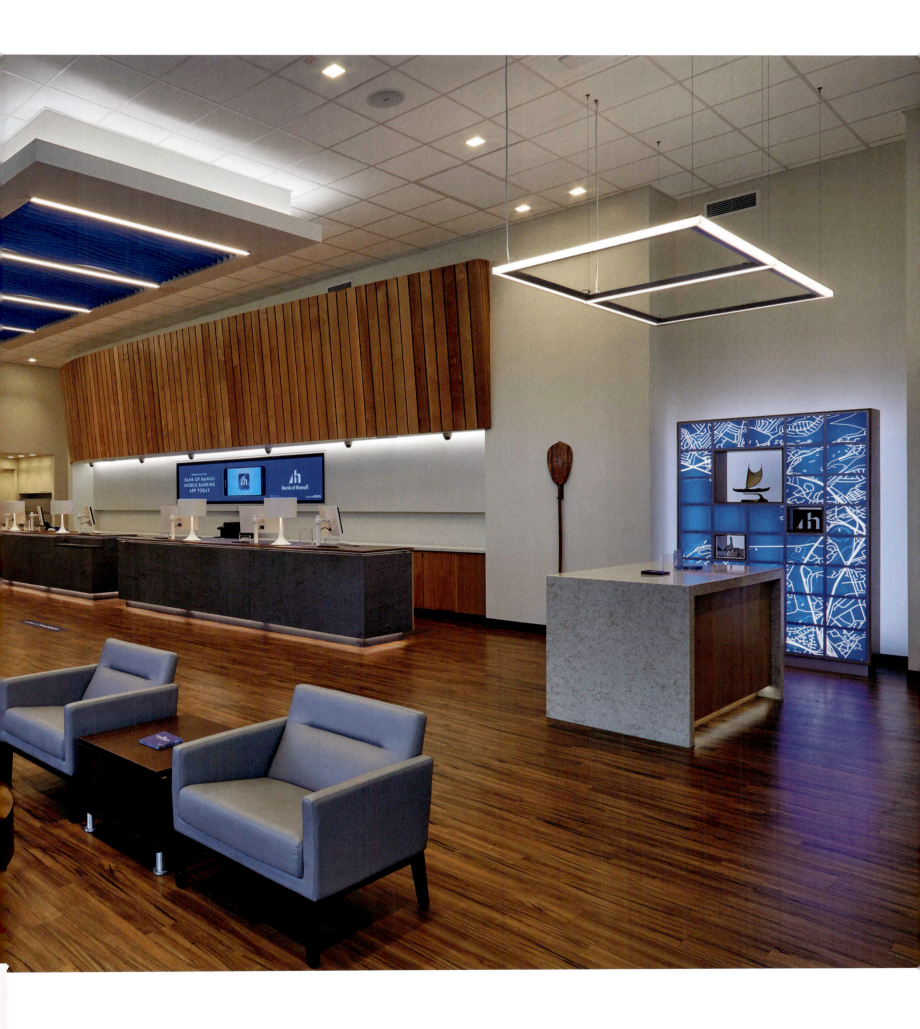

PUBLIC SPACES

Design incorporates lauhala-weave patterning, puka lava, and native plantings.

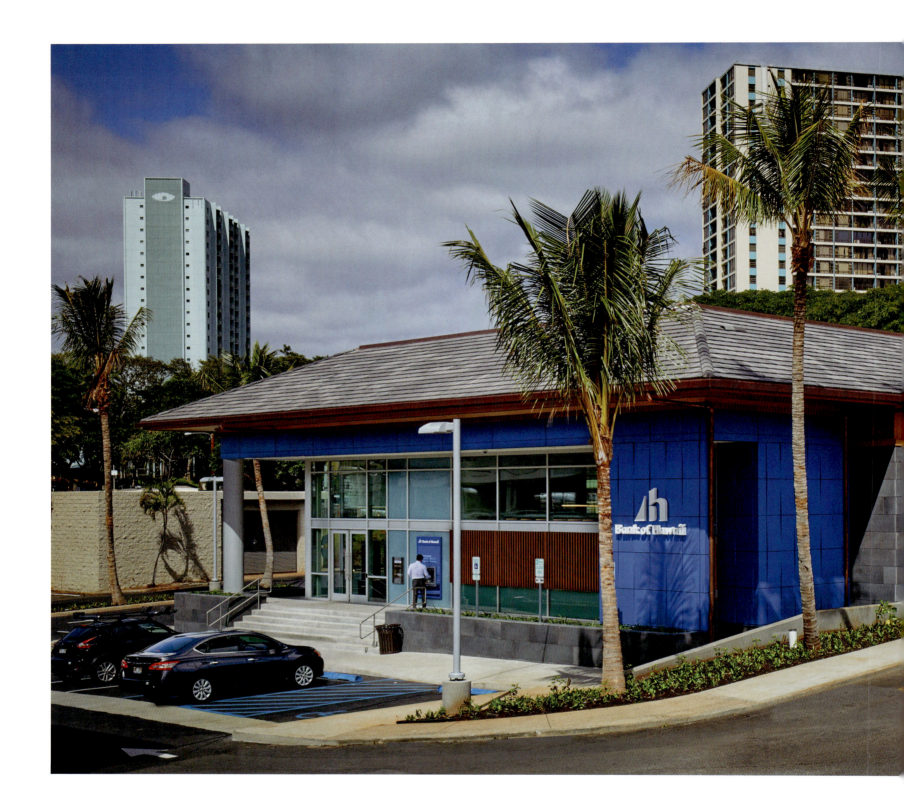

Advisory spaces create semiprivate areas for informal meetings.

In addition to its complex program, the design also needed to address a site much different than that of Bank of Hawai'i's downtown Honolulu headquarters. The stand-alone building is located next to the Pearlridge Center shopping mall, along busy Moanalua Road. Its proximity to Pearl Harbor and the Daniel K. Inouye International Airport makes this an active area. But the site is somewhat depressed, potentially hiding it from all the activity. PVA built up the bank to give it better visibility from the street. This allowed for a double-height interior, which works well for a banking hall.

The Bank of Hawai'i Pearlridge is contemporary yet reflects Hawaiian tradition. This is achieved with a modern take on the hip roof, use of natural materials, repeated geometric patterns, and native plantings. On the exterior, Bank of Hawai'i's signature blue color is complemented by a wood-toned aluminum soffit, blue-gray stone facing, and gray roof tiles. "The interior feels fresh," Peter says. Its wood floors, walls, and louvers bring an almost residential look to the design, while its large walls of monitors allow for changing displays. A branding wall features images and information about the community, such as local photographs or the branch manager's favorite noodle shop. Such images reinforce PVA's architectural incentive to foster a sense of connection between the bank and the community, "in a way that provides a friendly environment for its customers," Peter says.

AFTERWORD

Deborah L. Stanley

After twenty years of working with Peter Vincent Architects (PVA) on five different projects, I have come to appreciate that PVA is the firm to whom you hand your dream in order to make it come true. When I think of Peter and the time we spent in preparation for each project, I think of his quiet contemplation after listening to all my requirements, looking at all my collected photos and visiting my inspiration sites. It's a contemplation so lengthy that it made me wonder if he was still thinking about my project. However, when I saw his first sketches, I realized he heard every word and saw every picture and has masterfully woven them into a unique and totally cohesive design. He listened and he understood.

The beauty of Peter's approach is his ability to bring a global perspective to a very personal project. His international design experience, obtained from studying, living, and working around the world, is a lived experience, not a theoretical one. It is melded with his current exposure to the cutting-edge design he judges in national competitions for Lyceum's traveling fellowships in architecture. As a result, he is not tied to a geography or a genre and moves comfortably from designing a Hawaiian beach cottage to a sprawling California farmhouse. This breadth of expertise, combined with his almost complete lack of ego, enables Peter to thoughtfully create an environment that meets both emotional and functional needs, rather than impose a predetermined style on a client's life. His patience, flexibility and sense of humor gently guide the way to the ultimate creative destination.

Our most demanding project, the Los Gatos Farmhouse, is built on five hillside acres covered in oak trees. We began with a field trip to the Napa Valley, where we looked at homes, bridges, and commercial buildings with tree-studded surroundings. We drank wine and studied wood siding, stone flooring, dry stack walls, and winding roads. We wanted to build something that was simple yet elegant and that settled naturally into the rustic environment. We talked about accommodating both grandchildren and grandparents and wanting to be part of the land, not stand out from it. We discussed how we would live when there were only two of us in a large house, where we envisioned our families to be when they visited, and how we would entertain both small and large groups.

I would say that the time we spent with Peter, combined with his keen listening skills, enabled him to hit the mark with his design on the first pass. He placed the home perfectly down a winding road, over a bridge, and at the base of the hill, tucked beneath the heritage oaks. He assured that, at every turn, we could drink in the lush grasses, the oak canopy, and the ever-present deer. He brought the outside indoors by opening a great room onto an expansive porch, spanning both with rustic limestone floors and wire-brushed beams. The design felt as suited to the site as the historic barn that made way for the impending build. It was everything we were hoping for.

The real work began as we interfaced with an unyielding town in the process of abiding by creek setbacks, hillside restrictions, and environmental constraints. Peter continually kept in mind the totality of the project, bringing his expertise to bear on achieving our stated goals while at the same time complying with the never-ending requirements from the building department. Thankfully Peter's collaborative style enabled us to build a cohesive team of architect, builder, civil engineer, landscape architect, and interior designer—a team to which he was always responsive, available, and personally hands on. This was not a small feat when we were an ocean apart with a three-hour time difference.

Peter spent time upfront helping the builder to understand the design nuances of the project, which meant that very few problems were encountered during the build. His team-oriented approach created a comfortable environment in which questions were answered and obstacles easily overcome. Peter assured the flawlessness of the rough-sawn board-and batten-exterior by personally laying out the placement of every board as it encircled the house. The builders were in awe! The project went so smoothly and the outcome was such perfection that no one could believe our architect resided across the Pacific Ocean.

When we showed our newly completed home to family and friends, one of the first questions was always, "What would you have

Initial concept sketch of Los Gatos Farmhouse.

done differently?" And I would consistently respond, "Nothing (oh, except for the stone I selected in the powder room that continually had water spots)." People find it hard to believe, but I am sincere. Every detail was beyond what we envisioned, and Peter brought it all to reality, down to the smallest detail. He assured us that every enormous piece of our art was exactly placed and correctly lit, and that our collectibles had adequate homes on the abundant open shelving. Peter even designed a weathervane topped with the image of our German shepherd.

The ultimate compliment to Peter's work is that, shortly following the completion of the build, our Thanksgiving celebration comfortably accommodated twenty-five family members moving from the yard to the expansive porch to the great room with multiple family chefs preparing and serving in the open kitchen. It is the perfect family home, and a design like no other in our town. As I compare this and the other of our PVA projects, the common threads are livability, intimacy and warmth, informality, and openness to the outdoors—a recipe for an open invitation to family and friends.

We have since moved on to a hundred-year-old Spanish Colonial revival home much bastardized over the years by well-meaning residents. Peter is helping us to restore the beautiful structure to its former glory, and we trust that our now dear friend will work his magic once more.

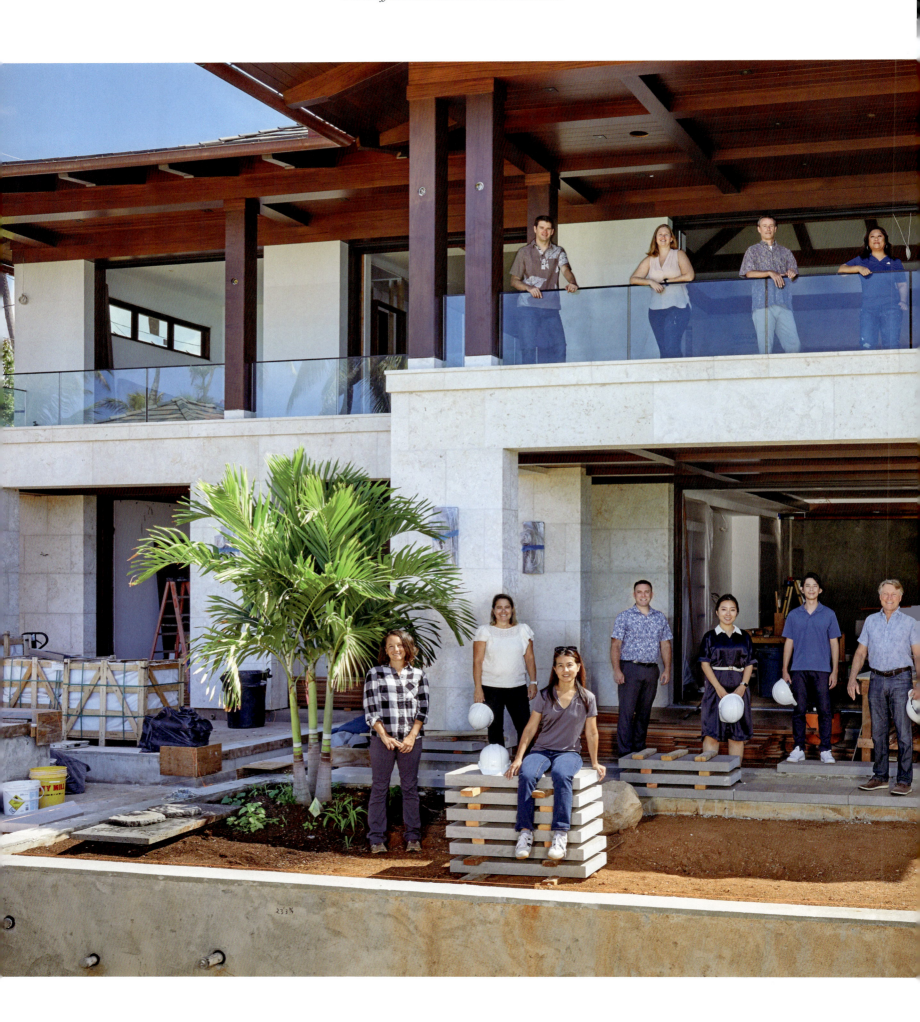
PVA staff at construction site visit to Haleakalā.

PETER VINCENT ARCHITECTS

Peter Vincent Architects (PVA) is a boutique architecture and interior design firm based on the Hawaiian island of Oʻahu. In projects throughout the Pacific and beyond, PVA crafts timeless, casually elegant works. The firm's design philosophy is to truly listen to and understand its clients and guide them in the process of creating enduring projects inspired by their locations. Sustainable principles and strong connections between the interior and exterior are guiding foundations of all PVA designs.

PVA's diverse and talented staff are led by partners Peter N. Vincent, FAIA; Michael Subiaga; and Todd Hassler, AIA, who take a hands-on approach, ensuring the highest level of service on each project. For more than thirty years, the firm's spectrum of styles and genres has responded to the unique needs and visions of each client. This diversity creates a unique portfolio of works born out of one common thread—design excellence.

www.pva.com

PROJECT CREDITS

MAUNALUA BAY ESTATE
Location: Honolulu, Oʻahu, Hawaiʻi
Date completed: 2002
PVA Staff: Peter N. Vincent, FAIA, NCARB; Wade Terao, AIA; Jared "Kaihaku" Chun; Sherri Smith
Structural: William Blakeney
Geotechnical: Weidig Geoanalysts
Civil: Bow Engineering & Development
Electrical: Leung & Pang Associates
Acoustical: D. L. Adams Associates
Home Automation: Home Automation Hawaii
Landscape Architect: The Mechler Corporation
General Contractor: Funke and Associates
Photographers: Tim Street-Porter (21T, 21BL), Augie Salbosa (21BR)

LANIKAI BEACH GRAND COTTAGE
Location: Winward Oʻahu, Hawaiʻi
Date completed: 2002
PVA Staff: Peter N. Vincent, FAIA, NCARB; Elizabeth Hallock, AIA, ASID; Joey Ann Marshall
Structural: William Blakeney
Landscape Architect: Greg Boyer Hawaiian Landscapes
Interior Design: Peter Vincent Architects
Art Consultant: Kelly Sueda Fine Art
General Contractor: The Residential and Commercial Renovators
Photographer: Linny Morris

LUALAʻI
Location: Kailua, Oʻahu, Hawaiʻi
Date completed: 2021
PVA Staff: Peter N. Vincent, FAIA, NCARB; Kelly Heyer, AIA, LEED AP BD + C; James Reilly; Minatsu "Mitz" Toguchi, IIDA
Structural: William Blakeney
Geotechnical: Shinsato Engineering
Civil: Island Enginuity
Mechanical: Inatsuka Engineering
Electrical: Douglas Engineering Pacific
Lighting: KGM and Delta Light
Home Automation: Complete Home Entertainment Systems
Landscape Architects: Surfacedesign and HHF Planners
Water Features: Pacific AquaTech
Furnishings: Niche Beverly
General Contractor: MNM Construction with Maloney Construction and Point Line Construction
Photographers: Kyle Rothenborg (24–27, 29–37, 42B), Marion Brenner (28, 38, 39, 40–41, 41, 42T, 43–45)

WAIʻALAE RESIDENCE
Location: Honolulu, Oʻahu, Hawaiʻi
Date completed: 2020
PVA Staff: Peter N. Vincent, FAIA, NCARB; Tom Kelleher, AIA;

James Reilly
Structural: William Blakeney
Geotechnical: Shinsato Engineering
Civil: Island Enginuity
Home Automation: Home Systems by Design Hawaii
Landscape Architect: HHF Planners
Interior Design: Indigo Republic
Art Consultant: Kelly Sueda Fine Art
Custom Furniture: Terry Doyle/Axiom Design
Owner's Representative: RPAPA Construction
General Contractor: Mokulua High Performance Builders
Photographer: Kyle Rothenborg

HALE PALEKAIKO
Location: Kailua, O'ahu, Hawai'i
Date completed: 2015
PVA Staff: Peter N. Vincent, FAIA, NCARB; Grant Chun, AIA; Wade Terao, AIA; Sherri Smith
Structural: William Blakeney
Civil: Bow Engineering and Development
Electrical: Leung & Pang Associates
Home Automation: Home Automation Hawaii
Landscape Architect: Greg Boyer Hawaiian Landscapes
General Contractors: Dan O'Sullivan Construction (original), The Residential and Commercial Renovators (completion)
Photographers: Kyle Rothenborg (58–59, 62–66, 68B, 69B), Andy Landgraf (60–61, 67, 68T, 69T, 70–73)

LOS GATOS FARMHOUSE
Location: Los Gatos, California
Date completed: 2019
PVA Staff: Peter N. Vincent, FAIA, NCARB; Kelly Heyer, AIA, LEED AP BD + C; Sherri Smith
Structural: Anderson Architects
Geotechnical: Earth Systems Pacific
Civil: Westfall Engineers
Architect of Record: DZ Design Associates
Landscape Architect: Kikuchi + Kankel Design Group
General Contractor: Mason Hammer Builders
Photographers: Erhard Pfeiffer (74–86, 87T, 87BL, 88–89), Ali Atri (87BR)
Rendering: Carter Black (90–91)

VENICE MODERN RESIDENCE
Location: Los Angeles, California
Date completed: 2019
PVA Staff: Peter N. Vincent, FAIA, NCARB; Brad Ladwig, AIA, NCARB
Architect of Record: Gabriel Ruspini Design
Structural: Structural Design Plus
Landscape Design: Alexander Champagne Landscape Design
Interior Design: Amber Interiors
General Contractor: Potter Mallis
Photographers: Luke Gibson (92–97, 101T, 103, 104), Erhard Pfeiffer (98–100), Tessa Neustadt (101B, 102, 105)

HALEAKALĀ
Location: Honolulu, O'ahu, Hawai'i
Date completed: 2023
PVA Staff: Peter N. Vincent, FAIA, NCARB; Todd Hassler, AIA, NCARB, LEED AP; Mary Rose Cacchione, AIA, LEED AP BD + C; Mary Schmitt, AIA; Olga Zakharova
Structural: William Blakeney
Geotechnical: Shinsato Engineering
Civil: Island Enginuity
Home Automation: Home Systems by Design Hawaii
Landscape Architecture and sketches pages 114 & 117: HHF Planners
Lighting: David Wilds Patton Lighting Design
Interior Design: MJM Interiors
General Contractor: Gregory Design Build
Photographer: Matthew Millman

DIAMOND HEAD RESIDENCE
Location: Honolulu, O'ahu, Hawai'i
Date completed: 2001
PVA Staff: Peter N. Vincent, FAIA, NCARB; Wade Terao, AIA; Sherri Smith; Jule Lucero, ASID
Original Architect: Vladimir Ossipoff, FAIA
Structural: Michael Kasamoto
Landscape: Greg Boyer Hawaiian Landscapes
Interior Design: Peter Vincent Architects
General Contractor: Darcey Builders
Photographer: Linny Morris

LANIKAI HILLSIDE RESIDENCE
Location: Kailua, O'ahu, Hawai'i
Date completed: 2002
PVA Staff: Peter N. Vincent, FAIA, NCARB; Michael Subiaga; Karl Mench; Jule Lucero, ASID
Original Architect: Alvin Badenhop
Structural: William Blakeney
Interior Design: Peter Vincent Architects
Faux Finish: Avant Palette Fauxs & Plasters
General Contractor: Lyle Hamasaki Construction
Photographer: Eric Hernandez

TANTALUS RESIDENCE
Location: Honolulu, O'ahu, Hawai'i
Date completed: 2016
PVA Staff: Peter N. Vincent, FAIA, NCARB; David Cook, Associate AIA; Minatsu "Mitz" Toguchi, IIDA
Original Architect: Vladimir Ossipoff, FAIA
Structural: William Blakeney

Home Automation: Design Systems
Landscape Design: Leland Miyano
General Contractor: Tommy S. Toma Contractor
Photographer: Kyle Rothenborg

NĀ MANU 'EHĀ RESIDENCE
Location: Honolulu, O'ahu, Hawai'i
Date completed: 2007
PVA Staff: Peter N. Vincent, FAIA, NCARB; Brad Ladwig, AIA, NCARB; Jamie Jasina, ASID
Original Architect: Albert Ely Ives
Structural: William Blakeney
Geotechnical: Shinsato Engineering
Civil: Hida, Okamoto & Associates
Mechanical: Miyashiro & Associates
Electrical: Moss Engineering
Home Automation: Design Systems
Landscape Architect: Monaghan Landscape Architects
General Contractor: Sutton Construction & Cole-Brooks Construction
Photographer: Kyle Rothenborg

MOKULUA HILLSIDE RESIDENCE
Location: Kailua, O'ahu, Hawai'i
Date completed: 2006
PVA Staff: Peter N. Vincent, FAIA, NCARB; Elizabeth Hallock, AIA, ASID; Jared "Kaihaku" Chun; Audra Treadway
Structural: William Blakeney
Landscape Architect: Monaghan Landscape Architects
Interior Design: Josephine Fisher Interior Design
General Contractor: The Residential and Commercial Renovators
Photographer: Erhard Pfeiffer

KOKO KAI CLIFFSIDE RESIDENCE
Location: Honolulu, O'ahu, Hawai'i
Date completed: 2022
PVA Staff: Peter N. Vincent, FAIA, NCARB; Todd Hassler, AIA, NCARB, LEED AP; Sherri Smith; Xiaotian "Winny" Duan, D. ARCH, LEED AP BD + C; Minatsu "Mitz" Toguchi, IIDA
Structural: William Blakeney
Landscape Architect: Monaghan Landscape Architects
Interior Design: Peter Vincent Architects
Art Consultant: Kelly Sueda Fine Art
General Contractor: Canaan Builders
Photographer: Kyle Rothenborg (all images except 191), Adam Taylor 191

HONOLULU HILLSIDE RESIDENCE
Location: Honolulu, O'ahu, Hawai'i
Date completed: 2012
PVA Staff: Peter N. Vincent, FAIA, NCARB; Garry Neavitt, NCARB; James Reilly; Jamie Jasina, ASID; Benika Kawarabayashi, AIA, NCARB, LEED AP
Original Architect: Howard Wong
Structural: William Blakeney
Electrical: Electech Hawaii
Interior Design: Peter Vincent Architects
Owner's Representative: Nate Smith Studio
General Contractor: Armstrong Builders
Photographer: Olivier Koning

LOCAL MOTION FLAGSHIP STORE
Location: Waikīkī, O'ahu, Hawai'i
Date completed: 1998
PVA Staff: Peter N. Vincent, FAIA, NCARB; Max M. Guenther, AIA; Jean-Louis Loveridge, LEED AP; Kimberly Harshman
Structural: Libbey Heywood
Geotechnical: Dames & Moore
Civil: Hida, Okamoto & Associates
Mechanical: Prepose Engineering Systems
Electrical: Applied Engineering
Landscape Architect: Brownlie & Lee
Contractor: Canaan Construction & Design
Photographers: Linny Morris (211T), Kyle Rothenborg (211B)

ROKKAKU AUTHENTIC JAPANESE CUISINE
Location: Honolulu, O'ahu, Hawai'i
Date completed: 2006
PVA Staff: Hiroto S. Suzuki, AIA; Michael Subiaga; Miho Matsui; Ina Johnson Rinderknecht; Janelle Smith
Mechanical: DHT Engineering
Electrical: HDL Engineering
Interior Design: Peter Vincent Architects
General Contractor: Gon Enterprises
Photographer: Kyle Rothenborg

KOBAYASHI AND KOSASA FAMILY DINING ROOM
Location: Honolulu, O'ahu, Hawai'i
Date completed: 2019
PVA Staff: Michael Subiaga, Peter N. Vincent, FAIA, NCARB; Brad Ladwig, AIA, NCARB; Minatsu "Mitz" Toguchi, IIDA; Lisa Nguyen, ASID
Structural: KAI Hawaii
Mechanical: Engineering Systems
Electrical: Electech Hawaii
Kitchen: Mizo & Associates
Interior Design: Peter Vincent Architects
Graphic Design: James Peters Design
General Contractor: Constructors Hawai'i
Photographer: Andrea Brizzi
Drawing of Ahupua'a: "Makamalunohonaokalani" by Marilyn Kahale Used with permission from Kamehameha Schools.

HOAKALEI GOLF COURSE CLUBHOUSE
Location: 'Ewa Beach, O'ahu, Hawai'i

Date completed: 2019
PVA Staff: Todd Hassler, AIA, NCARB, LEED AP; Peter N. Vincent, FAIA, NCARB; Michael Subiaga; Mary Schmitt, AIA; David Cook, Associate AIA; Minatsu "Mitz" Toguchi, IIDA; Lisa Nguyen, ASID
Structural: KAI Hawaii
Geotechnical: Stewart Engineering
Mechanical: MCE International
Electrical: Electech Hawaii
Civil: R.M. Towill Corporation
ADA: MH Consulting
Kitchen: RK Sales
Landscape Architect: Brownlie & Lee
Pool: Pacific AquaTech
Interior Design: Peter Vincent Architects
FF&E Designer: Jan Yamamoto
General Contractor: Haseko Construction Management Group
Photographers: Andy Landgraf (220–221), Kyle Rothenborg (222–224)

KOʻA KEA HOTEL AND RESORT
Location: Poʻipū Beach, Kauaʻi, Hawaiʻi
Date completed: 2010
PVA Staff: Max Guenther, AIA; Peter N. Vincent, FAIA, NCARB; Sherri Smith; Jamie Jasina, ASID; Melody Kolich; Jessica Work; Minatsu "Mitz" Toguchi, IIDA; Grant Chun; Brent Wollenburg; Joey Ann Marshall; Jonathan Weintraub; Rick Khan; Lupe Zarate, Associate AIA; Damon R. Gray, Associate AIA
Structural: Englekirk Structural Engineers
Mechanical: E.D. Ayson Engineering
Electrical: Moss Engineering
ADA: Accessibility Planning & Consulting
Kitchen: RK Sales
Landscape Architect: Walters Kimura Motoda
Water Features: Pacific AquaTech
Interior Design: Anita Brooks Design with Tandem and Peter Vincent Architects
General Contractor: Ledcor-U.S. Pacific Construction
Photographers: Glenn Cormier

BANK OF HAWAIʻI PEARLRIDGE
Location: ʻAiea, Oʻahu, Hawaiʻi
Date completed: 2018
PVA Staff: Michael Subiaga, Peter N. Vincent, FAIA, NCARB; Brad Ladwig, AIA, NCARB; Sherri Smith; Minatsu "Mitz" Toguchi, IIDA
Structural: KAI Hawaii
Geotechnical: Fewell Geotechnical Engineering
Civil: Hida, Okamoto & Associates
Mechanical: Engineering Systems
Electrical: Electech Hawaii
Landscape Architect: Walters Kimura Motoda
General Contractor: Gateside / J. Kadowaki
Photographer: Kyle Rothenborg

ADDITIONAL CREDITS
front cover: Lualaʻi, Kailua, Oʻahu, Hawaiʻi, photo by Kyle Rothenborg
back cover: Mānoa Retreat, Mānoa, Oʻahu, Hawaiʻi, photo by Kyle Rothenborg, interior design by ODADA
2–3: Kailua Beach, Oʻahu, Hawaiʻi, photo by Andy Landgraf
4–5: Hale Moku, Hawaii Kai, Oʻahu, Hawaiʻi, photo by Kyle Rothenborg
6–7: Laniakea ʻOhana Retreat, Haleiwa, Oʻahu, Hawaiʻi, photo by Adam Taylor
10: Kailua Beach, Oʻahu, Hawaiʻi, photo by Augie Salbosa
12–13: Diamond Head Oceanfront, Oʻahu, Hawaiʻi, photo by Kyle Rothenborg
14: Lualaʻi, Kailua, Oʻahu, Hawaiʻi, photo by Marion Brenner
16: photo by Olivier Koning
18–19: Kaʻapuni Beach Estate, Kailua, Oʻahu, Hawaiʻi, photo by Kyle Rothenborg
132-133: Mānoa Retreat, Mānoa, Oʻahu, Hawaiʻi, photo by Kyle Rothenborg, interior design by ODADA
208: Bank of Hawaiʻi, Surfrider room foyer, Honolulu, Oʻahu, Hawaiʻi, photo by Olivier Koning
240–241: photo by Kyle Rothenborg
246–247: Hanapēpē Estate, Honolulu, Oʻahu, Hawaiʻi, photo by Andy Landgraf

Special thanks to Lani Maʻa Lapilio of Aukahi Cultural Consulting for Hawaiian-language review.

CONTRIBUTORS

Clare Jacobson is a San Francisco–based design writer and editor. She is the author of the books *New Museums in China* and *Ten Principles for Urban Regeneration,* and co-author of *Jigsaw City* and *Karlssonwilker Inc.'s Tell Me Why.* Her articles have appeared in *Architectural Record, Interior Design, Landscape Architecture, Engineering News Record,* and other magazines. www.clarejacobson.com

Malia Mattoch McManus was raised in the small beach town of Kailua, Hawaiʻi on Oʻahu. She spent a decade reporting and anchoring the local news in Honolulu. She authored *The Hawaiian House Now* and *Dragonfruit*, a novel about 1891 Hawaiʻi during a time of historic upheaval. She continues to write and report for Hawaiʻi publications.

Deborah L. Stanley has collaborated with PVA on five residential projects located on the US mainland and Hawaiʻi over a span of twenty years. As a client, she brings a wealth of knowledge and design appreciation to a project. PVA has designed not only homes for Deborah and her husband, but also two different homes for her daughter and her growing family. She and her husband currently reside in a PVA-renovated home in Santa Barbara, California.